CELLULOID CHAINS

CELLULOID CHAINS

Slavery in the Americas through Film

Edited by Rudyard J. Alcocer, Kristen Block, and Dawn Duke

THE UNIVERSITY OF TENNESSEE PRESS
Knoxville

Library of Congress Cataloging-in-Publication Data

Names: Alcocer, Rudyard, editor. | Block, Kristen, editor. |
Duke, Dawn, 1965– editor.
Title: Celluloid chains : slavery in the Americas through film /
edited by Rudyard J. Alcocer, Kristen Block, and Dawn Duke.
Description: First edition. | Knoxville : University of Tennessee Press, 2018. |
Includes bibliographical references and index. |
Identifiers: LCCN 2018009751 (print) | LCCN 2018009998 (ebook) |
ISBN 9781621903284 (pdf) | ISBN 9781621903277 (hardback)
Subjects: LCSH: Slavery in motion pictures. | Motion pictures—America—
History and criticism. | Blacks in motion pictures. |
African Americans in motion pictures. | Motion pictures—Political aspects—America. |
BISAC: ART / Film & Video.
Classification: LCC PN 1995.9.S557 (ebook) | LCC PN1995.9.S557 C45 2018 (print) |
DDC 791.43/655—dc23
LC record available at https://lccn.loc.gov/2018009751

CONTENTS

ACKNOWLEDGMENTS vii

INTRODUCTION
The Broken Mirror of Memory:
Reflections on the Power of Slavery Films ix
 Rudyard J. Alcocer

Slavery in Service of the Revolution
in Sergio Giral's *El otro Francisco* 1
 Julia C. Paulk

Roots: The Re-making of Africa and Slavery
in the American Mind 24
 Robert J. Norrell

Inheriting Chains: Lighting Effects
in Humberto Solás's *Cecilia* 40
 Haley Osborn

Afro-Peruvian *Cimarrones*: Raiding
the Archives and Articulating Race 59
 Rachel Sarah O'Toole

Exoticization, *Mestiçagem*, and Brazilian National
Consciousness in Carlos Diegues's *Quilombo* 83
 Ignacio López-Calvo

Of Slavery and Humanity: Focus, Metaphor,
and Truth in Werner Herzog's *Cobra Verde* 104
 Rudyard J. Alcocer

Unshackling the Ocean: Screening Trauma and Memory
in Guy Deslauriers's *Passage du milieu ~ The Middle Passage* 121
 Anny Dominique Curtius

Mulattos and the Challenges of the Third Space
in *Roble de Olor / Scent of Oak* 147
 Mamadou Badiane

(Dis)Figuring the Plantation: Discourses
of Slave Space in Lars von Trier's *Manderlay* 163
 Edward R. Piñuelas

Exploring the Ugly Truth: Cinema of Integration,
Slavery, and the Poetics of Beauty in *El cimarrón* 180
 Nemesio Gil and Mirerza González-Vélez

Case départ: Slavery in Martinique
through the Lens of Comedy 198
 Gladys M. Francis

Django Unchained: Slavery and
Corrective Authenticity in the Southern 222
 Dexter Gabriel

Telling the Tula Slave Revolt: A Creolizing
Affair with Neo-Colonial Implications 242
 Daniel Arbino

This Film Called My Back: Black Pain
and Painful History in *12 Years a Slave* 262
 Janell Hobson

Exposed on Film: The (Un) Promised Land
of Nova Scotia in the Miniseries *The Book of Negroes* 277
 Emily Allen Williams

CONCLUSION
On Film, Historiography,
and Teaching the "Experience" of Slavery 299
 Kristen Block

APPENDIX
Additional Films about Slavery 311

CONTRIBUTORS 319

INDEX 325

It is not easy to pinpoint the origins of *Celluloid Chains*. All of us, editors and contributors alike, have been moved by the many wonderful films about slavery in the Americas that have appeared in recent decades and by the ongoing societal issues they register. It is fair to state, however, that the volume could not have appeared if Dawn Duke had not suggested that I organize a faculty seminar on Latin American and Caribbean Studies through the University of Tennessee's Humanities Center. This seminar has facilitated my acquaintance with several faculty members at UT who share an interest in Latin America and the Caribbean. In my first meeting with Kristen Block—one such faculty member—she asked which films about slavery I used in the classroom. Gradually, this question led me to the realization that at the time no comprehensive volume existed on films about slavery in the Americas. The rest, as they say, is history, and for this I owe a debt of gratitude to both Dawn and Kristen. I am further indebted to Chris Holmlund for her encouragement and to Millie Gimmel for her help in recruiting contributors. Furthermore, Haley Osborn, a doctoral candidate in UT's Hispanic Studies program (and a contributor to the volume in her own right), has been instrumental in countless ways: she has reviewed and indexed nearly all the submissions, and her efforts have greatly expedited the entire production process. Warm and heartfelt gratitude is also due to the Forrest and Patsy Shumway Endowment and to the University of Tennessee Press, which has guided the project since its inception. Lastly, I owe a debt of gratitude to the late Gabriel García Márquez: his brief reference to the broken mirror of memory in his classic 1981 novella *Chronicle of a Death Foretold* inspired the title of the introduction.

—RUDYARD J. ALCOCER

Without the challenge of teaching about the history of slavery in the Americas at Beloit College, Florida Atlantic University, and the University of Tennessee, Knoxville, I might never have delved so deeply in the connected spheres of film history and historiography. I want to first thank all the students who took my classes on slavery, and who sought to deepen their own understanding of the history and cultural memory surrounding slavery in the Americas. Gratitude is

also due to the participants in the roundtable entitled "Imagining the Unimaginable: Film, Fiction, and Fabulation in Narratives of New World Slavery," held at the 2015 meeting of the American Historical Association, as well as audience members who provided invaluable feedback to a paper that eventually became my contribution to this volume. In particular, the intellectual development of this project in particular owes a great deal to former and current colleagues Margaret Sumner, Kate Keller, Marisa Fuentes, Jenny Shaw, Christian Crouch, Elena Machado Sáez, Derrick White, Dawn Duke, and Rudy Alcocer.

—KRISTEN BLOCK

I would like to thank Dr. Rudyard Alcocer, professor of Spanish at University of Tennessee, Knoxville, for inviting me to be part of this book project. It was indeed a very rewarding experience working with him and Dr. Kristen Block, professor of history at UTK. There are not many occasions for faculty collaboration across disciplines, and it can be even more challenging is to get together and produce a publication. Under Dr. Alcocer's guidance, we worked well together and were able to compile a stellar collection of essays whose range and scope in many ways reflect the research interests and passion of the editors. A very special thank you to all the contributors who sent their texts and also to those colleagues who submitted but in the end were not published. It confirms the variety of scholars working on the topic and served as validation that the editors were on the right path in terms of the focus of this publication.

—DAWN DUKE

The Broken Mirror of Memory

Reflections on the Power of Slavery Films

Rudyard J. Alcocer

In June 2015, Rachel Dolezal's short-lived career in public service suffered a major and perhaps permanent setback. During this period doubts began to surface publicly with regard to Dolezal's racial identity which, according to job applications, she had described as White, Black, and Native American. Her mother, however, said that Dolezal was falsifying her racial identity, which was really almost entirely White, from a variety of European nations, and not at all Black. Compounding matters was the fact that Dolezal was the president of the Tacoma, Washington chapter of the National Association for the Advancement of Colored People (NAACP), not to mention a part-time instructor of Africana Studies at the University of Eastern Washington. In both her professional and personal lives, Dolezal had presented herself as an African American.

Dolezal's unmasking sparked a vigorous national debate that examined what it means to be African American. Despite her protestations that as a human she is technically of African descent, the court of public opinion was unconvinced and she was forced to step down from her position with the NAACP. While she may be "American," as in a citizen of the United States, she cannot lay claim— the argument went—to the crucial adjective that precedes the hyphen. For one, while she may have had ancestors living in Africa seventy thousand years ago, that is far too long ago to claim a meaningful African cultural, historical, and/ or genetic heritage.

In the U.S., Dolezal's country of residency, and in the rest of the Americas, whether North or South America, or the Caribbean region, being African American, i.e., of African descent, strongly suggests an additional legacy to which she was unable to lay truthful claim as a direct descendant: the legacy of slavery. In an online column hosted by Black Entertainment Television, Britt Middleton commented on the link (or its absence) between this legacy and Dolezal: "The sobering reality is that, unlike white people, we can't paint the brown on for as long as it serves us. We have been enslaved, beaten, belittled and even killed over our Blackness" (Middleton). This volume focuses on the first of these offenses: enslavement.

Slavery in the Americas is the transoceanic, centuries-long, world-altering regime of oppression, violence, and resistance so commonly associated with the region's residents of African descent, especially those who have been in the Americas more than just two or three generations, in other words since before the various moments of abolition spread out historically across the Americas. In sum, the case of Rachel Dolezal underscores, among other things, the crucial importance in the U.S., at least, of persistent official and unofficial schemes of racial categorization, and the ways in which such schemes are linked to complex historical phenomena, like the institution of slavery, that provoke—when we remember these historical phenomena—awkwardness if not pain and rage.

Anyone with any doubts about the ongoing social and historical importance of slavery would do well to consider the importance cinema has placed on the institution during nearly the entire history of the artistic medium. *Celluloid Chains*, the volume in your hands, casts a necessary, multifaceted new light on this cinematic genre: namely, films about slavery in the Americas. It is, to date, the most complete collection of critical essays (all original to this volume) on the genre and is, in fact, the first collection of its kind: a multi-authored volume expressing a range of disciplinary, ideological, and geographical interests and points of view, and in which each contributor focuses on a specific film. The most similar prior volume is probably Natalie Zemon Davis's slim but insightful study from 2002, the single-authored *Slaves on Screen*. One might say that *Slaves on Screen* is a stepping stone for *Celluloid Chains*. The number of films treated in the present volume has grown to fifteen from the five in *Slaves on Screen*; furthermore, there is no repetition between *Celluloid Chains* and its predecessor in terms of the films treated. For those readers wanting to learn more about *Spartacus* (1960), *Burn!/Queimada* (1969), *La última cena* (1976), *Amistad* (1997), and *Beloved* (1998), I encourage them to consult *Slaves on Screen*.

Readers engaged with Davis's general interest in acts of resistance among the enslaved in the films she examines may be hard-pressed to identify comparable

thematic unity within the expanded filmic range of *Celluloid Chains*, some of whose contributors examine films that—far from illustrating the resistance of the enslaved—border on the comic and/or absurd, and are critiqued by some contributors as exemplifying the opposites of resistance (i.e., ambivalence, passivity, and/or complicity with respect to institutions of slavery). Before a more detailed description of the specific chapters of the present volume, some comments on the volume's title and subtitle will help outline its scope and complexity.

ON THE TITLE AND SUBTITLE

Although one might be justified in assuming that the "Celluloid Chains" of the title refers to cinematic representations of captivity in general (perhaps even a pleasurable, romantic "captivity"), that person would be mistaken. "Celluloid Chains" refers, of course, to a very specific type of cinematic representation of captivity: slavery; the "chains" of the title refers in a metonymic manner to one of the principal (but by no means only) objects of bondage, an object often symbolically associated with the institution of slavery as a whole. Furthermore, in an era when even DVDs can seem outdated in comparison with newer technologies like digital streaming, perhaps "Celluloid" has become obsolete in its ability to refer to motion pictures. We disagree: despite the ubiquity of newer technologies, most readers will know that motion picture reels were made from celluloid and that celluloid commonly conjures associations with cinema.

The subtitle, too, merits commentary. Although in practice all terms in the subtitle function together in such a way that it is hard to extricate one term from the next, a focused look at each of these terms will shed light on the volume as a whole. We can begin with what for the purposes of this study is the least complicated term in the subtitle: "film," a term that not unlike "celluloid" may, technically, be increasingly antiquated. Innumerable studies of often terrific theoretical sophistication have shown the complexities of film. Although the entire volume focuses on individual films, we do not interrogate the nature or theory of the medium per se. That does not mean, however, that the volume would hold no interest to scholars of film. Broadly stated, *Celluloid Chains* will be of interest to anyone seeking to learn more about films depicting slavery in the Americas, regardless of which of the three terms in the subtitle is of greatest interest. In addition, the films in the study operate within a fluid and broad definition of the medium: *Celluloid Chains* includes feature films of varying degrees of fictionality and historical accuracy from a number of national and multinational film industries. There are also essays focused on documentaries of a number of

styles, including docudramas, fictionalized academic lectures, and avant garde, hybrid forms that blur conventional distinctions between documentary and fiction film. Some of the more interesting motion pictures depicting slavery in the Americas were television productions. Even though these serialized dramas were made for the small screen, this does not mean that their societal impact was also small; as such, the two essays in the volume that focus on television productions provide an invaluable complementary perspective on cinematic representations of slavery in the Americas. In addition, we shall see that films about slavery have varying origins: some are based on slave narratives written by enslaved or formerly enslaved people; others are based on fictional texts about slave life and were written—for a variety of reasons—by free people (including members of master classes) during periods of slavery (which varied depending on the location); yet others are based on famous and well-documented legal proceedings, while others are what Ashraf Rushdy has described as neo-slave narratives, i.e., "modern or contemporary fictional works substantially concerned with depicting the experience or the effects of New World slavery" (533). Finally, several films in the genre are based on scripts original to the filmmakers.

Conversely, in other respects *Celluloid Chains* operates within a limited understanding of visual representation. For example, we do not examine painting, sculpture, theatre, installation art, and so on, even if some of the films discussed are in some ways related with those art forms; in short, our focus is on cinematic discourse. It must be noted that there are at least two forms of such discourse that could have been included, in theory at least, but are not. An example that comes to mind is music videos, which have been known to represent slavery in the Americas (the late Joe Arroyo's 1986 salsa number "Rebelión," for instance). Another potential form is animated films about slavery in the Americas, of which there appears to be no examples with the exception of tangentially related animated films by Walt Disney: *Mickey's Mellerdrammer* (1933), which features the eponymous rodent in black face, and the partially animated *Song of the South* (1946), which depicts—in controversial manner—formerly enslaved people in the southern U.S.

The next portion of the subtitle that we will consider is the term "Americas." Each of the films in the study focuses either entirely or significantly on the Americas, whether North or South America or the Caribbean: regions that in an age of academic specialization are seldom viewed through the same lens. This focus, for instance, eliminates from our consideration films like *The Ten Commandments* (1956), the aforementioned *Spartacus*, and *Gladiator* (2000), all of which depict slavery in the Mediterranean of antiquity, as well as any other slavery film of

little or no thematic relevance to the Americas. Granted, not every area of the Americas is represented (or equally represented) in the volume: some areas, Canada, for instance, are not commonly associated with slavery. As such, even though Canada is known as being the preferred destination of enslaved persons using the Underground Railroad, there is, as of this writing, only one Canadian film about slavery, per se: the 2015 CBC television miniseries *The Book of Negroes* (see Emily Allen Williams's essay in this volume). Other areas are more closely associated with slavery, i.e., slavery existed there in a pronounced way during a significant period of time. The Dominican Republic and Mexico are examples of such areas; these countries, however, with the exception of *Yambaó*—a syrupy 1956 co-production between Cuba and Mexico that was filmed in Cuba—have to date produced barely any cinema that centers on the topic even though such areas (in this case nations) do have film industries, albeit a small one in the case of the Dominican Republic. On a related note, one of the underlying questions of this volume is why some areas within the Americas have a film industry more interested in slavery than others. Although later we will see variations on this question and address them, it is worth noting that the country in the Americas with the largest film industry, i.e., the U.S., has also produced the most films about slavery. What are the reasons, beyond the sheer size of this industry, that account for the number of films about slavery produced in the U.S.?

The U.S., however, is not the only producer in the Americas of films on slavery. This fact may seem to go without saying, but that is probably not the case. There is a common misconception among people in the U.S. that there were few if any Blacks, let alone slaves, in the entire hemispheric region south of the U.S.-Mexico border. That there have been films on slavery produced in a number of regions in the Americas may be of further surprise. Several of the films discussed in the volume were made in a number of Caribbean countries, including Cuba, Puerto Rico, and Curaçao. Brazilian cinema has also made important contributions to the genre. These film productions vary with respect to the degree of nationalization or bureaucratization of the cinema industries in their respective countries, with post-1959 Cuban cinema likely being the one most intensely managed by the state.

What about films that are set primarily outside the Americas? There are, for example, films set in England that pertain to the movement in that country during the late eighteenth and early nineteenth centuries to abolish the trade in enslaved Africans: *Amazing Grace* (2006) and *Belle* (2013). Because they do not directly depict slavery, however, we do not examine these films despite the fact that the events they recount shaped the destiny of both the Transatlantic

world as a whole as well as its constituent parts, which include the Americas, Europe, and Africa. The last of these areas merits additional commentary. For several hundred years it was almost always Africans who were captured and taken in bondage to the Americas. Other social groups besides Africans were also enslaved in the Americas, beginning with untold numbers of indigenous Americans. Especially before Bartolomé de las Casas encouraged Spain in the early sixteenth century to spare the indigenous Americans and to look to Africa instead for enslaved persons, the former group was subjected to a range of forced labor schemes. While indentured servitude was the type of forced labor scheme most commonly associated with Europeans (and, later, Asians) in the Americas, there are reported cases of enslaved Europeans in the Americas: as David Brion Davis explains, "In 1600 there were a few Greek and Slavic slaves in Spanish Havana ..." (49). Nonetheless, according to Leslie Rout, in the Americas and in a process that occurred very gradually beginning in the sixteenth century, slavery came to be associated the "black" skin color; in other words, with sub-Saharan Africans and their descendants in the Americas. There was, he argues, a

> growing correlation in the minds of all—Spaniard, American Indian, and African—that dark skin and debasing labor went together. Over the centuries, this may have been the greatest of all crimes committed against the New World's Negroid peoples. (Rout 79-80)[1]

Given the prodigious amount of forced labor that enslaved persons of African descent performed in the Americas, they were instrumental in shaping the hemisphere as we now know it. Indeed, according to Davis, prior to 1820 "more than three quarters of those who sailed toward the Americas were African slaves" (80).

In keeping with Rout's observation regarding the racialization of slavery, social groups besides Africans and their descendants are seldom associated in any general way with the fact of having been enslaved although many non-Africans *were* enslaved (including, for instance, Yucatecan Mayans who were sent to Cuba as slaves during the nineteenth century). Indigenous groups, in contrast, are often associated with the Conquest of the Americas and in varying ways with European colonial programs during the decades and centuries that followed. Perhaps mirroring the relative lack of a popular association between slavery in the Americas and any groups besides Africans and Afro-descendants, films about slavery in the Americas tend to be about the enslavement of these groups. Reasons for such a cinematic emphasis may include such powerfully dramatic realities as 1) the staggering number of sub-Saharan Africans victimized by the

Atlantic trade in enslaved Africans (numbers that are commonly estimated to range from twelve to twenty million); 2) the fact that the enslavement of indigenous Americans occurred earlier during the various European colonial projects, while the peak of both the Atlantic trade and the absolute number of enslaved persons in America occurred more recently and in both cases involved Africans and Afro-descendants; and 3) the fact that the most powerful film industry in the world is in a country, the U.S., in which the institution of slavery was long in duration, large in scope, and which has transmitted to the present day social wounds that are far from being healed; indeed, historical slavery is now accepted as a determining force in making the U.S. the country that it is, for better or worse. In contrast, Mexicans often forget that there was a sizable population of enslaved Africans during this country's colonial period.[2] Meanwhile, there is no shortage of films depicting the brutalities committed against indigenous American groups, brutalities that include torture, forced or exploitative labor, corporal and psychological punishment, and so on. Films like Werner Herzog's *Aguirre, the Wrath of God* (1972), Roland Joffé's *The Mission* (1986), and Nicolás Echevarría's 1991 *Cabeza de Vaca* come to mind. Still, while the indigenous groups depicted in these films may have been subjected to treatment that resembles the ways enslaved persons were treated, the former were neither called slaves nor thought of as slaves in those films.

If the films in the volume are without exception about the captivity of Africans and Afro-descendants in the Americas, how, then, and to what extent do the films register the importance of Africa? While some of the characters (or voices) in the film do make pointed, often nostalgic, mention of Africa, the continent is more often felt through suggestion, i.e., through the use of or admiration for African objects, words, traditions, and mindsets. Occasionally we witness some characters express or show their fear and/or contempt toward these same items of African derivation. On a slightly different note, it bears mentioning that—with the exception of *Cobra Verde* (1987)—none of the films that form part of this volume were filmed mostly or entirely in Africa. The scenes in *Roots* (1977) that are set in Africa, for instance, were filmed near Savannah, Georgia. Furthermore, although there are a number of fine African films that depict some form of slavery (or slave raids, as is the case in the 2000 film from the Ivory Coast, *Adanggaman*), such depictions are often centered on the slavery-related atrocities that were committed in Africa prior to the Middle Passage across the Atlantic. As such, these films emphasize the pain wrought within Africa by the institutions of slavery and the Atlantic trade, as opposed to slavery as it would play out in the Americas. As African film industries continue to grow, it will be

interesting to see how African filmmakers depict slavery in the Americas if a given film calls for such a depiction.

The *place*, then, of the films in *Celluloid Chains* can be a complex matter: they are, taken as a whole, primarily but not exclusively set in a specific region of the Americas, in which *region* usually corresponds to contemporary nation/ states and their respective film industries. In other words, a film on slavery that is filmed and set in Brazil will almost always provide a glimpse into historical slavery in that particular country. This is a pattern worth pondering inasmuch as it speaks to the power not just of the ideal of the nation/state and what are often film industries conceived and organized along nationalistic lines, but also to the forcefulness of all the trappings of nationhood: a shared language, shared traditions, visions—sometimes contested—of a common history, and so on. Furthermore, that films about slavery are often closely linked to individual, national film industries suggests the perceived importance of historical slavery in the development of the respective national societies.

Just because a film is made and set in a given region of the Americas does not mean, however, that its makers or producers are from the same region, or even from the Americas. The broader question can be expressed in three parts: who is making these films, where are they from, and should that matter? We can begin by stating that, unlike—for example—the case of a single-authored, nineteenth-century slave narrative, these films are a collective enterprise and are "made" or created by numerous individuals, often hundreds, including producers, actors, technicians, and so on. Given this large number of participants, it is often the case that they hail from various regions not only of the Americas but the world. Without delving into complex theoretical debates involving the authorship of films, it bears mentioning that, occasionally, the essays in this volume register, to varying degrees, tensions involving the place of origin and/or nationality of the creators of the film, as well as the possible motives they had in making the film. With respect to motives, nineteenth-century slave autobiographies provide an instructive contrast with cinema as their authors usually had easily identifiable and/or pragmatic motives in writing about their experiences. Annette Niemtzow provides an account of these motives—or in her phrasing—"motivations," a term that strikes me as being more positive and less often associated with self-interest and deceit:

> Ostensibly, the primary motivation was to woo white readers to ha-
> tred of slavery and to love of abolition; many narratives were written
> at the urging of white sympathizers. But white encouragement and

a sense of moral responsibility do not provide sufficient motivation. There were other motivations, too, motivations the slave writer shares with all other autobiographers, who attempt to describe a self—no matter how painful to acknowledge—before it disappears, to describe a self which, no matter how despicable, is so fragile that unless it exists on paper, it will hardly exist at all. (Niemtzow 96)

Yuval Taylor expands on the preceding description of motivations and uses, instead, the related notion of *function*, i.e., the functions or objectives of slave narratives. In making his description he refers first to another writer:

> "The function of the slave narrative," writes Crispin Sartwell, "is apparently straightforward: resistance to oppression by speaking the truth"—or, to quote a current catchphrase, "speaking truth to power." But this is the *central* goal, not the only one. Considering the great variety of narratives, one might name seven distinct functions: to document the conditions of slavery; to persuade the reader of its evils; to impart religious inspiration; to affirm the narrator's personhood; to redefine what it means to be black; to earn money; and, last but not least, to delight or fascinate the reader. (Taylor xvii)

We shall return to the last of these functions later in this essay. For now we can explore some interesting differences between the slave narratives Niemtzow and Taylor describe and the cinema of slavery. In contrast to the collective elements often associated with the production of films, usually no more than a few people were involved in the "authorship" of a slave narrative: the former enslaved person her/himself, maybe an amanuensis, and occasionally a sponsor or benefactor, to name just some of the very few typical collaborators. In addition (and in contrast to written slave narratives), it appears that no former enslaved person in the Americas became, after their liberation, a filmmaker. Thus, not only do filmmakers need not be formerly enslaved persons, but they also need not share cultural and ideological perspectives similar to the enslaved persons they depict and/or such perspectives as are held by the descendants of the enslaved. Lastly, if the enslaved or formerly enslaved person assumed significant personal risks in writing and publishing his/her narrative, what sort of risk do the filmmakers assume? While certainly any filmmaker runs the risk of ridicule and a negative critical assessment, few (and none of the filmmakers related to this volume) faced potential physical harm or enslavement on account of their film. The most likely serious negative outcome for the makers of slavery film is

marginalization from a nationalistic film industry if—for example, throughout much of the history of revolutionary Cuban cinema—a film is perceived by the authorities as not being sufficiently supportive of a revolutionary agenda. Another risk recalls the sixth function in Taylor's list of functions of slave narratives: to earn money. Filmmaking is often a capital-intensive enterprise and it is sometimes the case that inexpensive films make a fortune and expensive films flop. While few filmmakers will state openly that one of their significant motivations in making a film is to make money, given the costs of producing a film, it is generally understood that most films must at the very least earn some sort of profit, if not a fortune. Related to these financial realities is—as some of the essays in this volume show—the perception that some filmmakers have questionable motives: that is, they are mercenaries guided by the possibility of fame and riches, or some sort of hero complex, and are blind to the ideological subtleties involving the relationship between themselves and the societies they purport in some ways to speak for in their films.

A pivotal question seems to be, "whose story is being recounted in the film and who has the right (whether cultural, political, geographical, and so on) to recount it?" In terms of the possessive pronoun *whose*, how is such possession determined and by whom? Furthermore, can the "right" to recount be parceled out into degrees of "rightness"? If such a parceling does indeed occur, what logic governs the process? The questions are numerous and not easy to answer. Nonetheless, it is clear from this volume that numerous factors do matter as they pertain to the geographical background and identity formations of the "filmmakers," which is a term that often equals a film's director and producers. These factors include the relationship between the filmmakers and the communities represented in the film. Are the filmmakers, for instance, members of any of the communities depicted in the film and how is that membership defined? How, for that matter, is "community" defined? Do the filmmakers seem to have more in common with the community of enslaved persons depicted in the film or with the master class? Is the answer to this question based simply on the filmmaker's skin color? In addition, what impact does it have on the film if the filmmakers are or are not descendants of Africans who were enslaved? These questions, we shall see, are infinitely important. Similarly, the criticism of these films carried out by the contributors to the volume is complex and not often positive. One contributor, for instance, may praise a film's recreation of a slave revolt while another may critique an ostensibly similar revolt in a different film; interestingly, both evaluations may seem reasonable and justified.

Although the term or concept I now turn to does not figure explicitly into either the title or subtitle of the volume, it does serve as an undercurrent through-

out and as such warrants commentary. That concept is *time* and it is crucial; this concept, moreover, is closely linked to the systematic study of human change across time, i.e., the scholarly discipline of History. There are a series of questions pertinent to this discipline, and all the films in the study as well as their accompanying essays in some ways explore them: first, what was slavery like in terms both of the enslaved persons themselves, but also with respect to the masters and the broader cultures? In addition, how do we know this? What do we *not* know about slavery—whether as historians or as laypersons interested in history? Is an eighteenth-century receipt of a slave purchase any more or any less legitimate as an historical artifact than a contemporary, fictionalized first-person narrative account of the Middle Passage in the eponymous film? Why? Which one is more reliable from a historical standpoint? Which one better approximates "the truth" about slavery? The questions do not end there.

Taylor's outline of the functions of slave narratives suggests but does not fully encapsulate what has come to be seen as an additional and important—at least potentially so—function of films about slavery: to serve as instructional tools for learning about slavery. Such a function is premised on these films being at least somewhat historically accurate. While Taylor does explain that many eighteenth- and nineteenth-century narratives (whether factual or not, and whether focused or not on slavery) purported to "delight and instruct" (xviii), what I refer to here involves the capacity of slavery films to serve as teaching materials in university classrooms, a topic that Kristen Block explores more fully in the conclusion. Donald F. Stevens is probably accurate in stating that "more people today get their history in movie theaters, from broadcast and cable television, and on prerecorded videocassette tapes than from reading print" (4).[3] If, potentially at least, people are using films on slavery as their primary source of knowledge on the history of the institution, how reliable is this knowledge? With specific reference to the films of D. W. Griffith (who thought he could teach history in ways more interesting than historians could) and with general reference to historical films as a whole, Stevens draws negative conclusions as concerns the value of historical films as tools for the teaching of history. In this regard he agrees with fellow historian Robert Rosenstone, who has written, "Let's face the facts and admit it: historical films trouble and disturb (most) professional historians. Why? We all know the obvious answers. Because, historians will say, films are inaccurate. They distort the past. They fictionalize, trivialize, and romanticize" (5). Is there, then, zero or limited historical value to films about slavery? Should the sheer narrative force of a compelling film about slavery, *12 Years a Slave*, for instance, cause us to raise our guard as concerns its capacity to inform or instruct in a historical way? Or is it the case, conversely, that we are

deeply moved by such a film because we suspect that it is telling us the truth about what actually happened to Northup during the 1840s and 50s? While he addresses the slave trade in particular rather than slavery broadly writ, it is worth contemplating the historian Donald Harms's viewpoint on these issues:

> Although historical research has revealed a great deal about the mechanics of the slave trade, it leaves unanswered many questions about the emotions that such a brutal traffic generated, the corrosive effect on societies, the psychological scars on individuals, the way it corrupted slavers and captives alike, and the sheer horror and brutality of the trade in human beings. Such issues can perhaps be explored more effectively in novels, poetry or film than in footnoted historical studies. (60)

Paul Andrew Hutton reaches a similar conclusion about the general relationship between cinema and history: "It is simply ridiculous to expect films to be true to the facts of history. They are works of fiction. If, by chance, they use a story to tell us a greater truth about ourselves and our past then they have succeeded as art" (42). In sum, it may be difficult to paint with too broad of strokes the relationships between historical veracity and the narrative or aesthetic impact of the films analyzed in the study. On the contrary, we shall see that each essay in the volume addresses these questions (and answers them) in a unique manner as concerns the relevant films, each of which—in turn—must be assessed in terms of varying (and shifting) criteria of historicity and aesthetic aims.

An issue related to history and historiography involves memory: how and why do we remember something that may have occurred in the past? Similarly, is it possible to have a memory of something that did not happen to us, or that may not have happened at all? Just as memory and agreed-upon historical narratives are not necessarily identical, memory and remembrance can vary based on who is doing the remembering and the nature of the relationship between the subject of remembrance (i.e., the person who activates the memory) and the object of remembrance (in this case, the era of slavery), especially when the subject and object are separated—as is the case with slavery in the Americas—by decades, if not centuries. Needless to say, two individuals may behold the same historical phenomenon and activate it in entirely different, sometimes contradictory ways that can differ for innumerable reasons. Films about slavery in the Americas are in themselves acts of memory—almost always creative, usually polemical and controversial, and with varying commitments to historical accuracy—all notions

to which we shall return. For now, however, let us be clear about an important point: slavery films are as much about the present as about the past. Even when they are plainly about historical moments involving—accurately or not—the past, they must be considered in light of contemporary societal debates regarding the relationship of that past to the present.

The films depicted in the volume focus on the era of legal, bonded labor of Africans in the Americas, and their descendants: an era that spans the early sixteenth and the late nineteenth centuries. That stated, for our present purposes there are two basic ways of approaching issues of temporality. First, in terms of *when* the films were made, a criterion more meaningful when considered in light of *where* they were made. Films at least partially about slavery are nearly as old as the medium itself (for instance, D. W. Griffith's *The Birth of a Nation* [1915]), and such films appeared intermittently during the middle decades of the twentieth century, primarily in the U.S. These films, which include *Gone with the Wind* (1939), *The Adventures of Huckleberry Finn* (1939), and *The Foxes of Harrow* (1947), were large Hollywood productions of epic scope that often prioritized the perspectives and experiences of white characters, and targeted large, mainstream white audiences in such a way that the treatment of slavery would be sympathetic and/or paternalistic toward enslaved persons without being scandalous to the target audience. Interestingly, most of the 1960s was practically devoid of U.S. films on slavery, particularly films about slavery in the Americas as opposed to those set in antiquity. In fact, very few films on slavery in the Americas were produced anywhere; the exceptions are rare and include films like Puerto Rico's 1962 *El resplandor* and the Brazilian 1963 production *Ganga Zumba,* a film that was not released until nearly a decade later. It is fair to ask why few films about slavery in the Americas appeared during that decade. If Hollywood has been a trend setter as concerns the genre, it is not surprising that the 1960s would have been on the whole an awkward period during which to produce films explicitly about modern slavery for a mainstream white audience generally uneasy about the emerging civil rights movement and other challenges to the status quo. Then, beginning around 1968 began a period of growth in films about slavery, and not only in the U.S. Some may think, incorrectly, that the landmark television miniseries *Roots* led the charge in films about slavery in the Americas; between, however, 1968 and 1977 (the year *Roots* was released), there were at least seventeen major productions on the topic, and in several countries.[4] The growth in the genre stemmed at least in part from the growing awareness throughout the hemisphere that Africans and Afro-descendants have played a pivotal albeit

largely unrecognized role in the shaping of the hemisphere. We will see below further commentary on the ramifications involving the basic legal condition that characterized much of this "role," i.e., slavery.

Oftentimes sharply distinct from the year of a film's production is the time period the film seeks to recreate. Although Africans were first brought as slaves to the Americas during the first few years of the sixteenth century, films in the genre tend to focus on more recent periods, especially the years near the middle of the nineteenth century. Possible reasons for this focus are numerous: first, the greater abundance of written materials for the later periods, whether such materials are in the form of slave autobiographies or legal documents; second, the greater interest a nearer historical time period may hold for contemporary film and television audiences, especially when such a time period (the 1850s, for instance), was characterized by an institution as abhorrent and as foreign to contemporary sensibilities as slavery. Meanwhile, several films focus on time periods surrounding turning points in the history of slavery, particularly when such events weakened slavery as an institution: the abolition of the Atlantic trade, for instance, as depicted in *Amazing Grace* (2006), or the incorporation of Black infantry members to the Union troops during the Civil War, as depicted in *Glory* (1989). With the sole (and fascinating) exception of *Manderlay* (2006), all the films in *Celluloid Chains* reference the era of legalized slavery in the Americas. Although some potential contributors were interested in writing about films that depict the aftermath, social consequences, or metaphorical persistence of slavery, one volume cannot do it all: our focus is on representations of slavery in its epoch. Similarly, while slavery—sadly—continues to exist in several parts of the world (see, for instance, Kevin Bales's *Disposable People: New Slavery in the Global Economy*, 1999), and while films that in some way register this reality may have already been made, *Celluloid Chains* maintains its limited focus on a certain type of slavery during a specific period in the history of the Americas.

What is this "certain type of slavery"? This question bring us to the final term in the subtitle: slavery,[5] a term that is every bit as complex as any of the others, and is the name given to the terrible institution that led to every one of the films in this volume. Scholars who have worked closely on slavery as an institution have shown us that what it means to be enslaved can vary. Definitions have come, for example, from the field of sociology (Orlando Patterson 1982). More recently, Stephan Palmié, an anthropologist, has echoed earlier scholarship in arguing that the opposite of slavery is not necessarily freedom. He explains that, in an African context at least, slavery is better defined as removal from society and social belonging: "Freedom from social obligation spelled rightlessness.

Belonging, on the other hand, was both belonging in as well as belonging to social units defined by what [other scholars] call a 'slavery-to-kinship continuum'" (xv). Similarly, the historian David Brion Davis has argued that "in Africa and most other premodern societies, the opposite of being a slave has traditionally been defined as being a member of a specific tribe, chiefdom, or clan, with close ties to both ancestors and descendants" (28). Furthermore, if the enslavement of Africans in the New World occurred in large part to extract their labor in large-scale plantation operations, which in turn would produce riches for the owners of said operations, Davis adds that in some pre-modern societies, like the Tupinambá in what is now Brazil, the function of their slaves was primarily to make the Tupinambá "feel honored, superior, or almost godlike as they defined themselves as 'nonslaves'" (28). Lastly, in some societies, perceived differences of a categorical or essential nature between slaves and their masters would evolve (or intensify) in ways that usually were detrimental to the slaves. As Davis explains, "from the sixth century on, the gulf continued to widen between slaves and free citizens, in contrast to the much earlier Homeric slaves, who ate, drank, and worked side by side with their nonwealthy masters" (41-42). Along these lines, it is well known (or at least commonly perceived as such) in academic studies on slavery that the institution as it was practiced in the Dominican Republic was—at least in part due to an increasing neglect over the centuries on the part of Spain toward this colony—a more lenient,[6] or "Homeric," version of slavery, particularly in comparison with the more productive slave economy on the western side of Hispaniola, i.e., Saint-Domingue, which was later renamed Haiti. The type of slavery that occurred in the Dominican Republic could, in turn, explain why historical slavery seems not to be a central issue in a Dominican society that has produced, to date, no films on the topic.

While the films in this study tend not to explore in an organized way theoretical definitions of slavery like those mentioned above, they do share several relevant and important qualities. First, all the films focus rigorously on slavery and related matters such as the Middle Passage, the experiences of enslaved workers on different sorts of plantations, abolitionist movements, and slave-master relations, to mention a few. In other words, slavery is a central concern in each film; similarly, actors portraying enslaved persons are shown on screen, meaning that their existence is not merely referenced or suggested. Second, nearly every film in the study seeks to show the humanity and feelings of the enslaved: their pain, their aspirations, and their affection and protectiveness toward others in their community, to name only a few feelings; in other words, the very qualities that their masters tried to suppress or manipulate. Third, even if the films

do not explore definitions of slavery *per se*, they do often register an important issue that is often debated within scholarship on slavery, namely the amount of agency the enslaved had to shape their own destinies, an issue that according to John Thornton is in turn closely linked to debates surrounding the "Africanness" of the enslaved. According to him, it has been argued that American slavery

> stripped the slave of culture, initiative, and even personality. Thus, in spite of their general sympathy to the plight of the slaves and their descendants in the New World, they nevertheless reinforced the image of the slave as helpless and necessarily passive. Radical historians sought to explain slave culture and slave religion in terms of the institution of slavery and thus reduced the African identity of the slave. (4-5)

The issue, in some ways, is apparently akin to a "catch 22" in which the greater the horrors of American slavery, the lesser the agency and Africanness that would be attributed to the enslaved. Many of the filmmakers in the study seem tasked in some intuitive way with the challenge of somehow showing both: the brutality (of the masters, of the institution) *and* the agency of the enslaved, including the African cultural traits they have been able to preserve. Furthermore, several films address the issue of marronage, which occurred when fugitive slaves established communities (often called *palenques* in Spanish and *quilombos* in Portuguese) beyond the control their former masters. Such instances of marronage strongly suggest the presence of agency among the enslaved in certain regions of the Americas, especially ones that contained large tracts of unexplored and inhospitable land. In these communities, maroons often practiced African cultural forms. As Thornton explains,

> One should not therefore imagine the Americas as simply lying securely under European sovereignty. In many places a long struggle for control ensued; in other places frontier conditions without secure European sovereignty continued for a long time. When Africans were brought to the Americas as slaves, they found this situation often worked to their advantage, and for them, the unsettled nature of the Americas provided the opportunity to escape, to play off the contending parties, or to use the potential for defection or escape to improve their situation. (41)

We shall see in the volume that many films explore these issues as they depict these types of activities and attitudes on the part of the enslaved. Again, while the

films often do not hesitate to show the brutalities inflicted on the enslaved, the films and the characters they portray are seldom one-dimensional. Instead, they tend to show the enslaved plotting, organizing, occasionally fighting back, and lamenting their hardships. Such agency on the part of the enslaved runs counter to accepting hardships in some robotic manner: a condition that Frederick Douglass likened to becoming—and even wishing to become—a slave in fact and not just in form, like "a man transformed into a brute," without feeling, volition, or reason, inured to the brutalities and inhumanities of slavery (49).

ON THE APPEAL AND COMMON FEATURES OF SLAVERY FILMS

The popularity of films about slavery is high, as witnessed by the recent critical acclaim bestowed on *12 Years a Slave* (three Academy Awards, including best picture), not to mention its success at the box office (more than $56,000,000 in the U.S. alone): all stemming from the efforts of a filmmaker (Steve McQueen) who had been largely unknown to North American audiences. In addition, films about slavery continue to appear. In just 2016, for instance, there appeared a film about the 1836 Nat Turner Rebellion (*The Birth of a Nation*, not to be confused with W. D. Griffith's film from a century earlier), as well as two made-for-television miniseries: a new version of *Roots*, and *Underground*, about the Underground Railroad. What is more, films about slavery will continue to be made. The reasons for this affirmation are numerous. Let us consider, as an entry point, an interesting tension involving the kinds of stories slavery films tell. The film *The Middle Passage* (*Passage du milieu*), for example, is not anchored in a specific place and time; neither does it recount the experiences of specific persons who actually lived. Instead, it is a composite recreation of the overall (terrible) experience of the Middle Passage, told by a nameless male narrator held captive aboard a slave ship. This composite, generalized history stands in sharp contrast with more specific histories of slavery that have been retold in films: *12 Years a Slave*, for instance, which is the filmic rendition of a slave narrative co-written by Solomon Northup during the 1840s. In other words, a film about specific people, events, and historical periods. This brings us to an important point about slavery cinema: whether through fictionalized, composite, but on the whole historically accurate and verifiable filmic recreations of slavery, or through films that center on the specific histories of the enslaved or formerly enslaved, there is a broad palette from which potential filmmakers can choose. In other words, they can focus on generalized, composite histories of slavery, or more specific ones.

A filmmaker like McQueen relied on Northup's mid-nineteenth-century slave narrative as raw material for his film. According to Yuval Taylor these narratives share many similarities:

> The abolitionist slave narratives written during the genre's heyday— over eighty were published between 1836 and the end of the Civil War in 1865—exhibit a large number of common elements. The typical narrative includes a preface describing it as a "plain, unvarnished tale," the first sentence begins, "I was born . . ."; the plot includes, among other events, a slave auction, the separation of the narrator from his family, an exceptionally strong and proud slave who refuses to be whipped, and at least two escapes, one of them successful, and the narrative concludes with an appendix of some kind. (xvi)

I would add, on the basis of a panoramic view of numerous films about slavery— whether these films are rooted in slave narratives or not—the following recurring tropes: Taylor, for instance, mentions the slave "who refuses to be whipped." In slavery films such refusals sometimes involve suicidal leaps, whether from the slave ship (*Roots*, *The Middle Passage*), from a mountain top (*La última cena*), or a bell tower (*Cecilia*). Slavery films often depict coffles (forced marches), harsh whippings, and other forms of punishment and torture; when contemporary films merely suggest or altogether elide these punishments, critics and scholars—like several in this volume—take notice of this absence. Slavery films sometimes portray processes of cultural hybridization and resistance pertaining to names: *Roots'* Kunta Kinte insists on this African name and resists the name Toby; Aminata in *The Book of Negroes* and Femi in *El Cimarrón* similarly resist the names Mary and Carolina, respectively; meanwhile, Jane in *The Autobiography of Miss Jane Pittman* discards the name Ticey when she learns it is a "slave" name. Love triangles and quadrangles, and jealous masters (and mistresses) are also common in slavery films (as in *12 Years a Slave* and the earlier *Solomon Northup's Odyssey*, as well as *El otro Francisco*, *Roble de olor*, and *Mandingo*, to name a few). Slavery films also illustrate organizational structures among the enslaved, especially those involving leadership. How, for example, do leaders arise among their enslaved peers? How do their actions, including speech acts, inspire their followers? Similarly, the protagonists often receive the counsel of a wise and protective elder. Another trope involves the affirmation or suggestion on the part of the enslaved to their rightful place in the land they inhabit; in other words, they belong as much as anyone else to the societies they have helped to create, whether these societies are located in Cuba, Brazil, Curaçao, the U.S., and so on. Furthermore, if—as I have

argued—slavery films are as much about contemporary social debates as they are about the past, the films sometimes describe political and economic ideologies that stand as alternatives to prevailing modern-day ideologies (the socialism of the Brazilian maroon city/state of Palmares, as seen in *Quilombo*, is a good example). Contemporary Pan-Africanist ideologies also feature prominently in these films, and are expressed through music (for instance the anachronistic reggae music[7] in the soundtrack to *Quilombo*) and via religious practices. Music in general, particularly in unison with African-derived ritual ceremonies, often figures prominently in the films: several recreate ecstatic ceremonies accompanied by dancing, singing, and drumming, often at night; a common refrain is the contempt and fear on the part of the masters for such ceremonies. Lastly, slavery films often provide a documentary-style exposé of the work they were forced to perform, in cotton fields and—especially—on sugar plantations. It is within these contexts that we see not only their work but also their accidental injuries, their attempts to sabotage machinery, and their coded communications. Sugar plantations, quite interestingly, are often set aflame in the slavery films, and the sugar cane fields themselves can also serve as cover for imminent ambushes on the masters and slave drivers.

One might assume that, in light of all the preceding commonalities, any future slavery films would merely reiterate them. This will not be the case. Taylor, for instance, argues with reference to nineteenth-century slave narratives that "because the experience and voice of each slave was unique, most of the narratives avoid being formulaic" (xvi). Perhaps the same argument can be made about individual filmmakers, each with their own vision and agenda, and in which each film registers specific geographical, societal, and temporal concerns. In other words, despite strong thematic similarities, a film from the 1970s about a slave uprising in Cuba during the late eighteenth century will probably be a sharply different film from one made during the 2010s that recounts a slave uprising in Curaçao and that is set in approximately the same historical time period.

Though some slavery films certainly resemble others, there are simply too many variables involving both historical slavery and its legacies for anyone to claim that the genre has reached thematic exhaustion. Filmmakers undoubtedly continue to seek out as yet untapped slave narratives, legal documents, and contemporary cultural polemics involving slavery, as they look to develop future film projects involving slavery. Furthermore, scholars within various disciplines continue to shed new light on the "peculiar" institution. This new light may add detail to the commonalities or tropes outlined above involving slavery films; on the other hand, future films may choose instead to explore exceptional

occurrences, of which there appear to be many. While slave narratives and slavery films may hold many commonalities, David Brion Davis explains that "one can find exceptions to virtually any generalization made about slave occupations, treatment, families, resistance, population growth, and many other matters" (124). A fascinating exception he describes—and one that could make for a compelling film—involves an African slave trader who "sailed all the way to Barbados, where he sold his slaves before returning to Africa" (90).

We have seen that historical records provide perhaps unlimited fertile ground for films about slavery in the Americas. A slightly different matter involves the strong appeal of such films to both mass audiences and scholars. In this regard, I do not intend to prognosticate in specific ways about the future box office success of potential films about slavery. Instead, I offer reflections on why slavery films often make deep and lasting impressions on the societies that produce them and why they sometimes draw very large audiences; in other words, why films about slavery continue to resonate and to matter. In many ways, the following reflections on these questions also address the need for the current volume.

One could argue that the ubiquity and popularity of slavery films suggest that slavery is in many respects an unresolved societal issue within the places that produce the films. Marlene Allen and Seretha Williams argue that "historical slavery serves as a symbol for the continual oppression of African Americans, and authors revisit the site of slavery in hopes of excavating more truths" (2). Although one could interpret (or misinterpret) this assertion to hold that African Americans will continue to be oppressed *because* slavery existed, the authors' general point is well taken: explorations or excavations into the era of slavery are intended to yield truths, and presumably useful and healing truths about an institution whose effects continue into the present day. Their observations about film are even more relevant: in contrast with the written word, "film has become a powerful medium for representing slavery visually, allowing a viewing audience to connect with the experiences of slave characters onscreen . . ." (2). Let us pursue these ideas. Although slavery had numerous dimensions, many of them not necessarily of a visible or visual nature, it is fair to ask what it is about slavery that lends itself well to cinema. To pose the question in direct terms, is cinema superior to the written word as concerns depictions of slavery? I would hesitate to go that far. Speaking for myself, I was moved more by the book *Roots* than by the miniseries. On the other hand, cinema *is* the preferred medium for depicting content that is of potential visual interest, even if that content already appeared in written form.

What is it about slavery films that renders them of potential visual interest? Although the "birth" of cinema is debated, legal slavery in the Americas ended

in 1888 (Brazil), well before cinema became widespread. As such, while there is abundant film footage of formerly enslaved persons (and photographs of actual slaves), there is no film footage of slaves or slavery. In a way, then, films about slavery respond to this visual absence in the historical record. What is more, slavery films take us back to the scene of the crime, as it were: a crime that involved to a significant degree physical, visible transgressions against the enslaved. In other words, and to paraphrase Allen and Williams, slavery films allow viewers to actually *see* the crime (or to have the sensation of doing so) in a way that is closer to a real-life experience than reading about the same events in a book. Elsewhere, I have made a similar argument about time travel narratives involving the conquest of the Americas and the period of slavery (*Time Travel in the Latin American & Caribbean Imagination*, 2011). As potentially painful as filmic representations of slavery may be to view, a significant number of viewers nonetheless wish to do so. There is a final point regarding the visual aspect of films about slavery in the Americas, which amounts to yet another reason why they are distinct from films about slavery in the ancient Mediterranean or on some remote planet: the former recreate the experiences of slaves who may resemble people with actual and identifiable living descendants. These descendants, in turn, are able to trace their lineage directly to people like the ones they see on the screen. As such, slavery films transcend mere voyeurism; instead, they allow viewers to inhabit and share in a visual way the "world" of their ancestors.

Slavery films, however, can be powerful for reasons beyond their visual qualities. According to Yuval Taylor, the most underestimated function of written slave narratives but the one that most accounts for their success is "their capacity to delight or fascinate the reader" (xviii). In terms of film, the possibilities for delighting or fascinating viewers are vast, just as it is equally possible to bore viewers: something no film desires. How, then, do films decrease the likelihood of boring their viewers and increase the likelihood of delighting, moving, or shocking them? Natalie Zemon Davis explains that the popularity of a slavery film like *Spartacus* is best understood within the context of mid-twentieth century Hollywood, whose films often depicted organized violence: "A slave uprising could be just what was needed for a film industry that continued to flourish worldwide on epic and warfare" (19-20). Certainly such an uprising would be not only visually arresting but would also occur at a dramatic moment in the narrative. An additional feature of slavery films that may contribute to their power involves the precariousness of slave life, a precariousness related to filmic suspense. As David Brion Davis explains,

> It is ... important to remember that in most societies, even the most
> privileged slave—the wealthy farm agent in Babylon, the Greek poet
> or teacher in Rome, the black driver, musician, blacksmith, or boat cap-
> tain in Mississippi—could be quickly sold, or stripped and whipped,
> or raped, or sometimes even killed at the whim of an owner. All slave
> systems shared this radical uncertainty and unpredictability. (37)

Instances in slavery films of the kinds of events Davis recounts are too numerous
to describe: their terrible nature notwithstanding, such moments in films are of
the type that keep viewers at the edge of their seats. Certainly there are dimen-
sions to these films beyond the sheer horror and brutality of slave life; we have
seen already, for instance, that slavery films often dramatize to varying degrees
the ability of enslaved persons to exert their will on their social environment. In
addition, several of the common tropes in slavery films involve activities that—
rather than being painful or terrible—are heuristic expressions of community
life, leadership, spirituality, and so on. Nonetheless, when the character of Patsey
in *12 Years a Slave* savors tea and meaningful conversation after sneaking off to
the parlor of a more permissive plantation nearby, we sense that this is the calm
before the storm.

The uncertainty and unpredictability David Brion Davis identifies in slave
systems—indeed the general terror and brutality found in both these systems
and in their filmic counterparts—amount to some of the worst acts that one
group of humans can perform on another. Correspondingly, I would argue that
an additional source of power in slavery films is their ability to interrogate the
very limits of what it means to be human, beyond, for instance, the ancient
philosophical interrogations on the humanity of slaves or affirmations of the
"indelible stains" of slavery on a person's humanity. By "limits," rather, I mean
the outer fringes of human action: in these films we are often witness to both
the very worst and the very best qualities in our humanity, qualities evinced in
acts that can run the gamut from the inhumane torture and claim of ownership
of others to the most courageous acts of love, resistance, and perseverance.

Despite the ways in which slavery in the Americas is a strongly racialized
phenomenon, a longer historical and broader geographical view on the matter
suggests another reason for the power of slavery films and their cultural currency:
simply stated, whether we know it or not we probably all share an ancestral
heritage in slavery. In the words of David Brion Davis,

> Since Europeans in every region were enslaved in Roman and early
> medieval times (to say nothing of Asia and Africa), and since Barbary

corsairs continued to enslave white Europeans and Americans well
into the nineteenth century, it seems highly probable that if we could
go back far enough in time, we would discover that all of us reading
these words are the descendants of both slaves and masters in some
part of the world. (54)

And these remarks say nothing about the reality and menace of contemporary
slavery. Sadly, then, humanity has not eradicated this terrible blight, one from
which all or nearly all of us descend, and one into which we could fall, on either
side of the slave/master dichotomy. In some ways, when we view slavery films,
we are seeing ourselves. For this and many other reasons, it makes perfect sense
that in 1998, before becoming France's Minister of Justice, Christiane Taubira
introduced legislation (which eventually passed) that sought to recognize slavery
and the Atlantic trade as crimes against humanity.

In summary, whether the films discussed below address slavery in Cuba, Peru,
or Martinique, they have become part of our story, whether we understand "our"
in fragmented or broad terms. Moreover, collectively these films describe the
degree to which slavery continues to interest us, whether or not this interest is
based on historical accuracy or ideological sophistication. Those of us of a certain
age in the U.S. remember the image of Kunta Kinte in *Roots*, just as Cubans may
remember Úrsula Lambert from *Roble de Olor*, and Brazilians *Quilombo's* Ganga
Zumba. Kunta Kinte, for example, is—allegedly—Alex Haley's ancestor who
came to the Americas from Africa: in my mind Kunta Kinte *is* a young Levar
Burton, the actor who portrayed him. Kunta Kinte and many others like him
have—to a significant degree—helped create our memory and perspectives on
slavery because we saw and were moved by slavery films.

THE ESSAYS IN *CELLULOID CHAINS*

There are few scholars on the cinema of slavery in the Americas and none with
expertise in the entire range of this topic, which spans across languages, histori-
cal epochs, cultures, national boundaries, and academic disciplines. Hence the
need for the present volume, which showcases the disciplinary diversity of its
participants. Several of us, myself included, are housed in literature and culture
programs which are often, in turn, affiliated with a "national" language (English,
French, Portuguese, Spanish, and so on). Others may have a thematic disciplin-
ary affiliation (Women's Studies) or one that is both thematic and geographi-
cal (Africana Studies, American Studies). Meanwhile, several contributors are

historians. This disciplinary diversity suggests, simultaneously, the complexity of our topic and its importance. Within this diversity there are most certainly numerous common interests which manifest themselves in different and unique ways in each contributor. Stated succinctly, however, the common guiding interests lie in the topics of New World slavery and its heritage, and in cinema and its power to shape views on those topics.

In selecting the essays for *Celluloid Chains*, my co-editors and I sought submissions that had something both new and compelling to say about any relevant film, whether they were written by well-established or emerging scholars. Given our editorial demands, there were some films, like Tomás Gutiérrez Alea's influential and oft-commented *La última cena*, that drew no contributors, while other lesser-known films had the opposite response. Readers—whether professional historians, anthropologists, film scholars, or literary theorists—will find that the collection of essays in its entirety does not align itself neatly with any specific discipline. Indeed, just as each film treated in the volume poses different challenges to viewers and raises different questions about slavery, each essay must be considered on its own varying, disciplinary terms. Readers may find several of the essays surprising in their criticisms of films we may admire. Conversely, the essays may point to the strengths and value of films with which we may be unfamiliar. Lastly, in terms of the order of the essays, we found that there were several possible options, all of them tempting: varying arrangements based on geography, theme, genre, ideology, and so on. We settled on the simplicity of a chronological order with respect to the film's year of production. Such an order both registers the development of the genre providing for interesting transitions from one film to the next.

Julia Paulk's essay on *El otro Francisco* (1975) launches the collection. Sergio Giral's *El otro Francisco*, Paulk explains, is a reworking of *Francisco*, an influential nineteenth-century abolitionist (or reformist) novel written by Anselmo Suárez y Romero, a Cuban. Giral's film, meanwhile, is an odd and unique creature because he was satisfied with elements of Suárez y Romero's novel but dissatisfied with others. The result is in part a historical "period" film that resembles the original *Francisco*; elsewhere, however, the film largely consists in ideological propaganda that uses documentary techniques to "correct" the many mistakes in historical accuracy the filmmaker detects in the source novel. Not surprisingly, many of these corrections are in line with the standard communist orthodoxy that has characterized much of Cuba's film industry in the wake of the 1959 Revolution. Paulk, meanwhile, adroitly and convincingly identifies several blindspots

in Giral's film that register the ideological circumstances under which the film was made.

Roots, a television miniseries that aired in January 1977, achieved unprecedented popular success in the U.S. and helped residents in this country, both black and white, reassess its painful, divided past. Based on Alex Haley's eponymous autobiographical account of his family's origins in one Kunta Kinte, a young African who was taken from the savannahs of the Gambia, transported in chains across the Middle Passage, and sold to a Virginia planter, *Roots* encouraged African Americans to recall and assert their African ancestry. The film was also a powerful celebration of the triumphs of the African American family in the face of long odds. Inextricable to the success of *Roots*, however, has been the controversy it engendered: some argue *because* of its very success. In a masterful reappraisal, Robert J. Norrell locates *Roots* within the culture wars that ensued its airing and distinguishes between the tremendous symbolic power it generated, on the one hand, and the multifaceted accusations it provoked, on the other. These accusations, all very serious, ranged from plagiarism (lifting entire passages from previously published material, for instance) to utter falsification (did Kunta Kinte even exist? And if he did, was he indeed captured and brought to the Americas?). Norrell explains that in recent years *Roots*, on account of its debated authenticity, has been marginalized and silenced in academic scholarship, including that of well-known proponents of African American studies. We are left, then, with a paradox: arguably the most successful and influential slavery film ever is now forced to bear the asterisk or scarlet letter of illegitimacy. Perhaps, as Norrell contends, now is the time to reconsider *Roots* in terms of what it was all along: a captivating and relevant work of the imagination, despite the initial claims of Haley himself.

In her essay on *Cecilia* (1982), Haley Osborn examines the second Cuban film treated in the volume. Just as *El otro Francisco* reworked an important colonial-era novel about slavery and race relations on the island, Humberto Solás's film does the same with a similarly titled novel: Cirilo Villaverde's *Cecilia Valdés o la loma del ángel* (1882), for many Cuba's most emblematic novel of the nineteenth century. Following her general interest in adaptations involving written and filmic narratives, Osborn begins her analysis by comparing and contrasting the ways the two *Cecilias*—i.e., novel and film—develop crucial aspects of the storyline they have in common, most notably as concerns the fate of the eponymous protagonist: a beautiful, charming, and nearly white young woman of a partial African descent she is keen on hiding. As Osborn explains, the fate of the filmic

Cecilia is altogether different from her novelistic counterpart. The differences, moreover, are highly revealing about the trajectory of Cuban race relations as understood by Solás. In making these claims about Solás and his views on race relations, Osborn advances a startling and finely crafted argument regarding the filmmaker's use of lighting.

Much like his film counterparts elsewhere, Carlos Ferrand has in many of his films explored issues involving racial and ethnic relations, oftentimes within the context of his native Peru. In her contribution to this collection, Rachel O'Toole locates Ferrand's short film *Cimmarones* (1982) both within a broader tradition of 1960s and 70s revolutionary South American cinema as well in relation to the filmmaker's multicultural biography. *Cimarrones* is at first glance a straightforward recreation of an historical event that occurred in Peru in the early 1800s: a group of *cimarrones*, or fugitive slaves, lays ambush on an expedition comprising both colonizers and slaves. This historical event, moreover, is introduced by an "expert" on Peru's African heritage. The truth, however, is—as O'Toole adroitly explains—much more complicated. How much do we really know, for example, about the events that actually transpired in 1808? Furthermore, to what extent does Ferrand's creative "license" compromise the historical veracity of his film? In answering these questions, O'Toole productively distinguishes between the kind of historical truth she and her fellow historians seek and another kind of truth sought by a film like *Cimarrones*. As she shows through a detailed analysis of the film, the latter kind of truth is oftentimes most apparent in the very places that deviate from the historical record.

Ignacio López-Calvo's essay on *Quilombo* (1984) locates the film within the context of 1970s and 1980s politics and cultural production in Brazil. During this turbulent era, there occurred a popular and necessary reawakening of Afro-Brazilian consciousness, exemplified most poignantly in the imaginative cultural resurrection of *quilombos*, the societies developed by fugitive slaves in the Brazilian hinterland during the era of slavery. One such *quilombo* was Palmares, which existed as a veritable city-state for decades, at times in defiance and at others in accommodation with governing colonial systems. As López-Calvo explains, just prior to the release of Carlos Diegues's film, the ideal of the *quilombo* spawned the notion of *quilombismo,* which posited a cultural framework for the existence and ways of being of modern Afro-Brazilians. The film *Quilombo,* however—and as López-Calvo rightly signals—contains several fanciful elements that cast doubt on its capacity to shed meaningful light on the treatment of slavery as it was experienced historically in Brazil. In so doing, his essay raises important questions regarding the sometimes conflicting purposes of slavery films in a

given society and as concerns the fluctuating historical and critical perspectives that inform them.

My essay on *Cobra Verde* (1987, Dir. Werner Herzog) advances an argument on this film in relation to the thematic and conceptual boundaries of the slavery film genre. What features, for example, comprise a slavery film? The presence of slaves on screen? What happens when the principal character is a slave trader? Furthermore, how important is it that the majority of the film's duration be devoted to issues involving slavery or the Atlantic trade? Or are the genre's distinguishing features—assuming they exist to begin with—more interpretive and qualitative? *Cobra Verde* is bold and poetic not unlike Herzog's other films. What is more, it serves as an intriguing test case for many of the preceding questions. The film, I argue, is on the one hand clearly a slavery film: the eponymous protagonist first witnesses slavery in his native Brazil and then participates actively in the institution both in Brazil (as an overseer) and in Africa (as a trafficker). As such, slavery and enslaved characters appear frequently in the film, and its visual representation of some of the most brutal characteristics of slavery is unflinching. In other respects, this slavery film appears not to be a slavery film. How, it is fair to ask, is such a contradiction possible? The answer lies in *Cobra Verde's* thematic interests besides slavery: interests, no less, that—in ways that seem problematic to me—include and transcend slavery.

Guy Deslauriers's *Passage du milieu* (1999, *The Middle Passage*) is a docudrama, or fictionalized documentary, that recreates the infamous Transatlantic voyage enslaved Africans endured. There are ample written documents (ships' manifests, sales records, and so on) and physical artifacts associated with the Middle Passage, and these suggest the horrors of the voyage. Precious little is known for certain, however, about how enslaved persons themselves actually experienced this voyage. How did it feel to be enchained in the hold of a slave ship for the weeks-long voyage across the Atlantic? This, perhaps, is the central question of *Passage du milieu.* There are a host of crucial, related questions and these inform Anny Curtius's analysis of the documentary. For example, why are imaginative recreations like those seen in *Passage du milieu* necessary? Furthermore, are some ways of imagining and recreating the Middle Passage more effective or more acceptable than others? Which ways best fulfill the dual function of remembering and honoring the past while helping those in the present better to heal? Lastly, what are the implications for modern-day societies of fictional recreations of such a voyage? In providing answers to these questions, Curtius examines yet another layer of complexity involving the film: the voice-over narration in the 1999 French-language version of the film is suggestive of a certain cultural and

ideological context. The English-language narration in the 2003 HBO version is sharply different in both content and style. According to Curtius, these differences reveal much about the ideological diversity of Diasporic populations.

The anthropologist Peter Wade has argued that on account of their large black populations, Cuban and Brazilian cultural production have pioneered a "positive revaluation of blackness" (33). Nonetheless, such a revaluation has "tended to be integrationist in tone, with the emphasis on the emergence of a mixed society in which black input was valued as long as it was under control" (33). In his analysis of Rigoberto López's *Roble de olor* (2003), Mamadou Badiane registers the integrationist project described by Wade, with particular focus on Cuba, where the film is set. If integrationism and the emergence of a mixed society are generally desirable objectives in recent Cuban cultural production, Badiane explains that in *Roble de olor* these objectives—ironically—are presented as running counter to the mid-nineteenth-century historical backdrop of the film. By aligning his analysis with Frantz Fanon's and Homi Bhabha's notions of "the third space," not to mention his own work on the topic, Badiane identifies in the person of Úrsula Lambert, the *mulata* co-proprietor of a coffee plantation that actually existed in colonial Cuba, the social and conceptual difficulties of any challenge to the prevailing black/white dichotomy during the era of slavery.

To what extent do slavery's physical spaces inform the institution and underwrite its legitimacy? Can we imagine, for instance, a slavery deprived of the big plantation house and its proverbial white columns, or verdant fields of sugar cane? These are some the questions Edward Piñuelas explores in his essay on Lars von Trier's *Manderlay* (2005). The film's use of space is unconventional: like its prequel *Dogville* (2003), *Manderlay* employs a figurative, minimalist set that resembles a (very bare) theater stage. Although we see on a map that the story is set in Alabama, the filming took place entirely within a dark warehouse in Sweden (indeed, von Trier has never even been to the U.S.). Furthermore, the places commonly associated with plantation life are demarcated solely through the use of lines on the floor with accompanying labels such as "Mam's House"; in other words, *Manderlay*'s abstract visual aesthetic resembles a board game or an architectural blueprint. Such figurative spatial demarcations notwithstanding, to the characters the film's spaces are very real. The historical period in which *Manderlay* is set, however, is clearly identified and constitutes yet another of the film's unusual features: the 1930s, several decades after emancipation in the U.S. How can we make sense of these features in *Manderlay*? Some have argued that the film is a veiled critique of U.S. foreign policy (George W. Bush's, for instance). Piñuelas, however, argues forcefully that the film is very much centered on slavery

and that its unusual methods compel viewers to think about the institution in specific ways.

Puerto Ricans have addressed issues of racial and cultural identity in complex ways. In censuses from the last several decades, for instance, around three quarters of Puerto Ricans self-identify as white. Nonetheless, although Puerto Rico was never a plantation society to the extent of Saint Domingue or Jamaica, slavery existed on the island for centuries until its abolition in 1873. As such, the island's African heritage is popularly recognized—along with the European and the indigenous—as one of the three wellsprings of Puerto Rican society. In a well-known poem from 1942, for instance, Fortunato Vizcarrondo wrote in reference to Puerto Ricans that if they could not trace their lineage to the Dinga ethnic group in Africa, then they probably could trace it to the Mandinga ethnic group from the same continent.[8] *El Cimarrón* (2006), a film directed by the Iván Dariel Ortiz, recounts the experiences of an African couple—Dinga or Mandinga, per-haps—who were captured into slavery on their wedding night and then sold into slavery in Puerto Rico during the early nineteenth century. Viewers of this film would probably notice very quickly that it is in tone and atmosphere unlike many slavery films. While it depicts enslaved characters being subjected to tremendous violence and brutality, *El Cimarrón* is, oddly, in many ways as highly stylized as the more innocuous *Quilombo*. According to Mirerza González-Vélez and Nemesio Gil-Pineda, some of these apparent contradictions can be explained by the film's Puerto Rican cultural context and by the fact that Ortiz deliberately avoided prior slavery cinema in crafting his film's aesthetic direction, relying instead on other kinds of media and genres. The result is a film that, paradoxically, attempts to represent brutality in ways that are visually palatable.

Case départ was one of the top earning French films of 2011. It is also a com-edy: this helps explain its success at the box office. Improbably, it is also a slavery film. Since when did cheap laughs and silly puns go hand in hand with chains and whippings? They do not, generally speaking, although the combination makes more sense if we take into account France's historical silence on its involvement in slavery and the Atlantic trade: a context that Gladys Francis asks us to consider in her essay on this unusual French slavery comedy set in both contemporary France and colonial Martinique. Beyond being a slavery comedy, the film—as Francis explains—is further hybridized inasmuch as it depicts two half-brothers from modern Paris who magically travel both spatially and temporally to 1780s Martinique: it is, then, also a time travel "buddy" adventure, reminiscent of *Bill & Ted's Excellent Adventure* (1989); similarly, in its depiction of time travel from the present backward to the era of slavery, *Case départ* resembles both *Brother*

Future (1991) and *Sankofa* (1993). Francis argues that in theory it is not impossible for a comedy like *Case départ* to treat a subject like slavery effectively. After all, her examination of comedic theory suggests that humor may be uniquely suited to enable people to confront delicate, awkward, and silenced subjects like slavery. What, however, does it mean for a film—especially an unusual comedic film—to treat a subject like slavery *effectively*? Is *Case départ* able to do this? What, in other words, remains of the film and its delicate subject matter once the silly laughs have ceased? These concerns lie at the heart of Francis's analysis.

While much has been written on the Western, i.e., films—of which there are countless—about the U.S. West, and even on the Spaghetti Western (filmed in Italy and Spain), there is now in Quentin Tarantino's *Django Unchained* (2012) a new film genre: the Southern. As is suggested by the moniker, the filmic Southern (of which there appears to be only one example: *Django Unchained*) appropriates elements from the Western, including narratives structured around violence and revenge, but relocates them to the southern U.S. and its corresponding cultural dynamics. In the case of *Django Unchained* these dynamics involve the antebellum period, which was characterized by the existence of slavery: slavery, along with violence and revenge, is a constituent feature of the Southern as expressed in *Django Unchained*. In his essay on the film, Dexter Gabriel astutely identifies yet another feature of the Southern, namely its allusions to another cinematic genre: the slavery film. By grounding his discussion in the context of films about slavery, especially those produced during the Blaxploitation period of the 1970s, Gabriel is able to show the curious (but no less compelling) contradiction at the heart of Tarantino's film: on the one hand, it attempts to distance itself from and critique the corpus of previous slavery films; we see this distancing and critique both in the film and in Tarantino's own observations on his film. On the other hand, *Django Unchained* consistently and often subtly references the filmic genre it would otherwise critique. This tension in the film, according to Gabriel, is in turn reflective of a broader debate pertaining to the optimal way to portray slavery through cinema.

Tula: The Revolt (2013) recounts what some might consider the heroic and uplifting tale of Curaçao's eponymous rebel leader who in the late eighteenth century challenged and very nearly toppled the entire colonial government on the Dutch Caribbean island. Tula's speeches to his fellow slaves are meant to inspire in ways akin to similar speeches in *Spartacus* and *Amistad*. What is more, the film's director, Jeroen Leinders, saw the film as part of an effort to heal racial wounds in Curaçao, where he had spent part of his childhood. Who could ask for better premises for a slavery film, right? Daniel Arbino provides surprising

answers to this question through an insightful and persuasive analysis of the film. Arbino's answers hinge on several factors, including the extent to which Leinders is seen by Curaçaoans as one of their own, and whether the film's emphasis on racial harmony and creolization is more faithful to the historical record or to the filmmaker's own agendas.

The institution of slavery was underwritten by violence or the threat thereof. How and to what extent, however, should this violence be represented in films about slavery? In her essay on *12 Years a Slave* (2013), Janell Hobson is tasked with shedding light on a film about which many readers of this volume more than likely are already knowledgeable and passionate: a film, moreover, that represents violence "unflinchingly," much more so than the related *Solomon Northup's Odyssey*, a made-for-TV film from 1984. In a nuanced critique of *12 Years a Slave*, Hobson accomplishes her task by outlining, on the one hand, the film's own accomplishments. These accomplishments, not surprisingly, are numerous, and—as Hobson explains—must be understood not only within the context of other films about slavery (*Beloved*, for instance), but also in more specific relation to changing patterns in how earlier films represented enslaved characters. On the other hand, Hobson reminds us that no film, not even a brilliant one like *12 Years a Slave*, can do everything. A filmmaker like Steve McQueen must reconcile multiple, often contradictory, demands: should he, for instance, be faithful to Solomon Northup's eponymous 1850s slave narrative or should he bend it in some way for some present-day purpose? Such tensions, according to Hobson, are most apparent in relation to the film's enslaved female characters, especially Patsey.

If Canada was often seen by the enslaved in the U.S. and their sympathizers as the land of freedom and the ultimate destination of the Underground Railroad,[9] such a view presents only a partial view Canada and its history. Following the American Revolutionary War, thousands of Black Loyalists were granted safe passage to Canada from what would soon become the United States. Nova Scotia, their new home, was not only cold and barren but also reproduced many of the social divisions from which the Loyalists were escaping. As Emily Allen Williams explains, this post-Revolutionary Canadian lies at the heart of Clement Virgo's film, *The Book of Negroes* (2015), which is based on Lawrence Hill's eponymous award-winning novel. In her essay on the film, Williams balances its emphasis on a Canadian context while placing it within a broader panorama of slave narratives and black resistance to both white oppression and white tutelage. The result is a film that explores new thematic ground while building on the vast terrain of slavery cinema.

In the conclusion to the volume, Kristen Block examines the possible benefits and pitfalls of integrating fiction films about slavery into classes on the history of slavery. Block makes it clear that in a disciplinary environment that sometimes prioritizes potentially dehumanizing numerical data and archival materials that can amount to "mere fragments of historical documents," contemporary university students tend to be attracted to the visual and narrative force of slavery films. When these films stray, at best, from the historical record or, at worst, resort to unadulterated fabrications, the concern of professional historians seems justified. In response, Block outlines ways of turning the potential historical limitations of slavery films into productive—indeed, cutting edge—pedagogical tools. These tools, in turn, are uniquely capable of shedding light on historiography, i.e., the range of evolving factors that inform *how* histories are written.

Notes

1. Irish immigrants to the United States during the nineteenth century provide an interesting counterpoint to the gradual process of racialization Rout describes: despite the harsh regimes of abuse and degradation both the Irish and slaves of African descent experienced, the former had terms of indentured servitude that often came to an end; what is more, the children of the Irish indentured servants did inherit their parents' condition.
2. See, for example, the documentary *La raiz olvidada / The forgotten roots* (1998) and Herman Bennett's monograph *Colonial Blackness: A History of Afro-Mexico* (2009).
3. Stevens published his essay in 1997. By way of updating his list we might add Youtube and other streaming video platforms, DVDs, and so on.
4. These films include *The Scalphunters* (1968), *Burn!* (1969), *Slaves* (1969), *Addio Zio Tom* (1971, *Goodbye Uncle Tom*), *The Legend of Nigger Charley* (1972), *Ganga Zumba* (released 1972), *Black Snake* (1973), *The Soul of Nigger Charley* (1973), *The Autobiography of Miss Jane Pittman* (1974), *Mandingo* (1975), *El otro Francisco* (1975), *The Fight Against Slavery* (1975), *Drum* (1976), *La última cena* (1976), *A escrava Isaura* (1976), *Xica da Silva* (1976), and *Roots* (1977). Additional information on these films—besides *El otro Francisco* and *Roots*, which are treated in chapter essays—can be found in the Appendix.
5. Occasionally the volume's contributors employ the related term *enslavement*. While nearly interchangeable, *enslavement* and *slavery* vary slightly: the latter refers more strongly to the institution broadly writ, while the former refers more strongly to specific instances of the act (e.g., "Northup's enslavement lasted twelve years.")
6. Frank Moya Pons, a leading historian of the Dominican Republic, explains that during the colonial period, sugar cultivation on the island yielded to cattle ranching, in which the relation between masters and the enslaved tends to be quite different. With ranching, he argues, "there is little difference between master and slave. They

were both riding horses, they were both using machetes, so master-slave relationships here became quite different from the rest of the Caribbean" (quoted in Henry Louis Gates, Jr.'s *Black in Latin America.* New York: New York University Press, 2011. p. 124).

7. For example, Gilberto Gil's "A felicidade guerreira."

8. "Aquí el que no tiene dinga / Tiene mandinga ..." From "¿Y tu agüela, aonde ejtá?"

9. The 2014 film *Freedom* presents Canada in this light; please see the Appendix for a lengthier description of this film.

Works Cited

Alcocer, Rudyard J. *Time Travel in the Latin American & Caribbean Imagination: Re-reading History.* New York: Palgrave Macmillan, 2011. Print.

Allen, Marlene D., and Seretha D. Williams, editors. *Afterimages of Slavery: Essays on Appearances in Recent American Films, Literature, Television and Other Media.* Jefferson, NC: McFarland & Company, 2012. Ebook.

Bales, Kevin. *Disposable People: New Slavery in the Global Economy.* Berkeley: University of California Press, 1999. Print.

Bennett, Herman L. *Colonial Blackness: A History of Afro-Mexico.* Bloomington: IndianaUniversity Press, 2009. Print.

Davis, David Brion. *Inhuman Bondage: The Rise and Fall of Slavery in the New World.* Oxford: Oxford University Press, 2006. Print.

Davis, Natalie Zemon. *Slaves on Screen: Film and Historical Vision.* Cambridge, MA: Harvard University Press, 2002. Print.

Douglass, Frederick. *Narrative of the Life of Frederick Douglass, an American Slave. Written by Himself.* Introduction and notes by Dale Edwyna Smith. New York: Barnes & Noble, 2012.

Gates, Henry Louis, Jr. *Black in Latin America.* New York: New York University Press, 2011.

Harms, Donald. "The Transatlantic Slave Trade in Cinema." *Black and White in Colour: African History on Screen,* edited by Vivian Bickford-Smith and Richard Mendelsohn. Athens: Ohio University Press, 2007, pp. 59–81. Print.

Hutton, Paul Andrew. "Correct in Every Detail: General Custer in Hollywood." *Montana: The Magazine of Western History,* vol. 41, no. 1, 1991, pp. 28–57. Print.

Middleton, Britt. "Rachel Dolezal's Transracial America: If You Could Flip the Switch on Your Racial Identity, Would You?" *BET,* 12 June 2015, www.bet.com. Accessed 28 Sep. 2015.

Niemtzow, Annette. "The Problematic of Self in Autobiography: The Example of the Slave Narrative." *The Art of Slave Narrative: Original Essays in Criticism and Theory,* edited by John Sekora and Darwin T. Turner. Macomb, IL: Western Illinois University Press, 1982, pp. 96–109. Print.

Palmié, Stephan. "Introduction." *Slave Cultures and the Cultures of Slavery,* edited by Stephan Palmié. Knoxville, TN: The University of Tennessee Press, 1995, pp. ix–xlvii. Print.

Patterson, Orlando. *Slavery and Social Death: A Comparative Study*. Cambridge, MA: Harvard University Press, 1992. Print.

La raiz olvidada = The Forgotten Roots. Mexico City: Producciones Trabuco, 1998. VHS.

Rout, Leslie B. The African Experience in Spanish America. Princeton: Markus Wiener Publishers, 2003. (1976). Print.

Rushdy, Ashraf. "Neo-slave Narrative." *The Oxford Companion to African American Literature*, edited by William I. Andrews, Frances Smith Foster, and Trudier Harris. New York: Oxford University Press, 1997, pp. 533–35. Print.

Stevens, Donald F. "Never Read History Again?: The Possibilities and Perils of Cinema as Historical Depiction." *Based on a True Story: Latin American History at the Movies*. Wilmington, DE: SR Books, 1997, pp. 1-11. Print.

Taylor, Yuval. "Introduction." *I Was Born a Slave: An Anthology of Classic Slave Narratives*, edited by Yuval Taylor. Chicago: Lawrence Hill Books, 1999, pp. xix–xxxviii. Print.

Thornton, John. *Africa and Africans in the Making of the Atlantic World, 1400–1800*. Cambridge: Cambridge University Press, 1998. (1st ed. 1992). Print.

Wade, Peter. *Race and Ethnicity in Latin America*. 2nd edition. New York: Pluto Press, 2010. Print.

CELLULOID CHAINS

Slavery in Service of the Revolution in Sergio Giral's *El otro Francisco*

Julia C. Paulk

The feature-length film, *El otro Francisco*, was produced in Cuba in 1975, and directed by the Cuban–North American filmmaker, Sergio Giral. Giral's film, part of a trilogy of historical films that also included *El Rancheador* (1976) and *Maluala* (1979), was one of the first Cuban films to address issues related to slavery after the Cuban Revolution of 1959. With the intention of rescuing the neglected history of Cuban slaves, Giral conceived of the film as a critique of and correction to the first Cuban novel to confront slavery, *Francisco, el ingenio, o, las delicias del campo*, by Anselmo Suárez y Romero (1839).[1] Giral's critique of the novel asserts that the bourgeois, capitalist interests of Suárez y Romero as well as of the entire *tertulia* sponsored by Domingo del Monte prevented a sincere and accurate presentation of slavery and critique of the institution. Radically departing from a linear model of narrative story-telling and from obedience to the traditional genres of fictional feature film and documentary, Giral's film employs a revolutionary means of cinematic narration. Written and directed after the revolutionary leadership had already declared racism to be eradicated in Cuba, the film focuses attention on the historical oppression of Afro-Cubans subjected to the institution of slavery. Ultimately, however, the Marxist ideology of the Cuban Revolution promoted within the film prevents a disinterested evaluation of the contributions of nineteenth-century antislavery literature to discussions of Cuban national identity and of its attempts to

confront the problems of slavery. Further, adherence to this ideology also prevents the film from openly acknowledging racism and sexism in Cuba after a decade and a half of institutionalized Revolution. A desire on the part of the Cuban government to engage with the traditional canon of nation-building texts like *Francisco* rather than create entirely new works results in the continued privileging of Romantic ideologies, particularly with regard to gender representation. Despite these burdens placed on it, Giral's *El otro Francisco* marks a landmark moment in Cuban post-revolutionary film in that it did bring to the forefront the role of slavery in Cuba's past and suggests ways in which official history and the discourse of nation-building continue to be revised.

The narrative methods employed in Giral's film are more easily understood within the context of the history of Cuban filmmaking, so we must first look briefly at that history and the impact of the 1959 Revolution on Cuban film. Prior to the Revolution, the majority of films shown in Cuba were imported from Hollywood and Mexico.[2] As Joshua Malitsky points out, cinema-going was a popular pastime for millions in Cuba of the 1950s, but few filmgoers had seen actors resembling themselves on the silver screen: "Cubans, like the Russians at the moment of their revolution, had rarely seen themselves on cinema screens" (85). Recognizing the power of mass media in informing and shaping the public's point of view, the rebel army formed its own film department during the Revolution, Cine Rebelde, which was in operation from January to March of 1959 (García Osuna 39; Malitsky 63). Once they had seized full control of the island's government, one of the Cuban Revolutionary leadership's first acts was to establish a national film institute, the Instituto Cubano del Arte y la Industria Cinematográficos (ICAIC), on March 24, 1959; shortly after, production and distribution systems were appropriated, completing the process of nationalization. The local film industry was small prior to 1959, and, as Giral points out in a 1986 interview, at the time ICAIC was founded, "The few cinema technicians we had, had either already left or were packing their bags" (López and Humy 275). ICAIC of course had to be run by filmmakers approved by Castro and the Revolutionary leadership, which further narrowed the field of experts available. The ICAIC charter outlines the institution's conception of film as an artistic medium that is socially and politically transformative (Malitsky 4). For the founders and directors of the institute, film is, first and foremost, an art form. Further, true to its revolutionary founding, ICAIC's charter defines "cinema as an 'instrument of public opinion' capable of successfully communicating particular messages to a diverse audience (mass communicative aspect) and as possessing the '*power* to prove and make transparent the *spirit* of the revolution' (artistic

element)" (emphasis in original; Malitsky 63). With the founding of ICAIC, cinema became an integral part of the revolutionary project to build a new nation. The role of film within this construct was "to project (materially and psychologically), model (through examples on-screen) and instill (through the emotional and visceral dimension) a socialist revolutionary mode of thought and being" (Malitsky 4–5).[3]

Among the few Cuban filmmakers working in Cuba after the Revolution, two of the most influential, Tomás Gutiérrez Alea and Julio García Espinosa, had studied at the Centro Sperimentale in Rome in the early 1950s and were schooled in the Italian neorealist mode. Gutiérrez Alea spent many years with ICAIC and was a collaborator on *El otro Francisco* with Sergio Giral. With its focus on "the hidden underbelly of society," use of locations and non-professional actors for shooting, and narrative focus on daily life, the aesthetics and philosophy of Italian neorealism lent themselves well to the needs of the new Cuban film institute and to the production of both fiction and nonfiction film (Malitsky 67). Further, given the scarcity of resources and of skilled technicians in addition to the goal of disseminating the ideology of socialism, nonfiction film became the preferred mode of representation for Cuban filmmakers: "Cuban leaders, in fact, privileged nonfiction film as a form uniquely capable of aiding the effort to shape the new man ["el hombre nuevo"] and to unify, edify, and modernize the citizenry as a whole" (Malitsky 2–3). The production of newsreels and documentary films has tended to outweigh that of feature films in Cuba since the Revolution.[4] A central figure in the development of nonfiction narrative style in Cuban film is Santiago Álvarez Román, who produced the ICAIC's *Latin American Weekly Newsreel* from its beginnings in 1960 to its final issue in 1991 (Malitsky 70). Given the limitations on distribution and exhibition of the newsreels, Cuban newsreels developed differently from those produced in other nations, such as the United States. Typical newsreels of the time made outside of Cuba were understood to be vehicles that could quickly provide up-to-date news reports that would also rapidly become outdated. In Cuba, headline news could be more easily accessed by other sources of mass media, particularly television and radio. Thus, newsreels in Cuba under Álvarez were designed to be more durable in content and to participate overtly in the project of socialist nation-building. Álvarez developed his own narrative technique for Cuban newsreels, and this style appears to be an important influence for Sergio Giral's narrative approach in *El otro Francisco*.[5]

Under Álvarez's direction, the Cuban newsreel was dedicated to portraying the transformation of the centers of power, the stabilization of the nation, and

of the acquisition of political consciousness by the masses. Álvarez developed a narrative style that he called "anticipatory" that is unique among newsreels and was intended to engage audiences more fully with the topics presented. Álvarez's newsreels

> most often employed a single authoritative voice-over narrator and a fragmented narrative structure.... Occasionally, Álvarez ran a brief story on a political or cultural issue, moved to one or two stories completely disconnected from the original one, and then returned to the initial subject. He explained this editorial practice as "anticipatory," arguing that by citing a story and then returning to it, audiences were energized and engaged with the issue. (Malitsky 72)

Among the goals for ICAIC and Álvarez's newreels was a project of nation-building:

> Cuban leaders in the immediate post-revolutionary period proposed a new definition of the nation—one that was accepted, rejected or modified by the population at large. Newsreels and documentaries contributed to this political process by connecting locations, events, and the figures associated with them to shared public narratives. (Malitsky 72)

To support the goal of nation-building, post-revolutionary documentaries illustrate a new conception of the relationship of individuals to the collective, promote new international relationships, and remodel power structures (72). Further, nonfiction films of this period project "a vision of a people acquiring *conciencia* ['political awareness']" (Malitsky 62). Although it is not strictly speaking a documentary, Giral's film has a great deal in common with Álvarez's approach to newsreel.

Sergio Giral is one of very few Afro-Cubans to have worked as a director for ICAIC. He was born in Havana in 1937 to a Cuban father and a North American mother of Cuban descent.[6] His parents moved to the United States in the 1950s, and decided to go to New York City because they viewed it as the best place for the mixed-race family at a time when Jim Crow laws were still enforced in Southern states: "They chose New York, since in Miami, my mother and I would have been victims of racial segregation" (Morelli 34–35).[7] Giral attended high school in the Bronx and later studied painting with the Art Student League (Morelli 35). Giral's parents returned to Cuba, but the young

artist stayed in New York, having become a part of the Greenwich Village beatnik scene. Giral was an acquaintance of Allen Ginsberg, who was a regular at the coffeehouse where the future cineaste worked as a waiter, and he often attended beat poetry readings in the Village in the 1950s (Morelli 35). After moving back to Cuba in 1960, Giral reconnected with a Spanish friend he had met in New York, the celebrated cinematographer, Néstor Almendros, who had also studied at the Centro Sperimentale in Rome and was at that time working for ICAIC. Almendros encouraged Giral to join ICAIC, which he did as a "creator of educational documentaries" ("realizador de documentales didácticos") in 1961 (Morelli 38). While there were some filmmakers and technicians who remained in Cuba after the Revolution, many had to learn their jobs while doing them. As Giral relates to López and Humy, "My apprenticeship, like that of the great majority of ICAIC filmmakers, was autodidactic; it happened while we worked. We began making documentaries right away in order to learn how to make films" (275). Although Giral's first feature film, *El otro Francisco*, was not made until 1975, his early formation began years earlier in documentary film.

The narrative techniques used in *El otro Francisco* correspond closely to those employed in Álvarez's newsreels and reflect the goals of nonfiction film in postrevolutionary Cuba. Like Álvarez's newsreels, the narration in *El otro Francisco* is fragmented. The plot does not follow a linear development but jumps forward and back, disrupting itself, and recreates certain incidents in order to re-examine or portray them differently. An anonymous, didactic, voice-over narrator interrupts the action of the film to comment upon and "correct" the scenes portrayed. Indeed, the film could at first be confusing for those uninitiated in the Cuban approach to nonfiction film and also for those unfamiliar with the original Suárez y Romero novel. Although the original literary work remains the premise or pretext for the making of the film, *El otro Francisco* critiques and rewrites the Suárez y Romero novel, offers a lesson in the history of nineteenth-century slavery and on the writing of history itself, and illustrates the building of *conciencia* among the Cuban slave population. The final commentary from the voice-over narrator and the text that appears on the screen suggests that nineteenth-century slave rebellions in turn served as the precursors to the triumph of the 1959 Revolution and its eradication of the racial prejudices associated with slavery.

The film's narrative begins with what is the conclusion of Suárez y Romero's novel. The opening scene enacts the final, tragic meeting between Francisco, the beleaguered slave, and Dorotea, a favored, light-skinned house-slave, followed by his suicide by hanging. The initial scene of the film is exaggeratedly melodramatic and reiterates the Romantic exoticism of the American landscape that features

prominently in nineteenth-century literary works from both sides of the Atlantic, such as François-René Chateaubriand's *Atala*, Gertrudis Gómez de Avellaneda's *Sab*, and Jorge Isaacs' *María*. Further, the director employs a cinematic discourse in recreating these scenes that reiterates "the visual style and action ... of classic Hollywood films such as *Gone with the Wind*" (Mraz 105). Seated by a gently flowing river in the jungle, Francisco awaits his love interest, Dorotea, who has come to tell him that she has given herself to their owner, Ricardo, in order to safeguard Francisco from further persecutions. She has defiled herself to save him but now declares herself unworthy of Francisco's love; the two can never be together again. Francisco runs into the jungle and throws himself to the ground in despair, writhing in misery. Soon after this, Ricardo and Don Antonio, the *mayoral*, or overseer, find Francisco's body hanging from a tree and surrounded by carrion birds. These opening scenes closely correspond to the final pages of Suárez y Romero's *Francisco*.

However, the introduction of a voice-over narrator and a change of scene away from Francisco's body to an elegant, urban drawing room make clear to the viewer that the preceding was the enactment of a scene from a novel, and that the film has now transitioned to the historical moment in which Suárez y Romero presented his novel to the Domingo del Monte literary salon in Havana in 1839. In other words, the film transitions from a "fictional" story-telling mode to a "nonfictional" representation of the famous Del Monte *tertulia*, which was responsible for commissioning the earliest Cuban works of literature that confronted slavery and also that have been characterized as promoting a distinctly Cuban identity. The voice-over, in this case provided by the character of Suárez y Romero, who has been reading his novel aloud, cedes to another voice-over narrator who is never identified nor seen but who will guide the viewer through the interpretation of Giral's film for its duration. This authoritative and instructive narrator explains that the novel, *Francisco*, was commissioned by the bourgeois plantation owner, Del Monte, in order to send it to England with Richard R. Madden, the Judge Arbitrator of the Mixed Commission Court in Havana from 1836 to 1839. According to the didactic narrator, Suárez y Romero's novel, as the product of bourgeois interests, represents a false view of what life was really like for Cuban slaves and that the film will explore the idea that behind *Francisco* was a real, other Francisco, whose experience is not represented by Suárez y Romero's Romantic novel. As the film departs from the Suárez y Romero version of *Francisco*, the filmic discourse moves away from the classic, Hollywood form of representation to one that more closely resembles documentary form (Mraz 105). Giral's documentary-style scenes critique the novel's lack of realism through the

use of a hand-held camera, unbalanced lighting, and long takes that highlight production and group identity over individual desires and passions (107).

In an early critique, Francine Masiello characterizes the film as a form of socialist literary criticism. Referring in general terms to the objectives of film-making in Cuba, she states, "Concomitant with the goals of political re-education comes a lesson in literary competence designed to teach the public to evaluate the ideological world which art inhabits" (19). Having parodied the melodrama of Francisco's final scene with Dorotea and his despair at her betrayal, Giral's film proceeds by reformulating scenes from the Suárez y Romero novel and also by presenting documentary-style recreations of historical figures involved in the composition of the original novel as well as of real life for slaves on Cuba's sugar plantations. Having begun with the conclusion of the novel and then transition-ing to the "real life" scene of the Del Monte *tertulia*, Giral's film then moves to what corresponds to the beginning of the original *Francisco* by capturing a still image of Francisco dressed in livery and standing by the carriage he drove for Doña Mendizábal in Havana; the opening credits scroll by as Francisco poses picturesquely in front of the two-wheeled carriage, reflecting through film the antislavery novel's origins in *costumbrismo*. The film progresses further following its own narrative logic rather than that of the Suárez y Romero novel by next portraying the horrible abuse of Francisco at the sugar plantation at the hands of the sadistic *mayoral* and behest of Ricardo, and then finally recounting the tale of how Francisco and Dorotea, both favored slaves in Doña Mendizábal's household, fell in love and became star-crossed lovers. For Giral's didactic nar-rator, the Romantic portrayal of the two household slaves is absurdly removed from the realities that slaves faced in nineteenth-century Cuba, and, having recreated the Suárez y Romero version, albeit in reverse order, the narrative moves to make a number of corrections.

One of the main alterations Giral's film makes to the Suárez y Romero novel is the portrayal of the sense of community amongst slaves who work in the fields of the sugar plantation and the development of a collective awareness of the pos-sibility of taking action of a rebellious nature. This is done through the creation of additional slave characters and the portrayal of slave rebellion, culminating in a violent uprising near the conclusion of the film. As I will discuss further below, the scenes Giral adds to the story of Francisco would have been far too incendiary to be included in a novel of the type produced by the Del Monte *tertulia*. When Francisco is sent to cut cane in the field immediately after being whipped, other slave characters observe his physical suffering and communicate in Brechtian fashion through gestures, eye contact, and song (Lesage 57). As

Francisco sways, about to lose consciousness, the slaves around him are singing "Dale la mano" as a refrain; another slave steps in to do Francisco's work until violently stopped by the *contramayoral*.[8]

The idea that slaves could rebel does not enter into the Suárez y Romero novel. His Romantic hero and heroine are repeatedly characterized as docile and obedient. Antislavery literature of Suárez y Romero's era typically focused on "superior" slaves, usually described as being light-skinned mulattos, made as attractive and non-threatening as possible to the primarily white and privileged readership of the era. Even very mild commentary on slavery was considered threatening by Spanish colonial censors, and Cuban slave-owners lived in constant fear of uprisings, particularly after the violence of the slave rebellions that led to the independence of Haiti. Readers of the era were receptive to Romantic formulations of the individual sufferings of superior slaves, making this the favored rhetorical approach among antislavery writers. Doña Mendizábal frequently reiterates her belief in Francisco's docility in the film, demonstrating her blindness to what is really going on around her. However, the film first introduces the idea of rebellion through the small means by which slaves could make life difficult for owners, particularly through sabotage.[9] Through the encouragement of rebellious slaves and a recaptured *cimarrón* ("maroon" or runaway slave) on the Mendizábal plantation, the slave community the film portrays begins to demonstrate a collective consciousness while at work and also at their fireside dances, known in Spanish as *bembés*.[10] An unidentified slave inserts a broken piece of a machete into the new steam vapor machine, delaying sugar production for several days. Francisco is unfortunately blamed for the incident, but it also serves as an illustration of collective rebellion. The film also mentions suicide and abortion as other means of slave dissent. Encouraged by the recaptured Crispín and André el lucumí, both of whom are characters original to Giral's script, overt rebellion is incited when the slaves set fire to the plantation's bagasse storage hut. Communicating through eye contact and passing around a file, the insurgents encourage Francisco to join them; remaining closer to the Suárez y Romero character, however, he lowers his head and refuses to escape with them. Crispín and Andrés el lucumí are the leaders of the rebellion; they represent the true story behind the false *Francisco* authored by Suárez y Romero.

In her critique of Giral's film, Dawn Stinchcomb points out that the gathering around the fire, which occurs later in the film, is the first time any of the male slave characters really talk (81). While this is an accurate description of the film, this is one of the dilemmas presented by transforming a canonical nineteenth-century novel into a twentieth-century film; Giral begins with the

Suárez y Romero version of Francisco's story, and then moves to tell the story overlooked by the original author. The concept of slave rebellion does not and would not appear in the novel, but it becomes a key moment in the development of the Giral film. Crispín, André el lucumí, and several additional slaves file off their shackles and other markers of slavery and oppression, such as the bell Crispín has been forced to wear around his neck, and escape while Don Antonio, the overseer, and the remaining slaves fight the fire that has been set. Don Antonio and his fierce dogs begin to hunt the escaped slaves, and two of the slaves are killed in disturbing scenes of violence. Before long, however, the remaining slaves rebel and sack the Mendizábal plantation, setting fire to the cane fields, destroying equipment, and emptying the house. Don Antonio dies at the hands of angry slaves who asphyxiate him with his own whip. Notably absent during the uprising, white colonists arrive to put down the rebellion. Rather than commit suicide as in the Suárez y Romero version, Francisco is hanged in punishment alongside a female slave wearing a white dress from the plantation house. This uprising has been stopped, but, as the didactic narrator informs us, it is like the many uprisings that happened in nineteenth-century Cuba, which are listed in the film in chronological order. Finally, several of the escaped slaves make it to the relative safety of the *palenque*, a settlement formed of *cimarrones*. The film concludes with a group of escaped slaves contemplating an expansive, mountain view, surely reminiscent for Cuban movie-goers of the views of the Sierra Maestra as occupied by the soldiers of Fidel Castro's revolutionary 26 of July Movement.

The steam-powered mill introduced into the Mendizábal plantation in the film does not occupy a key role in Suárez y Romero's *Francisco*. The 1830s were actually the beginning stages of mechanization of the sugar industry in Cuba, and the steam-powered mill makes an important appearance in Giral's film and projects a vision of a history of industrialization in Cuba. Like much of Russia, Cuba was technologically underdeveloped at the time of the Revolution, yet the industrialization process is an important factor in the revolution of the workers as theorized by Marx and Lenin. One central ideological role of post-revolutionary film in Cuba was to project an image of industrialization and modernization of the national infrastructure (Malitsky 4). It is important to note that in Giral's film, mechanization is being promoted by foreign interests for their own benefit. The voice-over narrator claims that Richard R. Madden, who is described as being English, travels to Cuba not to see if Spain is abiding by the 1817 treaty suppressing the Atlantic slave trade, but rather to promote the sale of English machinery on the island and elsewhere in the Caribbean. Giral's

film is the only instance I have seen of Madden personally being characterized as having interests other than a desire to fight slavery.[11] Further, he was in fact Irish rather than English, which is important information in examining his potential motives. He was acting on behalf of England when representing the Mixed Commission in Havana, but his career as an activist suggests a sincere commitment to fighting against slavery as such activity was understood in the nineteenth century. Like Madden, the character of the technician installing the new steam-powered mill on the Mendizábal estate noticeably speaks Spanish with the accent of a native speaker of English. Malitsky points out that following the 1959 Revolution, Castro had considerable support from the island's populace. The biggest threat to his government came not from within but from the United States, which quickly took action to undermine the Revolution (14). A central goal of film was to "reconceive and rearticulate the meaning of 'Cuba' and 'Cuban-ness'" (Malitsky 14). Prior to the Revolution, the popular idea of Cuba was one that was both dominated by U.S. imperialism and also centered on the city of Havana. Film was conceived as playing an important role in re-defining what it meant to be "Cuban": films were meant to "establish a Cuban spirit aligned with the rural and committed to national liberation" (Malitsky 15). In the context of 1975 Cuba, the two English-speaking characters in Giral's film thus can be understood as stand-ins for other English-speaking capitalists who seek only to benefit themselves. As conversations between slave-owners visiting the Mendizábal estate reveal, the introduction of the steam-powered mill will not be beneficial to the workers themselves. The machines will simply increase the speed of production, which will mean that the slaves will have to work even more inhumane hours to keep up with the machines. The lives and humanity of the slaves are meaningless to the owners, who only debate whether it is cheaper to keep them as slaves and pay for their maintenance or to free them and pay a minimal salary. The only other possible advocate for slaves who appears in the film, the Catholic priest, does not represent himself well either. He is only concerned with proper burial of the deceased and the domination of what is "savage" within the slaves.

An interesting challenge in the analysis of Giral's film is that both the "fictional" scenes from the novel and "nonfiction" scenes depicting real life are presented on the same narrative plane. The voice-over narrator decries the falsehood of Suárez y Romero's compromised representation of slavery, yet characters from the novel also appear in scenes with people who actually lived. This is particularly notice-able when Richard Madden interviews Ricardo Mendizábal and Don Antonio, the overseer, Suárez y Romero's fictional creations, about the lives of slaves on the

Mendizábal plantation. Madden interviews several of the characters in the film, although the first two, Del Monte and Suárez y Romero, are historical characters. These interviews serve the didactic function of the film; Madden asks the slave-owners about the demographics of the island, living and working conditions of slaves, and expenses of slavery. While accused by the film's narrator of representing capitalist interests, Madden is nonetheless important in the promotion of information about the historical facts of slavery provided by the film.

There is a tendency in the criticism of Giral's film to overlook the implications of the mingling of the "fictional" with the "nonfictional." Masiello calls the narrative style of *El otro Francisco* "unique": "*The Other Francisco* becomes an exercise in seeing and reading which tests the limits of narrative reliability. . . . The film's self-conscious exegetic experiments and its recuperation of historical realities produce a highly sophisticated drama, unique in cinematic form" (19). The ways in which the film interrupts and comments upon itself trains the viewer in critical interpretation: "In this way, a new code of critical consciousness is created for the viewer. The continued intervention of the narrator makes us question the nature of the spectacle observed" (Masiello 25). Julia Lesage praises *El otro Francisco*'s recuperation of a past lost through racism (58) and, one might add, interests of power, without commenting on the interchangeable use of fictional and historical characters in a film. One can argue that placing the generically "fictional" alongside the generically "nonfictional" has the effect of compromising the information promoted by the film as "true." Suárez y Romero's novel is critiqued for presenting a false view of what life was like for slaves in Cuba in the nineteenth-century, yet Suárez y Romero's villains, Ricardo and his overseer, become informants for Madden in the film and for Giral's viewers about what is presented as the truth about those lives. The film reminds us that history can be rewritten yet demonstrates faith in the possibility of discovering and articulating a "true" history. In this case, the history of nineteenth-century Cuba is revisited in the service of ICAIC's goals in revolutionary filmmaking. The "false" story is deconstructed and reconfigured as the "true" one, yet the implications of this process, which is that all "truths" can be dismantled, are not recognized by the film itself because of its didactic goals.

Giral's discussion of his film career in Cuba changes somewhat between the two published interviews of him listed in the MLA International Bibliography. The first is from 1986, when Giral still worked in Cuba for ICAIC, and the second is from 2007, nearly two decades after the filmmaker's relocation to the U.S. in the early 1990s. In the earlier interview, Giral emphasizes the privileges and artistic freedoms afforded to him as a filmmaker for ICAIC. As he comments

in the 1986 interview, in Cuba "we have tremendous artistic freedom. From the outside, people always miss the point here. . . . But I will tell you that here I have complete artistic freedom of expression" (276). However, in his later interview with Morelli, Giral explains that, as an official organization of the Cuban Revolution, ICAIC is obliged to follow the dictates of the Revolutionary government:

> Let's say that any state organism in Cuba is subject to the exigencies
> of the regime, and in the particular case of art and literature, obliged
> to follow without question the autocratic edict, "With the revolution
> everything, against the revolution nothing." The choice of scripts as
> well as the approval of completed films changed according to the
> new orientations of the government, but it is clear that the political-
> ideological censorship was always present. . . . A good example would
> be the film that I made with a script by Manuel Cofiño, *Techo de
> Vidrio* (*The Glass Ceiling*), which suffered from censorship from the
> beginning and ended up in the storehouse of memory. (Morelli 39)[12]

No longer residing in Cuba, Giral speaks openly about the censorship at work within ICAIC in the later interview.

In both of the published interviews, Giral describes the purpose of *El otro Francisco* as that of rescuing history rather than of making a statement about contemporary Cuba. Gutiérrez Alea proposed that Giral make a film version of *Francisco*, and Giral saw the opportunity to investigate slavery in Cuba:

> Later I understood that the topic suggested other incursions into
> the study of slavery, the principal cause of racism in Cuba and the
> rest of the Americas in my way of seeing it. And at the same time it
> kept me outside of the regime's political-ideological game. It wasn't
> until *Plácido* and *María Antonia* that I became aware of the trans-
> position of a past time to the present. Both films speak of Cuba
> today. (Morelli 42)[13]

He continues to state that two of the films he made, *La Jaula* and *Techo de Vidrio*, which dealt with contemporary topics, were censored for being "detrimental to the revolution" ("perjudicial para la revolución") (43).

In the earlier interview, Giral is careful to propose that racism is not a problem in Cuba of the 1980s. When asked about black issues in film and the positioning of black filmmakers, Giral responds that race is not an issue in Cuba:

> It is very difficult for me to see things from the perspective that
> is implied in statements such as "black issues" or "the position of

blacks" in the Cuban cinema because our social reality is one that does not make such a phenomenon possible. Such issues do not come up because the problems underlying those issues do not exist here. (López and Humy 278)

In the Morelli interview, however, he is able to acknowledge racism in Cuba and describes it as being the result of slavery: "Racism in Cuba has its origins in slavery and the collective unconscious that the Cuban nation endures" (43).[14] He nonetheless credits ICAIC with providing an egalitarian working environment under the leadership of Alfredo Guevara: "In the case of ICAIC, Alfredo Guevara, the director, had a very open conception of race, although being the Marxist that he was he might not have taken the issue into consideration" (Morelli 41).[15] He also recognizes, however, an issue of elitism within ICAIC: "I do not think that ICAIC's elitism was based on skin color but rather on the individual's cultural and artistic level, without ignoring the potential for political integration" (Morelli 41).[16] One might question whether race is not a factor in who is able to achieve the cultural level necessary to earn admission into ICAIC; given the very small numbers of directors of color who have worked for ICAIC over the last several decades, one can only conclude that race becomes a barrier at some point in the system.

We have seen that Giral makes the connection between racism and slavery, and in the later interview acknowledges that racism has not been overcome in Cuba. Given that a major critique of nineteenth-century antislavery novels from various parts of the Americas has been the accusation of racism, one must ask why this issue is not more explicitly addressed in Giral's critique of *Francisco*. One of the most widely read antislavery novels in the world, Harriet Beecher Stowe's *Uncle Tom's Cabin*, was famously lambasted by James Baldwin's 1949 essay, "Everybody's Protest Novel," for its reliance on racial stereotypes. Among scholars of nineteenth-century antislavery literature of Latin America, David Haberly's characterization of Brazilian antislavery literature as being both "antislavery" and "anti-slave" is frequently cited (52). Scholars of Cuban antislavery literature frequently critique Del Monte not only for being a slave owner himself but also for being a strong promoter of "blanqueamiento" ("whitening") for Cuba alongside José Antonio Saco. *Sab* and most other antislavery novels are criticized for focusing on individual light-skinned slaves in privileged positions of domestic service and not on the larger numbers of darker-skinned agricultural workers. However, the critique that *El otro Francisco* makes of Del Monte and Suárez y Romero conforms to Cuban Marxist precepts that economic disparity is the root of all social problems; these slave-owners are criticized for their class

interests but not for their racial prejudices. For Cuba's revolutionary government, having pronounced the elimination of economic problems also meant the end of racism and other social problems. In the Morelli, interview, Giral is free to recognize this aspect of Cuban revolutionary political thought:

> Racism in Cuba proved itself not to be a question of either class or economic difference despite the regime's egalitarian proposition, which caused the absence of the black man at the level of government and the official mistrust of the black population in political and criminal terms. (Morelli 43)[17]

Dawn Stinchcomb strongly criticizes the failure of Giral's film to fully give voice to more slave characters. Although Giral's film presents the viewer with slave characters who actively fight for their freedom, moves the soundtrack from European music to African conga rhythms, and shows only people of color in the final scene (81), for Stinchcomb, the film's overall presentation does not do enough to give voice to the Afro-Cuban slave (82). The voice-over narrator's final words, which provide a list of primarily white men who rose up against Spanish colonial rule, are about national heroes whose names have been pressed into service to the Revolution through historical revisionism. Of the heroes mentioned, José Antonio Aponte is the most closely associated with slave rebellion; the remainder, notably José Martí and Ignacio Agramonte, were of European descent.[18] ICAIC and the revolutionary government have anachronistically pressed these nineteenth-century figures into the service of the Revolution by characterizing their actions as precursors to the 1959 Revolution. The wide-screen view shown at the end of the film places all viewers together, as a collective, placing the focus on "the unity of the nation that has just one history" (Stinchcomb 82).[19] The struggles that Afro-Cubans have had to face are erased in this projection of national unity. For Stinchcomb, the film "contributes to the belief that blacks are for Fidel Castro 'a secret weapon' in that Afro-Cubans always unconditionally support the ideology of the Cuban government" (82).[20] By conforming to official policy and not addressing racism more directly, Giral's film in the end cannot escape the reiteration of the official position that all social problems have their origins only in economic exploitation and not also in long-held beliefs that people of European descent were racially superior to those of African descent. Analogies created by the film between past forms of oppression, slavery and the interests of foreign capitalists, and the victories of contemporary Cuba side-step the issue of racism as anything other than an economic problem because to do otherwise would imply that a social problem could exist in Castro's Cuba. The

racism in nineteenth-century antislavery literature that is so frequently decried by contemporary critics is one of the few aspects of Suárez y Romero's novel that the Giral film does not take to task.

The film's presentation of the treatment of slave women leaves itself open to a similar critical commentary as well. Lesage's discussion, while more sympathetic to the ideological underpinnings of the film and goals of "Third Cinema," criticizes the film's presentation of slave women in particular.[21] The film's stylized representation of Ricardo's rape of Dorotea highlights her beauty and her tears rather than her anger, nor does the film represent women as organizers of slave communities: "Giral's failure here is both aesthetic and political. . . . He sees women slaves mainly in terms of sexual abuse and forced labor, not as organizers of slave resistance" (Lesage 57). Indeed, the representation of Dorotea's character is one of the ways in which Giral's film most closely follows Suárez y Romero's novel. While one of the film's interruptions of and corrections to the original text is to critique the absurdity of Francisco and Dorotea's secret, Romantic love affair and to highlight the abuse suffered by female slaves, it nonetheless continues on to faithfully portray Ricardo's sexual aggression towards Dorotea and her tearful submission to his will.[22] As Lesage puts it, the film "cannot develop Dorotea as a social person partly because it uses and cannot overcome conventional cinematic iconography for depicting the romantic heroine, an iconography which the film does not sufficiently critique" (57). The revolutionary leaders portrayed in the film, Crispín and Andrés el lucumí, are male, as are the national heroes named at the film's conclusion. As with racism, to suggest that social problems like sexism have any basis other than class is to question the triumph and ideology of the revolution.

Giral's criticism of Suárez y Romero's novel as unrealistic and as relying on Romantic and bourgeois concepts conforms to many contemporary readings of nineteenth-century Cuban antislavery literature. Sharon Fivel-Démoret, for example, categorizes *Francisco* and other nineteenth-century Cuban antislavery novels as "Propaganda Literature" that fail to question the basic assumption that slavery is a right guaranteed to the slave-owning class: "The excesses and abuses of Cuban slavery and slavery-based society are indeed attacked with varying directness and mordacity, but these writers do not challenge its basic premise—that one race should have the right to enslave, to own another" (3). Ivan Schulman characterizes *Francisco* as reformist rather than abolitionist (Schulman 36; Stinchcomb 76). Suárez y Romero is often characterized as simply following the outline prescribed by Del Monte and Madden rather than acting from a sincere interest in reforming or ending slavery. Critics frequently debate whether

novels such as *Cecilia Valdés*, *Sab*, or *Petrona y Rosalía* can be considered aboli-
tionist, antislavery, reformist, or even antiracist. The works are often described
as allegories, particularly allegories of independence, in the many senses of the
word. *Cecilia Valdés* is often referred to as the "national novel of Cuba," with the
infamous *mulata* Cecilia representing the colonized island of Cuba. Gómez de
Avellaneda's *Sab* is characterized by many critics as really being a treatise in favor
of the liberation of women or a formulaic application of Romantic conventions,
particularly that of the "noble savage," to the situation of the Afro-Cuban slave.
As I have argued elsewhere regarding *Sab*, one must consider the context in
which the work was written.[23]

However, to apply the codes of European Romanticism to the situation of
Afro-Cuban slaves was in itself a radical move for nineteenth-century writ-
ers. As William Luis remarks in his discussion of Gómez de Avellaneda's *Sab*,
firstly, the "Cuban bourgeoisie was not a homogeneous group with a unified
program. It was divided into two factions, those who supported the status quo,
represented by slavers and sugar planters, and those who opposed the current
colonial government on the island. The latter group was further divided into
Autonomistas, Independentistas, and Anexionistas" (181). Moreover, any work
of literature that addressed slavery in a critical tone was quickly censored: "For
their daring portrayal of Cuban slave society these works were censored and
could not be published in Cuba, where even their mild description of slavery by
today's standards represented a threat to the slavery system" (Luis 181); threats
to the slavery system were also understood to be attacks on the colonial system.
Giral's film does not fully examine the differing opinions with regard to Span-
ish rule among the planter class and what those differences might mean for the
production of antislavery literature, nor highlight the fact that *Francisco* was
censored under Spanish colonial rule. The *criollo* writers of the Del Monte *tertulia*
saw themselves as reformers and even as rebels, a view also held by the Spanish
colonial government; in Giral's film, they are recast as the upholders of capitalist
exploitation, even when, as one young planter does in the film, promoting the
move from slave to free wage labor.[24]

The antislavery novels written in Cuba in the 1830s are described as being
among the first works of literature demonstrating a sense of *cubanidad*, or Cuban
national identity. Schulman characterizes the late eighteenth-century *costumbrismo*
as being the first instance of Cuban literature that demonstrates an awareness
of cultural differences from Spain; in the 1830s, literary *costumbrismo* was "partly
subsumed by the antislavery novel" ("Reflections" 59). The first Cuban novels and
the work historically considered to be Cuba's "national novel" grew from a short

narrative originally written for Del Monte's *tertulia*, Cirilo Villaverde's *Cecilia Valdés*. Doris Sommer's *Foundational Fictions* also describes the role of antislavery literature in the development of a national body of literature in Cuba and its role in motivating Cubans both on the island and in the U.S. to rebel against Spanish colonial rule. Promoting abolition and a sense of shared nationality among Cubans of all colors became a way of projecting unity and independence for the colony. As Sommer explains in her discussion of Gómez de Avellaneda's novel,

> In Cuba, in other words, abolitionism becomes a *condition*, not a result, of independence.
>
> The fact that *Sab* makes a second appearance during the independence struggle, . . . and serialized in a Cuban revolutionary journal in New York suggests how important an ideological weapon this novel must have been. (125)

The same can be said of a number of Cuban antislavery novels. *Francisco* was deemed too threatening to publish in colonial Cuba. It was first published by Madden in England in translation and was not published in Cuba until the early twentieth century.

Too incendiary in their commentary on slavery to be published in Cuba, works of antislavery literature were understood by their contemporary readers also to be works of rebellion against colonial Spain. Giral's film recasts these novels as being produced by colonizers because of their bourgeois authorship and Madden's foreign influence. In Giral's 1986 commentary, he argues that making a film such as *El otro Francisco* is a way of reclaiming a narrative written by the proponents of colonial culture: "One of the greatest strengths of the Cuban cinema has been its ability to take the best of everything—that is the best of that culture that colonized us—because we cannot negate it" (López and Humy 279). Asked if this type of inversion is what he has done with *El otro Francisco*, Giral responds, "Yes, you have to take 'their' stories and make them 'yours'" (279). With this film, Giral intended to reclaim a story first told by bourgeois slave-owners and then employed in the service of *blanqueamiento* during the republican era (Morelli 43). Working for ICAIC, Giral reworks *Francisco* yet again in the service of nation building, this time with a Marxist orientation. The same works that were seen as opposing the colonizer in the nineteenth-century have become symbols of foreign oppression after 1959. Despite this change in interpretation, the antislavery novel's importance as an expression of Cuban identity apparently remains. ICAIC's need to recast *Francisco* and other works of nineteenth-century literature, such as *Cecilia Valdés*, which was made into a

film in 1982, speaks to the resonance of these works in Cuban culture and in definitions of Cuban national identity.

In retelling yet again the nineteenth-century antislavery novel, Giral draws critical attention to what other recent commentators have also deemed problematic with these texts, particularly their application of Romantic conventions and failure to represent harsh realities faced by slaves. Where he remains faithful to Suárez y Romero's original novel, particularly in the representation of Dorotea, Giral reiterates some outmoded ways of thinking. Conforming to the revolutionary dictate that all social problems are economic and by subsuming the history of Afro-Cubans into one, monolithic version of history at the end of the narration, Giral's film stops short of more fully exposing social problems, particularly racism and sexism, which could have left the film vulnerable to censorship by departing from a materialist interpretation of history. By remaking a canonical text, even with extensive commentary and corrections, Giral's film is ultimately privileging the original novel rather than creating an entirely new version of history.

Nonetheless, *El otro Francisco* was the first post-revolutionary Cuban feature film to portray nineteenth-century slavery and therefore bring a central, previously neglected issue to the forefront.[25] As Malitsky states, nonfiction film after the Revolution promoted a vision of a collective, unified populace working to build a new state but that the image projected of the populace was not necessarily fully inclusive: "Cuba's active attempt to construct a unified nation-state in cinema did not exclude racial or sexual 'others' per se but certainly denied the centrality of such identities" (16). The radical statement that perhaps could have been possible in Giral's film in giving voice to Afro-Cuban slave characters onscreen throughout the film and to the anger of women abused within the slavery system unfortunately is not realized. However, the attempt to capture the history of the struggle against slavery waged by slaves themselves does represent a landmark moment in post-revolutionary Cuban film. Placing the issue of slavery, which was an institution based both on perceived racial distinctions as well as on economic exploitation, squarely in front of Cuban movie-goers had the potential to make Giral's contemporaries ask themselves what continued effects slavery and racism have had on twentieth-century Cuban society, even after the revolutionary government had declared racism to be eradicated. As Giral himself points out, creating a historical film allowed him in some respects to work around official censorship (Morelli 42). Blurring the lines between fiction and documentary film provides further creative license to rewrite the national novel of the nineteenth century as a portrayal of a workers' rebellion, recasting

the original *criollo* writers who critiqued Spanish rule as the colonizers, and to suggest that history itself is a narrative under constant revision. In its final moments, Giral's film is careful to align itself with the revolutionary interpretation of Cuban history as a process inevitably leading up to the 1959 Revolution, thereby supporting the official position that racism no longer existed in Cuba, but it did put the topic of slavery, and therefore racism, in the spotlight and thus in the minds of film viewers. Perhaps they were left wondering what the next telling of Francisco's story will look like.

Notes

1. In addition to being the first Cuban novel to critique slavery, *Francisco* was also the first novel written in the Americas to oppose the institution.
2. According to García Osuna, in 1957, "Of the 509 films shown throughout the island, 49 percent were American, 16 percent Mexican, 10 percent British, 9 percent Italian, 8 percent French and 4 percent Spanish." The statistics provided by the author for the other years immediately prior to the Cuban Revolution are similar to those of 1957 (38).
3. Joshua Malitsky's *Post-Revolution Nonfiction Film: Building the Soviet and Cuban Nations* provides extensive information about the development of ICAIC and the production of nonfiction film in Cuba from the years 1959–1974. These were formative years for Giral at ICAIC, and *El otro Francisco* premiered in 1975.
4. In his 1986 interview, Giral states that ICAIC was at that time making twelve feature films and around forty documentary films per year (López and Humy 275).
5. Julia Lesage describes the influence of Santiago Álvarez's newsreel innovations on Giral's film in the final paragraphs of her article about the film (58). I based my discussion of Álvarez's influence on Malitsky's discussion of the development of nonfiction film in early, post-revolutionary Cuba.
6. My discussion of Giral's biography is based on two published interviews, one conducted by Ana M. López together with Nicholas Peter Humy and the other by Rolando D. H. Morelli. As explained to Morelli, Giral's mother was born in Brooklyn and was the daughter of a Cuban-American "tabaquero" from Tampa, Florida. Giral describes his maternal grandmother as "una mulata cubana clásica" (34).
7. In the original interview, Giral states in Spanish, "optaron por la ciudad de New York, ya que en Miami [por tratarse del sur] mi madre y yo hubiéramos sido víctimas de la segregación racial" (Morelli 34–35) All translations are original unless otherwise noted.
8. For those not familiar with the Spanish terminology of slavery, the *mayoral* is the overseer, usually a white man, who supervises slave labor, and the *contramayoral* is the assistant to the *mayoral*. In the novel and Giral's film, the *contramayorales* are of African descent, demonstrating the ways in which the slave community was pitted against itself.

Interestingly, the same actor who plays the *contramayoral* in *El otro Francisco* also plays the rebellious slave character in Gutiérrez Alea's well-known film, *La última cena*.

9. Mraz explains that Giral was particularly interested in portraying the different means by which nineteenth-century slaves rebelled and was motivated to make his film by Suárez y Romero's failure to address this important feature of slave life in Cuba (111).

10. Giral's film recognizes the contributions of African tradition to Cuban culture in the traditional song and dance performances by the fire. Nineteenth-century Cuban novels typically do not celebrate or even mention African music, dance, or religion or recognize their importance to the development of Cuban arts.

11. Dale T. Graden calls Madden an "avowed abolitionist" (95). Critical articles dedicated to Giral's film tend to repeat the film's characterization of Madden, but criticism of nineteenth-century antislavery literature does not present this characterization of him.

12. In the López and Humy interview, Giral refers to *Techo de Vidrio* as a failed film (277). Giral's original statement in Spanish is as follows: "Digamos que cualquier organismo estatal en Cuba está sujeto a las exigencias del régimen, y en el caso particular del arte y la literatura, obligado a seguir a pies juntillas el edicto autócrata de 'con la revolución todo, contra la revolución nada.' La selección de guiones así como la aprobación de los filmes terminados cambiaban según las nuevas orientaciones del gobierno pero está claro que la censura político-ideológica siempre estuvo presente.... Un buen ejemplo sería el filme realizado por mí con guión de Manuel Cofiño, *Techo de Vidrio*, que sufrió censura desde el principio y terminó en el baúl de los recuerdos" (Morelli 39).

13. "Después comprendí que el tema proponía otras incursiones en el estudio de la esclavitud, motivo principal del racismo en Cuba y el resto de las Américas a mi forma de ver. Y a la vez me mantenía fuera del juego político-ideológico del regimen. No fue hasta *Plácido* y *María Antonia* que concienticé la transposición de un período pasado a la actualidad. Ambos filmes hablan de la Cuba de hoy" (Morelli 42).

14. "El racismo en Cuba tiene su origen en la esclavitud y su inconsciente colectivo que sufre la nación cubana" (Morelli 43).

15. "En el caso de ICAIC, Alfredo Guevara, su director, tenía una concepción muy abierta de la raza, quizás como marxista que era no tomaba muy en cuenta este asunto" (Morelli 41).

16. "El elitismo de ICAIC no creo que consistía en el color de la piel sino en el nivel cultural y artístico del individuo, sin ignorar el potencial de integración política" (Morelli 41).

17. "El racismo en Cuba probó no ser cuestión de diferencias de clase ni económica a pesar de la proposición igualitarista del régimen, que instauró la ausencia del negro a niveles de gobierno y la desconfianza oficial a la población negra en términos politicos y criminales" (Morelli 43).

18. The nineteenth-century heroes named at the end of the film are "José Antonio Aponte, Ignacio Agramonte, José Martí, los hermanos Maceo, y Máximo Gómez" (Stinchcomb 82).

19. "La unidad de la nación que tiene sólo una historia" (Stinchcomb 82).

20. "[La película] contribuye a la creencia que los negros son para Fidel Castro 'un arma secreta' en que los afro-cubanos siempre apoyan sin condiciones la ideología del gobierno cubano" (Stinchcomb 82).

21. Lesage defines "Third Cinema" in the following way: "Teshome Gabriel calls cinema made either within Third World revolutions or by militant filmmakers in prerevolutionary societies 'Third Cinema'—a cinema resisting both imperialism and the dominant media's ideology without necessarily rejecting that media entirely" (53).

22. One of the more powerful scenes in the film represents the rape of a slave woman and her later self-induced abortion. In this, the film attempts to reckon with the violence perpetrated upon slave women. The representation of Dorotea, however, conforms entirely to the Romantic conventions of the novel.

23. Please see Paulk, "A New Look at the Strains of Allegory in Gertrudis Gómez de Avellaneda's *Sab*."

24. The closest the film comes to exploring political differences between slaveowners occurs in a scene representing a dinner party, during which a young planter argues for "transcendental changes" in the way Cuban plantation owners operate. He favors the transition to free wage labor and the end of slavery. His apparent abolitionist stance is not altruistic, however; free labor would in the end be cheaper for plantation owners because they would no longer be responsible for the care and maintenance of slaves. An older planter responds by criticizing the fact that the younger man's words suggest "Revolution." This scene does not explicitly explore the potential connection between antislavery sentiment and independence or annexation beyond the older man's reference to revolution.

25. While *El Rancheador* and *Maluala* also address slavery, John Mraz considers *El otro Francisco* to be Giral's best film on the topic: "*The Other Francisco* is the best of Giral's films on slavery, historically as well as cinematographically" (104).

Works Cited

Baldwin, James. "Everybody's Protest Novel." *Collected Essays*. New York: Library of America, 1998, pp. 11–18. Print.

Chateaubriand, François-René. *Atala*. 1801. Paris: Larousse, 1973. Print.

Fivel-Démoret, Sharon Romeo. "The Production and Consumption of Propaganda Literature: The Cuban Anti-Slavery Novel." *Bulletin of Hispanic Studies*, vol. 66, no. 1 (1989), pp. 1–12. Print.

García Osuna, Alfonso J. *The Cuban Filmography, 1897–2001*. London: McFarland, 2003. Print.

Gómez de Avellaneda, Gertrudis. *Sab*. 1841. Ed. Carmen Bravo-Villasante. Salamanca: Anaya, 1970. Print.

Graden, Dale T. *Disease, Resistance and Lies: The Demise of the Transatlantic Slave Trade to Brazil and Cuba*. Baton Rouge: Louisiana State University Press, 2014. Print.

Haberly, David T. "Abolitionism in Brazil: Anti-slavery and Anti-Slave." *Luso-Brazilian Review*, vol. 9, no. 2 (1972), pp. 30–46. Print.

Isaacs, Jorge. *María*. 1867. Caracas: Biblioteca Ayacucho, 1978. Print.

La Jaula. Dir. Sergio Giral. VHS. Giral Films, NA.

Lesage, Julia. "*The Other Francisco*: Creating History." *Jump Cut: A Review of Contemporary Media*, vol. 30 (1985), pp. 53–59. Print.

López, Ana M., and Nicholas Peter Humy. "Sergio Giral on Filmmaking in Cuba: An Interview." *Cinemas of the Black Diaspora: Diversity, Dependence and Oppositionality*, edited and introduced by Michael T. Martin. Detroit: Wayne State University Press, 1995, pp. 274–80. Print.

Malitsky, Joshua. *Post-Revolution Nonfiction Film: Building the Soviet and Cuban Nations*. Bloomington: Indiana University Press, 2013. Print.

Maluala. Dir. Sergio Giral. DVD. First Run Features, 2008.

Masiello, Francine. "The Other Francisco: Film Lessons on Novel Reading." *Ideologies and Literature: A Journal of Hispanic and Luso-Brazilian Studies*, vol. 1, no. 5 (1978), pp. 19–27. Print.

Morelli, Rolando D. H. "¡De película! (Conversando de esto y lo otro con el conocido director Sergio Giral)." *Caribe: revista de cultura y literatura*, vol. 10, no. 2 (2007), pp. 33–46. Print.

Mraz, John. "Recasting Cuban Slavery: *The Other Francisco* and *The Last Supper*." *Based on a True Story: Latin American History at the Movies*, edited by Donald F. Stevens. Wilmington: Scholarly Resources, 1997, pp. 103–22. Print.

El otro Francisco. Dir. Sergio Giral. DVD. Giral Media Productions, 2005.

Paulk, Julia. "A New Look at the Strains of Allegory in Gertrudis Gómez de Avellaneda's *Sab*." *Revista Hispánica Moderna*, vol. 2 (2002), pp. 229–41. Print.

Rancheador. Dir. Sergio Giral. DVD. Marakka, 1975.

Schulman, Ivan. "Portrait of the Slave: Ideology and Aesthetics in the Cuban Anti-slavery Novel." *Comparative Perspectives on Slavery in New World Societies (Annals of The New York Academy of Sciences 292)*, Edited by Vera Rubina and Arthur Tuden. New York: The New York Academy of Sciences, 1977, pp. 356–67. Print.

———. "Reflections on Cuba and Its Antislavery Literature." *Annals of the Southeastern Conference on Latin American Studies*, vol. 7 (1976), pp. 59–67. Print.

Sommer, Doris. *Foundational Fictions: The National Romances of Latin America*. Berkeley: University of California Press, 1991. Print.

Stinchcomb, Dawn. "*El otro Francisco*, la ideología, el cine y la voz todavía perdida del esclavo negro." *The Monographic Review*, vol. 15 (1999), pp. 75–84. Print.

Stowe, Harriet Beecher. *Uncle Tom's Cabin*. 1852. Intro. Alfred Kazin. New York: Alfred A. Knopf, 1995. Print.

Suárez y Romero, Anselmo. *Francisco, el ingenio, o, Las delicias del campo: novela cubana*. 1839. Miami: Mnemosyne, 1969. Print.

Tanco y Bosmeniel, Félix M. *Petrona y Rosalía*. 1838. La Habana: Editorial Letras Cubanas, 1980. Print.

Techo de vidrio. Dir. Sergio Giral. VHS. Giral Films, 1981.

La última cena. Dir. Tomás Gutiérrez Alea. DVD. New Yorker Video, 1976.

Villaverde, Cirilo. *Cecilia Valdés, o, La loma del Ángel*. 1882. Ed. Jean Lamore. Madrid: Cátedra, 1992. Print.

Roots

The Re-making of Africa and Slavery in the American Mind

Robert J. Norrell

In *Roots*, Alex Haley created a popular revision of the history of Africa and American slavery that altered the way Americans understood much of black history. Haley's book was read by several million and the television adaptation of the book was seen by hundreds of millions of people. It was aimed at popular audiences, but *Roots* echoed the work of anthropologists and historians who since World War II had formulated a new history of black Africans and African-Americans. *Roots* reshaped the popular understanding of Africa to a much harsher and realistic view, one told from the African's point of view. *Roots* was a mythic creation of the African past, a challenge to both the existing anti-civilizationist view—that there was no African culture—and the image of uncivilized Africa of the Tarzan movies. The televised "Roots" was most significant for revising the popular American understanding of slavery to a brutal, relentlessly inhumane institution. It stands as the main cinematic revision of *Gone with the Wind* and *Birth of a Nation*. It reflected the revision of the history of American slavery that had taken place among scholars during the two decades prior to *Roots* airing in early 1977. But in a sad irony, the large cultural impact of *Roots* has been largely unappreciated during most of the almost four decades since its airing.

ROOTS THE BOOK

Roots the television extravaganza would never have happened but for Alex Haley's 1976 book of the same name. Haley had gained some celebrity for his writing of *The Autobiography of Malcolm X*, generally considered the most influential of all black autobiographies and the most widely read book of the civil rights era of the 1960s. Though *Roots* was advertised as a saga of seven generations of Haley's family, it turned out to be far more a book about slavery than it is about freedom. More than half of it, 83 of 120 chapters, concerned the African Kunta Kinte. As the family earned its freedom, less detail was offered about their experience. Haley was proud of his family's achievements over the generations, but he had far less to say about the four generations that rose in freedom from a blacksmith to a prosperous lumber company owner, from a college professor to a world-renowned author. Over the twelve years he spent writing the book, his dominant concern was establishing the African origins of his family. He saw that as the greatest value that he added to American black history, the recovery of one family's African roots. Haley researched for years to create an idyllic origin for his family in the unspoiled African environment. Then he labored extensively, including spending nights in the hold of a freighter, to understand Kunta's horrific Middle Passage experience. Kunta is the African hero, fearless at every turn until he chooses a peaceful life on the plantation over futile and probably fatal rebellion.

Kunta was the second great hero that Haley had created, the first being Malcolm X, both of whom formed a new and cherished archetype for black Americans. But Haley's constant contemplation, in his writing and his lecturing, was his own story. His vocation was always the writing of his autobiography, even as he focused on ancestors or close associates like Malcolm. In 1985, the black literary scholar Selwyn R. Cudjoe reiterated what other scholars of American autobiography had asserted:

> The Afro-American autobiographical statement is the most Afro-American of all Afro-American literary pursuits. . . . [It] remains the quintessential literary genre for capturing the cadences of the Afro-American being, revealing its deepest aspirations and tracing the evolution of the Afro-American psyche under the impact of slavery and modern U.S. imperialism. (6)

The autobiographical impulse takes over *Roots* at the end when Haley narrates his visit to Juffure in Gambia. The critic Merrill Maguire Skaggs thought it

represented the return of the mythic hero Kunta Kinte, stolen by slavery, finally returning to his place of birth. When Haley and the villagers went to the village mosque, the worshipers chanted in Mandinka, "Praise be to Allah for one who has been long lost from us, whom Allah has returned" (46–47).

Roots emphasized the patriarchal authority in Alex Haley's family. Each main male character directed the action in the narrative more than do the women. Haley's men were of proud heritage and high social standing, men who understood how society worked and who had acquired skills. Haley's portrayal of passive slave women stands in stark contrast to the image of slave women that came down from slave narratives in which slave women endured inhumane treatment comparable to what men did, and much worse considering the sexual exploitation they experienced. Haley's treatment of women is difficult to explain without speculating on his personal life, which is beyond the scope of this essay. But there is no doubt that Haley was determined to develop the theme of the strength in black families. He suggested that over the generations, his family had turned chaos into order, ignorance into intelligence, and trauma into triumph. Each generation accomplished something powerful and lasting in the survival of the family. *Roots'* interpretation of black families captured the vulnerability of families under the constant threat of sale that broke them up. In his family's survival was triumph. As a family story, *Roots* has a happy ending, and that accounted for much of its huge popularity (Gerber 91–94).

Haley's portrayal of patriarchal power in a black family appealed to many blacks because of a decade-long debate about the failures of black families in the United States. In 1965, Daniel Patrick Moynihan, Assistant Secretary of Labor in the Lyndon Johnson administration, had prepared the report on black poverty in which he suggested that, despite the great gains of the civil rights movement, African-Americans as a group were not progressing economically. In *The Negro Family: The Case for National Action*, Moynihan wrote that the "the Negro family, battered and harassed by discrimination, injustice, and uprooting, is in the deepest trouble." Although Moynihan's purpose was to get an expanded welfare effort to shore up black families, civil rights activists responded with fury at his alleged aspersion on black culture. James Farmer of Congress of Racial Equality wrote that Moynihan had "implied that Negroes in this nation will never secure a substantial measure of freedom until we learn to behave ourselves and stop buying Cadillacs instead of bread." A white psychologist spoke for many academics when he denounced Moynihan for "blaming the victim." Moynihan said privately, "Obviously one can no longer address oneself to the subject of the Negro family." He no doubt felt more strongly about the public evisceration he endured for a decade after his report circulated.[1]

At exactly the same time that *Roots* appeared, Herbert G. Gutman answered the Moynihan report with *The Black Family in Slavery and Freedom, 1750–1925*, which argued that, while black families did not mirror the structure of white families, they remained intact through slavery and emancipation and into the first generation of migration to northern cities. The family was the slaves' salvation through the awful times. The breakdown that Moynihan described occurred after blacks had been oppressed in urban ghettoes for two generations. Neither Haley, who probably had not read *The Black Family in Slavery and Freedom* before he wrote *Roots*, nor Gutman put to rest the discussion in American public life about the failures of the black family structure—the percentage of female-headed households among blacks continued to skyrocket in the 1970s and 1980s—but they had made an argument for its success through much of American history.

The most fundamental contribution of *Roots* was the one that Alex Haley had sensed all along it would be: he had recovered the black American's African past. Since the nineteenth century, a few blacks had attempted from time to time to recapture their heritage in Africa without any widely noted success, but with the emergence of post-colonial nations on the continent in the 1950s and early 1960s, and the rise of black nationalism in the United States after 1965, a more popular and sustained curiosity about African origins had emerged. Now a black American's history did not have to begin on a plantation in the South but could reach much further back. Haley had offered an example of how to make a connection with one's black origins, something that had not been available before. "There has been a growing security in the belief that the connection really is there," one close white observer of the *Roots* phenomenon wrote in 1978, and "that it can be a source of new beginnings for Black America." For the most part, whites were fascinated by the *Roots* narrative and observed—but did not fully understand—its emotional content for blacks (Gerber 95).

CHALLENGING THE RACIST DREAMS ABOUT AMERICAN SLAVERY

Roots fell into a tradition of popular treatments of American race and slavery that worked together to form a national myth, an "unperceived Popular Epic," wrote the critic Leslie Fiedler in 1979. The first three books in the epic were *Uncle Tom's Cabin*, *The Leopard's Spots* (and its thematic echo, *The Clansman*), and *Gone With the Wind*. It was a myth "rooted in demonic dreams of race, sex and violence which have long haunted us Americans," Fiedler said. "They determine our views of the Civil War, Reconstruction, the Rise and Fall of the Ku Klux Klan, the enslavement and liberation of American Blacks." An accomplished

critic of literary fiction who had previously dismissed the first three books in the "popular epic," Fiedler now said they advanced a historical myth "unequalled in scope or resonance by any work of High Literature" (17, 84).

Harriet Beecher Stowe's *Uncle Tom's Cabin* made a strong statement against slavery, gave a defense of black character, and influenced the sectional crisis of the 1850s. It sold hundreds of thousands of copies in the United States and perhaps a million in Great Britain. Beaten to the point of death by two black slave drivers, Uncle Tom whispers to a white boy: "I loves every creatur,' every whar!—it's nothing *but* love! . . . what a thing 'tis to be a Christian!" After the 1850s, *Uncle Tom's Cabin* was read by millions of Americans at all ages. No one was more dismissive than James Baldwin, in an essay, "Everybody's Protest Novel": *Uncle Tom's Cabin* was a "very bad novel, having in its self-righteous, virtuous sentimentality, . . . sentimentality, the ostentatious parading of excessive and spurious emotion, is the mark of dishonesty." But in 1979, Fiedler wrote that Stowe "invented American Blacks for the imagination of the whole world." She created three black archetypes: Uncle Tom, the long suffering and ever forgiving Christian slave; Eliza, the heroic mother who escaped slavery; and Topsy, the foolish slave girl. Over the next century, the three characters became, Fiedler thought, "for better or worse, models, archetypal grids through which we perceived the Negroes around us, and they perceive themselves" (27).

The next influential and popular interpretation delivered an opposite message. Published in 1902, Thomas Dixon, Jr.'s novel, *The Leopard's Spots*, sold millions of copies. In 1901 Dixon had seen a stage production of *Uncle Tom's Cabin*, the message of which incensed him, and in sixty days he wrote *Leopard's Spots*. In the novel, an all-knowing preacher warns a racially naïve young white man: "The beginning of Negro equality as a vital fact is the beginning of the end of this nation's life. There is enough negro blood here to make mulatto the whole Republic." In 1905, Dixon reprised the message in *The Clansman*—an anti-Negro melodrama of Reconstruction with a strong emphasis on black soldiers' sexual assault of white southern women—and again was the most popular writer of fiction in the United States. In both of Dixon's works, African Americans were portrayed in the antebellum years as happy and loyal servants, but then after the war as dangerous beasts intent on sexual exploitation of white women. Dixon's black archetype was the black soldier and rapist Gus, who violated the virginal Marion and drove her to suicide. The newly formed Ku Klux Klan then lynched Gus.[2]

Margaret Mitchell's 1936 *Gone With the Wind* was a publishing phenomenon, selling a million copies within a year and more than twenty million by the time

Roots appeared. It was the fastest-selling novel in literary history (May 51). The book offered a view of slaves as happy, simple, and mostly harmless. Only with the exception of Mammy, black characters were not developed into textured characters, but Mammy became an archetype in the popular epic of American race and slavery—along with Scarlett O'Hara and Rhett Butler. Fiedler argued that Mammy was really Uncle Tom redone, "the Great Black Mother of us all." *Gone With the Wind*'s portrayal of Civil War Atlanta was remarkably accurate, whereas its depiction of Reconstruction Georgia follows the intensely racist and anti-Northern themes of Dixon's work. Blacks' lives were peripheral to the melodrama of the main white characters, and the central subject is the Civil War's impact on white southerners. But because *Gone With the Wind* was such a huge event in America popular culture, its interpretation of reality was seminal for American popular thought for the two generations after it appeared (Fiedler 61).

Roots represented a complete revision of the myths inherent in the popular epic. It departed drastically from Dixon and Mitchell with its focus on blacks and from Stowe with the kinds of blacks it upheld. The historian Jack Temple Kirby thought it had turned *Gone With the Wind* "inside out." *Roots*' whites were two-dimensional characters, "more widgets in a cruel system than special devils," whereas many black characters were "vivid and memorable." *Roots* overturned the white mythology about benign slavery, chivalrous Confederates, and a gallant redemption in Reconstruction. For blacks, it provided a mythology that was heroic in the other direction, one that blacks embraced (Kirby 166, 169).

Fiedler thought Haley's great contribution to the popular American epic of race and slavery was Kunta Kinte: "an unreconstructed Noble African." Haley's readers were not always aware that Kunta was "less a portrait of Haley's first American ancestor, legendary or real, than of Malcolm X as Haley perceived him" (17). Like Malcolm, Kunta had rejected his white name, dreamt of going back to Africa, and believed that women's place was at home. Both Kunta and Malcolm were, according to Fiedler, "inverted Racist[s], convinced that all Whites not only invariably do evil to all Blacks, but that have an offensive odor, and are properly classified not as human but as *toubob*, 'devils,' who must be resisted unto death." (17). By the time *Roots* appeared, *The Autobiography of Malcolm X* had sold six million copies, and Malcolm was a far more popular and admired figure than he had been during his life. But to make Kunta so heroic, Haley had to depart from the popular epic—and historical realism. He barely acknowledged the role of black Africans in the slave trade, leaving whites entirely responsible for slavery's brutality. Fiedler scoffed at Haley's handling of the sexual aspects of the popular epic. He made no mention of Mandinka polygamy, and he kept

Kunta a virgin until he was thirty-nine—both of which strained the credulity of his narrative (Fiedler 80).

Roots modified the popular epic for American whites. Many, if not most, blacks had already rejected the contributions to it from Stowe, Dixon, and Mitchell, and they overwhelmingly embraced *Roots*. But most of Haley's audience was white, and he affected millions of them. Ninety-nine percent of the letters Haley received from the *Readers Digest* condensed version of *Roots* was from whites. Questions about the historical accuracy of *Roots* were in Fiedler's view irrelevant, because Stowe, Dixon, and Mitchell had all "claimed to be more truth than fantasy—and were in that sense 'hoaxes'" (17). On the other hand, "all the Slave Narratives and White histories of Reconstruction on which they drew were, to one degree or another, fictional constructs" (Fiedler 52).

The power of the popular epic created by these novels depended heavily on their transference to other cultural media. Fiedler wrote that "a quality which distinguishes all popular art from high art" was "its ability to move from one medium to another without loss of intensity or alteration of meaning: Its independence, in short, of the form in which it is first rendered" (177). There had been hundreds of "Tom" touring theatrical presentations in the United States and around the world for at least two generations after the novel appeared. Thomas Dixon was only one of millions who acquired their understanding of the popular epic of American race first from a "Tom" play, as did at least as many from *Birth of a Nation*. More got their awareness from *Gone with the Wind*, and more than one hundred million would have theirs shaped by *Roots* on television (Fiedler 40).

ROOTS ON TELEVISION

When he decided to produce *Roots* for television, David Wolper knew that he was taking a big chance. Blacks had hardly been seen in television drama up to that time. A notable and recent exception was the 1972 production of *The Autobiography of Miss Jane Pittman*, based on Ernest Gaines's novel. Relatively few cinematic dramas had featured black characters (De Vito and Tropea 30). The *Roots* miniseries was part of a new trend in television. It followed *QB VII*, the first miniseries in 1974, based on Leon Uris's Nazi-themed courtroom drama, and *Rich Man, Poor Man*, a family saga adapted from Irwin Shaw's novel, which had run in 1976 for seven consecutive Monday nights and drawn a large audience and won four Emmys. The trend continued with the 1979 series *Holocaust*, which also won high praise and a big audience. *Roots* would follow the miniseries plot formula—a cast of established stars, suggestions of sex without being

explicit, ample violence, and characters of unquestionable heroism. Each of the successful 1970s miniseries explored the experience of "others"—Jews, women, and blacks who had not been examined positively in popular treatments of American society. This revision of American popular history came in the aftermath of the civil rights movement and in the midst of the women's movement, and the rising consciousness among many Americans of European immigrant heritage in the 1970s.

Roots was a departure from past treatments of one of the most disturbing stories of American history, the experience of slavery. Wolper's expectation of a high level of realism set *Roots* well apart from the last screen interpretation of slavery, the 1975 film *Mandingo*, which had dwelt on interracial sex and elicited harsh reviews. Having made that commitment, Wolper worried about how an American audience would tolerate a truly accurate account of the degradation of slaves. He was particularly concerned about scenes in the hold of the slave ship. But he thought the series would be accepted and watched by enough white Americans because it was a family story. The purposeful way that descendants of Kunta Kinte held on to their African heritage and survived slavery intact as a family gave the story the good feeling that offset the inhumanity—the beatings and family break-ups—that was necessary to portray. A master of the genre of documentary film, Wolper thought of himself as a "visual historian." He insisted that his documentaries were especially effective educational instruments because they were also entertaining, and thus he made no apology for his didactic purposes in *Roots* (Wolper and Troupe 179).

Wolper approached the American Broadcasting Company (ABC), whose executives were intrigued but also concerned that there had never been a successful black dramatic series on television and doubted that advertisers would support one. ABC agreed to go ahead but set a relatively low production budget, given the length of the series and the large cast, of five million dollars, later raised to six million. The producers' first concern in casting *Roots* for television was how whites would receive the show. Wolper said he was "trying to appeal to whites—they make up 90% of the audience," thus "to reach and manipulate" white minds to watch the show and not think of it as a "black" show (230). He lined up white television stars to get white audiences to watch. The ABC executive Brandon Stoddard said they used actors whom white viewers had seen a hundred times before "so they would feel comfortable." The most familiar white actors included some who had starred in long-running television series: Lorne Green, Sandy Duncan, Lloyd Bridges, Chuck Connors, Edward Asner, Ralph Waite, Macdonald Carey, Doug McLure, and Yvonne De Carlo (King 73).

Wolper cast many well-known black actors in the series. John Amos played the mature Kinte; Leslie Uggams was Kizzy; Cicely Tyson portrayed Kinte's mother Binta; and Richard Roundtree was the carriage driver. Though he had not worked in television, Ben Vereen had just won two Tony awards for starring roles in *Jesus Christ Superstar* and *Pippin*. If the producers mostly wanted identifiable black actors, they sought an unknown for the role of Kunta Kinte. Stoddard said that "from a purely casting standpoint it was essential that Kunta Kinte be seen not as an actor being Kunta Kinta" but as embodying Kunta entirely (King 73). They cast LeVar Burton, who had no credits, in the role, and he proved to be a great success. For their work in *Roots*, nine black actors were nominated for Emmy awards, and Olivia Cole and Louis Gossett, Jr. won for best supporting and best lead actor, respectively. Leslie Uggams received a Golden Globe award.[3]

The script adaptation changed the emphases drastically from the book. Almost the first fourth of the book dwelt on the African environment, but the television series devoted only part of the first episode to it. The rich anthropological material that Haley used in the book was almost entirely lost. Stoddard of ABC explained that "what seems to interest Americans most are Americans. . . . In *Roots*, we got out of Africa as fast as we could" (King 73). The action arrived in America early in the second episode. *Roots* on television hardly challenged the Euro-centric cultural perspective of Africa as the "dark continent." In the book, Haley made a point of emphasizing the African survivals in the culture of American slaves. That was lost on television. The script made some white characters "good," whereas in the book there are almost no admirable white characters. The book said almost nothing about Captain Davies of the slave ship, but he was portrayed on television by Edward Asner as a religious man with a tortured moral character. Davies was paired in the plot with the seasoned slave-trader called Slater, a violent, abusive character whose inhumanity made Davies seem like a good white man. When Slater thrust a young African girl on Davies for his sexual pleasure and he accepted her, Davies seemed human in his sinfulness and vulnerability. Asner won an Emmy for his performance.

The television script created a character, the slave woman Fanta, who on the slave ship was forced to have sex with Davies, and later in Virginia was Kunta's first love interest. She seemed to have been inserted to titillate viewers. When she argued loudly with Kunta the morning after their night together, her explosion led to his entrapment. This characterization seemed false because a consistent point of *Roots* was that slaves were always careful in keeping their thoughts and emotions from whites.[4]

Roots the book and the miniseries were such departures from previous popular interpretations of slavery that they shifted mass culture to a new understanding

of slavery and the black family. More than a decade after *Roots* aired, the cultural historian Donald Bogle, perhaps the closest student of African Americans in film and television, thought that the series was rare among television dramas in that neither the black characters nor the actors in the series were "standard, comfy, middle-class, reassuring types" but were instead figures "larger than life with aches, pains, or struggles that filled the viewers with a sense of terror or awe.... None pulled back from a moment that might disturb or upset a viewer" (Bogle 340–44). Bogle concluded that the black experience was "far wider, far denser, far more complicated, far more unmanageable than 'Roots' implied," but the series still "captured the raw, archetypal, mythic essence of human experience." Seeing on commercial television the atrocities of American slavery but then "witnessing the victorious spirit of those who survived it all, audiences have been affected in unanticipated ways." Bogle considered it a "pop triumph" (Bogle 340–44).

The question remained whether *Roots* would have a significant impact on Americans. Would the mass of Americans really entertain a whole new interpretation of their history? To be sure, the civil rights movement had brought *Gone with the Wind* and its racial interpretations into question for many people. But a new cultural exemplar was needed to override its influence on the American cultural understanding.[5]

Fred Silverman, head of entertainment programming at ABC, decided to run the show on consecutive nights rather than once a week for eight weeks. That way, if the series was a failure, its effects on ABC's ratings would be minimized. Silverman publicly offered a more positive rationale, saying that to run it over eight or ten weeks would have dissipated the emotional impact. Wolper Productions and ABC had done something no one in television had ever done before: "Let's show it in a way that no one has ever shown television before!" ABC hoped that over those eight nights *Roots* would garner fifty million viewers in total, not a big overall audience, and the network was not confident about that goal. It sold advertising on the promise of a thirty "share," or percentage of television viewers watching the show. The network decided not to broadcast it during the "sweeps" period, when network ratings were used to set subsequent advertising charges. Advertisers paid $120,000 per minute for a spot during *Roots*, as compared with a broadcast like the Super Bowl, which had the biggest audience of any program and sold for $150,000 per minute. This miscalculation cost the network millions of dollars.[6]

Roots was broadcast in the midst of one of the hardest and most prolonged cold spells in American history, which some commentators thought might have accounted for the huge viewership it earned from the first night. At least fifty million viewers, the audience that ABC hoped for the entire series, tuned in the

first night. Nielsen Ratings service reported that that the show received between a sixty-two and sixty-eight "share" (percent) of those Americans watching television each night. Eighty million Americans, "the largest television audience in the history of the medium," Nielsen reported, watched the final episode of *Roots*. That represented 51.1 percent of all television sets in homes across the country, or 36,380,000 homes, and that exceeded by 2.4 million the audience reached by the first half of the television release of *Gone With the Wind* the previous fall. ABC estimated that 130 million viewers, about 85 percent of all homes with televisions in the United States, saw some part of the series.[7]

Almost nine of ten blacks watched some portion of the series, and more than seven in ten whites did. Blacks watched an average of six episodes, whites more than five. Eighty-three percent of the watchers thought *Roots* was one of the best television programs they had ever seen. Black and white viewers both thought the show was accurate in its portrayal of both blacks and whites, although blacks rated it a little higher for accuracy. The overwhelming feeling prompted by the show was the same for blacks and whites—sadness. White viewership tended to be a more liberal segment of the white population. Polls found that whites who did not watch the show were hostile to laws against housing discrimination and believed blacks were inferior to whites in intelligence and trustworthiness. A third of white viewers thought blacks' historical experience was no worse than the struggles of European immigrants (Hur and Robinson 19–24).

Roots the book and the miniseries was used as the syllabus for new college courses. By February 1977, 250 colleges were offering credit courses based on *Roots*. Random House sold 150 institutions a *Roots* curriculum. Black Studies departments saw a sudden upsurge of interest in their curricula. Travel agencies around the country reported a surge of interest in "heritage" tours to Africa. "It has produced a virtual explosion of American interest in travel to Africa," said the marketing manager for Air Afrique. In New York City in the days after *Roots* aired, there were twenty black babies born who were named Kunta Kinte or Kizzy. There were fifteen in Los Angeles, ten in Detroit, and eight in Atlanta. In Cleveland, a pair of twins, male and female, were so named. It is not clear how long the naming phenomenon lasted beyond 1977.[8]

A phenomenon so pervasive naturally drew some dissenters. *Time* magazine's critic, Richard Schickel, was the most noted naysayer, calling the production a "*Mandingo* for middlebrows." A well-to-do white woman in Atlanta thought *Roots* was awful: "The blacks were just getting settled down, and this will make them angry again." David Duke, national director of the Knights of the Ku Klux Klan, charged ABC with airing a "vicious malignment of the white majority

in America and a serious distortion of the truth." A white woman in Queens complained that *Roots* did not have any good white characters. Her husband answered, "The good whites had their day with *Gone with the Wind*." The black journalist Chuck Stone called *Roots* "an electronic orgy in white guilt successfully hustled by white TV literary minstrels."[9]

A poll of one thousand Americans, half black and half white, taken a month after *Roots* aired, found that 42 percent of those who had watched at least two episodes thought it would be "inflammatory." But also important, 60 percent of blacks and whites thought they had an increased understanding of the psychology of black people. Respondents thought the most memorable scenes were those of violence—the capture of Kunta, the cutting off of his foot, the rape of Kizzy. Ninety-five percent of viewers believed *Roots* was realistic and 77 percent thought it was relevant for contemporary race relations.[10]

The *Roots* revision of the American popular epic of race and African-American history continued in 1979 with *Roots: The Next Generation*, shown in fourteen hours over seven consecutive nights. It followed Haley's family from the 1880s through World War II, which was the time covered in the last thirty pages of *Roots*. But it also contained many new characters, mostly whites, and scenes created just for television that filled out the narrative of black history from Emancipation in the 1860s to the civil rights movement of the 1960s. *Roots II* emphasized several new themes. It explored the ways that race complicated romantic love among blacks and between blacks and whites, suggested mostly with characters not present in Haley's writing. The series rendered in realistic scenes the ugliness of post-Reconstruction race relations, including segregation, the convict-lease system, lynching, disfranchisement, the persistent racism of working-class whites, and the amorality and arrogance of white paternalism. It captured the demeaning compromises that blacks had to make to survive in the white supremacist South. In the end, the largest significance of *Roots II* was to keep the American popular imagination focused on the continuing story of African American history past the *Roots* revision of the understanding of slavery. Together the two *Roots* miniseries had filled in huge gaps in the public's knowledge of black history, and it had given Americans vivid images that would enable them to hold on to that new awareness (Bogle 343–34).

Despite the publishing success and the celebrity that came with it, controversy enveloped Haley soon after the publication of *Roots*. In April 1977, Mark Ottaway, a writer for the *Sunday Times* of London, claimed to have happened on to information in Gambia that exposed Haley's research as fraudulent. He reported that residents of Juffure were involved with slave trade not as victims

but collaborators. Several sources told Ottaway that Haley's alleged griot was a fraud who had been coached to tell a story about a Kunte Kinte. Ottaway wrote that in Juffure, "No villagers can remember the name of any ancestor captured by slavers." Ottaway doubted that the person Haley said was taken to America in 1767 was in fact Kunta Kinte. At almost the same moment, two authors sued Haley for alleged copyright infringement. Margaret Walker Alexander charged that Haley had taken his depictions of the plantations on which Kunte and his family had lived from portraits she had drawn in her 1966 novel *Jubilee*. Harold Courlander, a folklorist, filed a claim that there were numerous similarities of theme, structure, and language between *Roots* and his book *The African*, published in 1967. Haley spent the better of two years defending himself in court, and he expended much of his *Roots* earnings on lawyers. Alexander's case was dismissed, but Haley endured a long trial before settling with Courlander. He admitted that several short passages in *Roots* were virtual copies of parts of *The African*, but he could not explain how that had happened. In 1981, Donald R. Wright, an African historian who had studied griots in Gambia, published an article raising further doubts about Haley's Gambian research, and two genealogists, Gary B. and Elizabeth S. Mills, exposed many mistakes in Haley's story about his family in Virginia and North Carolina.[11]

"The one who really lost was me," Haley said, because what the public remembered was not the substance of the findings in the cases but that he was sued. "What I learned was if you're fortunate enough to do anything that becomes highly acclaimed, especially if it makes money, you can almost bet that somebody is going to come along and say, 'You took something from me,'" he told the *New York Times*.[12] Alex Haley had worked hard, struggled against formidable odds, and thought he deserved success. He did not begrudge the expertise of academics, but neither did he believe he should be held accountable to their standards of objectivity when he was aiming for a higher, symbolic truth. He believed that many critics simply wanted to deflate someone whose celebrity had grown large, and he was right about that. But it was also true that he had made a fundamental mistake in proclaiming the historicity of *Roots* when he knew it was not present, at least in some of its parts. Did the alleged misrepresentations warrant the onslaught of attacks he was enduring? Were they so grievous as to undo the salutary effects of *Roots* on the American popular mind? No, they were not, but in the world of American celebrity, the fair or correct judgments often did not prevail.

What writing Haley produced in the 1980s followed a familiar pattern—it was autobiographical and it was meant to end up on television. He had a project called "Queen," about his paternal grandmother, which would, as he said, "square

another debt" to his father, who had hinted for years that his side of the family, particularly his mother Queen, would make a good book. Queen had cared for Alex and his brothers for a time after his mother had died. He had heard many stories about her and her white father, Colonel Jackson. In the late 1980s he worked on a miniseries script that David Wolper produced in the early 1990s. His co-author on the script actually wrote the novel *Queen*, which appeared after Haley's death in early 1992.[13] The controversy hurt Haley's professional reputation and undermined the influence his works had on American culture.

Much of the positive impact of Alex Haley's writing on the thinking and attitude of Americans was lost—at least to the popular media. It was easier to ignore Haley than to sort out the details of his alleged wrongs. Haley was all but left out of the creation of a canon of black American literature. When the *Norton Anthology of African-American Literature*, a work of almost three thousand pages covering hundreds of literary excerpts, appeared in 1997, there was no passage from *Roots* included. Henry Louis Gates, Jr., editor of the anthology, thus excluded a work that sold more than any other, that arguably touched the racial sensibilities of more Americans than any other, and that recast Americans' popular understanding of slavery more than any other. Gates admitted that "most of us feel it's highly unlikely that Alex actually found the village from which his ancestors sprang. *Roots* is a work of the imagination rather than strict historical scholarship. It was an important event because it captured everyone's imagination." That was an accurate assessment of Haley's work and perhaps justification for including it in the canon of African American letters, because all the works in the anthology were, after all, works of imagination. The anthology did include an excerpt from *The Autobiography of Malcolm X* (with the wrong publication date given) that carried only a brief mention that Haley had helped with the book. By then, virtually all students of black literature were crediting Haley with creating and preserving Malcolm's story.[14]

Ultimately Gates paid a silent tribute to Haley with a successful television series on the genealogy of celebrities. In 2005 and 2006, he produced and hosted a miniseries, *African American Lives*, in which the lineage of black celebrities, using historical evidence and DNA testing, was traced and revealed to the person on camera. It might have been Alex Haley's fate to do the show, had he lived. It might never have emerged under the astute direction of Gates had Haley not done *Roots*. Haley was at least partly responsible for the ongoing exploration of Americans' roots.

If measured by the tens of millions who read *Roots*, and the hundreds of millions who saw the television renderings of it, Haley wrote the most important

work in black culture in the twentieth century. More than any other writer, he changed the way the masses of Americans understood the black experience. He gave whites a compelling reminder of the ugliness of racial exploitation and blacks a sense of ownership in their past, with all its travails but also its triumphs. It was a great contribution to American culture and race relations, and it deserves to be remembered.

Notes

1. Office of Policy Planning and Research, United States Department of Labor, *The Negro Family: The Case for National Action*, March 1965, 3–47; Lee Rainwater and William L. Yancey, eds., *The Moynihan Report and the Politics of Controversy*, Cambridge, MA, 1967, p. 410; Nicholas Lemann, *Promised Land: The Great Black Migration and How It Changed America*, New York, 1991, pp. 175–76, 181; *New York Times*, November 15, 1965.

2. Joel Williamson, *The Crucible of Race: Black-White Relations in the American South Since Emancipation*, New York, 1984, pp. 151–58; Thomas Dixon, Jr., *The Leopard's Spots: A Romance of the White Man's Burden—1865–1900*, New York, 1902, pp. 244, 263.

3. Hemant Shah and Lauren R. Tucker, "Race and the Transformation of Culture: The Making of the Television Miniseries *Roots*," *Critical Studies in Mass Communication*, vol. 9, 1992, pp. 325–36; *Seattle Times*, July 15, 2007; *New York Times*, March 18, 1979.

4. *Roots*, 276; Shah and Tucker, "Race and the Transformation of Culture," 331.

5. Pauline Bartel, *The Complete Gone with the Wind Trivia Book: The Movie and More*, Taylor Trade Publishing, pp. 64–69, 161–72.

6. Leslie Fishbein, "*Roots*: Docudrama and the Interpretation of History," *American History American Television: Interpreting the Video Past*, edited by John E. O'Connor, New York: Frederick Ungar Publishing, 1983, pp. 279–80; *Newsweek*, February 14, 1977.

7. Kenneth K. Hur and John P. Robinson, "The Social Impact of 'Roots,'" *Journalism Quarterly*, vol. 55, Spring 1978, p. 19; *New York Times*, February 2, 1977.

8. Entire paragraph, in order: *Newsweek*, February 14, 1977; *New York Times*, March 6, 19, 1977.

9. *New York Times*, March 19, January 28, 1977; Chuck Stone, "Roots: An Electronic Orgy in White Guilt," *The Black Scholar*, vol. 7, May 1977, p. 40.

10. *New York Times*, June 7, 1977.

11. Entire paragraph, in order: *Margaret Walker ALEXANDER, Plaintiff, v. Alex HALEY, Doubleday & Company, Inc., and Doubleday Publishing Company, Defendants.* 460 F.Supp. 40 (1978); Haley direct testimony, 1391–1395, *Courlander v. Haley* trial transcript, Anne Romaine Papers, University of Tennessee Special Collections, 2032, 5, 7; Donald R. Wright, "Uprooting Kunta Kinte: On the Perils of Relying on Ency-

clopedic Informants," *History in Africa*, vol. 8, 1981, pp. 205–17; Gary B. Mills and
Elizabeth Shown Mills, "'Roots' and the New 'Faction': A Legitimate Tool for Clio?"
The Virginia Magazine of History and Biography, vol. 89, January 1981, pp. 3–26.

12. *New York Times*, December 10, 1988.

13. *New York Times*, February 14, 1993.

14. Entire paragraph, in order: *Boston Globe*, November 3, 1998; *The Norton Anthology of African American Literature*, edited by Henry Louis Gates, Jr., and Nellie Y. McKay. New York: Norton, 1997.

Works Cited

Bogle, Donald. *Blacks in American Films and Television: An Encyclopedia*. New York: Garland, 1988. Print.

Cudjoe, Selwyn S. "Maya Angelou and the Autobiographical Statement." *Black Women Writers*, edited by Mari Evans. London: Pluto, 1985. Print.

De Vito, John, and Frank Tropea, *Epic Television Miniseries: A Critical History*. Jefferson, NC: McFarland, 2010. Print.

Fiedler, Leslie. *The Inadvertent Epic: From Uncle Tom's Cabin to Roots*. New York: Simon and Schuster, 1979. Print.

Gerber, David A. "Haley's Roots and Our Own." *Journal of Ethnic Studies*, vol. 5, 1977–1978, pp. 87–111. Print.

Gutman, Herbert G. *The Black Family in Slavery and Freedom, 1750–1925*. New York: Pantheon, 1976. Print.

Hur, Kenneth K., and John P. Robinson. "The Social Impact of 'Roots.'" *Journalism Quarterly*, vol. 55, Spring 1978, pp. 19–24. Print.

King, C. Richard. "What's Your Name? *Roots*, Race, and Popular Memory in Post–Civil Rights America." *African Americans on Television: Race-ing for Ratings*, edited by David J. Leonard and Lisa A. Guerrero. Santa Barbara: Praeger, 2013, pp. 69–81. Print.

Kirby, Jack Temple. *Media-Made Dixie: The South in the American Imagination*. Baton Rouge: Louisiana State University Press, 1978. Print.

May, Robert. "*Gone with the Wind* as Southern History: A Reappraisal." *Southern Quarterly*, vol. 17, Fall 1978, pp. 51–64. Print.

Skaggs, Merrill Maguire. "Roots: A New Black Myth." *Southern Quarterly*, vol. 17, Fall 1978, pp. 42–50. Print.

Wolper, David L., and Quincy Troupe. *The Inside Story of T.V.'s "Roots."* New York: Warner Communication, 1978. Print.

Inheriting Chains

Lighting Effects in Humberto Solás's *Cecilia*

Haley Osborn

The social climate of Cuba in the 1970s and 80s was not one that encour-
aged dialogue about racial discrimination since Castro's social reforms in
the 60s had supposedly dismantled all forms of racism. Despite this conjecture,
there was a failure to fully acknowledge African contributions to *cubanidad*
(De la Fuente 33). Indeed, the growing number of blacks in positions of power
during the 80s made it difficult for society to recognize that in Cuba, "black-
ness was still identified by many people (of different ethnicities) with negative
stereotypes, such as antisocial behavior and lack of family values and morality"
(*Cuban Cinema* 365). These topics were growing in interest among many Cuban
artists and intellectuals, and clearly needed to be brought to a public light. Cuban
film director, Humberto Solás, was one who noticed this late twentieth-century
racism. Hence, Solás directed his tragic film, *Cecilia* (1981), with the aim of spur-
ring interest in a recovery of national identity, culture, and historical memory
within Cuba (Martin 157).

Inspired by *Cecilia Valdés o la loma del ángel*, Cirilo Villaverde's nineteenth-
century novel, Solás's film portrays a fair-skinned mulatta's quest to "better her
race" by marrying a white man. Unlike other fictional representations that often
depict the active participation of slaves in their fight for freedom through heroic
acts of defiance, *Cecilia* focuses on the less romanticized aspects involving the
lived daily experience of slavery, with particular attention to physical appearance.

Though the film was widely criticized for its "disrespect to Cuban cinema" and to Villaverde's classic novel (*Cuban Cinema* 388), Solás's representation of this struggle, particularly through the manipulation of lighting by the film's cinematographer, Livio Delgado, compares and contrasts productively with Villaverde's literary representations that were obviously devoid of such cinematographic techniques. Through these lighting techniques, the cinematic adaptation works to resurrect the novel's nineteenth-century tale with a contemporaneous relevance to twentieth-century Cuban society. Solás and Delgado achieve this through what Kris Malkiewicz and Barbara J. Gryboski describe as *hard lighting*—when dark shadows are created by a single, off-screen lighting source. Furthermore, we see the use of *low key* lighting, because much of the film is "underlit, but some parts are correctly exposed or even overexposed" (Malkiewicz and Gryboski 86). Malkiewicz and Gryboski affirm that low key lighting is an important technique for creating the visual mood through light contrast and distribution (86). That is, the cinematographer may "distribute" light unevenly in a given *mise en scène* by choosing to brighten or spotlight certain objects or characters while dimming others that are less important or maintained darker for symbolic purposes. In this way, Solás and Delgado apply opposing lighting tonalities to the traditional Cecilia Valdés story in order to: a) externalize internal cultural identity crises of Cuban society, both past and present, b) underline the oppressive elements that keep racial segregation and class superiority in place, and c) highlight the societal self-destruction that inevitably follows these issues.

While Solás's film employs these powerful techniques to recreate and reinterpret aspects of Cuba's past, cinematic representations of history were not unique to Solás's interests alone; rather, historical representation was a topic that influenced many other Cuban directors throughout the seventies long before the production of *Cecilia*. This was due in part to the pressure put on filmmakers by the ICAIC to meet the artistic standards of García Espinosa's philosophy of "imperfect cinema," which called for the creation of cinematographic art that was not only entertaining but could teach its audience and support ideas of the Revolution. In theory, this would require a more active viewer who was willing to participate intellectually in viewing a film in order to understand and activate the film's pedagogical purpose. According to Timothy Barnard, rather than forcing blatant attempts at satisfying the ICAIC's requirement of portraying purely revolutionary themes in the seventies, many directors focused on the recreation and reinterpretation of historical events because these themes "offered better opportunities for more subtle and profound analysis than the revolutionary themes" (235). In other words, because the Cuban government discouraged criticism of

the harmonious and seemingly discrimination-free social atmosphere of post-revolutionary Cuba, it often proved difficult to express oneself artistically without worry of upsetting the system. Therefore, in order for filmmakers to convey any intended criticism of weak social structures of Cuba past and present, they had to do so by indirect, esoteric means, as did Solás in *Cecilia*. Without doubt, the need to camouflage any counter-revolutionary ideas in his filmic projects would have been made easier by choosing to focus on historical topics. Since teaching the viewer was part of the ICAIC's pedagogical mission, portraying important stages of Cuba's history and especially, in Solás's case, drawing attention to one of Cuba's major literary contributions to the intellectual world, would be two revolutionary purposes difficult for the ICAIC to contest.

Latin America's long history of colonialism and its lasting effects on the Americas further contributed to the popularity of historical films in the seventies. Thus, political and ideological *decolonization*, or in Espinosa's words, the "breaking with traditional values, be they economic, ethical, or aesthetic" (*Cuban Cinema* 306), became one of the main objectives of imperfect cinema. John Hess adds that, for Cubans, confronting colonial past through film meant movement towards a "cultural renewal," which "involves, as Fanon has made very clear, a recovery of national culture and history. History, and its more personal form, memory, become necessary tools for this recovery" (116). Indeed, this appears to have been the interest among other directors of the seventies, many of whom chose to focus on the image of slavery and African roots in the Caribbean, including Juan Carlos Tabío (*Miriam Makeba* [1972]), Tomás Gutiérrez Alea (*La última cena* [1976]), Sergio Giral (*Rancheador* [1979] and *Maluala* [1979]), and Julio García Espinosa, to name a few. Tabío, García Espinosa, and Gutiérrez Alea also collaborated on the making of *El otro Francisco* (1975; see relevant essay in this volume), another slavery-themed film.

Humberto Solás continued the trend of historical films with the creation of *Cecilia*, despite the fact that this genre was beginning to fizzle out by the eighties. It is not surprising, then, that the public's response to the film was none too laudatory, as was mentioned previously. On the contrary, *Cecilia* was considered a financial disaster due to the cost of its production and lack of public interest, despite the fact that the talent behind Solás's prior films had earned him considerable merit among his peers and the public. They were experimental in technique as well as revolutionary in their themes. Immediately following the Revolution, for example, his films primarily dealt with themes of the revolutionary cause. Two of these are *El acoso* (1965) and *Manuela* (1966). *El acoso* focused on the events surrounding the Bay of Pigs and told the story of a soldier on the

run, while *Manuela* portrayed a virtuous female guerrilla soldier's fight for social justice. Later, in 1972, Solás completed another revolution-themed work, *Un día de noviembre*, but because of the censorship powers of the Cuban government, its release was prevented until 1978, when the film was no longer relevant, according to Solás. The ICAIC considered the plot highly controversial in that it portrayed a man struggling with the ethical nature of the revolutionary fight. He considered this work his "most personal" and struggled emotionally with the artistic limits imposed by the ICAIC (Elena 115).

A characteristic that many of Solás's films share is that the plots develop around a female protagonist, as will be crucial in a closer look at *Cecilia*. After he finished the female-centered film *Manuela*, Solás began to shift his focus from the theme of the revolution to colonialism with his film, *Lucía* (1968), which, according to Michael Chanan, has received more attention by critics than any other Cuban film, apart from Gutierrez Alea's *Memorias del subdesarrollo* (*Cuban Image* 225). *Lucía* focuses on three different women named Lucía that come from three distinct periods in Cuban history: colonialism, neocolonialism, and social revolution (*Cuban Image* 225). His choice to portray female protagonists in many of his films is not a feminist issue; rather, according to an interview, Solás chooses to focus on women because, in his opinion, women are the most vulnerable and transparently affected characters when confronted with social change (*Cuban Image* 225). It is no wonder, then, that he chose the expressive and melodramatic talent of Daysi Granados as the protagonist in *Cecilia*, as through her acting, Granados fearlessly displays and even exaggerates the changing emotions she experiences.

Cecilia begins in nineteenth-century colonial Cuba, a time marked by the beginnings of national identity formation and struggles for independence from the Spanish monarchy. A surge in slave revolts accompanied these sentiments, which Laurent Dubois attributes to a "contagion of French revolutionary ideas" (Dubois 28–29). Such a "contagion" would have undoubtedly contributed to the Haitian Revolution and rebellions elsewhere, such those in Guadeloupe that achieved a temporary abolition of slavery in 1794 (Napoleon had it reinstated in 1802 and it continued until 1848). In other words, talk about freedom during the nineteenth century was not unique to Cuba; rather, it consumed the western intellectual world as a whole. Equally important to consider is that most of the Americas had already abolished slavery, the Atlantic slave trade, or were approaching these social changes. Cuba (at the time still a colony of Spain), along with Brazil, was one of the few places that had not yet embraced emancipation. Consequently, Cuba became the major producer of slave plantation crops until the abolition of slavery on the island in 1886.

The film recreates this tense moment in history in a sensational way through the melodramatic nature of the characters and the way they interact and react to the social barriers of Cuban colonialism. *Cecilia* takes place in 1830, eighteen years after the start of the Aponte Rebellion revolts. Historian Matt Childs suggests that the growing sugar industry and the widening of the already spacious divide between social classes and skin colors sparked these revolts (48). An influx of slaves from Africa followed to meet the demands of the "sugar boom" despite the treaty that ordered the termination of slave trafficking in 1820 (Paquette et al. 236–37).

The protagonist, Cecilia, is a sexualized mulatta who is desperate for the love and acceptance of Leonardo, the spoiled yet emotionally afflicted son of white, wealthy parents. He is enamored with Cecilia, but due to social standards, his desire to be with the young mulatta never blossoms into a desire for marriage; a few heated sexual encounters is as far as the relationship goes. His mother, Doña Rosa, is determined to see him marry the white aristocrat, Isabel, who better fits the family's interest in maintaining its elite bloodline. José Dolores, on the other hand, truly cares for Cecilia. This darker-skinned mulatto musician is also an abolitionist and conspirator against the Spanish crown. Like Leonardo, he is also restricted by social standards through his visibly mulatto "condition." Consequently, his love for the whiter-skinned Cecilia can never be returned. Further problematizing this disastrous love triangle are Seña Chepa, Cecilia's grandmother, and Doña Rosa, Leonardo's mother. They are the domineering figures of the film and play fundamental roles in determining the fates of their children.

Light frequently intervenes in the portrayal of these characters, their actions, and attitudes, which enhances the film's overall meaning. While I do not plan to analyze lighting techniques in Villaverde's novel in depth, it is important to refer to the general way in which lighting is implemented in the novel as compared to the film, as well as how the scenes that I will discuss compare to their original textual representation. For instance, in the novel, detailed description on lighting is abundant. Light is often included in background descriptions and is capable of shaping a scene's ambiance through details of darkness, light, or even the fading brilliance of a fluorescent sunset. For example, in the narrator's description of the story's tropical setting, lighting is an important detail:

> ... the glorious sun of the tropics was just setting, its burning rays
> sending beams of light through the branches of the trees, mak-
> ing the shadows of the palms grow longer and longer on the green

field dotted with brightly colored striped flowers, as they set afire
the impalpable earthly atom blooming in the tranquil atmosphere.
(Villaverde 283)[1]

The lighting in Villaverde's novel is an accessory that provides an artistic
and convincing backdrop for the action. Suggesting in his prologue that critics
might consider him a sort of literary Rembrandt because of the vivid images
he creates in his writings, Villaverde explains: "I pride myself on being, before
all else, a writer who is a realist, taking this word in the artistic sense attributed
to it in the modern era" (Villaverde *xl*).[2] While Villaverde's interest lies in the
artistic and realistic value of his descriptions, the lighting in the film works as a
transforming tool that interacts with characters. Accordingly, it functions as its
own narrative voice that is capable of revealing more than what the audience
sees on the surface. David Bordwell and Kristin Thompson affirm the influential
nature of cinematographic light manipulation, specifically through the way it
contributes to the photographic image of a scene. Through such manipulations,
"the filmmaker can select the range of tonalities, manipulate the speed of mo-
tion, and transform perspective" (Bordwell and Thompson 185). The lighting in
Solás's film does just this, starting with the way it alters perspective through
contrast, which we see in the slave rebellion scene. At this point in the film, José
Dolores and Cecilia have fled from the chaotic revolt on the street and find
themselves alone in a dark, ambiguous, ruin-like space. This dimly lit *mise en scène*
depicts Cecilia and José Dolores in a state of desperation because, not only has
someone exposed the plans of the rebel abolitionists' revolt to authorities, but
Cecilia has also discovered that Leonardo is going to marry Isabel. Only days
before, Leonardo promised Cecilia in an intimate encounter that he would reveal
their love to his parents. For Cecilia, the news of the marriage cuts like a knife.
Nevertheless, the furious José Dolores believes that Leonardo is responsible for
the information leak, and so throws the mourning Cecilia to the ground. After
all, Leonardo had to know about the rebel plan since, in exchange for Cecilia's
affection, he agreed to hide a refugee abolitionist. To José Dolores's knowledge,
the plan would have been carried out successfully if not for Cecilia's insistence
on being with Leonardo.

The lighting contrast in this scene works on a few different levels in that it
"narrates" the inner conflicts of characters, enables the visualization of less vis-
ible, psychological conflicts that deal with race and identity, and facilitates the
cultural transformation of characters. For example, the shot depicts the empty,
dilapidated space with a single light illuminating its center. Cecilia is shown

DESPITE HER REJECTION OF HER AFRICAN HERITAGE, CECILIA EVOKES
THE POWER OF CHANGÓ. CINEMATIC LIGHTING HIGHLIGHTS THIS RITUAL
AND JOSÉ DOLORES'S TRANSITION TO CHANGÓ.

HIGH-KEY LIGHTING ILLUMINATES CECILIA'S INTERNAL RACIAL CONFLICT
AND SYMBOLIZES HER INABILITY TO ESCAPE HER BLACK OR WHITE ROOTS.
SHE IS TRAGICALLY CHAINED TO BOTH.

crying alone in this lighted space. José Dolores has backed up, almost completely out of the scene, into the shadowy area near an old, cracked column. From the dark, he watches Cecilia in her fetal position. With her face still pressing against the dirt and the light shining down on her, Cecilia begins to breathe heavily, extending her hands forward with palms open towards the sky as if she were trying to evoke some divine power. As she begins to rise, José Dolores emerges from the shadow, changed. His physical appearance has not changed, but later we see that Cecilia's ritual did in fact evoke the power of an Orisha—the spirit of Changó, the Yoruba deity of war, manifested in the body of José Dolores.

Just as the light functions as a tool for exposing cultural identity conflicts, it also highlights the related issue of race. The light illuminates only portions of José Dolores's and Cecilia's faces while the camera cuts between three different frames: a) the couple that could never be—Cecilia and José Dolores kneeling, face to face, and partially embracing one another; b) a direct focus on Cecilia's face, which is positioned in the perspective of José Dolores; c) a direct focus on José Dolores's intensely expressionless face staring into the camera, which the viewer perceives as Cecilia's gaze. As the camera cuts back and forth between these views, Cecilia declares that justice must be done. She has not recognized that she is now speaking to Changó. He replies that justice will be done, but it will not be the justice that she wishes, which is to kill Leonardo's mother. "Mi justicia será otra," he repeats. His justice will be the murder of Leonardo.

The conflicted way in which Cecilia perceives her own racial identity is represented in this scene through the shadows cast on Cecilia's face. Only half of her white skin is illuminated by an unknown light source while the other half is blacked out by opaque shadow. As an illustration, David Silveira Toledo notes metaphorically that Cecilia, like many people wishing to identify with one social group or another, cannot remove herself from the shadow of her heritage (177). Solás and Delgado conjure up the visible representation of this figurative shadow that clings to her throughout the entire scene. These contrasts are not mere coincidence of the filming; rather, they establish a symbolic pattern of two divided racial identities and the inability to claim both due to colonial Cuban society's and its modern counterpart's unwillingness to accept difference.

This visual phenomenon reinforces the idea that even though the free people of color, including the mulattos, were given special legal "freedoms" and exceptions due to their lighter skin color, they were actually still very much enslaved. They were slaves of antiquated social institutions that hindered progress for anyone other than whites. Meanwhile, Cecilia cannot side fully with either her

African roots or white society because she is connected to both. On the other hand, her white skin allows her access to upper class whites. In a study of the representation of the eroticized mulatta figure in Villaverde's novel and Solas's aim to contest that vision in the filmic adaptation, Alison Fraunhar relates this idea to mimicry:

> Cecilia's vanity, social climbing and desire for whiteness are her trag-edy and cause her downfall. Her performance of Cuban colonial social codes recalls Bhabha's discussion of mimicry; she is a "bad" subaltern whose mimicry of and desire for whiteness oblige her to cross social/racial boundaries, and a "good" subaltern because she does not (at least in the novel) work to undermine that social order. That is, the whites desire (and fear) the blacks for their purported sensuality, and the blacks want the authority and security that is the domain of the white. (229–30)

But Cecilia's mimicry of white social codes suggests a more complex mutual objectification by blacks and whites. Even as a "free" female mulatta, she is still objectified by society like a slave. Robert Padgug explains the idea of commodi-fication in colonial slavery:

> . . . the slave can be bought or sold or otherwise alienated and exchanged, and is, as a laborer, subject to an amount of direct force normally greater than that found in other labor relationships. Thus the slave is both a producer of objects (often in the form of com-modities) as well as an object himself (often, again, a "commodity"); that is, he is defined as the property of others. (4)

While Padgug refers broadly to physical slave labor anywhere, this idea echoes in the lives of "freed" mulattos in Cuba. To put it another way, Cecilia is an object of desire to white males because she symbolizes and embodies pleasure, exotic excitement, and perhaps the envy of their colleagues (i.e., a status sym-bol). Neighboring on Padgug's ideas, Cecilia is, at times, "alienated" by both elite whites because of her lineage and by other mulattos for not aiding in the betterment of the mulatto social condition. She is also "exchanged" by both of these groups. Consequently, when one group rejects her, she seeks the other. On the one hand, white men see her as something new, a forbidden fruit to be tasted and savored temporarily. Nevertheless, Cecilia mutually commodifies the whites, because, marriage to a white male would provide her with instant power

and security. Consequently, the white male becomes a commodity who, when possessed, symbolizes power for the mulatta.

As a result, she assumes the role of both the chosen mulatta queen and sexualized slave to the whites. Because she remains connected to her black roots, she is chosen as the mulatta queen who will "better the race." The film first underlines this idea of royalty and martyrdom with her grandmother's telling of the Oshún deity myth in the opening scene. To summarize Seña Chepa's version, Oshún, born from honey, desired by all men, and envied by all other women for her beauty, arrived in Cuba from Africa after she was captured by white, European conquistadors and brought to the island against her will. She was sold as a slave to Changó, the deity of war, who was disguised as a rich, white woman at the time of the purchase. He then reveals his true self to Oshún and teaches her how to trick the whites by disguising herself as a white person. He then anoints her in honey and dresses her in a queen's robe and crown. As the story finishes, the camera cuts to a scene of Cecilia years later as a young adult, anointing her own body with honey while praying to the Virgin Mary for a white man who loves her. Similar to Oshún who learned how to blend in with the whites, Cecilia prays to La Virgen, a holy figure of white, European culture, as if Cecilia too were white and had come from solely Catholic roots. In other words, while like a faithful Yoruba follower she pays homage to the Yoruba goddess Oshún by covering herself in honey, at the same time she consults the holy deities of white society, trying to convince them (La Virgen, for instance) and herself, that she, too, is worthy of a "white" future. Nevertheless, throughout the film, the frequent allusions to Oshún and Santería culture—she witnesses possessions of her family members by Orisha deities and practices Santería rituals—reaffirm the strong connection to her Afro-Cuban roots, despite any desire to hide them as an adult.

Obviously, Solás's version puts infinitely more emphasis on the mulatta characters' connection to their African roots than Villaverde's novel. Only rarely does the book portray supernatural happenings, such as when someone becomes "espiritada," or possessed, but it is clear that Villaverde was not concerned with or informed about the nuances of Santería and its strong influence in the development of *cubanidad*. Chanan comments that because of the dualism of Cecilia-Oshún and Pimienta (i.e., José Dolóres)-Shangó, the original novel version is altered in the film to shift meaning. He explains that "the effects are peculiarly problematic for an audience for whom these are not just characters in a novel but have lives beyond the page, as idealized projections of national character types. *Cecilia Valdés* is not only a novel but also a zarzuela and a ballet" (390). This explains why many in Cuba felt offended at the classic's new cinematic adaptation.

On the other hand, this adaptation forced viewers to reconsider the hidden truths and real meaning behind Cuban national identity. Understanding that these things make up Cubanness and influence the nature of Cuban society still today would, in theory, instill a greater sense of pride for that past and present.

Lighting contrast aids in the production of this dual slave/queen image during the Holy Week celebration. Cecilia seems to intuit that Leonardo has been murdered in the very moment that it occurs, which sends her running frantically through the crowded streets screaming his name. Like the other contrast scene, this one is very dark and takes place at night, on a street filled with black faces, sounds of drums, and dancers, paying tribute to the Orisha, Ochún. Cecilia's highlighted white face is easy to spot in the predominantly black crowd. She finds herself being pushed and pulled through the mass of celebrating blacks, and though she tries to fight her way through the dancers, she is crowned with the Ochún headdress and the ceremonial cloak. Forced into her position as ceremonial queen, she begins to spin and dance in a fury. Despite her reluctance, she participates almost naturally in the ritual dance. The juxtaposition of her white, illuminated skin spinning through the darkness in traditional African ceremonial clothing symbolizes her emotional and psychological spiraling from the inability to fully accept her "middle color" identity as mulatta, and her role as the sacrificial "mulatta queen."

The lighting in the film also *distorts* certain characters in various moments in order to reveal issues that hinder the progression towards cultural acceptance. One way in which we see this distortion involves how light and shadow "mangle" the faces of the mother figures, Doña Rosa and Seña Chepa, making them appear inhuman. For example, the light makes Doña Rosa look like a demon or a malevolent, gothic creature during the wedding and murder scene. Interrupting this depiction of the traditional Catholic wedding is the sudden entrance of José Dolores dressed as the Yoruba god Changó, who, upon arrival, is surrounded by a seemingly ethereal light. Replete with symbolism and irony, the collation of these two religious images, Catholicism and Yoruba culture, insinuates both the clash of these two ideologies and the empowering rescue of an ignored African past in the Caribbean. Representing the difficulty of reaching full acknowledgement and acceptance of other cultures even in contemporaneous societies, the ancient war deity, Changó, first has to return and forcibly rescue this memory by eliminating the cultural intolerance hindering racially diverse coexistence, which is here symbolized by the traditional and historically discriminatory European culture. By contrast, the novel dedicates substantially less detail to Leonardo's murder. Similar to the film, José Dolores plays the role of the assassin; however,

there is no mention of possession by Changó nor José Dolores's dramatic entrance. Villaverde describes the scene quite bluntly and with minimal detail. We learn that José Dolores has snuck into the wedding wearing a hat so that he can avoid being recognized. He "disappears from sight" and without further explanation and no mention of the action of the stabbing, "Leonardo raised his hand to his left side, gave a muffled moan, tried to lean on Isabel's arm, and collapsed at her feet, spattering her gleaming white silk wedding gown with blood" (Villaverde 490).[3]

Unlike Solás's allegorical Changó-José Dolores amalgamation, this novelistic description is not loaded with the same emphasis on that which defines Cuban society and culture as a collective nation, including neglected African cultural roots.

Paralleling the idea of the necessary fight for cultural incorporation is the acknowledgement of the barriers that impede social progress, which, in the wedding scene, is represented by Leonardo's mother. Doña Rosa acts as Leonardo's "possessor" throughout the film in that she makes it a point to govern his every move and tries to shape his destiny to fit the one that she desires. She refuses to allow Leonardo to learn responsibility for his own mistakes and covers for him in various instances. One example is when Doña Rosa finds out that Leonardo is hiding the rebel fugitive. She reveals the crime to the authorities but advises them that his decision to take part in the crime was due to Cecilia's seductive

BRIGHT LIGHTS DRAIN THE COLOR FROM BOTH LEONARDO'S AND DOÑA ROSA'S FACES. AS A RESULT, LEONARDO RESEMBLES A CORPSE AND DOÑA ROSA BECOMES HIS UNDERTAKER.

DOÑA ROSA AND LEONARDO RESEMBLE MICHELANGELO'S *PIETÁ*.

ways, thus demanding that her son go unpunished. Because of her revelation of the hidden fugitive, Leonardo's mother is ultimately the one that murders him.

Moreover, Doña Rosa's role as possessor is evident symbolically through lighting in the wedding scene. The camera cuts to the image of her colorless face and emphasized, animal-like, black eyes. She stands, dressed in all black, shielding an even more pallid, corpse-like Leonardo. While Leonardo has previously been portrayed as a youthful character with pinkish-yellow cheeks, his face is now drained of all color except for the darkish-red circles surrounding his eyes. More importantly, he seems neither frightened nor defensive, but instead, for lack of emotion and color, appears to be already dead. His mother guards him as if refusing to release his soul from her symbolic underworld of pedigree blood and elite society.

The most curious detail, however, is her reaction to José Dolores's stabbing of her son. Sinking to the floor and writhing painfully, she groans as if Leonardo's life were leaving her own body. And one must not ignore what happens next—the mortally wounded Leonardo finds enough strength to stand and execute a sort of "zombie walk" over to his mother, who kneels with upwardly extended hands. It appears to be a summoning gesture rather than an attempt to position her arms to catch Leonardo when he falls. Thus, with raised arms she

"summons" this walking corpse. As he falls into her arms and dies, one cannot help but think of Michelangelo's famous statue, "Pietá" of the Roman Vatican, depicting the crucified Jesus lying across his mourning mother's lap. By contrast, the film's Doña Rosa-Mary figure is dressed in black and, given her more gothic appearance, insinuates a corruption of Christian ideals shaped by colonialism, and the way Christianity was often used by the elite as a tool to reason their domination over blacks and maintain them in their subservient position.

It can also be argued that by killing Leonardo, José Dolores has liberated him from the grasp of his mother's talons. In other words, he has figuratively "murdered" the demon by eliminating a breeding source of segregationist attitudes. While the lighting transforms the nurturing maternal figure into a grim-reaper-like presence, it reveals the symbol of inescapable determinism and inevitable failure that derives from inherited ignorance. In turn, this learned discrimination results in limitations and division rather than unity; or, in metaphorical terms, binding, social chains that can only be loosened by the social progression of previous generations. Leonardo represents the potential prolongation of his mother's socio-politically retrogressive attitude for generations to come. Therefore, through José Dolores's violent act, he eliminates her ability to replicate these rigid social attitudes through Leonardo's young mind. No longer having living children, Doña Rosa's elitist mindset will die along with her.

We see a similar psychological brainwashing by Cecilia's grandmother on her granddaughter's emotions. Beginning with the opening storytelling of the Changó and Oshún myth, each scene with Seña Chepa seems to show her veiled in darkness, aside from the occasional flicker of a candle or a torch light from an outside passerby. What we can see through this scanty lighting, however, are the cave-like walls and the weathered dirt floor of the house. Simultaneously, the shadows exaggerate her age by highlighting her timeworn skin. Moreover, despite the fact that the opening monologue depicts the decrepit Seña Chepa talking to Cecilia who is a small child at the time, later in the film during Cecilia's young adult years, it appears that her grandmother has maintained her age from the earliest depictions of her in the film. To clarify, Seña Chepa's appearance seems eternally old, while her pessimistic, complaining disposition is highlighted through her ever-frowning facial expression and the sound of her gravelly voice. This image diminishes her human form and turns her into a sort of old, one-dimensional, cave creature that never submerges into the light of day. On the one hand, the grandmother's image in the film further echoes the theme of challenging outdated, extremist traditions that threaten social progression. On the other hand, the fact that Seña Chepa seems to eternally maintain her old

age suggests that her outlook, although pessimistic, is ageless in that the same social problems, such as racism and social exclusion, would carry on for generations to come. In this way, just as Doña Rosa "possesses" Leonardo, Seña Chepa psychologically "owns" Cecilia. Metaphorically speaking, Seña Chepa's role is like that of a brothel madam who demands Cecilia to "sell herself." Raised to believe that her race is inferior to the whites and discouraged from confronting her own roots, Cecilia has been trained by her grandmother to believe that as a whiter mulatta, she must accept the moral duty of "bettering the race" by marrying white. In addition, Cecilia's grandmother criticizes her for not exploiting her beauty to obtain this better future. Ramón Ferrera suggests that this predestined failure and Cecilia's self-destruction is a result of racial and social barriers that impede her personal need for progression (93). These barriers, unfortunately, are the products of the elite elders on both sides of the Cuban racial divide, who set certain social standards and encourage the alienation of those who do not abide by them. This idea is pertinent even to the twentieth century.

The lighting technique in the final scene emphasizes the inevitable internal self-destruction that Ferrera mentions, which stems from feelings of being stuck in a social order that does not allow the freedom to embrace one's own beliefs and culture. The scene shows Cecilia running desperately through the streets after she has finally escaped the bustling streets of the Holy Week festivities. Pursued by José Dolores, she approaches a tower and proceeds to run up the dark stairway, still wearing her Ochún garb. As Cecilia runs from José Dolores, she is symbolically resisting Changó, who symbolizes her African roots. Next, Cecilia slowly approaches the edge of the tower, a scene in which bright, white lights illuminate her pale, terrified face, and create a gleam on her crown of Ochún. She stares at her future below, lets out a fearful scream, and lets herself fall forward to her death.

Solás closes the film with Cecilia's suicide, which completely contradicts Villaverde's "happy ending." In the novel, the narrative concludes with the news that Cecilia has given birth to Leonardo's child, a baby girl. For Leonardo, the freshly graduated JD, and for his family's desire to maintain their *pureza de sangre* (purity of blood), this is all but a celebratory occasion. Forcing him to feel the consequences for his irresponsible "amorous ecstasy" that has now faded at this point in the novel, Leonardo prefers to forget Cecilia and marry Isabel while continuing to build upon his wealthy family lineage. After all, in his mind, Cecilia, or as he later considers her, "that woman," "was not his wife, much less his equal" (Villaverde Kindle 10083). Despite the rejection of the child and his abandonment of Cecilia, the eventual death of Leonardo and the survival of the

female child can be interpreted as a positive message about the progression of racial synchronization, social advances for blacks, and racial equality.

So, why Solás's negative reworking of a classic novel? Villaverde's ending fits the attitude of the historical context in which it was written and concerns pertinent social issues of the nineteenth century. Solás insinuates that a century later, the novel's idealistic ending does not apply to the realities of late twentieth-century Cuba. While progress has been made with respect to the erasure of forced physical labor based on skin color, racism is still present, and the tendency to hide or deny African roots eliminates important aspects of Cuban identity. In a sense, Solás's negative ending sparks curiosity in this history that "killed itself," so to speak, due to peoples' willingness to keep it hidden. The baby in Villaverde's novel never arrived, as it were, according to Solas's adaptation.

Cecilia dies representing the very cultural and racial hybrid that she was trying to eliminate, and this mulatta death symbolizes society's inability to embrace this hybrid, despite its undeniable presence in *cubanidad*. The film closes with a far-range shot of José Dolores's silhouette sitting and staring down mournfully over the tower's edge. Despite the fact that the film ends in this tragic fashion, some critics interpret these events as an optimistic message of societal progression. Sarah Rosell, for example, describes Cecilia's suffering as a positive transformation from victim to revolutionary figure, while demystifying the mythical image of the passive slave by showing the slave taking action towards change (15). Nevertheless, because Cecilia has to end her own life in order to "liberate" herself from oppression, in my view, this ending cannot be interpreted as a "positive" one. The spirit of the closing images clearly represents defeat, an alternative interpretation of the original work that speaks for itself—that, even a century later, the need to recognize racial syncretism and enduring societal inequalities in Cuban society still persists. As Solás himself commented in an interview, the mulatto symbolizes the success of syncretism and its importance in Cuba's social development (Rueda 157). Contrasting with Villaverde's final image of Cecilia as a new mother that will nurture and guide the new generation, however, the mulatta suicide in the film represents the death of true *cubanidad* that results from Cubans' failure to recognize and embrace the country's hybrid roots.

The film, nevertheless, does not suggest that the progress towards embracing the island's true and complete history is lost; rather, it optimistically insinuates a progress that is still very much in a transitional state. This idea resonates with the opening scene of the film in which a cave-like tunnel is portrayed and a group of Afro-Cuban people can be seen quietly walking through this space. The viewer does not know where the cave leads, but it emphasizes movement as

a collective unit. Therefore, the scene can be interpreted as a transitional phase of liminality for descendants of Africans in Cuba, between one state of reality, embracing true origins, and another, the colonial, white-washed history of Cuba. To be sure, Cecilia is a liminal character who emphasizes the ambiguous reality of the mulatta condition.

In a speech given in 1961 at La Biblioteca Nacional in La Habana, Fidel Castro declared, "With the revolution, everything; against the Revolution, nothing" (Castro n.p.). And as such echoes the mission of the ICAIC in the eighties; in the words of García Espinosa, the Cuban filmmaker "should place his role as revolutionary or aspiring revolutionary above all else" (García Espinosa 465), which Solás may not have achieved with *Cecilia*, at least according to the film's initial criticism. It is possible, however, that Solás and Delgado set the stage for the return of a revolutionary Cecilia, a version that refuses to lie to viewers about the strong presence of African roots in *cubanidad*, nor about the discrimination and limited social choices experienced by mulatta women. As Chanan suggests, "In short, as the personification of Cuban feminine beauty, [Cecilia] represents, on the one hand, a tacit acknowledgment by all social classes of the blackness in Cuban blood, and, on the other, of tragedy" (*Cuban Cinema* 391). With the use of varying lighting tonalities, Solás and Delgado implicitly project shades of this "blackness" on the viewer, enhancing the culturally diverse images and themes of the film. With the artistic and ethical purpose of the film in mind, it is clear that the cinematic lighting "can create a great many moods, but the task of the cinematographer is to choose the type of lighting that will best help to tell the story" (Malkiewics and Gryboski 2). In that regard, the lighting techniques used in *Cecilia* aid in telling the story while drawing needed attention to the reworked "mood" of the film's events. Solás's version of Villaverde's classic undoubtedly implores viewers and readers to face the unpleasant truths of history and, despite the different centuries in which they were created, both works function as a societal mirror that reflects varying national identity struggles. The filmic adaptation of this nineteenth-century classic provides a pertinent view of these issues, relative to modern-day Cuban, and more broadly, Caribbean society.

Notes

1. " . . . se ponía entonces el glorioso sol de los trópicos, cuyos abrazadores rayos lanzaban manojos de luz a través de las ramas de los árboles, tendiendo cada vez más larga la sombra de las palmas sobre el campo verde, tachonado de gayadas flores, a tiempo

que encendían el átomo térreo impalpable que se cernía en el tranquilo ambiente" (Villaverde 1981, 235).

2. "me precio de ser, antes que otra cosa, escritor realista, tomando esta palabra en el sentido artístico que se le da modernamente" (Villaverde 1981, 6).

3. "Llevose el joven la mano al lado izquierdo, dio un gemido sordo, quiso apoyarse en el brazo de Isabel, rodó y cayó a sus pies, salpicándole de sangre el brillante traje de seda blanco" (Villaverde 1981, 402).

Works Cited

Barnard, Timothy. "Death is Not True: Form and History in Cuban Film." *New Latin American Cinema*, edited by Michael T. Martin. Detroit: Wayne State University Press, 1997, pp. 143–54. Print.

Bordwell, David, and Kristin Thompson. *Film Art: An Introduction*. 4th ed. New York: McGraw-Hill, 1993. Print.

Castro, Fidel. "Palabras a los intelectuales." La Biblioteca Nacional. La Habana, Cuba. 16, 23, and 30 June 1961. Closing speech of Las Reuniones con los Intelectuales Cubanos.

Cecilia. Dir. Humberto Solás. Icestorm, ICAIC, 1981. DVD.

Chanan, Michael. *Cuban Cinema*. Minneapolis: University of Minnesota Press, 2003. Print.

———. *The Cuban Image: Cinema and Cultural Politics in Cuba*. Bloomington: Indiana University Press, 1985. Print.

Childs, Matt D. *The 1812 Aponte Rebellion in Cuba and the Struggle Against Atlantic Slavery*. Chapel Hill: University of North Carolina Press, 2006. Ebook.

Covarrubias, Gisela Arandia. *Población afrodescendiente cubana actual*. La Habana: Instituto Cubano de Investigación Cultural, 2012. Print.

De la Fuente, Alejandro. "The New Afro-Cuban Cultural Movement and the Debate on Race in Contemporary Cuba." *Journal of Latin American Studies*, vol. 40, no. 4, 2008, pp. 697–720. Print.

———. "Race and Inequality in Cuba, 1899–1981." *Journal of Contemporary History*, vol. 30, no. 1, 1995, pp. 131–68. Web.

Dubois, Laurent. *A Colony of Citizens: Revolution & Slave Emancipation in the French Caribbean, 1787–1804*. Williamsburg: Omohundro Institute of Early American History and Culture, 2004. Print.

Elena, Alberto, and Marina Díaz López. *The Cinema of Latin America*. New York: Columbia University Press, 2003. Print.

Ferrera, Juan Ramon. "Variaciones renovadoras de Cecilia Valdés en el cine." *Desde las tierras de José Martí: estudios lingüísticos y literarios*, edited by Carmen Morenilla Talens and María Julia Jimenez Fiol. Valencia: Universitat de Valencia, 2001, pp. 93–103. Print.

Fraunhar, Alison. "Tropics of Desire: Envisioning the Mulata Cubana." *Emergences*, vol. 12, 2002, pp. 229–30. Print.

Garcia Espinosa, Julio. "For an Imperfect Cinema." *The Cuba Reader: History, Culture, Politics.* Durham: Duke University Press, 2004. Print.

Hellín-García, María José. "Politics at Play: Game Metaphors in Spanish Political Discourse." *Hipertexto*, vol. 19, 2014, pp. 132–51. Print.

Hess, John. "Neo-Realism and New Latin American Cinema: Bicycle Thieves and Blood of the Condor." *Mediating Two Worlds: Cinematic Encounters in the Americas*, edited by John King, Ana M. López, and Manuel Alvarado. London: BFI Publishing, 1993, pp. 104–18. Print.

Malkiewicz, J. Kris, and Barbara J. Gryboski. *Film Lighting: Talks with Hollywood's Leading Cinematographers and Gaffers.* New York: Prentice Hall Press, 1986. Print.

Martin, Michael T., and Bruce Paddington. "The Baroque as Cinematic Style and Metaphor: Humberto Solas on *El siglo de las luces*." *Quarterly Review of Film & Video*, vol. 18, no. 2, 2001, p. 157. Print.

———. "Restoration or Innovation?" *Film Quarterly*, vol. 54, no. 3, 2001. Print.

Padgug, Robert A. "Problems in the Theory of Slavery and Slave Society." *Science & Society*, vol. 40, no. 1, 1976, pp. 3–27. Print.

Paquette, Gabriel, Matthew Brown, Brian Roger Hamnett, and Will Fowler. *Connections after Colonialism: Europe and Latin America in the 1820s.* Tuscaloosa: University of Alabama Press, 2013. Ebook.

Rosell, Sarah. "Revisión de mitos en torno a Cecilia y Francisco: de la novela del siglo XIX al cine." *Hispania*, vol. 83, no. 1, 2000, pp. 11–18. Print.

Rueda, Amanda, and Humberto Solas. "Encuentro con Humberto Solás." *Caravelle*, vol. 83, 1988, pp. 137–45. Print.

Silveira Toledo, David. "Cecilia: de la literatura al cine." *Desde las tierras de José Martí: estudios lingüísticos y literarios*, edited by Carmen Morenilla Talens and María Julia Jimenez Fiol. Valencia: Universitat de Valencia, 2001, pp. 177–78. Print.

Villaverde, Cirilo. *Cecilia Valdés or El Angel Hill.* Edited by Sibylle Fischer. Translated by Helen Lane, New York: Oxford University Press, 2005. Print

———. *Cecilia Valdés o la loma del ángel.* Edited by Iván A. Schulman. Caracas: Biblioteca Ayacucho, 1981. Print.

Afro-Peruvian *Cimarrones*

Raiding the Archives and Articulating Race

Rachel Sarah O'Toole

When Carlos Ferrand, a Peruvian-Québécois, completed the film *Cimar-rones* (meaning "fugitives" or "maroons") in 1982, he reflected on Peru's legacy of slavery as well as its vanquished revolutions. The short film depicted a nineteenth-century fugitive community of enslaved Africans who freed them-selves. Speaking to a Canadian audience, *Cimarrones* begins with a narrator, describing in English or in French (depending on the version), how millions of Africans were forcibly traded not to North America, but to Peru. This forgotten history is further underlined when the narrator points to a map and highlights how the official history textbooks do not mention how seventeenth-century Lima was predominantly black. In answer to this historical silence, *Cimarrones* creates a fictive account of a credible historical event. In the film, fugitives attack a Spanish foreman with Andean assistants, taking captured fugitives to their execution. When they return to their *palenque* (a fugitive slave settlement), Ferrand fills the screen with sights and sounds of a utopian community headed by a queen, as a *curandero* (healer) attends to the spiritual wounds of the newly liberated. The narrator explains that, days later, the Spanish would destroy the *palenque* in retaliation for the raid, dispersing members into bandit bands who would eventually join independence struggles. In the early 1980s, Ferrand completed the film with the assistance of the National Film Board of Canada (Ferrand

2016). In it, he reflected to a North American and global audience a Peruvian history and an Afro-Peruvian vision of a radical future.

This chapter explores how Carlos Ferrand placed Africans and their descendants into a Peruvian revolutionary trajectory. A director of over sixty films, as well as a screenwriter and cinematographer on numerous other productions, Carlos Ferrand has sharpened his insider/outsider gaze to focus on the struggle for equality. Researched, written, and filmed in the early 1980s, *Cimarrones* employed the colonial past—as did contemporaneous Peruvian film biopics about Garcilaso de la Vega and San Martín de Porras by other filmmakers—but placed Africans and their descendants at the narrative center. Ferrand's work was part of his historical moment. With the 1972 "cinema law" Juan Velasco Alvarado's government (1968–75) had encouraged national Peruvian film production (Bedoya 2009, 164). The Velasco regime of the late 1960s and 1970s marked a clear revolutionary break from past governments, to consciously include indigenous Andeans as peasant citizens. In a clear corrective to centuries of racial injustice, the "revolution from above" abolished servitude on rural estates and redistributed holdings from vast *haciendas* to landless people. At the same time, the revolutionary government attempted to erase ethnic and cultural signifiers (Seligmann 3; Mayer 3) with the exception of folkloric expressions (Feldman 127), and ignored a historical legacy of enslaved African resistance in the Andes in favor of Inca symbolism such as the popularization of the indigenous rebel hero, Túpac Amaru (Seligmann 91; Cant 22; Middents 169). Peruvian cinema responded with more explicit depictions of historical Peruvian realities. In his 1977 feature *Kuntur Wachana* (*Donde nacen los cóndores* or *Where the Condors are Born*), Federico García re-told the story of an abusive white *patrón* or boss of the Huarán *hacienda* who had resisted an "Indian" takeover in the 1950s. In a similar use of historical events, Francisco Lombardi narrated the night in 1957 when an accused murderer was executed to characterize an impoverished black man as an outsider in his 1977 feature, *Muerte al amanecer* (*Death at Dawn*). Like these contemporary films, *Cimarrones* built on a cinematic technique of employing past events with the purpose of positively integrating Afro-Peruvians into a national past.

Carlos Ferrand engaged in the practice of Foucaultian counter-memory as well as an anti-racist politic. Like his contemporaries in Latin American New Cinema and Third Cinema, in *Cimarrones* he recalled the omitted or silenced history of national subalterns (Bedoya 1995, 220–21). The film's markedly triumphal tone of fugitives who broke the chains of bondage is also similar to Andean film aesthetics with clear distinctions between enemies and heroes (Middents 6, 117) that emerged from the 1952 Bolivian Revolution and the revolutionary politics

surrounding the Velasco government (1968–1975). In this sense, the film takes part in the Velasco revolution when the Peruvian government was dedicated to agrarian reform, intending to resolve centuries of socio-economic inequality and cultural disenfranchisement of the country's indigenous majorities. At the same time, Ferrand activated a counter-memory of the Peruvian "revolutionary" national imaginary that required historical figures of indigenous Andean heroes. In a transgressive act of "forgetting" what was nationally essential (Clifford 134), Ferrand replaced the usual revolutionary figure of an Andean masculine peas- ant savior with a collective of Afro-Peruvian men and women. Drawing on the emerging hybrid articulations of cinema in Montréal, Québec (Pike 4), Ferrand was further driven to examine his own location as a white, privileged Peruvian to tell an Afro-Peruvian story. In the process, the film, and the reasons surround- ing its making, lay bare ongoing racial dynamics. The technique, however, is an elaborate historical revision. *Cimarrones* claims history's authority—as rooted in archival documentation, factual presentation, and a story well told—to confront national myths and racial ideologies of late twentieth-century Peru and the hemisphere as a whole. In doing so, Carlos Ferrand's short film attends to the ongoing problematic of Afro-Peruvian history by raiding the archive.

RAIDING THE ARCHIVE

In *Cimarrones*, Ferrand and his colleagues engage in a transformative historical reconstruction that challenges the past and the present. With historical research provided by Dr. Luciano Correa Pereira, Ferrand and Enrique Verastegui wrote a script that crafted a historical account. As a historian of the Peruvian African Diaspora, I recognize how the short film was inspired by the findings of his- torians. *Cimarrones* is based on specific judicial cases, as its narrator suggests, and Carlos Ferrand affirmed, from Peru's Archivo de la Nación (Ferrand 2016). The film, however, is not tied to the need to reproduce or analyze these specific historical events. Instead, *Cimarrones* creates a seamless narrative made of events, circumstances, and personages from many cases (Ferrand 2016) with additional ethnohistorical and historiographical evidence. *Cimarrones*, I suggest, following Trouillot, sidesteps "the tyranny of facts" (Trouillot 145) that plagues a historian in favor of creating a filmmaker's narrative. Still, the archive makes an appearance in the film, but primarily to bestow authority onto the film which in turn allows Ferrand and his colleagues to portray fugitives according to their own vision.

Cimarrones is clearly inspired by the historiography and the historians of the 1970s and 1980s, who were dedicated to the agency of fugitive slaves and

their communities in Perú. The film depicts a *palenque* as described by historians. Alberto Flores Galindo explained that *cimarrones* fled into the wooded and swampy areas of the coastal valleys (117). There, protected, according to Carlos Lazo García and Javier Tord Nicolini, inhabitants of the early eighteenth-century *palenque* near the *monte* (or uncultivated areas) established homes with orchards, fields of maize, squash, and prickly pears (430). In addition, historians agree with what is suggested in *Cimarrones*, that fugitive communities included people identified as *lucumi* (from Yoruba-speaking West Africa) and *criollo* (born in the Americas) (Lazo García and Tord Nicolini 428) as well as those from the Gold Coast (*mina*) and the Bight of Benin (*arara*). Leaders of *palenques* could be women (Kapsoli 59, 70) and included African religious specialists (34) as well as supervisors of military, civil, and economic affairs (35). Underlining the resistance of African Diaspora communities, historian Wilfredo Kapsoli described how one man, Gaspar Congo, broke the doors of the slave quarters during a revolt on the San Jacinto hacienda in 1768, encouraging his *compañeros* to fight for a better life (55). Therefore, the cinematic depiction of a diverse village in *Cimarrones* headed by its queen and its chief, and attended by its *curandero* (or healer), clearly coincides with the historiography on this period prevalent during the 1970s, a time when scholars in Peru were attending to the histories of the African Diaspora.

By relying strictly on archival evidence, historians, however, created a criminal narrative. In Peruvian historiography, historians of fugitives have reported that *cimarrones* robbed estates, assaulted travelers, and terrorized Indians (Aguirre 1995, 265; Flores Galindo 118; Lazo García and Tord Nicolini 433, 435). I, too, focused on the criminal accusations against *cimarrones* in my work regarding African and indigenous relations on the northern Peruvian coast (O'Toole 2006). Kapsoli listed the items that fugitives stole (56) and which Spaniards Julián Grande, the "captain of the blacks" during the 1768 San Jacinto revolt, intended to kill (59). The archive, however, influenced a particular narrative, one that can be revealed by recent attention to how the judicial nature and the concerns of the colonial state shaped the historical record (Bryant 2004; de la Fuente 2007; McKinley 2010). In particular, evidence of fugitive activity has often surfaced in criminal cases filed by royal officials or slaveholders who are seeking to capture escaped slaves. In my examination of the judicial trials pertaining to fugitive slaves in early nineteenth-century Peru, the accusations in the lawsuits include robbery, sedition, homicide, insolence, and other crimes against the colonial state and the slaveholder. As a result, the archive delivers a message to the historian that a fugitive is a criminal, normalizing or making real a dominant perspective (Trouillot 84). The narrative is "true" insofar as these are events and circumstances

recorded in the archive, but our attention to the archive also can reduce Afro-Peruvians into thieves and murderers.

Carlos Ferrand's *Cimarrones* engages in a counter-memory. The short film highlights intense solidarity among fugitives, which challenges the evidence from the archives produced within a Spanish judiciary. Historians, on the other hand, have explored how founding *castas* (or ethnic groups) such as the *terranovas*, who governed an early eighteenth-century *palenque*, refused to admit *congos* (Lazo García and Tord Nicolini 428). Furthermore, while historians debate whether fugitives were involved in *cimarronaje* or banditry (Vivanco Lara 31, 36; Kapsoli 50) and fugitives' economic motivations (Espinoza 32), the film recalls an Andean-African solidarity. Historians rarely find evidence of what fugitives said or how they acted towards each other and, when we do, the evidence is fragmented and scattered. In *Cimarrones*, Ferrand and his colleagues united small pieces of information into a coherent narrative. The story line of the short film is that Africans and their descendants create a sustainable community—a vision that historians like me suspect but have been unable either to prove or disprove given our evidentiary methods and fealty to the archives. Ferrand, in contrast, communicates the keen intelligence of the fugitives who work exceptionally well together to take back their stolen community members. Fugitive slaves, in this accounting, execute a communal justice, releasing indigenous Andeans and punishing the Spanish overseer.

In order to produce this imagery, Ferrand did not follow a historian's approach to the archive. In a 2016 interview, he recounted that historian Luciano Correa Pereyra transcribed the trials of the *cimarrones* from bound volumes in the Archivo General de la Nación as depicted in the film (Ferrand 2016). From these judicial records, Ferrand explained that

> that's where I found the names, and I kind of put together a couple of stories to create this one which is very generic. . . . There are many stories that resemble that . . . though the background of the story is plausible and based on facts, the actual names and the actual events is a mix of different stories.

Indeed, parts of a Real Audiencia 1808 criminal case from Peru's Archivo General de la Nación appear to have inspired the short film. In judicial trial, which resembles but varies slightly from the events depicted in the film, enslaved and free men and women provide testimony regarding a group of fugitives who assaulted a convoy. Near the *tambo* (or inn) of Laguna Bujama, near Mala,

south of Lima, Manuel Bravo, a white *moso* (youth), led two of his companions, José Primera (a black man of unspecified legal status) and Pablo Falcón (a free black man) to liberate his *compadre* (or fellow) Pancho (AGN. RA. CC. Leg. 114. Exp. 1382 (1808), f. 11). In *Cimarrones*, the judicial case is revised so that the young white man, Manuel Bravo, is transformed into a mature Afro-Peruvian leader of the fugitives as the *cimarron* group is individualized, given skills, and other identifying characteristics. In the cinematic version of historical events, *Cimarrones* recounts the successful assault on the slaveholders' proxies, and draws on the archival material. According to the criminal case, the small group joined twenty or so other fugitives who emerged from the *monte* and together assaulted the muleteers who were conducting Pancho along with other enslaved men and women, including enslaved *criollos* (African-descent men born in the Americas), two Benguela men, a *sambo* slave, and a *mozambique* man who did not speak Spanish (ff. 22v, 23v, 27v, 28, 29). The film directly takes the historical action, repeating the resistance but rewriting the crime. According to the criminal case, after robbing the muleteers, the fugitives broke the shackles of the prisoners to "set them free" (f. 23). By borrowing and revising the narrative provided by the criminal cases, Ferrand constructed a vibrant counter-memory to the official version provided by the colonial archive. In his account, fugitives were no longer criminals but heroes. Afro-Peruvians were not depicted as slaves, but as free people.

The film raids the archive for its narrative purpose, but hides the analytical work of the historian. During the film's introduction, the narrator describes how the "story of this film is based on facts. We found them written in the old manuscripts in the national archives of Peru." The film depicts an unnamed man walking the streets of Lima of the late 1970s and early 1980s, presumably towards Peru's National Archive. Then, another unnamed man approaches the shelves to pull down a large bound volume, and opens it for consultation. Facts, then, come from archives, as the film teaches us, and these facts will assist the filmmakers to recall a forgotten past. Furthermore, the film participates in an internationalist paradigm as well as an anti-racist cinema of subversion, to show black people as authors of their own history (Beller 2322, 2324). Ferrand chose Bert Henry, a black professor of drama at Concordia University in Montréal to depict the narrator in the English version, with a Haitian actress, Denise Petrusse, in the French version. Both narrators were cast to depict a vibrant "Third World intellectual in possession of her and his knowledge" (Ferrand 2016), with the film further recreating a counter-memory with Afro-Peruvian men as protagonists and women as leaders within a communal economy.

CIMARRONES: CONSULTING PERU'S NATIONAL ARCHIVE.

While a recognizable location to a historian, the archive in *Cimarrones* acts as a figure and a site for the filmmakers. By not naming the historians or the archivists, the filmmakers erase historians as interpreters of archival evidence. In contrast, it is the archive that is named. As a character, the archive bestows authority on the film's narrative, assuring the viewers that the following account is "real." As a location, the film shows the archive in a radical act of demystification, revealing the source of historical narratives. The sequence, however, erases the process of interpretation both of the historian and of the filmmakers, to remake the viewer as a passive recipient of past events as well as their discovery, receiving a revolutionary narrative rather than uncovering the making of a historical narrative. Carlos Ferrand and his colleagues engage in a dialogue with the archive, or visit it for the riches that it holds, but they are not bound by its logics. A historian like me would have felt compelled to explore the complicated relations between an Andean *tributario* (tribute-payer) who joins the accusations against Manuel Bravo as well as the robberies supposedly conducted against Indians traveling from Chilca discussed in an adjacent case (AGN. RA. CC. Leg. 114. Exp. 1378 (1808), ff. 1, 15). Ferrand, instead, tells another story through the act of solidarity between Manuel el Luco and the indigenous assistants of the convoy. As the filmmaker explained in 2016, "it was a film to celebrate some of those people,"

designed to highlight the integrity of Afro-Peruvians, and driven by an acute understanding of colonial racial relations. My historical interpretation of hostile relations between coastal indigenous inhabitants and African *cimarrones* was rooted firmly in an archival fascination with each community's legal location as "Indian" and "black" (O'Toole 2006). But *Cimarrones* is not bound by the archive and the categories of colonial control. In contrast, the film depicts interaction, exchange, and cooperation. Andeans and Africans understood that the meaning of freedom was to break from the shackles of Spanish service and control. For this narrative of solidarity, the archive is a beginning place, a resource, and an inspiration, playing a central role in the film's creation of countermemory.

AFRICAN DIASPORA WITHIN
REVOLUTIONARY POLITICS

With its message of enslaved liberation, *Cimarrones* was part of revolutionary Peruvian culture of the late 1960s and 1970s, yet the work of Carlos Ferrand challenged contemporaries with a more inclusive politic. As Ferrand described himself, he was 'born white" (Ferrand 2015) to a bourgeois family in Peru (Laurendeau 16). Having finished high school and college in the United States and then studied film in the Institut national d'études cinématographiques (INSAS) in Brussels (Belgium), Ferrand returned to his native Peru in the 1970s. Already immersed in the late 1960s European counterculture, Ferrand spent a few years crossing Peru with his camera and working with other artists such as the filmmaking collective, Liberación Sin Rodeos (Bedoya 1995, 199). The group completed films such as one about the death of a poet, Javier Heraud, who was killed while attempting to ignite a *foco*, or a revolution of local people involving small guerrilla warfare, in southern Peru. By offering visions of more radical and subaltern transformations, Ferrand and his fellow artists critiqued Peru's military government and made themselves known as an irreverent collective of artists. In turn, their work was not supported by the state-sponsored film industry, especially as the government grew more repressive under Morales Bermúdez (Mayer 8). In particular, COPROCI, the government's Commission for Promotion of Films, refused to approve their films for commercial distribution (Alexander). By 1979, Liberación Sin Rodeos had dissolved having lost the original prints of many of their films.

By the early 1980s, Carlos Ferrand developed the short film *Cimarrones* working with local community members. The idea for the film came from Enrique Verastegui, a poet from Cañete, and Luciano Correa, a historian also

from Cañete, who conducted the historical research for the film. He was directed to the Ballumbrosios, a famous family of Afro-Peruvian cultural workers, artists, and activists who became active supporters with Amador Ballumbrosio playing the role of Manuel Bravo el Luco (the leader of the *Palenque*). In turn, the people of El Carmen, a well-known district in Chincha, became the main actors of the film (*Americano*), most of whom had never even seen a film (Ferrand 2016). Accustomed to filming in the location and with the local community like his peers, Ferrand included members of the local community in the production of his film.[1] Homerio Calderón, who played the older slave traumatized by enslavement and then cured by the curandero, quickly became part of the team, providing advice about how to position the camera (Ferrand 2016). As a result, *Cimarrones* was a collaboration between local leaders and artists based in Lima.

Cimarrones transitions quickly from a somber narrative of historical context to a liberating vision of African Diaspora history—a story of fugitive resistance. With this choice, Carlos Ferrand and his colleagues contributed to a Peruvian pantheon of twentieth-century revolutionary heroes. The main protagonists are introduced one by one, including Manuela Manolo Mandinga, "the One Who Walks on Fire," Hortensio Banto, "the Black Cat," and Manuel Bravo el Luco, "the King of the Hills" and the leader of the group. *Cimarrones* also presents a clear distinction between heroes and villains. The fugitives track a convoy escorting their *compañeros* who have been sentenced to death for the crime of rebellion. The group includes two Spanish soldiers and their Andean assistants led by a foreman who, according to the narrator, was known for his cruel and sadistic punishment of slaves. Andeans are presented with cohesive families, struggling to survive, just as the fugitives in *Cimarrones* merely seek to be with their companions and therefore are forced to fight the whites to do so.

Carlos Ferrand elaborates and editorializes on the triumphal message of the cinematic revolutionary genre. In *Cimarrones*, the collective remains strong. In a tightly edited sequence, the convoy ambush is enacted with a sparse soundtrack and the sounds of the approaching horses. Communicating with whistles, the fugitives coordinate their attack and joyfully reunite with their released *compañeros*. The screen fills with images of men embracing, and sounds of people greeting each other. The victorious travelers turn to the ocean where sounds of surf meld with the marimba as the village signals their arrival with the call of a conch shell. Scenes of abundant cornfields, women in full skirts, and men embracing each other intermingle with smiling and laughing. Ferrand's camera takes in the joy of people reuniting and the plenty of their village in contrast to the desolation of the uninhabited, inland sugarcane fields.

RETURNING *CIMARRONES* GREETING FELLOW *PALENQUE* MEMBERS.

With funding from the National Film Board of Canada, Ferrand was able to complete his film, but in the languages of his adopted country: French or English. Subtitles for the Peruvian actors further facilitated the translation of a Latin American reality to North American and European audiences. To these viewers, the narrator explains how a mostly black city such as seventeenth-century Lima lost its African past by the nineteenth century due to slavery's high mortality rates. Ferrand educates, but carefully manages the structural violence of slavery and the slave trade. With a running time of twenty-four minutes that includes a substantial introduction as well as ending credits, Ferrand chose to narrate, but not enact the extensive slave trade and fatalities of Peruvian slavery.[2] It is only in the final scene that the narrator explains in an off-screen voice, against the backdrop of a vibrant community meeting, that days later, Spanish soldiers would destroy the *palenque*. The film takes on a global revolutionary tone, equating the oppression of the Inca with the enslavement of Africans in the Americas and places the viewer on the side of the exploited. As a result, it is a Latin American film completed in Canada directed to a transnational audience. A Spanish version was never completed.

An African Diasporic cinematic vision, in the metaphorical landscape of *Cimarrones*, then, Africans and their descendants work to build a Diasporic world in the coastal Andes. Having broken their chains, the *cimarrones* leave the arid inland cane fields, the site of enslavement, and move towards the coast, a direction recognizable to Andeans (Salomon 6, 8, 12). Among coastal Andean inhabitants, water is the key, regardless of its form, as nurturing irrigation, fickle rain, rising rivers, or the fecund ocean (Diez Hurtado 112; Ramírez 52, 54; VanValkenburgh 311). Critically, among the African Diaspora, water is also a powerful transformer. When Ferrand turns the camera to the vast Pacific Ocean, the scene recalls the diasporic symbolism of the Middle Passage. The *cimarrones*, thus, engage in a return voyage towards the saltwater, where free Africans were made into slaves through a forced migration (Smallwood 8). Water also functions as a critical player in African Diaspora religious practices, as believers call on Yemanjá, the *orisha* of the ocean, or emphasize water immersion, as among nineteenth-century Afro-Jamaicans (Schuler 36). As depicted in the film, the *cimarrones* cross a stream into the *palenque* settlement, returning to freedom and their queen, possibly an adaptation of a Dahomeyan or West Central African cultural practice (Karasch 247; Bay 57).

Cimarrones, therefore, rewrites a narrative of liberation in Peruvian cinema. In other contemporary films such as García's *Kuntur Wachona*, Andean laborers and farmers struggle to recuperate their land from the estate and to found a union, while in Figueroa's *Los Perros Hambrientos* (*The Hungry Dogs*), they struggle to eke out a living while providing service to the *patrón*. In contrast, *Cimarrones* with its Afro-Peruvian narrative, does not rotate around the acquisition of land, but around breaking the chains of slavery. At a key point in the film, the character José Macau Jesús Laboco faces the camera to pull apart Jacinto's shackles (who the camera frames as the audience's perspective). The film, then, demonstrates how freedom is about ridding ourselves and our companions of the physical bonds of slavery. Furthermore, liberation is psychological, as once freed the elderly Simón Manuto seeks out a *curandero* or healer in the *palenque* to clear his mind of the horrible memories of slavery. Recalling Ferrand's artistic critique of both the left and the right, *Cimarrones* suggests that revolution does not only require change in material circumstances, but a mental, spiritual, and emotional adjustment.

Cimarrones's revision of revolution's idealized outcome requires including Africans and their descendants into the Peruvian narrative of liberation. Similar to other Peruvian and Andean films made of the same period, there remains an aspect of punishment, revenge, and reparations. In *Cimarrones*, once the group

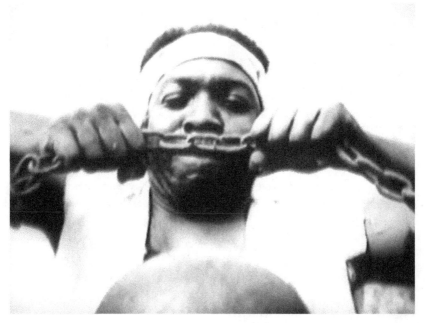

JOSÉ MACAU JESÚS LABOCO BREAKING JACINTO'S CHAINS.

has captured the convoy, the fugitives take the goods from the Spanish soldiers and the foreman. Indeed, taking back what was stolen is also a theme in García's *Kuntur Wachana* when peasants organize because the patron has appropriated their cattle and cut off their water. Andean laborers and farmers are vindicated when they invade and transform the *hacienda* into a cooperative. The justice meted out in *Cimarrones*, however, is more poetic than literal. Ferrand depicts how Hortensio Banto and the elderly fugitive Simon Manuto wish to kill the captured foreman, who has been so abusive. The others stop the men, and instead abandon the foreman in the desert, half-naked and without food so that he may "understand what it means to be a slave." The revolution of the fugitives includes a reclaiming of their freedom, but also a need to teach the value of liberty.

Similar to other Peruvian revolutionary films of the time, *Cimarrones* excludes Spaniards and their descendants from the utopian future. Andeans, however, remain part of the collective. Huaman Huacha Sasapay, who the narrator explains is a direct descendant of the Inca Tupac Yupanqui, is a member of the fugitive community and rides with the group to take back the stolen members from the

convoy. Speaking in Quechua, Huaman Huacha Sasapay translates for Manuel Bravo el Luco, who approaches the apprehensive Andean servants of the Spanish after the fugitive companions have been freed. Indicating a revolutionary vision, the fugitive leader offers gifts of gold and a goat from the raid, and a promise of, "Dear people from here, you will live in freedom." Unlike the Peruvian revolutionary politic in which Andeans organized to obtain land and gain autonomy, in *Cimarrones*, African and African-descent fugitives liberate Andeans from their onerous service to Spaniards. In Ferrand's transnational vision of radical change, the film elevates men and women of the African Diaspora into the symbolic roles usually played by Andeans.

Freedom's politic is further developed in the last scene of *Cimarrones* as the fugitives return to the *palenque*. The narrator explains that the encampment resembles a small African village, with a clear gender division of labor as women harvest and men plant. Ferrand's camera moves over men and women sharing or exchanging food, drink, and other goods, to rest on an older woman sitting in a raised platform, the queen of the *palenque*. Freedom, therefore, is both a state of breaking the chains of bondage, but also a coherent community ethic quite similar to that shown in *Kuntur Wachana*. At the same time, the short film offers a more expansive vision than a reclaiming of land and return to tradition. By demonstrating how men and women freed themselves from slavery, *Cimarrones* offers an alternative politic that included cooperation with Andeans, living communally, and shared gendered leadership. Firmly located within a tradition of New Latin American Cinema and Third Cinema, *Cimarrones* thus requires a reading within Peruvian historical narratives of inequality, such as the Velasco politic of agrarian reform. At the same time, *Cimarrones* resurrects a forgotten history of Peru—that of Africans and their descendants—and engages in a narrative of racial justice for an African Diaspora. In addition, during the 1980s, the film suffered from difficulties in distribution, was not screened in Peru, and was shown rarely in North American and European film festivals. Thus, it is a film that has been forgotten, or better stated, misplaced, a film that has yet to locate its audience.

ARTICULATING RACE

The cinematic choices expressed in *Cimarrones* also reveal Carlos Ferrand's dedication to producing anti-racist media, but also the resulting problematic of representing Africans and their descendants in the past. To generate his neo-Marxist, anti-racist revolutionary vision, Carlos Ferrand brought his own

immigrant experience to *Cimarrones*. The Peruvian filmmaker had been living outside of his native country for years, first in the United States, then in Europe, and finally in Canada. He arrived in Montréal in 1977 (Laurendeau 16), but continued to return to Peru, and maintains his family connections to the present day. Ferrand, though, is neither solely a Peruvian filmmaker, nor an outsider to the Andes. Instead, he identifies as a person who is "naturally placed north and south" (Laurendeau 17), between what he names as the clean and orderly "First World" and the place of his dreams, or a Latin America of striking poverty, as he explains in his autobiographical memoir film *Americano* (2008). Ferrand experiences his internationalist location as generative but also with pangs of guilt, as he confesses to enjoying living in a rich society, knowing that returning to the place of his birth, Lima, would mean confronting poverty, infrastructural deficiencies, and political instabilities. *Cimarrones*, thus, articulates Ferrand's understanding of whiteness and blackness in Peru, and when read within his other work, is itself a text of racial politics.

Cimarrones also reflects Carlos Ferrand's own life experiences. Ferrand immigrated to Canada with *Cimarrones* half completed, thus he finished one of his first films as South Asians as well as Caribbean people were increasingly calling Québec their home. Ferrand joined the immigrant populations with a sharp consciousness, having just spent a year as an undocumented worker in Amsterdam while waiting for his visa (Laurendeau 16). Montréal was a compelling place to land, as immigrants were not antithetical to Québécois identity, since claiming to be a local meant rejecting the idea of a singular national identity. French-speaking Québec had developed an ambivalent relationship with the rest of Anglophone Canada while simultaneously expressing anticolonial sentiments towards France (Pike 4). Speaking French from his student days in Belgium, Ferrand joined a vibrant nationalist and anti-nationalist conversation as artists and activists called attention to what could be defined as an original hybrid Québécois identity created from First Nation peoples, French Canadians, Anglo-Canadians, and Jewish communities. In this milieu, Ferrand further absorbed an internationalist perspective to counter the nationalism of the Peruvian revolutionary ideologies of the 1960s and 1970s. As one of the participants in Ferrand's documentary, *Scattering of Seeds* (1998), asks, "What is a Québécois? Some speak French, some English, some are born here, others born elsewhere, and all make a new Québec." These anti-nationalist immigrant communities, then, participated in filmmaking that included a politic about the process as well as the product. Working with and under the sponsorship of Québec's Société Nouvelle, filmmakers strived to bring the means of production into the hands of the people and to "to make films

with rather than *about*" marginalized communities (Honarpisheh 81; MacKenzie 148). Given Ferrand's sensibilities of working with the communities he filmed and photographed, *Cimarrones* would have been a welcomed project.

The border-crossing that is so evident in Québec infused *Cimarrones*. For Ferrand, Montréal, while still harboring xenophobia, has become a place that feels like Latin America, but is less stratified (Laurendeau 16–17). In interviews, Ferrand has explained that he seeks a place of malleability where the search for identity is permanent (Ferrand 2015), working to feature in his work the lives of those who blur these boundaries as well as the locations that do not follow the imagined political geography. Ferrand, then, brought a border-crossing aesthetic into *Cimarrones*, especially by working with the musician and composer, Carlos Hayre. A celebrated musicologist, Hayre trained with the renowned Afro-Peruvian scholar and poet, Nicomedes Santa Cruz in the 1960s (Amigo xiv, 286). Hayre's music for *Cimarrones* combined Andean zampoñas, strings, drums, and a marimba in a minimalist and punctuating score but did not re-create the canon of 1970s and 1980s "Black" Peruvian music.[3] Instead, Hayre was already deeply invested in working between tradition and experimentation, and intent on producing an artistic variance built into the repetition (Amigo 294, 301–02; Pajares Cruzado 57). In its creative mixing of genres, Hayre's music in *Cimarrones* illuminates a restless search for identity, and a questioning of strict North-South divides.

First Nations or indigenous communities have remained central to Ferrand's work. In his 2003 documentary, *People of the Ice*, the narrator explains how Mica Mike, a young Inuit woman, had traveled extensively and enjoyed an autonomous life, but now has returned to her community with deep ties to local elders. Ferrand's narrative suggests that "Indians" therefore are not isolated from the global world. With a non-native audience in mind, Ferrand films Mica's father making a pair of traditional Inuit sunglasses, thus passing on the tradition to his daughter and other family members. The scene continues as Mica's father delights in his new electric can opener and makes a telephone call with Ferrand filming, deliberately underlining Inuit advanced technological knowledge, and humorously making fun of viewers who would think otherwise. In his 2008 memoir film *Americano*, Ferrand expands his cinematic argument to include past and ongoing genocides (Bouchard 254) such as that against the Selk'ham of Tierra del Fuego, who have radically declined in numbers since the early twentieth century. He then celebrates the Hoopa in northern California, who continue to defend their sovereignty. Turning the gaze towards a more intimate example, Ferrand emphasizes how Andean peoples have struggled against labor

exploitation as well as for their right to land, recalling his own activism in Peru's Agrarian Reform. Repeatedly, Ferrand expresses his solidarity as a white person with indigenous people. By living, working, and creating family with indigenous Andeans, Ferrand actively counters a Peruvian racial discourse that constructed Indians as occupying distinct social locations from whites (and *mestizos* or blacks) due to their supposedly immutable cultural abilities. These racial characteristics, expressed culturally, have shaped the nation (De la Cadena 26, 141). For example, through this cultural logic, regional and *limeño* elites blamed indigenous people, Peru's majority, for holding back the development of the nation due to poverty and a lack of education (Drinot 13, 15). As a result, part of Ferrand's story as an *Americano*, his need to find his "familia americana," is an accounting for historical injustices against First Nations people.

Repeatedly, Ferrand's cinematic and artistic objective has been to produce a dignified portrait of subaltern peoples. As the cinematographer in *Le Système D*, a 1989 documentary exploring how microenterprises thrive in contrast to tax-paying businesses in Dakar, Lima, and Kathmandu, Ferrand both underlines and counters the film's emphasis on economic structures. Against the narration of why a Lima fiberglass manufacturer chose not to legalize his business, Ferrand pans over the faces of the men working without masks and gloves against the sheer white of the panel under production. The narrator explains that such workshops function with unsafe electrical equipment, unsanitary water supply, and have been known to cause the death of entire families who live where they work. Ferrand, however, is attentive to the lived experiences of people in their workplace. Just as he emphasized individuals in *Cimarrones*, as a filmmaker of Velasco's agrarian reform, Ferrand documented people, taking photographs of hacienda workers and their families, and then mounting an exhibit of the images in their community. To people who had never or rarely seen images of themselves, Ferrand recounts that respectful portraits were remarkable.

Ferrand, therefore, rarely reproduces the structural causes of poverty or racism in his work. In the 1998 documentary entitled *Scattering of Seeds*, that Ferrand directed about Karl Lévêque, a Jesuit leader of Quebec's Haitian community, the narrator provides details, in this case regarding the Haitian exodus from the Duvalier dictatorship and the ongoing racial discrimination in Montréal. The film, however, is an exceptionally joyful portrayal of Lévêque, a motorcycle-riding priest who taught karate, hosted a popular radio show, and was known to be the first to dance at a party. Infused with an account of a community's mourning for Lévêque's early and sudden death, the film celebrates a spiritual leader who taught that militancy was not martyrdom, and activism included good parties.

Ferrand would rather highlight how people win, describing *Cimarrones* as "a victory film" (Ferrand 2016). Likewise, in his short film entitled *Voodoo Taxi* (1991), two Haitian taxi drivers, José and Baptiste, plot against their racist white boss who refuses to promote José and leers at Haitian women. In response, José and Baptiste engage in voodoo but only succeed in ending their boss's backache and helping him win the lottery. Finally, to frighten the boss into a confession that he is taking money from the taxi business, Baptiste's girlfriend dresses up as a "goddess of fire and water." Clearly, the film points a finger at the racist attitudes and actions of some white Québécois. Nonetheless, Ferrand directs a quirky and funny film where, in the end, all are happy, with José hired as the accountant and the boss's artistic girlfriend re-painting the taxi as a colorful *Voodoo Taxi*. As in *Cimarrones*, Ferrand refuses to engage in what he calls "a pornography of violence" (Ferrand 2016), that would include representations of slave gang coffles or raids of immigration officials. The message is that racism and xenophobia are enacted as daily and significant events, but also ones that can be resolved among individuals

As a result, individual accountability and self-identity figure prominently in Ferrand's racial politic. Ferrand repeatedly explains that he was "born white in an Indian country" (Ferrand 2015) to disrupt a silence around whiteness that pervades the modern Andes (Weismantel xxix–xxx). In his film *Americano*, Ferrand presents a recording of a television broadcast in Santa Cruz, Bolivia while he narrates how all the faces are white in the commercials and in the news. He explains that in the morning he emerges into an Indian world. Again, Ferrand removes the structural racism to narration, but this time reflects on his own positionality. Indeed, in Ferrand's native Peru, media has reflected the racial structure of an Andean world where the term *indio* (Indian) has been a common insult (Weismantel xxxv; Manrique 27) while a white is perceived as a happy, prosperous professional (Portocarrero 193). Ferrand is poetic, but direct. One segment of *Americano* includes black and white footage of Andean men carrying immense, impossible loads (from his silent documentary filmed in Cuzco, *Cargadores*). Again as the narrator, Ferrand provides a voiceover, explaining that as a Peruvian, how sad it is "to be born in a country that is ashamed of its founding population. It's like being in a family ashamed of its own mother." Moving from his own experience, Ferrand speaks against, but also within, blatant images of exploitation, to actuate whiteness, a status made powerful because those who hold it take it for granted (Weismantel 214). In one sense, Ferrand provides a history lesson in *Americano*, reviewing how the colonial legacies of Catholic conversion (Silverblatt 184) meant that today's devil in the Andes has

blue eyes. In his characteristic defense of indigenous logics, Ferrand recognizes the superior capacity of Andean people to interpret global structures of power.[4] Ferrand's anti-racism takes the form of articulating white positionality in Latin America, overruling the silencing of racial privilege through his own experiences.

To articulate his racial position, Ferrand also names a problematic debt. In *Americano*, Ferrand narrates over clips from *Cimarrones* to explain his personal connection to the short film. He describes how he had dedicated *Cimarrones* to Miguel, the son of "Mamacha," his nanny and "second mother." In our 2016 interview, Ferrand was more direct. When I asked why he made *Cimarrones*, he responded: "I had two mothers: My biological mother that [sic] I loved very much. And then the woman that [sic] held me in her arms and nursed me who was black" (Ferrand 2016).

Cimarrones, according to Ferrand, was a demonstration of respect for people who were worked as domestics in his family's household. Yet, Ferrand's narrative of the reason why he made *Cimarrones*, a film about fugitive slaves in the early nineteenth century, reinforces a common Peruvian mythology of the affection lavished by a black domestic caretaker woman on a white family. As Ferrand continued to explain,

> And in growing up, it was basically quite a big shock to find out that my parents that [*sic*] I love and my whole family were racist. And it is a shame that I, basically, have never been able to recover from completely. (Ferrand 2016)

In this light, *Cimarrones* is an act of white guilt, and a recognition of a historic and domestic debt owed by white people to Afro-Peruvian (and indigenous Andean) women and men. Ferrand, while testifying to his own experience of affection, is also engaging a narrative performance that does not recognize a need for reciprocity to create emotion. What would be a counter-narrative of Afro-Peruvians such as the woman who worked as his nanny?

Americano is Ferrand's testimony where Afro-Peruvians are spoken for and about, but do not offer their own experiences. Ferrand interviews Fortunata Gomez (a woman from the Andean highlands), who worked as his family's cook, in her home. Into the domestic scenes in a Lima *pueblo joven*, or informal neighborhood, Ferrand inserts images of Afro-Peruvians singing the classic *boleros*, "Hola Soledad" ("Hello, Loneliness"), and "Ahora Seremos Felices" ("Now We Are Happy"). The lyrics complement the filmed exchanges between Gomez and Ferrand. The first song describes greeting loneliness, an old friend, before

Ferrand greets Fortunata while the second song declares, happily, that a promised house is ready, in celebration of Fortunata's household. However, in contrast to the dignified, joyous, and triumphal representation of Afro-Peruvian resistance in the past as depicted in *Cimarrones*, the black men who sing the nostalgic songs of Lima's past appear in *Americano* as folkloric decoration in the film. Their placement recalls Afro-Peruvian music as tourist entertainment in the 1980s (Feldman 5). In other words, in *Americano* Afro-Peruvians represent the cultural coastal culture of *criollismo* (Feldman 18) but do not articulate themselves or their experiences as *criollo*. Instead, later in the film, Afro-Peruvians appear in clips from Ferrand's film, *Cimarrones*, or as figures from the past (Pagán-Teitelbaum 74), but not necessarily as citizens of today's Peru. In this way, Ferrand participates in an ongoing Peruvian media discourse that includes Afro-Peruvians as an "ingredient" of a national culture (like dance or food), especially the coastal *criollo*, but not necessarily a subject of the past or present.

Ferrand, though, gracefully examines himself and his position in *Americano*, suggesting an additional reading of *Cimarrones*. The contrast between the two films suggests how presenting an Afro-Peruvian past can speak to, but does not need to directly address, the dynamics of contemporary racism. In *Cimarrones*, Ferrand artfully and thoughtfully depicts complicated Afro-Peruvian characters who achieved freedom from slavery (if only temporarily). His film indisputably confronts a national and transnational erasure of Afro-Peruvians as he boldly reflects that the impetus for its making was a political recognition of his own racism and racial privilege. Ferrand's representations of Afro-Peruvians in *Americano* include a recollection of his black nanny while *Cimarrones* depicts a defiant collective of fugitive slaves. Both, however, are part of a white racial imaginary, or construction, both international and national, of blackness.

CONCLUSIONS

As a factual and fictional film, *Cimarrones* teaches a historical lesson. Enslaved men and women in colonial Peru understood the value and the meaning of freedom. Together, they organized to free themselves and each other, bonding together as "fugitives" to build *palenque* settlements that sustained themselves from goods taken in raids as well as those grown in their own fields. Slaveholders and those who benefited from slavery could inflict physical, emotional, and mental injuries that could afflict generations. But, remembering and enacting the past, for Afro-Peruvians, was and remains a clear method to addressing what Carlos Ferrand has come to identify as national wounds as well as international injustices.

As Ferrand moves from the geographic and social North to South, and back again, he deftly communicates visions of exiles and immigrants as well as how racial hierarchies shaped the Americas. As revealed in *Americano* and suggested in *Cimarrones*, Ferrand has networks within indigenous communities that allow him to illuminate structural inequalities. *Americano*'s personal approach, though, reveals weaknesses in a project rooted in the search for identity. Ferrand's examination of his own identity and whiteness is central, and exacting. But, in the process, he puts on display a national racism against Afro-Peruvians who appear as folkloric and historical images, but not full participants. Reading *Cimarrones* within Ferrand's larger work reveals a construction of whiteness as well as blackness in the present and in the past.

Simultaneously, *Cimarrones* disrupts the archive by bringing Afro-Peruvian history to an international audience—in spite of its limited, almost nonexistent release, in Peru. By telling a story of how fugitives defeated their enslavers and created a lasting community, Ferrand and his colleagues put Africans and their descendants back into the narrative of a Peruvian nation, not yet sufficiently addressed by historians, in spite of our repeated efforts (Aguirre 2005; Arrelucea Barrantes and Cosamalón). More critically, Ferrand's short film demonstrates the limitations of historical interpretation. Drawing from a compilation of historical cases as well as historians' work to develop a dramatic narrative with compelling characters, *Cimarrones* communicates facts, but also a sensation of slavery's past as well as the spirit of today's Afro-Peruvian history.

To order the film (in its English or French versions), contact the filmmaker:

CARLOS FERRAND
3642 Clark
Montreal H2X-2S2
Quebec. Canada.
Email: film@carlosferrand.ca
Tel: 514-915-3730

Notes

The University of California, Irvine Humanities Collective (2014–15) provided research funding for this article. I thank Rudyard Alcocer, Kristen Block, Paulo Drinot, Kristen Hatch, Ann Kakaliouras, and Tamara Walker for their comments and suggestions as well as Surekha Davies and Sarah Farmer for their translation assistance. I thank Carlos Ferrand sharing his films and his warm interest in discussing his work.

1. In *El caso Huayanay* (1981), Federico García filmed in the actual location, using the survivors of the event, to tell the real story of Matías Escobar, a functionary who was murdered by the community he abused (Middents 35). Likewise, in his film *Kuntur Wachana* (1977), García called on the assistance of the *hacienda* community to write the script and to act in the scenes (Middents 154).
2. The slave trade that could take as long as two years across the Atlantic and the Pacific and there were high mortality rates on the coastal sugar estates (O'Toole 2012, 38; Bowser 95).
3. During and after the Velasco regime, Afro-Peruvian music had developed a sound of rhythmic drums and a dense soundscape (Feldman 148).
4. As Michael Taussig recognizes, workers in twentieth-century Andean mines and coastal plantations understood that the devil represented alienation in commodity production (Taussig 17).

Works Cited

Aguirre, Carlos. *Agentes de su propia libertad. Los esclavos de Lima y la desintegración de la esclavitud 1821–1854.* Lima: Pontificia Universidad Católica del Perú Fondo Editorial, 1995. Print.

———. *Breve historia de la esclavitud en el Perú: Una herida que no deja de sangrar.* Lima: Fondo Editorial del Congreso del Perú, 2005. Print.

Alexander, Buzz. "Interview with Pancho Adrienzén: Radical film in Peru today." *Jump Cut*, vol. 28, 1983, pp. 27–30. Online.

Americano. Dir. Carlos Ferrand. Third World Newsreel, 2008. CD.

Amigo, Cristian. *Latino Music, Identity, and Ethnicity: Two Case Studies.* Dissertation, University of California, Los Angeles. Ann Arbor: ProQuest, 2003.

Archivo General de la Nación (Peru). Real Audiencia. Causas Criminales. Legajo 114. Expediente 1378 "Autos criminales seguidos de oficio contra Manuel Bravo y otros reos, también ladrones y asaltadores en los caminos de Chincha, Cañete, Chilca, en agravio de José Patricio Cevallos, hecho por ocurrió en el mes de Junio de 1808, a horas cuatro de la madrugada, fue en que lo asaltaron a la altura de Lurin" (1808). 211 fs. Manuscript.

Archivo General de la Nación (Peru). Real Audiencia. Causas Criminales. Legajo 114. Expediente 1382 "Causas seguidas contra José Espinoza y otros por salteadores de camino" (1808). 41 fs. Manuscript.

Arrelucea Barrantes, Maribel, and Jesús Cosamalón Aguilar. *La Presencia afrodescendiente en el Perú.* Lima: Ministerio de Cultura, 2015. Print.

Bay, Edna. "Protection, Political Exile, and the Atlantic Slave-Trade: History and Collective Memory in Dahomey." *Rethinking the African Diaspora: The Making of a Black Atlantic World in the Bight of Benin and Brazil*, edited by Kristin Mann and Edna Bay. London: Fran Cass, 2001, pp. 42–60. Print.

Bedoya, Ricardo. *100 años de cine en el Peru: Una historia crítica*. Lima: Universidad de Lima. Fondo de Desarollo Editorial, [1992] 1995. Print.

———. *El cine sonoro en el Perú*. Lima: Universidad de Lima Fondo Editorial, 2009. Print.

Beller, Jonathan. "Third Cinema." *New Dictionary of the History of Ideas*, edited by Maryanne Cline Horowitz. New York: Charles Scribner's Sons, 2005. Electronic.

Bouchard. Dominic. "Americano: Voyage au pays de l'autre." *Séquences: la revue de cinema*, vol. 254, 2008, p. 254. Print.

Bowser, Frederick. *The African Slave in Colonial Peru 1524–1650*. Stanford: Stanford University Press, 1974. Print.

Bryant, Sherwin K. "Enslaved Rebels, Fugitives, and Litigants: The Resistance Continuum in Colonial Quito." *Colonial Latin American Review*, vol. 13, no.1, 2004, pp. 7–46. Print.

Cant, Anna. "'Land for Those Who Work It': A Visual Analysis of *Agrarian* Reform Posters in Velasco's Peru." *Journal of Latin American Studies*, vol. 44, no.1, 2012, pp. 1–37. Print.

El caso Huayanay. Dir. Federico García Hurtado. 1981.DVD.

Cimarrones. Dir. Carlos Ferrand. 1982. DVD.

Clifford, Michael. *Political Genealogy After Foucault: Savage Identities*. New York: Routledge, 2001. Print.

de la Cadena, Marisol. *Indigenous Mestizos: The Politics of Race and Culture in Cuzco, Peru, 1919–1991*. Durham: Duke University Press, 2000. Print.

Diez Hurtado, Alejandro. *Fiestas y cofradías: Asociaciones religiosas e integración en la historia de la comunidad de Sechura siglos XVII al XX*. Piura: CIPCA, 1994. Print.

Drinot, Paulo. "Nation-building, Racism and Inequality: Institutional Development in Peru in Historical Perspective." *Making Institutions Work in Peru: Democracy, Development and Inequality since 1980*, edited by John Crabtree. London: Institute for the Study of the Americas, University of London, 2006, pp. 5–23. Print.

Espinoza, Victoria. "Cimarronaje y palenques en la costa central del Perú. 1700–1815." *Primer seminario sobre poblaciones inmigrantes. Actas. Lima, 9 y 10 de mayo de 1986.* Tomo II. Lima: Consejo Nacional de Ciencia y Tecnología, 1988, pp. 29–42. Print.

Feldman, Heidi. *Black Rhythms of Peru: Reviving African Musical Heritage in the Black Pacific*. Middleton: Wesleyan University Press, 2006. Print.

Ferrand, Carlos. Interview. La Fabrique culturelle.tv, Web de Télé-Québec, 27 Feb 2015. Internet.

———. Personal communication. July 27, 2016.

Flores Galindo, Alberto. *Aristocracia y plebe: Lima, 1760–1830 (Estructura de clases y sociedad colonial)*. Lima: Mosca Azul Editores, 1984. Print.

Fuente, Alejandro de la. "Slaves and the Creation of Legal Rights in Cuba: *Coartación* and *Papel*." *Hispanic American Historical Review*, vol. 87, no. 4, 2007, pp. 659–92. Print.

Honarpisheh, Farbod. "You Are on Indian Land by Mike Mitchell, Mort Ransen, 1969." *The Cinema of Canada*, edited by Jerry White. London: Wallflower Press, 2006, pp. 81–90. Print.

Kapsoli, Wilfredo E. *Sublevaciones de Esclavos en el Perú. XVIII.* Lima: Universidad Ricardo Palma. Dirección Universitaria de Investigación, 1975. Print.

Karasch, Mary C. *Slave Life in Rio de Janeiro 1808–1850.* Princeton: Princeton University Press, 1987. Print.

Kuntur Wachona (Donde Nacen los Cóndores). Dir. Federico García. 1977. Youtube.

Laurendeau, Francine. "Carlos Ferrand." *Séquences: la revue de cinéma,* vol. 146, 1990, pp. 15–19. Print.

Lazo García, Carlos, and Javier Tord Nicolini. "Cimarrones, palenques y bandoleros (Lima, siglo XVIII)." *Obras escogidas de Carlos Lazo García.* Tomo II. Historia *de la economía colonial: Hacienda, comerico, fiscalidad y luchas sociales (Perú colonial).* Lima: Fondo Editorial del Pedagógico San Marcos, 2006–2008, pp. 419–65. Print.

MacKenzie, Scott. *Screening Québec: Québécois Moving Images, National Identity, and the Public Sphere.* Manchester: Manchester University Press, 2004. Print.

Manrique, Nelson. *La Piel y la pluma: Escritos sobre literatura, etnicidad y racismo.* Lima: SUR Casa de Estudios del Socialismo, 1999. Print.

Mayer, Enrique. *Ugly Stories of the Peruvian Agrarian Reform.* Durham: Duke University Press, 2009. Print.

McKinley, Michelle A. "Fractional Freedom: Slavery, Legal Activism, and Ecclesiastical Courts in Colonial Lima, 1593–1689." *Law and History Review,* vol. 28, no. 3, (2010), pp. 749–90. Print.

Middents, Jeffrey. *Writing National Cinema: Film Journals and Film Culture in Peru.* Hanover: Dartmouth College Press, 2009. Online.

Muerte al amanecer. Dir. Francisco J. Lombardi. 1977. DVD.

O'Toole, Rachel Sarah. *Bound Lives: Africans, Indians, and the Making of Race in Colonial Peru.* Pittsburgh: University of Pittsburgh Press, 2012. Print.

———. "'In a War against the Spanish': Andean Protection & African Resistance on the Northern Peruvian Coast." *The Americas,* vol. 63, no. 1, 2006, pp. 19–52. Print.

Pagán-Teitelbaum, Iliana. "Glamour in the Andes: Indigenous Women in Peruvian Cinema." *Latin American and Caribbean Ethnic Studies,* vol. 7, no. 1, 2012, pp. 71–93. Print.

Pajares Cruzado, Gonzalo. "Carlos Hayre: Entre La Tradición y la experimentación." *Libros & Artes: Revista de cultura de la Biblioteca Nacional del Perú,* vol. 56–57, 2012, pp. 7–8. Print.

People of the Ice. Dir. Carlos Ferrand. 2003. Madacy Home Video, 2005. DVD video.

Los Perros Hambrientos. Dir. Luis Figueroa. 1976. Youtube.

Pike, David. *Canadian Cinema Since the 1980s: At the Heart of the World.* Toronto: University of Toronto Press, 2013. Print.

Portocarrero, Gonzalo. *Racismo y mestizaje.* Lima: Sur Casa de Estudios del Socialismo, 1993. Print.

Ramírez, Susan. *The World Turned Upside Down: Cross-Cultural Contact and Conflict in Sixteenth-Century Peru.* Stanford: Stanford University Press, 1996. Print.

Salomon, Frank. "Introductory Essay: The Huarochirí Manuscript." *The Huarochirí Manuscript: A Testament of Ancient and Colonial Andean Religion,* edited by Frank Salomon and Jorge Urioste. Austin: University of Texas Press, 1991, pp. 1–40. Print.

Scattering of Seeds. Series "Karl Lévêque's Montreal." Dir. Carlos Ferrand. White Pine Pictures, 1998. Videocassette.

Schuler, Monica. *"Alas, alas, Kongo": A Social History of Indentured African Immigration into Jamaica, 1841–1865.* Baltimore: Johns Hopkins University Press, 1980. Print.

Seligmann, Linda. *Between Reform & Revolution: Political Struggles in the Peruvian Andes, 1969–1991.* Stanford: Stanford University Press, 1995. Print.

Silverblatt, Irene. "Political Memories and Colonizing Symbols: Santiago and the Peruvian Mountain Gods of Colonial Peru." *Rethinking History and Myth: Indigenous South American Perspectives on the Past,* edited by Jonathan Hill. Urbana: University of Illinois Press, 1988, pp. 174–94. Print.

Smallwood, Stephanie. *Saltwater Slavery: A Middle Passage from Africa to the American Diaspora.* Cambridge: Harvard University Press, 2008. Print.

Le Système D. Dir. German Gutierrez. 1989. Cinema Guild, 2005. DVD.

Taussig, Michael. *The Devil and Commodity Fetishism in South America.* Chapel Hill: University of North Carolina Press, 2010. Digital.

Trouillot, Michel-Rolph. *Silencing the Past: Power and the Production of History.* Boston: Beacon Press, 1995. Print.

VanValkenburgh, Parker. "Building Subjects: Landscapes of Forced Resettlements in the Zaña and Chamán Valleys, Peru, 16th and 17th Centuries, C.E." Ph.D. Dissertation. Harvard University, 2012. Print.

Vivanco Lara, Carmen. "Bandolerismo Colonial Peruano: 1760–1810. Caracterización de una respuesta popular y causas económicas." *Bandoleros, Abigeos y Montoneros: Criminalidad y violencia en el Perú, siglos XVIII–XX,* edited by Carlos Aguirre and Charles Walker. Lima: Instituto de Apoyo Agrario, 1990, pp. 25–56. Print.

Voodoo Taxi. Dir. Carlos Ferrand. Beacon Films, 1991. Videocassette.

Weismantel, Mary. *Cholas and Pishtacos: Stories of Race and Sex in the Andes.* Chicago: University of Chicago Press, 2001. Print.

Exoticization, *Mestiçagem*, and Brazilian National Consciousness in Carlos Diegues's *Quilombo*

Ignacio López-Calvo

A graça (nos dois sentidos) do cinema, ou pelo menos do melhor cinema que se conhece, foi sempre saber chegar a essa exceção repartida, saber identificar o que é de todos, sendo expresso por um só.

—"O POVO NAS TELAS E NAS SALAS,"
CARLOS DIEGUES 2001[1]

Is it a coincidence that in the early 1980s two Brazilian historical films, Tizuka Yamasaki's *Gaijin* (1983) and Carlos Diegues's *Quilombo* (1984), examined African and Afro-Brazilian resistance to slavery and Japanese indentured servitude, respectively? We may be able to find an answer in Frantz Fanon's critique of Eurocentrism, colonialism, and the racialization of thought in the chapter "On National Culture" of his *The Wretched of the Earth* (1961):

> It is in fact a commonplace to state that for several decades large numbers of research workers have, in the main, rehabilitated the African, Mexican, and Peruvian civilizations. The passion with which native intellectuals defend the existence of their national culture may be a source of amazement; but those who condemn this exaggerated passion

are strangely apt to forget that their own psyche and their own selves
are conveniently sheltered behind a French or German culture which
has given full proof of its existence and which is uncontested. (209)

Even though Fanon was referring to a different context in which "native intel-
lectuals" begin to appraise their own autochthonous culture vis-à-vis the imposi-
tion of European cultures, which are assumed to be "universal," in the Brazilian
scenario we have a case of "internal colonialism," rather than a classic example
of European colonialism overseas. These two directors were attempting to res-
cue the history of African and Afro-Brazilian runaway slaves, as well as that of
Japanese indentured workers. The latter had to escape the plantations at night
once they realized that they had been swindled by their own government, the
emigration companies, and the Brazilian plantation owners. The exploitation of
labor, blended with xenophobia and racism, is brought to the fore in these two
films. And even though they involve both historical facts and fiction, they try to
deliver an ultimate truth through that very fiction. After all, as Natalie Zemon
Davis has argued, "As long as we bear in mind the differences between film and
professional prose, we can take film seriously as a source of valuable and even
innovative historical vision. We can then ask questions of historical films that
are parallel to those we ask of historical books. Rather than being poachers on
the historian's preserve, filmmakers can be artists for whom history matters" (15).

Indeed, Fanon's advice on fighting colonialism and its long-lasting remnants,
which decolonial thinker Aníbal Quijano called "coloniality," may be behind this
1980s Brazilian effort to rediscover the emancipating efforts of others of non-
European descent. These two films, therefore, can be interpreted as a collective
effort to create a different type of Brazilian national consciousness and a more
inclusive national culture. From this perspective, I now center my analysis on
the film *Quilombo*, which deals with black African and Afro-Brazilian slavery as
well as "marronage" in seventeenth-century northeastern Brazil. In carrying out
this analysis, I will also study the role of film in social memory and the struggle
against epistemicide and racialization, in this particular case via the exoticization
of an ethnic community. This way, I hope to explain why *Quilombo* fails as a film
about slavery, despite the laudable inclusiveness of its nation-building objective.

While the Brazilian filmmaker Carlos Diegues (better known as Cacá
Diegues, 1940–) is of European descent, he is keenly interested in the African
roots of Brazilian national culture and attempts to celebrate relevant popular
cultural practices and to rescue the silenced history of African and Afro-Brazilian
slaves and maroons during the colonial times.[2] Influenced by the contemporary
interest in Afro-Brazilian political consciousness, he contributes to the incorpo-

ration of Brazilians of African descent to the national project and to Brazilian national consciousness. This is particularly important if we take into account first that Brazil has the largest community of people of African descent outside Africa and, secondly, that Afro-Brazilians continue to be marginalized and racialized despite the national pride in the myth of "racial democracy." While with other cultural production, Afro-Brazilians may have to see themselves through the eyes of white Brazilians (i.e., the descendants of the imperial Other), thanks to films such as *Quilombo*, they are given the opportunity to revisit an alternative history that celebrates their achievements and their national belonging, even if the director is not of African descent. Afro-descendants who view *Quilombo* would not experience the double consciousness process conceptualized by W. E. B. Du Bois since there are no scenes where blacks are portrayed as inferior either ontologically or in any other way. While Diegues may not be Afro-Brazilian, the film clearly prioritizes Afro-Brazilian characters, perspectives, and concerns. In fact, several critics have pointed out that *Quilombo*, like Diegues's previous film *Ganga Zumba* (1963), "memorialize the seventeenth-century fugitive slave republic Palmares, seen as the very prototype of a utopian democracy in the Americas" (Shohat and Stam 79). This approach is commendable, particularly if we take into account that it was released during the military dictatorship and at a time when Eurocentrism in official history of Brazil was still rampant. Yet, in my view, with *Quilombo* these same viewers are faced with a celebratory tone that often exoticizes and romanticizes their ethnic group.

AN AFRO-BRAZILIAN EPIC OF THE BIRTH OF A MESTIZO NATION

Brazil was the last nation in the Americas to abolish slavery; it finally happened in 1888, sixty-six years after becoming an independent nation. This tardy emancipation has undoubtedly left an indelible mark in its national culture, which *Quilombo* tries to echo. As is well known, there are numerous historical examples of attempts to escape from bondage, one of which—a successful one—is reenacted in *Quilombo*. And it is important to keep in mind the strong symbolism of the *quilombo* in Afro-Brazilian culture, which is apparent in Abdias Do Nascimento's proposal to the Second Congress of Black Culture in the Americas, which took place in Panama, in March 1980:

> *I propose*
> That this Congress recommend to the African descendants of the
> New World the formation of sociopolitical movements and/or

organizations, and corresponding theoretical/ideological systems, inspired by the examples of the *cimarrones, palenques, cumbes,* maroon societies, quilombos, and all African free and militant social entities, as an alternative form of political action in their respective countries. (175)

Indeed, following the advice of the Brazilian filmmaker Glauber Pedro de Andrade Rocha, Diegues decided to direct this semi-fictional film, one of the four (the others are *Ganga Zumba* [1964], *Xica da Silva* [1976], and *Orfeu* [1999]) in which he has dealt with black slavery in colonial Brazil and the Afro-Brazilian community. And he was not the only Brazilian director who began to pay attention to the Afro-Brazilian cultural heritage in Brazil. As Zuzana M. Pick points out,

> From the mid-1970s on, filmmakers such as Nelson Pereira dos Santos (*Ogum's Amulet*, 1975; *Tent of Miracles*, 1976), Walter Lima, Jr. (*The Lyre of Delight*, 1978; *Chico Rei*, 1982) and Carlos Diegues showed an increased engagement in Afro-Brazilian culture. They acknowledged historical forms of racial exclusion often overlooked during the *cinema nôvo* period. In this way, Brazilian cinema began to align itself with the resurgent consciousness of and commitment to black historical experience as exemplified by a variety of artistic practices. (144)

When asked in an interview with *Revista de Cinema* in 2000 if the fact that his father was an anthropologist had influenced his interest in the Afro-Brazilian community, Diegues acknowledged the possibility: "I have an enormous curiosity in certain aspects of Brazilian people and popular culture, which, although it is progressively losing its original style, continues to be an original source of ideas, creativity, and behavior. My father, the anthropologist Manoel Diegues Jr., a person who taught me many things, may have influenced me in this."[3] Therefore, Diegues interprets Afro-Brazilian issues as an important aspect of Brazilian popular culture in general, which deserves to be brought to the fore.

While colonialism in Brazil disappeared a long time ago, the consequences are long-lasting. Afro-Brazilians' experience of the colonial wound and their awareness of coloniality may lead them to contest the tenets of Eurocentric modernity and to propose other, equally valid ways of being in the world. One way to do it is to express pride for African-rooted differential knowledges, which have historically been dismissed as folklore, myth, or black magic. *Quilombo* presents

such an attempt to incorporate, in a respectful and celebratory way, these cultural traditions. This rebellious "maroon consciousness" is perceived throughout the plot. Diegues, a member of the *Cinema nôvo* movement of the 1960s, tries to combat the epistemic racism that devalues or ignores Afro-Brazilian cultural practices and epistemologies. His film demands the inclusion of "racial" others as a way to help them recover their human dignity and the long-overdue recognition of their cultural difference.

As is well known, African slaves had different reactions to slavery throughout the Americas and the Caribbean, including accommodation, self-assertion, and resistance. As David Barry Gaspar points out,

> Slave resistance must be broadly understood to include forms of slave behavior other than insurrection. Suicide, theft, lying, infanticide, insolence, insubordination, laziness, feigned illness—these were weapons that slaves possessed and used. Such day-to-day resistance, largely individual and nonconfrontational, was essential to survival. In fact, every willed response of the slaves to bend the system in their favor, to secure space for themselves within it, could be interpreted as resistance, even though such responses can also be interpreted as adaptation. Paradoxically, slaves' resistance involved some accommodation with slavery. (Gaspar 1991: 130–31; qtd by Mintz)

Of all these types of reactions, this historical film explores, for the most part, escape, defiance, revolt, and military defense. However, several scenes also include black soldiers within the Portuguese army that is trying to capture fugitive slaves. As Stephan Palmié points out, "Since the massive revisionist turn in the historiography of slavery that occurred during the 1960s and 1970s, our perception of the slaves' agency and experience has changed significantly. . . . By the mid-1970s, a flood of publications on the resilience and vitality of cultures developed *in spite of* slavery was providing the answer" (xvi–xvii). Indeed, *Quilombo* is such an example of a group of slaves who refuse to accept their social death or the passive role of abject victims, choosing, instead, to risk their lives and to be agents of their own liberation. The film, therefore, is based on a documentable historical event and can be considered a case study of active resistance to slavery in which first an uprooted, enslaved African prince and then his godson born in Palmares manage, against all odds, to lead a self-governed multiethnic community, partially based on African institutions. It is also a case study of a maroon society.[4]

Quilombo takes us back to seventeenth-century Palmares (also known as Quilombo dos Palmares or, later, Angola Janga), where a community of African

runaway slaves, along with other disadvantaged groups (mulattos, mestizos, indigenous people, landless white Portuguese) have formed a multiethnic community ruled by an African leader. As Freitas explains, "Not only blacks or former slaves lived in Palmares. Although in small numbers, there were among them Indians, mestizos, mulattos, and whites. This fact underscores the essentially social content of the Palmares movement. From the beginning, Palmares became an open refuge for all those persecuted or disinherited of colonial society."[5] Free whites moved to Palmares fleeing the Dutch invasion, escaping misery, or deserting from the army and the expeditions sent against the former slaves (Freitas 71). The action takes place in colonial times in what is today the Northeastern Brazilian state of Alagoas (Carlos Diegues was born in Maceió, Alagoas). Although the presence of quilombos of runaway slaves was fairly common throughout Brazil, none reached the size of Palmares. It has been estimated that by 1690, the community had a population of approximately 11,000, making it the largest community of fugitives in the history of the Americas. Amazingly, for almost a century it managed to survive attacks from the Portuguese and the Dutch, who were concerned about the bad example that Palmares set. Between 1680 and 1686, six different Portuguese military expeditions failed to conquer Palmares; the Dutch, led by John Maurice of Nassau, also sent failed expeditions. These escaped slaves took advantage of the prolonged low-intensity war between the Dutch and the Portuguese (1602–1661). In 1630, the Dutch West India Company sent a fleet to conquer Pernambuco and was able to conquer the city of Recife. In line with the film's objective of reenacting the maroons' perspective of this epic story, in *Quilombo* Ganga Zumba points out that they need to take advantage of this war "among whites" to strengthen their community and prepare it for upcoming wars. The opening scene of the film also makes reference to the presence of the Dutch in the area and to the war against them.

The establishment of free maroon communities in remote areas was not uncommon throughout the Americas and neither were the official peace treaties with them, like the flawed one included in the plot of *Quilombo*. As Natalie Zemon Davis explains,

> By the early years of the nineteenth century, two new models had emerged for Caribbean politics. The British in Jamaica and the Dutch in Suriname developed the first during the eighteenth century. They made peace with the warring maroon communities and wrung promises from them to stop attacking the sugar plantations and inciting the slaves to flee. They also set up military units, with manumitted slaves as soldiers under white officers. (41)

As we see in the film, the first chieftain or "king" of Palmares was Ganga Zumba (also named Ganazumba in other historical texts; he was also the inspiration for Carlos Diegues's 1964 film *Ganga Zumba*) and the last one was Zumbi (or Zumbí) dos Palmares. Their rebellion lasted from 1605, when maroons founded a settlement in Serra de Barriga, through 1694, when Pedro Almeida, governor of Pernambuco, sent an army led by the ruthless Bandeirantes (Portuguese Brazilian colonial slavers and fortune hunters) Domingos Jorge Velho and Bernardo Vieira de Melo, who defeated them and destroyed the last stronghold through the use of artillery. This last battle was quite unusual, as the Palmaristas typically abandoned and burned their villages once they discovered the advance of Portuguese soldiers. In the film, Zumbi, like his predecessor before him, grows tired of the never-ending state of war and wants this one to be the last battle. For this reason, he calls upon all the people in the villages of Palmares, including children and women, to come to the capital city to be trained as soldiers, hoping to dishearten the Portuguese forever. Different types of maroon resistance continued in the area's settlements for another century, even though there was no longer a united political entity in the mountainous area of Palmares. As we read in the closing remarks of the film, "Camuanga became leader of the Palmares resistance until 1704, when he was killed in battle with the Portuguese. Other warriors took his place. The colonial forces never managed to exterminate Palmares completely. Resistance in the area was last heard of in 1797, more than a century after Zumbi's death."

Quilombo is not a documentary but a feature film that includes fictional information. In an interview in *Filme sobre filme*, Carlos Diegues states: "The fact that Quilombo is based on historical facts doesn't mean that it is a movie about history. It is, first of all, a movie. It's a very specific and original way of seeing the world, of seeing reality, of seeing things" (Gordon 110).[6] There is indeed no explicit suggestion of complete verisimilitude. Yet it proposes an ultimate truth: Afro-Brazilians have endured a harsh historical struggle for equality and acceptance, which deserves to be rescued from oblivion. Several lines in the film remind us of this central message, including one in the closing song (the film, which is full of singing and dancing, flirts with the musical genre): "Quilombo washed in the water of so many tears, built of love and toil untiring, *even now, our hearts inspiring.*" Earlier in the film, the chieftain Zumbi dos Palmares (played by Antônio Pompeo), had a dream in which Acotirene (the wise, elderly woman who was the leader of Palmares before naming Ganga Zumba [played by Tony Tornado] its first king)[7] told him that Palmares was eternal. Once Zumbi realizes that the Bandeirantes are destroying the walls of the fortification (called

Macoco) and conquering the capital city of Palmares, he asks Acotirene for an explanation, but it is an apparition of the deceased Ganga Zumba who provides the answer: "Palmares will live forever, even without us." The filmmaker's message—that Palmares will live forever even after the death of its inhabitants—is later given nuance throughout the film: this is the past not only of Brazilians of African descent but of all Brazilians, and it should be part of Brazilian national consciousness. Gordon shares this perception of the film: "What stands out in *Quilombo* . . . is the way the film gradually builds a stable proposal for how to reconceive Brazilianness. Importantly, the film avoids communicating this vision of the national group through a single vehicle as is generally the case in *Aleijandinho* and *Cafundó* [i.e., two other historical Brazilian films]. Instead, *Quilombo* rotates among several characters the status of national stand-in and model of social identity" (n.p.). *Quilombo*, therefore, is a cinematic microhistory based on a particular historical event that attempts to capture the larger topic of slavery and marronage in Brazil and combine it with a didactic goal: concerned with the popular memory of historical trauma, the film wants to immortalize this episode as a celebration of Afro-Brazilian culture, thereby fulfilling Acotirene's pledge regarding the eternal nature of Palmares.

But the film moves beyond the realm of Afro-Brazilian history. It is well known that in Palmares there were also indigenous people, mulattos, mestizos, and white Portuguese who were escaping mandatory military service or hiding for other reasons. The fact that in *Quilombo*, Abiola, the future Ganga Zumba, invites a struggling white man and his family, who fear being expelled by the large landowners, to go with them to Palmares suggests that he does not see the struggle as a racial war. Throughout the film, we are presented with a process of transculturation by which this white man begins to enjoy the African-derived rhythms and dancing styles while in the company of his African neighbors; he also begins to wear an African-styled outfit and braids in his hair. There is also a process of *mestiçagem* (miscegenation) emblematized by the relationship between one of the protagonists, Ganga Zumba, and a white woman, Ana de Ferro, or other couples such as the aforementioned white man and his indigenous wife. Along these lines, Ganga Zumba also encourages a group of errant indigenous people to stay in Palmares, whom we later see participating in the dances in their own way. And when Zumbi avenges the death of Acaiuba, one of the Palmares soldiers, he kills both white Portuguese enemies and the blacks among their ranks. In a way, in these scenes we are witnessing a cinematic representation of the harmonious birth of a mestizo nation: Brazil. The discourse of *mestiçagem* pervades the entire plot as an identitarian flag.

As stated, Zumbi's determined defense of his capital city against the Portuguese, which we see in *Quilombo*, was unusual. Instead, Palmares's inhabitants usually abandoned and even burned their villages before fading away into the mountain forests whenever they saw sizable Portuguese armies approaching. As the film also reenacts, Portuguese raids were rarely successful in the capture of prisoners. This is emphasized in the second scene, when the sugar plantation owner, who is trying to buy slaves, tells the captain "What an amazing failure!" after learning that an expedition of approximately three hundred Portuguese soldiers to Palmares has only been able to capture three prisoners. We also see that some of the few remaining Portuguese soldiers are severely wounded.

In *Quilombo*, we first have an individual act of resistance in the Pernambuco of 1650: Abiola, a recently arrived slave who happens to be the son of the king of Arda, kills a foreman who was beating another slave to death. This seemingly isolated event suddenly turns into a collective act of resistance, after Abiola convinces the others, with a smile on his face, to join forces and escape the sugar plantation. Initially, it seems that they just want to change their own fate. Later in the film, however, when the Palmares warriors free other slaves during their raids of surrounding towns and continue to defeat the Portuguese, we realize that this uprising, which perhaps was initially only a reaction to their own enslavement, has turned not only into a struggle against the system of slavery itself but also against Portuguese colonialism. The film also highlights women's contribution to the rebellion, with several female characters in positions of power. Besides Acotirene, the first leader of Palmares, we have Dandara, a female warrior who dares to contradict the chieftain Ganga Zumba when he is trying to convince his people to move to the Cucaú Valley.[8] Ana de Ferro, the former prostitute from Recife turned Ganga Zumba's lover and adviser, also attains a position of power and even talks for Ganga Zumba during his conversations with the Portuguese. Interestingly, among the Bandeirantes, we also see a seemingly indigenous woman giving orders to the soldiers to fire a cannon.

In the film, after Abiola kills the foreman, the slaves divide into two groups, some going to the coast with the goal of returning to Africa, and the rest, mostly the ones born in Brazil, going or returning to Palmares, in the northeastern mountains, to join an already settled community of escaped former slaves. Once there, the elderly leader Acotirene scolds Abiola for bringing a white man with him to Palmares, but the escaped slave dares to tell her that she is stuck in the past and afraid to face the new truths. A soothsayer, she suddenly senses the presence of the *orisha*[9] Shango hovering over the recently arrived Abiola's head and decides to anoint him as the new king of Palmares: "You are the chosen

one. You are Ganga Zumba."[10] Abiola/Ganga Zumba reluctantly accepts the position, but soon becomes a successful and respected ruler. After many years of autonomous existence and self-governance in Palmares, however, he becomes tired of constantly fighting and repelling Portuguese expeditions. As a result, he is persuaded by the governor of Pernambuco, in the name of the king of Portugal, to leave the mountains in exchange for peace and freedom. He is asked to move to an arid valley, a reservation from where his people will not be allowed to leave, under penalty of being enslaved again.

At this point, the younger and more energetic Zumbi, who has just returned from avenging the death of Acaiuba and from liberating slaves in the area, accuses his godfather, Ganga Zumba, of treachery. Zumbi, progressively emerging as a larger-than-life figure, asks Ganga Zumba and the Palmaristas a rhetorical question: "How can we be friends with the whites when their happiness depends on our enslavement?" And when one of Ganga Zumba's advisers reminds Zumbi that the Portuguese have promised them freedom, he proudly replies: "The king of Portugal cannot give me what is mine!" In a later scene, he continues his defiance by adding: "You only become a slave if you're afraid of dying." Henceforth, Zumbi, supported by Dandara, emerges as the new king. It is under his leadership that the chiefs of the different villages in Palmares express their mistrust of the Portuguese and refuse to leave the mountains. In a previous scene, Francisco/Zumbi, bothered by Ganga Zumba's passivity, asks him for permission to avenge Acaiuba. This encounter foreshadows the incipient differences between the two men. This is also the moment when Ganga Zumba gives him the warrior name Zumbi dos Palmares, the immortal one. In subsequent scenes, Zumbi frees not only black slaves but also unfree white people who then celebrate their liberation. The now battle-tested Zumbi grows to be a capable leader, showing his newfound wisdom by refusing to take Recife when he has a chance to do so: "If we take Recife, Dandara, we'll end up with slaves like them."

In 1679, the Portuguese sent new military expeditions against the historical Zumbi, but it was not until 1694 that an army led by the Bandeirantes from São Paulo, Domingos Jorge Velho and Bernardo Vieira de Melo, managed to conquer Cerca do Macaco, the main fortification in Palmares, killing most of its inhabitants, including Zumbi. Although in the film we see, along with indigenous people, blacks and women, the Bandeirantes' army was composed mostly of indigenous soldiers who had been promised land grants in the area. Again following historical accounts, in the film Zumbi is wounded but manages to escape. One of the Portuguese soldiers then tells his leader that Palmares cannot be considered conquered until they find Zumbi's remains. Eventually, Zumbi is

betrayed by Teodoro, one of his men (under torture, according to the film), and, in the film, he is shot to death in 1695. According to historical records, however, Zumbi was beheaded and his head was exhibited for several days in a public square in Recife as a warning against potential future uprisings.

Therefore, as we have seen, along with the recreation of the heroic resistance of this mostly Afro-Brazilian community, the director, Diegues, made an effort to present the Palmares epic as a multiethnic struggle on both sides, rather than strictly a black versus white war. In the background of these battles, we witness a process of transculturation taking place, which will give way to the epic birth of a mestizo nation.

FROM REALITY TO FICTION AND BACK

Although Diegues based his film on the then-recent research on the Quilombo dos Palmares carried out by Decio Freitas in his 1973 book *Palmares: A Guerra dos Escravos*, and could count on a sizeable budget and top-notch technology for the film, there are in *Quilombo* a few disconnections between historical reality and fiction, which should not surprise the viewer, since, as stated, Diegues does not present it as a documentary. Besides the military resistance that lasted for almost a century, *Quilombo* also echoes different types of cultural resistance, such as the rejection of Christian names and Catholic religion in general. However, the film's take on religion is not exempt from ambivalence and contradictions. On the one hand, early in the second scene of the film, when the runaway slaves kill all the Portuguese soldiers returning from an expedition to Palmares, one of them, Acaiuba, collects their weapons and mysteriously laughs after picking up one of their crosses. Then, after Acaiuba is killed by the Portuguese, Ganga Zumba picks up the cross from his neck and brings it, seemingly with devotion, to his own face. From that moment on, he wears that cross hanging from his neck. In another scene, when Zumbi frees one of the slaves, the freed man thanks Jesus Christ.

By contrast, later in the film Francisco (soon to be Zumbi dos Palmares) rejects the Christian name given to him by Antonio Melo, the priest who bought him as a slave when he was a child and with whom he lived for fifteen years, working as his assistant in religious services. In a carnivalistic scene in which the world is turned upside down, the priest exchanges with Zumbi Latin phrases used in the Catholic mass (in this way, the film emphasizes how the priest managed to acculturate Francisco/Zumbi) and then reminds him that he forgot his iron cross when he escaped at the age of fifteen. Zumbi answers that he no

longer needs it, unless he turns it around to use it as a sword. In another scene, a dying elderly man rejects the priest's use of Latin, telling him that while it (the language, symbolizing Catholic religion) was useful in his life, it will not be in his death. The elderly man then proceeds to sing in Yoruba. This suggests that he still is a follower of a forbidden African creed. An earlier scene tellingly includes the image of the infant Francisco, with his hands tied, in front of the altar right after a priest purchases him as a slave. This, like the cross/sword scene, emphasizes the hypocrisy of the Church's behavior. Finally, during a theatrical representation in Palmares, the Church's connivance with the system of slavery is again evoked when a character crosses herself while a slave is being flogged.

This critique of Christianity, however, may be a reflection of the filmmaker's creative license, particularly considering that presumably reliable seventeenth-century descriptions by the Dutch of abandoned quilombos or *mocambos* in Palmares included the existence of churches. Indeed, many of the escapees had been Christianized by the Portuguese either in Africa or during their enslavement in Brazil. As a result, they continued to practice the religion, even though their practices were probably altered due to the absence of priests in Palmares and the syncretism with African religions. In this regard, Freitas points that "more than the language, religion was a factor of dispute among the slaves,"[11] a source of division that was encouraged by colonial authorities. Likewise, Shohat and Stam have pointed out other potential historical inaccuracies in the portrayal of religious practices in Palmares: "The only problem with these homages to Yoruba religion is that Palmarino culture was in fact Bantu rather than Yoruba; the Yoruba were relative latecomers to Brazil" (80). At the same time, the film suggests biblical intertextualities between the history of the Palmares resistance and the exodus of the Jews toward the Promised Land: on their way to Palmares, the runaway slaves find a house where a man named Samuel, who "represents the many Sephardi Jews and *conversos* who fled the Inquisition and took refuge in Brazil" (Shohat and Stam 80), is telling Moses's story of liberation to his children with an emphasis on how he parted the waters and drowned the Pharaoh's army. This scene foreshadows the epic struggle of the Palmaristas for their freedom.

To continue with the contrast between historical fact and filmographic rendition, the scene in which, one by one, all the leaders of each village voice their opinion against Ganga Zumba's decision to leave the mountains reflects the historical fact that Palmares was a sort of confederation led by a king. The film also follows historical accounts in its description of Zumbi as a boy born in Palmares, captured by Portuguese raiders while still a child, and raised by a priest who taught him Portuguese and Latin. As in the film, in real life he also

escaped during the plague of 1664 and returned to Palmares, where he became the leader of the quilombo. By contrast, while the film describes a verbal agreement between Ganga Zumba and Zumbi, in reality the latter orchestrated a rebellion against him. And while in the film Ganga Zumba commits suicide by poisoning himself, some historical records claim that it was actually Zumbi who poisoned him. Freitas, for instance, argues that Zumbi's supporters conspired against Ganga Zumba, poisoned him, and massacred his closest allies (120). These deviations from historical reality once again seem to obey the filmmaker's interest in glorifying the figure of the two main chieftains of Palmares so that they may be seen as historical role models and kindred spirits despite certain ideological differences. Along these lines, in the film Ganga Zumba solves a dispute by teaching his subjects that the land does not belong to anyone and therefore its products must be shared equitably. Freitas speculates that lands were communally owned, because that was the African tradition, but clarifies that there is no evidence of it (44). In real life, there were also judges in Palmares, according to the anonymous "Relação das Guerras de Palmares" (Account of the war of Palmares, 1678) and another chronicle written by Manuel Injosa in 1677.

In a celebration of Afro-Brazilian culture, the film incorporates, without the typical derogative references to black magic or superstition, African forms of knowledge, such as Acotirene's divination techniques and the belief in the orishas of the Yoruba religion or the Candomblé practices in Brazil. Overall, the film portrays the Palmaristas' attempt to re-create the performance of African customs and cultural practices in Brazil. Likewise, the film shows the Palmaristas practicing capoeira and using this martial art in their battles with the Portuguese; it is also mentioned in the lyrics of songs in the film. Yet there is actually no historical record of the practice of capoeira in Palmares. And while the residents of Palmares in the film fight with spears, bows, and arrows (they do not use the firearms seized from the Portuguese in various scenes), there is documented evidence that they did use guns bought from the Portuguese in their battles. *Quilombo* also reflects the historical defense tactics of the Palmaristas pointed out by Freitas (44, 81–82), including retreat whenever they were attacked, the building of fortifications, palisades and pit traps, as well as the collaboration of spies in Portuguese mills and cities.

The African outlook of the film is completed with the representation of rituals and ceremonies for birth, burial, naming a new king, battle (praying to the Yoruba deity Ogun), different types of magic (flaming sticks, apparitions, prophetic comets, the prediction of Zumbi's return to Palmares), along with African masks, outfits, dances and music, often suggesting the happiness that the

free inhabitants of Palmares feel when performing their own cultural practices in a sort of re-Africanization. We see men walking while holding hands, as is done in some African cultures, and the practice of polygamy is also represented: Ganga Zumba first has a relationship with Dandara and then has two partners throughout the film. The first of these is the young and naïve Namba, followed by Ana de Ferro, a white woman who used to be a prostitute for the Dutch in Recife. However, in real life, rather than polygamy, there was a system of polyandry in Palmares. Because most of the slaves in the Portuguese colonies were men, the quilombos were also mostly populated by men, who sometimes organized raids to procure women from nearby villages, as Freitas explains: "There were no women. This forced them to descend periodically to the plantations with the goal of kidnapping their sabinas: not only black ones, but also Indians, mulattas, and even whites."[12]

Diegues, however, was not interested in cultural authenticity in his film. The Afro-Brazilian composer and performer Gilberto Gil's pan-Africanist musical score, for example, includes the sound of electric guitars and saxophones, instead of the musical instruments used at the time or a more traditional African sound.[13] Rather than historical accuracy, then, the sense of magic, blended with samba music, carnival rhythms, costumes and atmosphere, seem to be the order of the day. As Pick indicates, Gilberto Gil and Waly Salomao created a syncretic musical score "in which Brazilian expressions are blended with rhythms associated with black consciousness such as Jamaican reggae, Nigerian juju, soul, and funk" (145). Moving even further away from historical accuracy, there is even a humorous reference to soccer, centuries before the sport existed.

Finally, there is a historical fact that is not mentioned in the film. As seen in the film, war fatigue and trusting the Portuguese were Ganga Zumba's tragic flaws. Acotirene had foreshadowed this outcome by warning him to be careful with the enemy's smile. This episode of Ganga Zumba's attempted reconciliation with the Portuguese is also based on real-life events. When, after a bloody incursion by captain Fernão Carrilho in 1676–1677, Ganga Zumba requested a peace treaty from the governor of Pernambuco, the latter agreed to pardon the Palmaristas if they moved closer to the Portuguese settlements by the coast and returned all the former slaves not born in Palmares. As Freitas explains, "Simple common sense indicates that the pact must have provoked multiple and obstinate types of resistance, mainly due to the cruel clause that immolated all those born outside Palmares to captivity."[14] As we see in *Quilombo*, Ganga Zumba agreed to the terms of the treaty, but the Portuguese sugar planters did not respect the treaty and ended up re-enslaving many of his followers. The film, however, does not mention such a redelivery of former slaves not born in Palmares.

EXOTICIZATION WITH GOOD INTENTIONS

In spite of this historically documented episode of potential betrayal, many scenes in *Quilombo* imagine Palmares as a black El Dorado, as the opening and closing songs in the film describe it. It is a mostly Afro-Brazilian utopian society, free and egalitarian, where a dream has successfully been implemented and where a new Afro-Brazilian identity is being forged. There are seemingly no major sociopolitical or economic problems, and Palmaristas exchange products in the market with smiles on their faces and no need for currency. The film presents Palmares as a foundational event for Afro-Brazilian as well as Brazilian culture writ-large. And it also places Afro-Brazilians center stage in yet another way. As Pick explains, "By casting some of Brazil's best-known black performers, musicians, and dancers, Diegues reversed the tendency within popular media to marginalize blacks" (145).

Yet, while all these efforts to re-create and celebrate Afro-Brazilian contributions to Brazilian culture are commendable and well intentioned, in my view, they unintentionally exoticize, mystify, and romanticize both the Palmares community and Afro-Brazilian culture, which, in the end, is reduced to a stereotypical view of African and Afro-Brazilian cultures. Other critics coincide with this perception: "As the director of three compellingly 'regenerative' yet problematic films—namely, *Ganga Zumba*, *Xica da Silva*, and *Quilombo*—Carlos Diegues may have set out to document Afro-Brazilian history, but in many instances in these films, he has actually reinforced stereotypes" (Afolabi 188). In the end, the numerous scenes of apparitions, Ganga Zumba's ability to transform himself into the orisha Shango and then return to his original state, the scenes of magic with fiery spears, the sudden disappearance of Acotirene, the frequent mist in the background, and the colorful and cheerful carnival-like dances and music end up creating a sense of unreality that borders on the exoticization of African and Afro-Brazilian cultures. The counterpart of this exoticizing approach is the ridiculing of Portuguese characters in the film, some of whom are closer to caricatures than to credible and realistic historical characters. A case in point is the contrived and grotesquely dressed captain Fernão Carrilho, who pretends to have destroyed Palmares and defeated Ganga Zumba in order to get the sugar mill owner's reward. His clownish and kitschy behavior seem out of place in a film about slavery.

On a more positive note, beyond the idealization of life in the quilombo and of the two main chieftains of Palmares, they do have certain flaws, which makes the film less Manichaean. Ganga Zumba, for example, steals Ana from another maroon recently arrived in Palmares, despite the latter's refusal to give her up. He also agrees, after a treaty with the Portuguese crown, to move to the

valley of Cucaú where he would be unable to accept any runaway slaves, having to return them to the authorities instead. Likewise, Zumbi, fearing betrayal, imprisons his close friend Katambo. Dandara, a woman whom Zumbi reveres, frowns upon the imprisonment, which suggests some sort of injustice or abuse of power being committed.

In part, the lack of verisimilitude in *Quilombo* is due to the semi-musical genre chosen for the film. As Robert Stam reveals, "Carlos Diegues has said that he conceived both *Xica da Silva* and his most recent *Quilombo* (1984) as 'samba enredos' (samba plots), i.e., as films analogous to the collection of songs, dances, costumes, and lyrics that form part of that popular narrative form called a samba school presentation" (69). As a result, the numerous songs and dances often interrupt the action and the solemnity of the situation, showing more concern with spectacle and with suggesting a direct connection between the cultural practices of seventeenth-century runaway slaves and today's Brazil than with historical accuracy and verisimilitude. In fact, it may be more important to contextualize the film historically with the 1970s and 1980s sociopolitical framework than with that of the seventeenth century. And perhaps the director's decision not to spectacularize violence in the film, putting more emphasis, instead, on the happiness of life in Palmares and the overall contribution of African cultural practices to Brazilian national culture (carnival, capoeira, Candomblé, and so on) makes the story less convincing in its historical accuracy. In addition, the fighting scenes in the film tend not to be very convincing, as they tend to contain melodramatic overacting, comical outcomes, and, altogether, lack of verisimilitude.

The festive, carnivalesque, Bakhtinian atmosphere ultimately romanticizes the story, when it takes over the suffering and the harsh environment of slaves and runaway slaves, perhaps deterring the film from achieving a more convincing message. This is not to say that there is no violence in the film. Diegues opens the first scene with the bloody torture with stocks of a black slave who is accidentally killed, to the dismay of his somewhat ridiculous Portuguese mistress, who first laments the economic loss and then blames the slave himself for dying. Meanwhile, a pregnant slave named Gongoba, the future mother of Zumbi, silently cries while she witnesses the atrocity and caresses her pregnant belly, plausibly pondering the sad future that awaits her offspring. Then, we see a white boy sitting on the back of a slave dwarf and pulling on his leash as if he were a dog.

Yet the scenes that celebrate Afro-Brazilian culture and the birth of a mestizo nation are more numerous. We see, for instance, an elderly man teaching traditional medicine and words in an African language to the children around him. Contributing to the overall harmony, the Palmaristas collectively plow the land and

build huts, among dances and songs. Yet, as stated, the director's lack of interest in verisimilitude somehow detracts from the seriousness of the topic and message in the film. For example, when Palmares suffers a raid by Portuguese soldiers, the children, among laughter, effortlessly repel the invaders, who have just defeated the mighty Dutch, by rubbing pepper in their eyes and by dropping snakes inside their clothing. In a way, perhaps influenced by it, *Quilombo* is reminiscent, in both its successes and failures, of Marcel Camus's 1959 classic film *Orfeu Negro* (*Black Orpheus*). As Robert Stam points out, referring to *Orfeu Negro*:

> The film suggests a primitive capacity on the part of the happy Black Brazilians to enjoy life no matter how devastating the conditions. As a kind of Brazilian *West Side Story*, *Black Orpheus* prettifies the favelas of Rio and isolates carnival from its social context. Authentic carnival offers a dialectical critique of the injustices of everyday life, not a metaphysical transcendence against a postcard backdrop. Black Orpheus enlists all the elements of carnival dance, rhythm, music, color, laughter—but ultimately in the service of a stereotypical vision. (56)

Meanwhile, the Portuguese characters' evil demeanor at times (one of them kills Francisco's mother) also loses credibility with their clownish behavior around the children. The casting itself is sometimes questionable. For instance, instead of actual indigenous actors in Palmares, we seem to find white actors with their faces painted red or wearing a couple of feathers in their hair.

Another factor that debilitates the credibility of the story is the lack of linguistic diversity. While, in an attempt to increase the sense of authenticity, Diegues has his characters speak several times in African languages, he does not attempt to reflect the accent of the recently arrived African slaves: all the African characters, including Abiola, seem to speak with the same Portuguese accent as the ones born in Brazil, which decreases the credibility of the story. Likewise, the language used in Palmares is no different than the one used by outsiders, even though, as Stam points out, "The Palmarinos spoke a kind of esperanto which fused Portuguese, African and Indian languages, a linguistic reflection of the ethnic make-up of the population" (80). Freitas clarifies that "the language spoken was basically Portuguese mixed with African languages,"[15] because Portuguese was the only common language for all these African groups.

Perhaps encouraged by the impressive commercial success of his previous film, *Xica da Silva*, Diegues returned, in *Quilombo*, to a Tropicalist formula full of music and dances. Overall, *Quilombo* fails in its attempt to create a convincing

snapshot of Palmares because it reduces Afro-Brazilian culture to magical scenery and the festive, colorful celebration of dances and samba music. Shohat and Stam have addressed the presence of samba and carnival in *Quilombo*:

> The 1970s and 1980s witnessed a "recarnavalization" of Brazilian cinema, not only as a key trope orienting the filmmakers' conception for their own production, but also as a means of renewing contact with the popular audience. The stories of Diegues' *Xica da Silva* (1976) and Walter Lima Júnior's *Chico Rei* (1982), for example, were first presented as samba-school pageants for Rio's carnival. Indeed, Diegues conceived *Xica da Silva* and *Quilombo* (1984) as *samba-enredos* (samba-narratives), that is, as formally analogous to the collection of songs, dances, costumes, and lyrics which form part of the annual samba-school pageants. (306)

This reductionist approach runs the risk of essentializing an entire ethnic group, which ends up being romanticized and mystified as a sort of timeless protagonist of the Brazilian carnival, a cultural phenomenon often associated with liberation from sociopolitical and religious constraints. For the most part, the century-long life of the Quilombo dos Palmares, until the moment of the final defeat, is portrayed as a never-ending party full of laughter and a celebration of negritude, Afro-Brazilian cultural practices, and life. There is virtually no injustice or fear, and no significant sociopolitical, racial, or economic problems are suggested. And neither is there a connection between the oppression of slaves and run-away slaves in seventeenth-century Brazil and the sociopolitical and economic destitution of many blacks in Brazil today. *Quilombo*, then, is a film oriented toward the present and the utopian future of Brazil, rather than its past. Other critics have noticed this peculiarity: "That this film [*Xica da Silva*] and *Quilombo* unambiguously refer to the present has not gone unnoticed in criticism such as Lúcia Nagib's 2007 comment that the two films 'allegorize situations of oppression and rebellion in the present'" (Gordon n.p.). Likewise, Steven K. Smith points out that "this historical drama also includes other contemporary moral messages, while still clearly situating itself in a specific seventeenth-century context" (Bayman and Pinazza, 145). While this would be acceptable in other contexts, perhaps a film about the harsh realities of slavery and marronage should be expected to focus more rigorously on historical accuracy and to portray a less festive atmosphere. After all, modern nation-building projects such as Diegues's *Quilombo*, notwithstanding their good intentions and entertainment value, are more effective when grounded as much as possible on historical truth rather than on escapist wishful thinking.

Notes

1. "The point of cinema, or at least of the best cinema known to us, has always been to know how to reach this shared exception, to be able to identify what belongs to all, while being expressed by just one." ("The people on screen and in the movie theaters").

2. The title of the film refers to the term used today to refer to settlements of formerly enslaved Africans who escaped looking for their freedom, which appeared along with the inception of African slavery in Brazil during the mid-1530s. At the time, however, the term used to refer to Palmares was *mocambo*, rather than *quilombo*. Along with *Quilombo*, Carlos Diegues has directed the short films *Fuga* (1959), *Brasília* (1960), and *Domingo* (1961), as well as the feature films *Five Times Favela* (1962), *Ganga Zumba* (1964), *The Big City* (1966), *The Inheritors* (1969), *Quando o Carnaval Chegar* (1972), *Joanna Francesa* (1973), *Xica da Silva* (1976), *A Summer Rain* (1978), *Bye Bye Brazil* (1979), *Subway to the Stars* (1987), *Better Days Ahead* (1989), *Tieta of Agreste* (1996), *Orfeu* (1999), *God Is Brazilian* (2003), and *The Greatest Love of All* (2006), among others.

3. "Tenho enorme curiosidade por certos aspectos do povo e da cultura popular brasileira que, embora esteja perdendo cada vez mais o seu estilo original, continua uma fonte de idéias, criatividade e comportamento bastante inédita. Talvez exista nisso alguma influência de meu pai, o antropólogo Manoel Diegues Jr., uma pessoa que me ensinou muita coisa" (n.p.).

4. There are several studies of these types of societies in different parts of the world. As Palmié indicates, Thoden Van Velzen has studied the abuse of power in the maroon societies of Suriname, thus providing new nuances to the notion and contradictions of resistance, and Bartl has also studied the exploitation and even re-enslavement of fugitive slaves by other maroons. Diegues has received several lifetime achievement awards, including the Fest Aruanda (Brazil 2010), Roberto Rossellini (Italy 2008), Festival de Santa Cruz de la Sierra (Bolivia 2007), Gloria (USA 2005), Eduardo Abelin, Fetival de Gramado (Brazil, 2003), Golden Reel Award (HBO 2000), Institute Lumière (France 1995), and Outstanding Achievement in the Art of Film (United States 1990).

5. "Nem só negros ou ex-escravos viviam nos Palmares. Ainda que em pequeno número, havia entre eles índios, mamelucos, mulatos e brancos. Este fato sublinha o conteúdo essencialmente social do movimento palmarino. Desde o início, Palmares se constituiu em um asilo aberto a todos os perseguidos e deserdados da sociedade colonial" (70).

6. "O fato de o Quilombo ser um filme baseado num tema histórico não significa que ele seja um filme sobre a história. Ele é antes de tudo um filme. Ou seja uma maneira específica e original de ver o mundo, de ver a realidade, de ver as coisas."

7. According to Shohat and Stam, Acotirene is "a symbolic figure associated with African strength and spirituality" (80).

8. According to Shohat and Stam, Dandara is "associated with the African spirit Iansã, whose performance of religious rituals saves Ganga Zumba" (80).

9. Orishas are spirits that reflect one of the manifestations of God in the Yoruba religion.
10. While Ganga Zumba is associated with Shago, Zumbi's orisha is Ogum.
11. "Mais que a língua, a religião era um fator de discórdia entre os escravos" (48).
12. "Faltavan mulheres. Isso os obrigou a descerem periodicamente às plantações a fim de raptar as suas sabinas: não apenas negras, mas também índias, mulatas e até mesmo brancas" (35).
13. Gilberto Gil also created the musical score of Nelson Pereira dos Santos's 1977 *Tenda dos Milagres* (Tent of Miracles), another film dealing with Afro-Brazilian culture.
14. "A simples razão indica que o pacto deve ter suscitado múltiplas e obstinadas resistências, principalmente devido à cláusula cruel que imolava ao cativeiro todos os nascidos fora de Palmares" (115).
15. "O idioma falado era basicamente o português, misturado com formas africanas de linguagem" (46).

Works Cited

Afolabi, Niyi. *Afro-Brazilians: Cultural Production in a Racial Democracy*. Rochester, New York: University of Rochester Press, 2009. Print.

Bayman, Louis, and Natália Pinazza. *Directory of World Cinema: Brazil*. Chicago: University of Chicago Press, 2013. Print.

Black Orpheus. Dir. Marcel Camus. Dispat Films, Gemma Films, Tupan Filmes, 1959. DVD.

Diegues, Carlos. "O povo nas telas e nas salas." Carlos Diegues's personal website. Sep. 2001. http://www.carlosdiegues.com.br/artigos_integra.asp?idA=3. Accessed 10 Jan. 2015.

Do Nascimento, Abdias. "Quilombismo: An Afro-Brazilian Political Alternative." *Journal of Black Studies*, vol. 11, no. 2, Dec. 1980, pp. 141–78. Print.

Fanon, Franz. *The Wretched of the Earth*. New York: Grove Press, 1968. Print.

Freitas, Decio. *Palmares: A Guerra dos Escravos*. Porto Alegre, Brazil: Movimento, 1973. Print.

Gaijin—Ama-me Como Sou. Dir. Tizuka Yamasaki. Brazil. Ponto Films, Scena Films. 2005. DVD.

Gaijin—Caminhos da Liberdade. Dir. Tizuka Yamasaki. Brazil. CPC, Embrafilme, Igreja, Mondial do Brasil, Ponto Filmes, Sociedade Brasileira de Cultura Japonesa, 1980. DVD.

Gaspar, David Barry. "Antigua Slaves and Their Struggle to Survive." *Seeds of Change*, edited by Viola and C. Margolis. Washington, D.C.: Smithsonian Institution Press, 1991, pp. 130–37. Print.

Gordon, Richard A. *Cinema, Slavery, and Brazilian Nationalism*. Austin: University of Texas Press, 2015. Print.

Mintz, Sidney W. "Slave Life on Caribbean Sugar Plantations: Some Unanswered Questions." *Slave Cultures and the Cultures of Slavery*, edited by Stephan Palmié. Knoxville: The University of Tennessee Press, 1995, pp. 12–22. Print.

Palmié, Stephan. "Introduction." *Slave Cultures and the Cultures of Slavery*, edited by Stephan Palmié. Knoxville: The University of Tennessee Press, 1995. Print.

Pick, Zuzana M. *The New Latin American Cinema. A Continental Project*. Austin, TX: University of Texas Press, 1993. Print.

Quilombo. Dir. Carlos Diegues. Brazil. CDK Produçoes Ltda, 1984. DVD.

Revista de Cinema. Interview with Carlos Diegues. Carlos Diegues's personal website. Sep. 2000. http://www.carlosdiegues.com.br/artigos_integra.asp?idA=23. Accessed 10 Jan. 2015.

Rodríguez Pastor, Humberto. *Hijos del celeste imperio en el Perú (1850–1990). Migración, agricultura, mentalidad y explotación*. Lima: Sur Casa de Estudios del Socialismo, 2001. Print.

Shohat, Ella, and Robert Stam. *Unthinking Eurocentrism: Multiculturalism and the Media*. London and New York: Routledge, 1994. Print.

Stam, Robert R. "Samba, Candomble, Quilombo: Black Performance and Ethnic Cinema." *Journal of Ethnic Studies*, vol. 13, no. 3, 1985, pp. 55–84. Print.

Trazegnies, Fernando de. *En el país de las colinas de arena*. Vol. 1. Lima: Fondo Editorial de la Pontificia Universidad Católica del Perú, 1995. Print.

Zemon Davis, Natalie. *Slave son Screen. Film and Historical Vision*. Cambridge, MA: Harvard University Press, 2000. Print.

Of Slavery and Humanity

Focus, Metaphor, and Truth in Werner Herzog's *Cobra Verde*

Rudyard J. Alcocer

O ne of the central questions raised by many of the essays in this volume is how best to represent, through the medium of cinema, slavery as it existed in the Americas. Not all representations are equally (take your pick): powerful, respectful, historically accurate, politically correct, and the like. Furthermore, as we saw in the introduction to the present volume, there are exceptions to nearly every generalization we can make about slavery, particularly given the tremendous historical, geographical, and cultural ranges that have characterized the institution. There are, broadly stated, films that inhabit what might be described as the central ground as concerns common features of slavery films and what we know about the history of slavery: they recount or resemble well-known slave uprisings and legal cases, they register the inhumanity of bondage, the quest for dignity, and so on. Some films, however, are more difficult to position in terms of the regular features of slavery cinema and for that reason make for interesting case studies. One such film is *Cobra Verde* (1987, Dir. Werner Herzog, Germany 1942–).

Cobra Verde, a film that in addition to being unique is also in many ways powerful and poignant, seems to be—on the surface, at least—a film about slavery. It closes, for example, with a quotation from the 1980 novel *The Viceroy of Ouidah* (Bruce Chatwin, England 1940–1989), on which the film is based: "The slaves will sell their masters and grow wings," a quotation that also appears as the tagline on the DVD case. The subject of slavery is also directly addressed throughout

the film, including toward the end in a dialogue involving Francisco Manoel da Silva, also known as Cobra Verde. What will a former bandit and now failed slave trader have to say about the institution of slavery as it becomes clear that the days of slavery and the Atlantic trade in Africans have reached their end? The present essay attempts to make sense of both the film's closing epigraph, and its sustained ruminations on slavery, in light of a number of—sometimes difficult to reconcile—features in the film. Indeed, in terms of the film's unusual qualities, we might ask if this "slavery" film is really about slavery, and if it is about slavery, what does it tell us (or try to tell us) about the institution? Furthermore, if the film is not about slavery then what *is* its central subject? These are the basic questions I explore in this essay. My contention is that this captivating "slavery" film is really about other matters, and problematically so.

The film has a complex relationship with Chatwin's novel. One might say that the former is a poetic interpretation of the latter, which in turn is already a poetic and atmospheric novel. According to Herzog, when he purchased the film rights to the novel,

> The first thing [he] did was explain to Chatwin that the story in *The Viceroy of Ouidah* was not a film story *per se*, which meant there would be certain technical problems in adapting the book. It is narrated in a series of concentric circles, and [he] knew a film would have to proceed in a more linear way. (*Herzog on Herzog* 212)

Comparing the two texts with any degree of rigor is beyond the scope of this essay: its focus instead is on Herzog's film rather than on Chatwin's novel; the former became—as Herzog rightly observes above—a very different product.[1] Furthermore, comparing the two in terms of their common historical referent (the Brazilian slave trader Francisco Félix de Sousa) brings its own difficulties given that a) Chatwin, who was initially interested in writing a biography of De Sousa, abandoned that project and wrote a fictional work due to the scarcity of historical materials about his subject (Shakespeare 356), and b) Herzog was not drawn to Chatwin's novel based on its historical accuracy or lack thereof, and—as we shall see—neither was he interested in this sort of accuracy in his own film project. Of additional consideration with regard to any analysis of the film, irrespective of its relation to the novel, is the film's linguistic and geographical complexities: it is a film set in both Africa and Brazil; the Brazilian scenes, however, were filmed primarily in Colombia; the scenes set in Dahomey (modern-day Benin) were filmed in nearby Ghana; meanwhile, the language of

the film is almost entirely German (i.e., the native language of both Herzog[2] and Kinski), shooting locations or the actual language used by the actors during filming notwithstanding. In some respects, then, *Cobra Verde* approximates the amount of linguistic and cultural diversity and complexity that characterized the Atlantic trade in Africans; in doing so, it is a film that merits a broad, comparative approach.

I am drawn toward Werner Herzog's films—which span a long and distinguished career in cinema—because they often explore and interrogate the outer limits of human actions and affairs. Whether it is a documentary or a feature film, Herzog is keenly interested in topics involving outliers.[3] A Herzog film will not, for instance, recount a love affair between two office workers in a large, modern city. In fact, Herzog often employs non-professional actors and, according to Paul Cronin, dislikes the very conventionality of filming in studios (*Herzog on Herzog* 103). Instead, Herzog's films—in both content and production style—live at the boundaries of the human experience: his 1972 classic, *Aguirre: The Wrath of God*, retells the story of a sixteenth-century Spanish conquistador whose quest for riches in South America would eventually drive him crazy; *Fitzcarraldo* (1982), meanwhile, is about an early-twentieth-century European visionary who goes to great lengths to bring his idea of civilization to the South American jungle. Herzog's documentaries share his feature films' thematic focus as nearly all of them explore some unusual person, place, thing, or event: *Encounters at the End of the World* (2007), for instance, documents life at the McMurdo research base in Antarctica; *The Cave of Forgotten Dreams* (2010) shows pre-historic art in a cave in southern France that is off limits to tourists; *Grizzly Man* (2005), in turn, is a documentary about a man who abandoned conventional life in order to go live among grizzly bears in Alaska, one of which tragically devoured him and his girlfriend. Similarly, Herzog is known as a filmmaker who likes to take risks, even excessive ones, while making his films, although he denies this claim (*Herzog on Herzog* 19). Indeed, the stories surrounding the production of certain Herzog films have become documentary films in themselves (for instance, Les Blank's 1982 *Burden of Dreams*, which chronicles the making of *Fitzcarraldo*, and Steff Gruber's 1987 *Location Africa*, which explores the filming of *Cobra Verde* itself).

Several of Herzog's fictional films feature the talented but mercurial Klaus Kinski (1926–1991), an actor with a love-hate relationship with the director (it has been said that on at least one occasion Kinski tried to murder Herzog).[4] In the role of the title character in *Cobra Verde*, Kinski seems to be playing a version of himself (or the way he wanted to be seen): he is perfectly cast as a solitary and erratic man who is feared by whichever society surrounds him, whether the

empty and impoverished Brazilian hinterland, a decadent sugar plantation society, or a decrepit African slave trading post. Indeed, many of Herzog's published statements on *Cobra Verde* pertain to working with Kinski.[5] Clearly, working with Kinski came at a cost. Herzog has stated, "Every single day I did not know if [*Cobra Verde*] would ever be finished because Kinski terrorized everyone on set" (*Herzog on Herzog* 210). Nonetheless, it is similarly clear that Herzog may have been drawn toward Kinski's erratic qualities, which as Brad Prager asserts, may have also contributed to Herzog's adventurousness in the making of his films: "In this way, Kinski has often been understood to stand in for the director himself as he attempts to stage a lavish production that exceeds the borders of the cinematic frame" (3).

Cobra Verde begins with a Brazilian troubadour who, with his singing and his rustic violin, introduces viewers to the legend of the title character, the "master of the slaves." The narrative then takes us backward in time to Cobra Verde's humble origins in the desolate Brazilian *sertão* or backcountry.[6] He is alone: the sole survivor of a drought. We see, in this way, that he is no stranger to pain and suffering. After abandoning his home he finds employment panning for gold. That endeavor, too, proves futile, this time on account of his unwillingness to tolerate the exploitation and discrimination meted out by his boss, whom he later kills. It is thereafter that people begin referring to him as Cobra Verde: a larger-than-life outlaw who appears to operate under an enigmatic, personal moral code.[7] Much of this moral code pertains to slavery, surely one of the extreme arrangements that can characterize the relationship between two or more individuals. In a way, then, it is not surprising that Herzog would turn his cinematic attention to slavery, given that the topic fits well within his broader thematic interests into the fringes and exceptions of the human experience, as understood in relation to the typical conventions of modern life in technologically advanced societies. In other words, while slavery may have been a common, legal feature of societies in many parts of the world during certain historical moments, this no longer holds true. Furthermore, even when slavery was commonplace, this did not keep it from being a uniquely perverted and oppressive relationship among humans.

While Cobra Verde may already have been personally familiar with his own suffering and exploitation, his introduction to the formal and institutionalized enslavement of others occurs in his native Brazil: during a public flogging on the town square, one of the enslaved men being held captive in preparation for flogging breaks loose and makes a dash for freedom. The camera during this escape captures the runaway's perspective as he runs through the crowd in the

square, until he reaches the man standing at the edge of the gathering: Cobra Verde. Cobra Verde stands his ground and, nearly expressionless, addresses the runaway, who is paralyzed at the sight of the blond bandit: "Don't run away," Cobra Verde warns. "It'll only be worse for you." He then entreats the authorities who had been giving chase to the runaway to "let him go! He can find the [whipping] post by himself!" At this point the runaway calmly turns back to the post and begins receiving his punishment. Oddly, then, Cobra Verde is a figure capable of identifying in some mystical way with a runaway slave while at the same time—and without lifting a finger—compelling him to accept his condition, which in this particular case entails brutal and graphically depicted corporal punishment.

In the director's commentary that accompanies the DVD, Herzog is asked by Norman Hill, his interlocutor in this optional audio feature, if the Afro-Colombians[8] who participated in the flogging sequence were comfortable in their role as enslaved characters. While I am at times reluctant to accept as the final word on a film DVD paratextual features like director's commentaries, Herzog's response to Hill is illuminating and irresistible: "They somehow understood that they [the Afro-Colombians] were taking part in something that was a great metaphor on the slave trade. That there was something that has not really been the subject of films until that time." Depending on how one interprets the phrase "great metaphor on the slave trade," Herzog's affirmation on the newness of this film subject may or may not be accurate. In terms, for instance, of films about the Atlantic trade, other films predate *Cobra Verde*, sometimes by decades (*Foxes of Harrow* 1947, *Tamango* 1958). In broader terms about slavery itself, the list of films that predate *Cobra Verde* multiplies. Graphic scenes of corporal punishment, like the one in which Cobra Verde first comes face to face with a slave, are one of the common tropes of slavery films (see Introduction), and can be seen in many films that Herzog may have already been familiar with, including *Roots* (1977).

Later in the film, a wealthy slave owner, Coronel Octavio Cotinho, having witnessed Cobra Verde's panache during the scene on the public square, invites him to be the overseer on his vast sugar plantation. The detailed, guided tour Cotinho gives Cobra Verde of one of his estates is, too, reminiscent of similar surveys in other slavery films. As such, Herzog's claim regarding the originality of *Cobra Verde* seems problematic. That stated, it may be the case that *Cobra Verde* is, as Herzog affirms, the first *metaphorical* treatment of the Atlantic trade in Africans; nevertheless, such a claim would be difficult to confirm given the vagueness to which the term *metaphor* lends itself, which according to *The Oxford English Dictionary* can mean

1. A figure of speech in which a name or descriptive word or phrase is trans-
 ferred to an object or action different from, but analogous to, that to which
 it is literally applicable; an instance of this, a metaphorical expression.
2. Something regarded as representative or suggestive of something else, esp.
 as a material emblem of an abstract quality, condition, notion, etc.; a symbol,
 a token.

Even if the film is not the first to treat slavery metaphorically, perhaps its treat-
ment is indeed metaphorical given any of the above definitions. Before we explore
this possibility, let us first clearly reaffirm that *Cobra Verde* is at least to a degree
a film about slavery: while still in Brazil, the protagonist witnesses the institu-
tion as an outsider, then he becomes intimately involved in slavery as Cotinho's
overseer; it is worth reiterating that many features of these sequences are typical
of the slavery film genre. Later, after falling out with Cotinho, Cobra Verde is
sent to Africa: he is tasked with the seemingly impossible (and suicidal) job of
reestablishing the trade in Africans with the king of Dahomey, who is reputed
to be insane. Once in Dahomey Cobra Verde oversees repairs to the abandoned
slave fort and eventually accomplishes his mission of reviving the trade.

 Cobra Verde also registers the abolitionist movements that began to contest
the Atlantic trade in Africans during the first half of the nineteenth century. As
Cotinho explains to Cobra Verde during their tour of one of the latter's sugar
plantations, the British have on the one hand begun to restrict the Atlantic
trade; on the other hand, however, they are hypocritical given their dependence
on the cotton produced by slave labor. Furthermore, intentionally or not, in his
depictions of Cotinho's unabashed lasciviousness toward enslaved females and
his recognition of his mulatto daughters, Herzog registers the exceptionalism
of slavery as it was practiced in Brazil: according to scholars of Brazilian slavery,
"in contrast to slavery in North America and in most Caribbean colonies, the
extreme exploitation of slaves [in Brazil] 'was set in an ideological context in
which the metaphors of family, obligation, fealty, and clientage predominated.'"[9]
In addition, the film is one of the very few that explores issues of slavery not just
in terms of the Atlantic trade but also as concerns slavery as an institution writ
large and in hemispheric contexts pertaining to both the Americas and Africa.
Slavery can mean very different things depending on which of these contexts is
prioritized. As John Thornton explains,

> Seen from the American side of the Atlantic and conditioned by the
> widespread belief that Europeans can be held solely responsible for

> the slave trade because of the sufferings of the slave trade because
> they captured Africans directly or forced a fairly direct collabora-
> tion with African leaders, the slave trade appears to have been an
> independent force that shaped Africa and Africans. In the African
> perspective, it is obvious that Europeans often played a limited role,
> or no role, in the actual enslavement of Africans, and the slave trade
> was itself more often a manifestation of local politics—the solution
> to problems raised by war. (277)

It is unclear how pervasive or accurate such an "African perspective" would have
been. After all, there can be little doubt that non-Africans—especially with the
firearms they hoped to trade for enslaved captives—fomented fragmentation
and strife on the African continent. That stated, the important point here is
that Africans had (and continue to have) their own perspective on slavery and
the Atlantic trade.

While in Dahomey, Cobra Verde becomes intimately familiar with the
African side of slavery as it may have been practiced in that particular kingdom.
He learns, for example, the "skills" of slave traffickers, including how to barter
with African slave merchants, how to inspect enslaved persons for physical
fitness, how to conceal their infirmities from potential buyers, how to keep
them captive in preparation for the Middle Passage, and so on. He is greatly
aided in his education on both Africa and slave trafficking by Taparica, the
African drum major of the prior Portuguese contingent at the Ouidah slave
fort. When Cobra Verde initially questions the justice involved in sending the
King's war prisoners to enslavement in the Americas, Taparica explains that
in many ways the King is doing them a favor given that the alternative would
have been to sacrifice them by sending them as messengers to dead ancestors.
In multiple ways, then, not only does *Cobra Verde* oftentimes pertain clearly
and directly to slavery, it does so in ways that are both interesting and probably
accurate as concerns the historical record surrounding slavery. With regard to
Taparica's explanation, for example, the historian David Brion Davis offers a
related justification for the enslavement of Africans (a justification common
among Europeans during that time):

> Even the slaves should benefit, it was claimed, since they were rescued
> from being killed, starved, or cannibalized in primitive Africa and
> were taken to Christian lands where they were fell fed (suppos-
> edly in the owners' self-interest), where they had their own garden
> plots, and where they at least had a chance of becoming gradually
> "civilized." (81)

While their captors (whether from Africa, Europe, or the Americas) may have thought they were doing the enslaved a favor, the latter probably interpreted their captivity differently. It is reported, for instance, that enslaved persons commonly thought they would be eaten by whites and that their skin would be used as leather.[10]

Despite its depictions of enslavement and related issues, there are, on the other hand, reasons not to think of *Cobra Verde* as being a slavery film, and certainly not one typical of the genre and its conventions. Both reasons pertain to the film's management of its narrative focus. Herzog has stated in an interview, with specific reference to the African context in *Cobra Verde*, "In terms of cinema, I've always wanted to show things which up to now have been ignored" (*Werner Herzog: Interviews* 104). While it may be problematic for Herzog to affirm the originality of *Cobra Verde* as concerns its treatment of slavery, it is difficult to argue against the assertion that Africa and African themes are often neglected by mainstream Western cinema; moreover, his affirmation in the interview seems especially to the point with regard to his filmic oeuvre in general, which strongly reflects his desire to show things hitherto ignored. One might ask, however, if there are ways in which Herzog's desire to show the unknown compromises his more specific goals in a film like *Cobra Verde*. I am thinking, in particular, of his improvisational style of filmmaking, which extends both to the decisions he makes as a director, which include the liberties he would allow an actor of Kinski's stature. It is worth pondering, for instance, a scene set in a small mountain village in Brazil, where the residents flee at the mention of Cobra Verde's name. The scene, although it depicts the chaos that Cobra Verde provokes, is both elaborate and carefully orchestrated in that it involves numerous extras from the (Colombian) village, including children, members of a (disrupted) funeral procession, and a large wooden barrel that slowly rolls down the cobblestone plaza. There is a moment during the scene, however, that was probably not planned by Herzog. After the bandit is left alone in the village square, he approaches a fountain and drinks from it. This sequence, although quite possibly improvised by Kinski, is nonetheless part of an extended motif in the film pertaining to Cobra Verde's strong connection to water. Furthermore, the bandit—as he surveys the square and then, still vigilant, drinks the water—resembles an animal at a watering hole: this effect, too, may be by design. In the midst of these well-planned, intricate sequences comes an improvised one: on the square there were also several loose pigs; the camera pans to follow the path of one pig; then, however, two of the pigs begin copulating, and the camera focuses on that activity. While this activity in its apparent spontaneity and wildness may furnish the scene an air of

authenticity, how does it pertain to the film's interest in slavery? Why not edit the scene out despite the excitement with which the film crew may have observed the animals in their spontaneity? Herzog explains in an interview that

> If a scene develops differently from my original idea because of "external" elements—the weather, the environment, the actors working with each other, things like this—but does so originally and without major deviation from the original story, I will generally try to encompass those new elements into the scene. As a filmmaker, you must be open to those kinds of opportunities. (*Herzog on Herzog* 104)

Such opportunities (e.g., the scene with the two pigs) may pertain in some way to Herzog's general outlook on life and the cosmos, in which randomness and brutality reign.[11] They may also correlate to his notion of ecstatic truth, as expressed in his 1999 so-called "Minnesota Declaration on Truth and Fact in Documentary Cinema." There he argues that "there are deeper strata of truth in cinema, and there is such a thing as poetic, ecstatic truth. It is mysterious and elusive, and can be reached only through fabrication and imagination and stylization" (*Herzog on Herzog* 301).

In light of the preceding, it is not inconceivable to draw a thin connecting line between on the one hand a random event (the two pigs) in which one creature could be seen as exerting a type of control over another one and, on the other, the institution of slavery. Viewed this way, a scene like the one involving the pigs reveals an ecstatic truth and makes poetic sense with respect to the film's thematic[12] interest in slavery, particularly if we accept that only through "fabrication and imagination and stylization" can the truth about anything, including slavery, be communicated. While this may be the case, it is also fair to interrogate the appropriateness of the focus the film evinces in other moments as concerns slavery. We can, for example, draw interesting conclusions if we think about focus and perspective as related categories. While the film is undoubtedly to a significant degree about slavery, its focus on the activities and perspective of Cobra Verde—that is, a white, solitary bandit who later becomes a slave trader—is problematic. On the one hand, the figure of Cobra Verde stands as an interesting counterpoint to many others complicit in the slave trade given that he is able in some ways to identify with enslaved persons, is not averse to manual labor, and is visibly contemptuous of slave masters like Octavio Cotinho. On the other hand, the characters in the film who are unequivocally enslaved (the man, for example, who is flogged in the town square)

are voiceless. To a person, they do not speak, but *are* variously whipped, kept in holding cells, physically evaluated for sale, marched, forced to work sugarcane, mutilated by plantation machinery, forced to perform sexual acts, and so on. It seems, then, that there is at the very least a problem with the film's perspective: while the narrative focus may at times get distracted, when depicting enslavement, the camera sustains its focus more diligently. It is during these same moments, however, that the film suffers from unfortunate, one-sided lapses in perspective that prioritize a bizarre, hybrid white savior/slaver at the expense of the perspective of the enslaved.

We can ask, then, what constitutes in cinema the truth about slavery and who (in terms of fictional filmic characters) is best positioned to express that truth? Is this truth elusive and ecstatic as suggested by *Cobra Verde* and Herzog's stated film aesthetic, or is it brutally painful and direct, as suggested by Steve McQueen's *12 Years a Slave*? Furthermore, should we uphold *Cobra Verde*'s laconic and explosive white bandit/slaver as being able to communicate an indirect, metaphorical truth about slavery, or should we instead uphold the perspective of an articulate and thoughtful former slave, as is the case in McQueen's film?

If *Cobra Verde* is elusive and circuitous in its affirmations on the truth about slavery, what truth, specifically, does it attempt to express? Brad Prager provides a couple of compelling paths toward an answer, first by pointing out that "*Cobra Verde* is not intended to be a film about the history of the slave trade but one about hardship and character formation" (13). I agree with this assessment inasmuch as the film makes no claim to historical accuracy. It is not, for example, historical docudrama. In this vein, Herzog himself has indicated (in ways that seem to unrealistically describe potential relationships between history and fiction films): " . . . I do not consider [*Cobra Verde*] a historical film just as I never saw *Aguirre* as being in any way historical" (*Herzog on Herzog* 212). Similarly, while I agree that hardship and character formation are central to the film, especially in terms of the experiences of Cobra Verde himself, I would also argue that the film is in many ways about both slavery and the slave trade even if it does not pretend to be an accurate representation of the *history* of the slave trade.

Prager contends further that a central thrust in Herzog's film is to discount or challenge the role racism played in the Atlantic trade, an argument he makes in terms of the film's relationship with Chatwin's novel:

> Instead of making a film about how racist ideology subtended the
> slave trade, which would have been consistent with the aims of the
> book, Herzog actively seeks to contest the claim that racism both

motivated and was used as a justification for imperial expansion in
the nineteenth century. (Prager 2–3)

Prager's argumentation is also informed by the polemic—both for and against—
Joseph Conrad's *Heart of Darkness*. Is that, then, the "truth" about Herzog's film,
i.e., that it downplays—in ways absent from Chatwin's novel—the role of racism
in the slave trade? Although I understand to an extent why Prager might advance
such an argument, I am reluctant to subscribe to it fully because doing so en-
tails, as a starting point, interpreting Herzog's film in terms of Chatwin's novel,
which—as I explain above—is not the focus of this essay.[13] There is, however,
an additional feature of the film itself that is worth exploring.

More so than perhaps being an attempt by Herzog to contest the role of
racism in the slave trade, the "truth" about slavery and the slave trade in *Cobra
Verde* seems to lie elsewhere. This elsewhere, once again, pertains in some regard
to our earlier discussion and definitions of metaphor. If, generally speaking, a
metaphor occurs when something stands in the place of something else that is
similar, and if *Cobra Verde* is "a great metaphor on the slave trade," it is reason-
able to ask what other similar and analogous item sits opposite the slave trade
in the metaphorical equation. Through this logic, there would indeed need to
be something analogous to the slave trade in the film, thereby establishing the
metaphor on the slave trade.

My contention is that the metaphorical equation in the film runs in the
opposite direction. In other words, rather than the film being a great metaphor
on the slave trade, the slave trade in the film is itself a metaphor *for* something
else. As such, slavery and the slave trade are a secondary focus in *Cobra Verde*.
This, in turn, could explain why the film is vulnerable to accusations—not so
much of racism *per se*—but of not being forceful enough in its condemnation of
racism. Furthermore, my contention pertains to the film's management of focus,
which includes but does not limit itself to slavery. What focus, we might ask, can
exceed or transcend slavery and the slave trade? Indeed, for what "analogous"
item or concept do slavery and the slave trade serve as metaphors? The answer
is the human condition itself.

Although in an essay the historian Donald Harms ultimately focuses on the
proximity of several films to the historical record, including *Cobra Verde*, he asks
a highly pertinent question:

> In Herzog's case, the problem lies in identifying which deeper truth
> he is trying to express. Is it a deeper truth about the slave trade, or

> is he merely using a fictitious representation of the slave trade to
> express a deeper truth about the human condition? (61)

While our answers may differ, the question seems necessary. Harms, for example, echoes Prager's views about the film being about hardship and character formation when he asserts that "the film is really about the impact of the slave trade on Manoel da Silva" (77). Both Harms and Prager are right, in my estimation, but only to a point. This is because *Cobra Verde*'s focus ultimately transcends its protagonist. Allow me to explain.

In the introduction to the present volume I argued that part of the power of slavery films pertains to their ability to interrogate the very limits of what it means to be human. *Cobra Verde* does this. When, for example, Herzog explained that *Cobra Verde* is not a historical film, he added in the same breath that the film "is about great fantasies and follies of the human spirit, not colonialism" (*Herzog on Herzog* 212). On the one hand, Herzog's assertion could lend credence to Prager's views on the film's attitude toward racism given the possibility that it may be impossible for an artist or a work of art to be somehow completely extricated from politically charged discourses and realities like those surrounding colonialism and racism. Similarly, in his declarations on what his film is or is not *about*, Herzog's hermeneutics may be simplistic and ultimately self-serving. On the other hand, however, if we examine his declarations in relation to certain scenes in the film, it appears that Herzog has a point.

How, specifically, does *Cobra Verde* depict the "great fantasies and follies of the human spirit"? Or, one might add in a similar vein, the human condition? One of the ways it does this is by interrogating the dividing line between humans and other creatures, a line suggested first of all by the protagonist's nickname, Cobra Verde.[14] Beyond the examples of the pigs and Cobra Verde at the "watering hole" mentioned previously, there are additional references to animals that more explicitly place them on a level comparable to humans. For instance, in a large ceremony held in the royal compound, a courtier announces the arrival of the King: "The Leopard has risen." The same courtier then adds, as a warning to the congregation: "The dogs [insurrectionists, perhaps] assemble in the streets, and try to talk like humans. But if they succeed, it will bring a plague upon the people." Further allusions to the "human spirit" in the film seem reminiscent of Shakespeare's *Hamlet* in their morbidity. Death, after all, is yet another unifying feature of humanity. We see this in the film's opening sequence when Cobra Verde kneels over a grave and is, in fact, surrounded by graves and dead (or dying) animals. Half a world away, Taparica later shows him the graves of the Portuguese

who had previously governed the slave fort. There are, in addition, numerous verbal references and visual depictions of human skulls, which abound in the King's royal palace. When, for example, Cobra Verde and Taparica are brought, hogtied, before the King, the latter declares quite unceremoniously, "Hey, white man. One day I will drink from your skull!," just as he already has with the skulls of neighboring kings. While this essay is not the place for an anthropological investigation into fact or fiction pertaining to human sacrifice and the ritualistic use of body parts in African societies,[15] one can surmise a number of things from the King's declaration that he intends to use Cobra Verde's skull as a chalice: that doing so will reflect his complete dominion over his victim, that he intends to usurp his life force, that he intends to enter into ritualistic communion with his victim, and so on. The point, however, is that in this and similar sequences in *Cobra Verde*—and as is the case with Yorick's skull in *Hamlet*—the very essence of what it means to be human is called into question. Furthermore, one could argue that this and similar sequences add depth and texture to the narrative.

The most sustained questioning of the human condition in the film pertains specifically to the institution of slavery. Indeed, the latter serves to metaphorize the former. Despite his eccentricities and flaws, which include but are not limited to murder and slave trafficking, the title character possesses a uniquely clear and honest perspective on human existence in general and slavery in particular. In a pivotal scene toward the end of the film, after it becomes clear that the days of slavery and the slave trade are over, Cobra Verde and the captain of a slave trading ship drink a melancholic toast to the end of their dark enterprise. The latter raises his glass and remarks, "To slavery. The greatest misunderstanding in the history of mankind!" Cobra Verde retorts, "It was no misunderstanding. It was a crime." After a pause, he continues: "Slavery is an element of the human heart. To our ruin!" In making this claim, as a "fictional" character from the mid-nineteenth century, he anticipates by a century-and-a-half France's Taubira Law from 2001, which proclaimed slavery and the Atlantic trade in Africans as crimes against humanity. We might ask, however, to whom does Cobra Verde refer with the possessive article "*our* ruin"? It bears noting that the article is pluralized, suggesting a focus beyond just himself. Similarly, if slavery was a crime, a crime against humanity even, in what ways was this the case? In an interview regarding the film Herzog suggests an answer: "By showing a long line of slaves [being marched to the slave fort] in the film, the suggestion is that the entire world is implicated in slavery."[16] Cobra Verde's observation that slavery is an element of the human heart may be even more to the point: we

are all, apparently, complicit given that it is part of who we are as humans. "Our ruin," then, refers to everyone, both enslaved and enslavers. Along these lines, the crime against humanity committed by the institution of slavery would be a crime committed against everyone, by everyone. Such a broad understanding of crimes against humanity was probably not Christiane Taubira's intent in her famous law from 2001 or, for that matter, the similar declaration issued by the United Nations Conference held in Durban, South Africa the same year.

Cobra Verde's unique perspective on slavery can be attributed at least in part to the hardships he endured on the *sertão* but also to his later misadventures: shortly after arriving in Ouidah on the Dahomey coast he is held captive by its king and—as Prager astutely observes (7)—has his face painted in black tar. This scene, however, beyond commenting in some way on racism or its absence in colonial Africa, also develops one of the central ideas of Herzog's film: to wit, that—given, perhaps their common humanity—the separating lines between captive and captor, and beyond that between slave and master, is a blurry one. Indeed, even though we do not see a clear instance of this reversal in the film, the enslaved person has the potential to enslave the master, as evinced by the final words in the film, which appear on screen in the closing epitaph: "The Slaves Will Sell Their Masters and Grow Wings . . ." It bears mentioning that this epitaph is yet another instance of the lines between humans and other (in this case winged) creatures becoming blurry.

Furthermore, the monopoly on violence is not—in theory at least—restricted to the master. When, for instance, Cobra Verde takes the captain of the slave ship on a tour of his fort, he asks his guest to select a concubine from a holding cell containing enslaved young females. The captain asks, "Who are these women?" While this question may in a sense be improbable given the obviousness of the women's situation, the question has its place insofar as it provokes Cobra Verde's pithy reply: "Our future murderers." Once again: a plural pronoun, *our*. Finally, while at some moments in the film there is no doubt about whether someone is enslaved or not, at other moments there is greater ambiguity. We see this first in Brazil, in Cotinho's house: the wealthy slave owner surrounds himself with a number of Afro-Brazilian concubine/servants who may or may not be enslaved. In Dahomey, enslavement is even murkier. While many of the voiceless, enchained captives are undoubtedly enslaved and destined for the Middle Passage, there are a number of additional laborers (those, for instance, who refurbish Cobra Verde's fort) who at times seem to possess some degree of volition and at others are quite clearly coerced by the whip.

CONCLUSION

Werner Herzog's *Cobra Verde* stands as a unique contribution to the genre of slavery cinema despite the fact that the film has fallen into relative obscurity both with respect to this genre and also in terms of Herzog's own massive and stellar oeuvre. Like many of his films, *Cobra Verde* has sparked debate, partly in terms of its relationship with the novel on which it is based, but more likely on account of its own unusual treatment of slavery: a treatment that, on the one hand, prioritizes the perspective of a mercurial white bandit who becomes a slave trader and, on the other hand, one guided by the director's idiosyncrasies and aesthetic sensibilities. The film is at times erratic in its focus, but always ambiguous: it is simultaneously about and not about slavery. Rather than being a slavery film *per se*, let alone a historical film about historical slavery, *Cobra Verde* seeks a larger goal that includes but ultimately transcends the title character: to mine the depths of the human condition; a noble goal, one could argue. The problem with the film, however, is one of focus: in pursuing its lofty goal, it reduces its often ambiguous representation of slavery and enslaved persons to a vehicle designed to attain that goal. In so doing, it deprives the enslaved persons it portrays (and purports to champion) of a voice, a will, and their own opportunities for character formation: in other words, of qualities frequently associated with the human spirit.

Notes

1. The protagonist in both the novel and the film is Francisco Manoel da Silva, who is loosely based on the historical Francisco Félix de Sousa: a Brazilian slaver who did, in fact, rise to power in the Kingdom of Dahomey in West Africa. The novel contains story elements that are absent in the film; interestingly, the opposite also holds true: there are numerous story elements in the film that are absent in the novel. In addition, in Chatwin's novel "Cobra Verde" is a minor character (a "bush wanderer" who Francisco Manoel meets [60]) whose presence in the novel is limited to a few lines. In contrast, in Herzog's film, Francisco Manoel *is* Cobra Verde; that is, "Cobra Verde" is the feared protagonist's nickname. Lastly, in terms of the epigraph so prominent in the film ("The slaves will sell their masters and grow wings"), is in the novel much less prominent: it is one of Francisco Manoel's many "incoherent prophecies" (147), and it is slightly different in phrasing ("The slaves will sell their masters and *buy* wings" [147, emphasis added]).
2. Herzog has stated that Bavarian, not German, is actually his first language (*Herzog on Herzog* 22).

3. He might argue, however, that "outlier" is a relative term: "People often tell me that all my leading characters are so-called marginals and outsiders, but I always felt that a figure like Kaspar Hauser [a man in nineteenth-century German who claimed to have grown up in complete isolation] was not an outsider. *He* is the centre . . ." (*Herzog on Herzog* 68).

4. According to Paul Cronin, Kinski never threatened to kill Herzog but did threaten fellow actors on Herzog sets; he would also fire his rifle indiscriminately on the set of *Aguirre* until Herzog confiscated it (*Herzog on Herzog* 88–89). With the same rifle, Herzog threatened to shoot *him* if he abandoned the set of *Aguirre*, as he threatened to do (*Herzog on Herzog* 91). In his director's audio commentary to *Cobra Verde*, Herzog adds that it was during the making of this film that Kinski attempted to physically assault Herzog with a large stone (*Cobra Verde* 3'53").

5. See, for example, *Werner Herzog: Interviews* p. 101.

6. Indeed, my initial interest in *Cobra Verde* was based on its partial Brazilian context. This geographical context is quite clearly at most a partial one given the prominence of Africa in the second half of the film. Herzog explains in an interview when asked if Africa is the "star" of the film, as opposed to Kinski (or Brazil, for that matter): "I think so, yes. When writing the screenplay I preferred to let the story move through the action at its own speed and always felt the sequences in South America were quite heavy, while it was the African part of the story that really interested me" (*Herzog on Herzog* 213).

7. According to Prager, Cobra Verde is "Nietzschean through and through, interested in sensuality and rejecting the hypocritical morality that accompanies civility" (12).

8. Even though this part of the story is set in Brazil, the filming took place in the main square in Cartagena, Colombia.

9. David Brion Davis (p. 118), quoting Stuart Schwartz, *Slaves, Peasants and Rebels*, pp. 42–43, and Schwartz, *Sugar Plantation in the Formation of Brazilian Society*, pp. 133–34, 157.

10. See relevant discussion in Mullin pp. 34–35. See also John Thornton's "Cannibals, Witches, and Slave Traders in the Atlantic World."

11. While *Grizzly Man* was released nearly two decades after *Cobra Verde*, it is possible that the outlook on existence Herzog communicates in the former applies generally to both time periods: as part of his narration in *Grizzly Man*, Herzog comments on Tim Treadwell, who spent several summers living among grizzly bears in Alaska. In one scene showing Treadwell's own film footage, he (Treadwell) expresses grief and surprise upon discovering the mutilated cadaver of a bear cub. Herzog observes: "Here I differ from Treadwell. He seemed to ignore the fact that in nature there are predators. I believe the common denominator of the universe is not harmony, but chaos, hostility, and murder."

12. Herzog states, in fact, that his interest lies in stories not in themes (*Herzog on Herzog* 67).

13. In addition, perhaps on account of my two years' residence in Benin (the former Dahomey) I do not find Chatwin's fictional recreation of life in that country lacking in superficiality and condescension.

14. Interestingly, when Cobra Verde is appointed Viceroy of Ouidah, the King renames him Adjinakou. The King's deputy explains that in the local language this means "green snake."

15. In his *Domingos Álvares, African Healing, and the Intellectual History of the Atlantic World* (University of North Carolina Press, 2011), James Sweet describes accounts of temples in eighteenth-century Dahomey that featured elaborate and extensive use of human heads (p. 11).

16. Jean-Pierre Lavoignat interview with Herzog: "Tu n'as pas peur de mourir? Je n'ai jamais essayé," répond Francisco Manoel alias Cobra Verde," *Studio*, July–August 1987, pp. 47–52. Translated by Paul Cronin. Quoted in *Werner Herzog: Interviews* p. 104.

Works Cited

Chatwin, Bruce. *The Viceroy of Ouidah*. New York: Penguin Books, 1988. Print. [1980]

Cobra Verde. Dir. Werner Herzog. Anchor Bay Entertainment, 1987. DVD.

Davis, David Brion. *Inhuman Bondage: The Rise and Fall of Slavery in the New World*. New York: Oxford University Press, 2006. Print.

Harms, Donald. "The Transatlantic Slave Trade in Cinema." *Black and White in Colour: African History on Screen*, edited by Vivian Bickford-Smith and Richard Mendelsohn. Athens: Ohio University Press, 2007, pp. 59–81. Print.

Herzog on Herzog. Edited and with interviews conducted by Paul Cronin. London: Faber and Faber, 2002. Print.

Mullin, Michael. *Africa in America: Slave Acculturation and Resistance in the American South and the British Caribbean, 1736–1831*. Urbana: University of Illinois Press, 1992. Print.

Prager, Brad. "The Face of the Bandit: Racism and the Slave Trade in Herzog's *Cobra Verde*." *Film Criticism*, vol. 28, no. 3, Spring 2004, pp. 2–20. Print.

Shakespeare, Nicholas. *Bruce Chatwin*. New York: Nan A. Talese, 2000. Print.

Sweet, James H. *Domingos Álvares, African Healing, and the Intellectual History of the Atlantic World*. Chapel Hill: University of North Carolina Press, 2011.

Thornton, John. "Cannibals, Witches, and Slave Traders in the Atlantic World." *The William and Mary Quarterly*, vol. 60, no. 2, April 2003, pp. 273–94. Print.

Werner Herzog: Interviews. Edited by Eric Ames. Jackson: University Press of Mississipi, 2014.

Unshackling the Ocean

Screening Trauma and Memory in Guy Deslauriers's
Passage du milieu ~ The Middle Passage

Anny Dominique Curtius

I see her body silhouetting against the sparkling light that
hits the Caribbean at that early dawn and it seems as if her
feet, which all along I thought were walking on the sand . . .
were really . . . walking on the water . . . and she was travelling
across that middle passage, . . . our psychology is tidalectic like
our grandmother's action . . . like the movement of the ocean
she's walking on, coming from one continent / continuum,
touching another, and then receding ('reading') from the
island(s) into the perhaps creative chaos of the (ir) future . . .

—KAMAU BRATHWAITE

Now it is a matter of seizing and admiring a new art, which
while leaving man in his true place—fragile and dependent—
opens up to the artist unsuspected possibilities however, in
the very spectacle of things ignored and silenced.

—SUZANNE CÉSAIRE

When Guy Deslauriers's documentary *Passage du milieu* [*The Middle Passage*]
came out in 1999, some critics[1] praised the stylization of the film, the
remarkable voice-over narration that accompanies a series of staccato, blurred

images in slow motion. Yet, other critics[2] questioned Deslauriers's choice to proceed with what they perceived as over-stylized and over-poeticized dramatic images of slavery. However, people have generally wondered about the message proposed by the film, and have more precisely raised the question of the manner in which the tragedies surrounding slavery and the slave trade should have been adapted for the cinema.

Guy Deslauriers is a Paris-based filmmaker of Martinican descent who has consistently tackled the cinematic representation of the entanglements of trauma and memory in postcontact French Caribbean societies. In *Passage du Milieu*, a slave ship's hold and a captive's gripping narration of the Middle Passage constitute key paradigms through which Deslauriers and Martinican co-scriptwriters Patrick Chamoiseau and Claude Chonville dissect the repressed memory of slavery and the healing dynamics involved in a duty of memory. Haitian-born guitarist, composer, and ethnomusicologist, Amos Coulanges, composed the music, nonprofessional actors played the role of slave-captives, and Maka Kotto, a Quebec-based actor, stage director, and politician of Cameroonian descent, is the narrator of the film. For the 2003 HBO and English adaptation of Deslauriers's film under the title *The Middle Passage*, Benin-born actor Djimon Hounsou was selected as the narrator of the voice-over.

Thus, this essay seeks to explore the way the captive's omniscient narrative, the cinematic slow motions, long shots, and lap dissolves of the captive bodies in the hold complement each other, and stitch several complex layers of memory, agency, and historical modalities. Drawing from Kamau Brathwaite's tidalectics—an ecopoetic counter-epistemology to a Hegelian dialectic that underscores the anthropology of historicized bodies and voices crossing the Middle Passage and that interweaves Caribbean landscape, seascape, and history in the shaping of new Caribbean cultural forms and diasporic imaginaries—I contend that Deslauriers reshapes the slave ship's hold as an intangible heritage where spatial complexity, agency, guilt, complicity, and variously poeticized, historicized, and fragmented bodies are intertwined. Additionally, focusing on American novelist Walter Mosley's[3] rewriting of Chonville's and Chamoiseau's narration in the HBO version for a North American audience, I argue that the postcontact entanglements between France and Martinique, and the post–Jim Crow and post–Civil Rights predicaments in the U.S. that sustained the artistic imaginaries of the Martinican and American artists, unfold a tidalectical cinema of slavery in which memory, resilience, and agency are interrogated through the tenets of both Postcolonial and Trauma studies. I further contend that Deslauriers's film is an insightful example of a hybrid cinematic theory of trauma in the sense

that it encapsulates a cross-generational and diasporic cinematic postmemory of slavery.

The first Sub-Saharan African films on slavery date back to the 1960s and 70s' West African cinema of Ousmane Sembène's *La Noire de . . .* (1966), and Med Hondo's *West Indies: Les nègres marrons de la liberté* [West Indies: The Maroons of Freedom] (1979). Both films are adaptations, the former of Sembène's 1962 short story *La Noire de*, the latter of Daniel Boukman's play, *Les Négriers* [The slave ships/The slave traders]. Both films have the merit of transposing the traces of the period of the slave trade and slavery in contemporary contexts by way of a reworking of history through a memory of the past in order to reflect upon today's conditions of modern slavery in the case of Sembène, and the migrations of French Caribbean people to France through the BUMIDOM[4] in the 1960s in the case of Hondo and Boukman. With both films, this release of the memory of the slave trade and slavery is brought about by a clear dialectic between the written and the visual. Haile Gerima and François Woukouache have also questioned how to build a memory of slavery with their films *Sankofa* (1993) and *Asientos* (1994), respectively, while Roger Gnoan M'Bala articulates in 1998 a reflection on the responsibility of African kings concerning the slave trade by staging a pro-slavery king from the Gulf of Guinea in the seventeenth century in his film, *Adanggaman*. By deciding to put an end to the silence of African artists and intellectuals on slavery, these filmmakers focus the attention of Africans on this delicate topic of the slave trade and on the absence of an objective critical gaze on this particular aspect of the history of Africa in contemporary African societies. As for the French Caribbean, it can be argued that slavery is the subject that inaugurates its cinema. From the first film entirely dedicated to slavery by Christian Lara in 1980, *Vivre libre ou mourir* [To Live Free or Die], to his most recent, *1802, l'épopée guadeloupéenne* [1802, the Guadeloupean Saga] (2004), slavery has been at the heart of the concerns of Caribbean filmmakers. Slavery also remains the necessary starting point for any reflection on contemporary Caribbean societies; in that respect, one should mention Christiane Succab-Goldman's documentary *Les descendants de la nuit* [The Inheritors of Darkness] (1998), in which she has descendants of slaves and slave owners speak about the "tortures of memory caused by the sugar cane" and the various forms of coexistence between these two groups that can occur today on many levels of society, whether economic, political, social, cultural, or individual. Finally, one must pay attention to Fabrice Éboué's, Thomas N'Gijol's, and Lionel Steketee's satirical film *Case Départ* [Starting Point] (2011) that did quite well at the box office in France with more than one million tickets sold. Laughter and satire as

a way to think about slavery and racism was the major objective of *Case Départ*. On the other hand, Deslauriers's film was well received only in independent movie theatres and international film festivals.

In the opening scenes of Deslauriers's film, a historical "post-it"[5] appears on the gloomy scenery of the agitated waves of a dark ocean. The absence of light and the intensity of this dark perspective are meant to coalesce with the text[6] that appears on the screen and that reminds the audience of the horrors of the Middle Passage:

> For nearly four centuries in order to exploit the resources of the New World, Europe developed the triangular trade route. The second side of the triangle, its black underside, deported millions of Africans to America. Many died at sea. This route continues to haunt history under the mysterious name of: The Middle Passage.

The mention of the duration of the slave trade[7] in France (1670 to 1831) and in the United States (1678 to 1860), its massive human losses (millions of Africans), and its economic purpose (the European exploitation of the New World) rapidly inscribe the film within the vein of a documentary. However, at the beginning of the film, the viewer is slowly drawn closer to the waves, as the eye of the camera, through a variety of extreme close-ups, moves closer to the water, as if to excavate this history, and most specifically the voice of the narrator-captive, from the bottom of the ocean.

The intentional instability of the camera (the shots are taken from a ship) that espouses the movements of the waves intensifies the gloominess of the scenes and purports to make the viewers feel dizzy before they are plunged, through a three-second fade out, into a black hole, namely, the ocean, and an entangled and suppressed history. This feeling of dizziness imposed upon the viewers, this black hole moment, is meant to put the viewers into a state of consciousness that demands a specific mindset in order to watch what is about to be screened, to hear a captive narrator's harrowing story, and to go through a difficult process of rememory.[8] In addition to representing the state of a new consciousness, the three-second fade out can also be identified as the birthing of the proto-slaves who became the architects of the creole societies of the New World. Thus, the cinematic techniques that are deployed right from the beginning, Amos Coulanges's soothing piano, violin, and violoncello trio, the sound of the waves, and most importantly the gripping and poetic voice-over, quickly reveal that this subjective documentary cannot be identified as a docufiction, but most accurately as a performative and hybrid documentary.

Then, by interweaving the captive-narrator's voice-over account of the trans-atlantic slave trade and the peaceful presence of a young boy walking on a beach and watching the peaceful turquoise waters of the ocean, Deslauriers unveils the urgency to craft an intergenerational memory of slavery.

Two aspects of Deslauriers's film need to be discussed: first, the choice of the hold of the slave ship as the location where most of the action takes place, then the association between poetic images enhanced by scenes in slow motion and blurred images, a series of tracking shots, combined with the narration that accompanies and reinforces the photography as a way to re-appropriate history.

It is important to note that Deslauriers's objective is to inscribe the slave trade and slavery in memories as "an unprecedented genocide in the history of humanity." On the other hand, he also intends to interrogate for the peoples of the African Diaspora the very notion of heritage that has been anchored exclusively until now in monuments and statues as supports of an official colonial history. His intent is to advance the idea that the slave ship, as the central theme of the film, is a part of the cultural heritage of the peoples who have suffered slavery:

> In fact, for them, for a long time, the word heritage has been as-sociated with the monuments that bear witness to the colonial side of History, in Africa, the Caribbean, and the Americas. To valorize places such as the slave ships, that are symbols of the death of earlier peoples and the birth of "creole" peoples, to study and know them, to prolong them by appropriation is also to give them a chance to exist in the eyes of a world that has never wanted to acknowledge the extent and consequences of the transatlantic slave trade, still affecting us today. And to allow them to exist is to fight to have these slave ships become part of the heritage of humanity in general. Furthermore, it allows us, the descendants of slaves, to regard our own history not with shame (we were not the organizers of this system and of the raids that decimated Africa), but with pride: the pride of people who, out of chaos, were reborn, who became be-ings "in our own right," beings rich with history. In the face of the institutionalization of silence, looking at Slavery through the prism of the slave ship is a way for us to lay, in the garden of the countries, which organized or were accomplices to this atrocity, the first stone of the first monument in memory of the 250,000,000 anonymous Africans that came before us.[9]

Deslauriers's project is linked to a number of events that have preceded and fol-lowed the sesquicentennial ceremonies of the abolition of slavery in the French West Indies and Reunion in 1998. To this effect, one should mention Christiane

Taubira's December 22, 1998 sponsorship of a bill that recognizes slavery and the slave trade as crimes against humanity. The law was passed on May 21, 2001 and is named after Taubira, who was the deputy of French Guiana at the time, and has been France's Minister of Justice since 2012. The Taubira Law led to former President Jacques Chirac's January 31, 2006 decree[10] stipulating that May 10 be the official day of the annual commemoration of the abolition of slavery in metropolitan France. Similarly, in 1998, the City Council of Nantes, the largest French slave port in the eighteenth century, decided to erect a monument to commemorate the abolition of slavery in the French colonies. The Memorial to the Abolition of Slavery opened on March 25, 2012 and is meant to be "a testimony to a memory which the city has accepted, and stretches beyond the context of local history as it carries a universal message of solidarity and brotherhood." Former Deputy and Mayor of Nantes, Jean-Marc Ayrault declares on the Memorial's website:

> Taking responsibility for such a past, without feelings of repentance, allows us to carry on our struggles with our eyes wide open. . . . My wish is for [the Memorial] to become a place where younger generations can learn and develop awareness. The Memorial will then have fulfilled its promises: it will be a living site, a place where people unite and commit collectively to upholding the memory of past struggles and continuing our fight for the recognition and promotion of human rights.[11]

Among other events, one should also mention the *Comité devoir de mémoire Martinique* [Committee for the Duty of Memory from Martinique] created under the aegis of *Médecins du monde* [Doctors of the world] and the Committee for the Memory of Slavery presided by Maryse Condé and instituted by a decree of January 5, 2004, in accordance with the law of May 2001.

What also led to the need to fight against forgetting is a series of events such as the controversy that surrounded an auction sale in Lyon on January 12, 2005 of eighteenth-century family and commercial archives such as correspondence and old manuscripts that belonged to French ship owners and slave traffickers, and that addressed the transatlantic slave trade. Lyon residents originally from the French Caribbean, French Guiana, and Reunion strongly protested against the sale and, along with Christiane Taubira, required that these documents should not be dispersed and sold to individuals. They demanded that the State use its pre-emption rights to acquire them, in order to keep them in museums, libraries, and cultural centers, so that they could be available to the public. The second event that has a direct echo with Deslauriers's intention to redirect the duty of memory from being based on the presence of colonial monuments toward

seeking the true loci of memory in instances that are not part of official history, is the recurrent defacements of the statue of Empress Joséphine in Fort-de-France, its ambiguous restoration, and the latest symbolic re-appropriations of the beheaded statue by Sarah Trouche, a French visual and performance artist.[12]

On a global scale it is worth mentioning UNESCO's choice of August 23 as Slavery Remembrance Day as a reminder of the 1791 slave uprising in Haiti that subsequently gave birth to the Haitian Republic in 1804. Similarly in 1994, National Museums Liverpool opened the Transatlantic Slavery Gallery, the first of its kind in the world, and then the Liverpool International Slavery Museum opened on August 23, 2007, a date that corresponds to the annual Slavery Remembrance Day, but also the year of the bicentenary of the abolition of the British slave trade, and the city of Liverpool's[13] 800th birthday.

In their effort to highlight the hold of the slave ship as the central location in the film, Deslauriers, Chonville, and Chamoiseau not only interrogate the scarcity of monuments[14] related to the slave trade, but they also disentangle the thick temporality (400 years) of the slave trade, which in my opinion might be the reason why slavery is often forgotten in analyses of trauma and memory by cultural theorists in Trauma studies. Furthermore, by focusing on the hold, they make clear aesthetic and narrative choices such as using a subjective camera and a narrative approach that is both poetic and political as a way to follow the different steps that mark the physical and psychological deterioration of the captives during the crossing of the Atlantic from the island of Gorée to the Caribbean. The motions of the camera are reinforced by the commentary of the captive-narrator, a witness to the tragedy, who follows with a questioning gaze the rapes of women that will never be shown, the revolts of the captives, the bodies thrown overboard. Through a series of flashbacks, he reaches back to the raids of captives by slave traders, the exchange of captives for barrels of powder and knick-knacks. The narrator, who is also an archivist of sorts, keeps track of the duration of the crossing and his narration regularly informs us, as a leitmotiv, of the number of days that have elapsed since the ship left the island of Gorée. The story he tells is somewhat like a journal—a narrative space typical of the process of reconstructing forgotten events. As Deslauriers observes:

> Tying together a documentary story with a fictional narrative allows me to reinforce the reality of many a scene and to push my dramatization further. There exist many written documents but very few images: a few engravings that do not transcribe the complete reality since they always present the gaze of the Other on the ship's hold. It seemed important to us to set up things differently: the *Middle Passage*

is a story that comes from the hold. It is the omniscient narration of
a slave in his effort to reconstitute scenes seen from inside the hold.[15]

Besides, the narrator has a precise knowledge of the high number of captives in
the hold, "more than 600 when the ship only had room for 300," of the number of
bodies thrown at sea, and of the number of the dying when the ship approaches
the coast in the Caribbean. These precise remembrances are in contrast with the
fact that he has forgotten the name of the slave ship that has taken him away from
Africa, as well as the precise period of time when this event takes place. "The slave
trade," says the captive-narrator, "was the same time that stretches indefinitely.
The period starts under the reign of Agadja, King of Dahomey, who sold me to
the French." These contrasting blanks and excesses of the narrator's memories
are remarkably underlined by the alternating images of the slow choreography
of the bodies of the captives thrown overboard by the sailors and the slow, yet
quick and jerky motion of the slaves being flailed in the hold by the sailors. The
discourse of the narrator is not lyrical in itself. What seems to be lyrical in the
sense that it contributes to the passionate and poetic expression of individual
emotions is the way in which a collective and political message is transmitted
with the function to fill in the blanks of the untold. What is left unsaid is the
silence of the captive, dehumanized and voiceless. In that sense, Gilles Deleuze's
reflections on the function of myth and lying in non-Western cinema are perti-
nent here, insofar as such movie productions are "words in action or speech acts
that produce collective statements capable of elevating misery, the intolerable,
the unbearable to a strange positivity, the invention of a people" (*L'image-temps,
Cinéma 2* 289). The story of the personal tragedy of the narrator is indeed poetic
and political, but it is above all a speech in action or an act of non-lyrical speech
because it can be interpreted as a conscious and collective memory of slavery
whose objective is to disrupt the discourse of "masters" (Deleuze 289). As for
repetitions, as signs of the confusions and certainties of memory, the constant
return to the ship's hold constitutes the most significant leitmotiv of the film.
Most scenes have been spliced so that each one starts with several types of shots
where the framing methodically isolates in a very suggestive way, chests, shoul-
ders, a hand, an arm, part of a face. When Deslauriers approaches the bodies of
the captives in a poetic fashion with his discreet camera—since one hears no cries
of pain—he refuses to present them to the viewers as yet one more compact herd.

Text and image are not mutually cancelled by the repetitions; instead the
camera extends the occasionally imprecise memory of the narrator through the
repetition of the text and image interconnectedness. Indeed, the entire archi-
tecture of the film relies on the complementarity between the two. Deslauriers

uses the technique of lap dissolve, not only to have the end of a shot overlap with the beginning of the next shot, but also to have the story merge with the image and vice versa. For example, the story of the rapes of the women and the young girls is extended by their silence, by the slow motion over their empty gaze, by their bodies swaying with the pitching of the ship.

Unlike Haile Gerima who opted for a long, extremely disturbing[16] and graphic scene of the rape of a slave woman in *Sankofa*, Deslauriers tells us that showing the sexualized brutality against the women captives is less significant to him than the sexual traumatization that the ferocity of the rape has stitched within the mind of the young girls and the women in the hold. To me, this poetically crafted slow motion over their empty gazes is cinematically more effective than the representation of the destructive and uncontrollable force of the rape.

The three images above are the cinematic representations of the rape of the girls from Deslauriers's perspective. The following lines appear at the fifteenth minute of the film, and are then repeated at the thirty-fourth minute:

> Allow me to evoke only in the light of day what happens during the night. We don't like to think about it. We turn our thoughts away from it. . . . The lecherous sailors laboring on top of the women and underage girls . . .

The third image where the little girls raises her head toward the shackles hanging from the ceiling of the ship's hold is powerful as the slow movement of their gaze

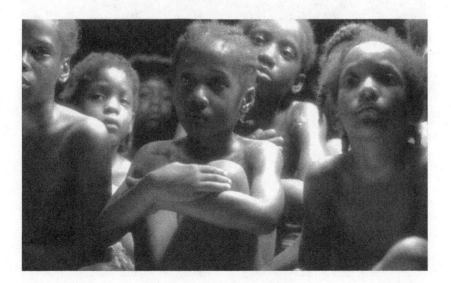

at the shackles is accompanied during twenty-three seconds by the sound of the shackles that resembles that of wind chimes. Through this cinematic technique, Deslauriers insightfully shows how the girl's innocence and childhood have been stolen by the traumatic experience of the rape. Here, the wind chimes normally symbolizing peacefulness and safety have been transformed into the shackles of shame and dehumanization. This is a poignant moment where Deslauriers ultimately creates a female captive presence in the film. He does not give the young girls a real voice, there is no female voice-over sharing the narration with

the male captive narrator in order to tell the horrific experiences of rape, and the bodies thrown overboard are only male captive bodies. Instead, Deslauriers chooses to build a multiple voice dynamic by giving the underage girls a symbolic voice through their silence and the slow motion of their bodies.

It is important to remember that the narrator commits suicide when the ship nears the coast of the Caribbean. The narrator diving in the sea is a significant ending because it allows him to join the other dead captives so that together, he says, "we may form an army that will forever disturb the peace of the ocean." Therefore the entire narrative is articulated by a narrator/archivist who recalls the entire crossing from the bottom of the ocean. In addition, anxious as he is to find out how much the child who appears at the beginning of the film, and by extension any descendant of a slave, know about their own history, the un-named captive also becomes a storyteller who tells the child the history of the Middle Passage by taking him "back in time."

In the last minutes of the film, the young boy reappears. He is now watching with curiosity a cruise boat being fitted out in a port of the Caribbean. The film ends in a sort of coda, with the repetition of a scene from the beginning where that same boy is walking along the beach. The memory of the young boy, "im-peached" and "manipulated" (Ricoeur 575–76), is revived by this reminder since the captive-narrator gave him the resources necessary to fight against forget-ting. So the traces that lay dormant in the unconscious mind of the child at the beginning of the film are now participating in the process of irrigating memory and allowing the boy, now made aware of the slave trade, to question, at the end of the film, which links may exist between the cruise boat and the slave ship.

TRANSMITTING THE TRAUMA OF SLAVERY

As previously mentioned, Walter Mosley took the liberty to change the original scenario by Chamoiseau and Chonville. Here, in order to analyze the distinction between Mosley's text and the original version, I will focus on two moments of the film: the opening scene and the closing scene when the narrator addresses the young boy. Several questions arise as we notice the intensity of Mosley's specific vocabulary that contrasts with the subdued pace of Deslaurier's account of the violence of the slave trade. In an interview with Rhonda Stewart in *The Crisis*, Mosley declares:

> I was hired by HBO a while ago to basically rewrite the voice-over
> of Patrick Chamoiseau's extraordinary film *The Middle Passage*. It's
> as if you went back 300 years and got on a slave ship with a video
> camera. It's like a documentary. (49)

Later in the interview Mosley explains how rewriting the voice-over gave him the impetus to write *47* (2006), a book for children and young adults about slavery. Thus, one can wonder if Mosley was not strongly encouraged by HBO to reconfigure Deslauriers's poetic rumination so that the film could attract a larger North American audience. Indeed, HBO's acquisition and programming of the film was part of the HBO's 2002 Black History Month campaign. Because of its "realistic look at the horrors of the trans-Atlantic slave trade," it was chosen for a programming dynamics that "not only explores the historical relationship between Africa and America, but is also reflective of the African-American culture today." Similarly, HBO created local community outreach efforts,[17] and students from Texas Southern University, Clark University, Temple University, and Howard University were given the opportunity to participate in screenings of *The Middle Passage* and panel discussions featuring academics and celebrities.

Likewise, is Mosley ideologically convinced that the Martinican filmmaker and scriptwriters did not succeed in using the appropriate narrative tenets to adequately address the memory and trauma of slavery, and its after-effects in the African Diasporas? While HBO's and Mosley's intentions are somewhat intertwined as regards the impact of the film on a North American audience, I argue that while the first ones are pedagogical and also may be aimed at profit, Mosley's is profoundly related to the transmissibility of the trauma of slavery to generations of North American spectators.

OPENING SCENE

Original Version

The child coming this morning to the sea could not imagine the horrors its waters have witnessed. He would never believe what took place there with the help of the trade winds and sea currents. Were it not for the raging tsunami, we would never know the magnitude of an earthquake, the memory of which lies deep beneath the waves. To explain it to the child, you must go back over the ocean, back over to the other shore of time, to run straight into the beginning. And yet, it wasn't so long ago. . . . For me, it was only yesterday.

Mosley's Narration

The child who looks out over this ocean cannot imagine the horror it holds. It is beyond him to understand what took place on these waters. No hurricane or mythological sea-demon can compare to the dreadful fate visited upon the black skin of the humanity across this

bloody sea. When it comes time for us to teach our children about this malevolent age, we must be willing to remember the holocaust in its entirety. This will prove to be a difficult task. Many of us seek to forget or even deny the monumental genocide and enslavement of these millions. For others it may seem like some long forgotten past, but for me it was only like yesterday.

The words "genocide" and "holocaust" do not appear in the original version; similarly, the four metaphorical layers, namely "trade winds," "sea currents," "tsunami," and "earthquake" are absent from Mosley's narration. Thus, while the original text suggests that slave rebellions and the subsequent abolition of slavery can be compared to a tsunami, and the slave trade and slavery to an earthquake, Mosley's text relies on the terms genocide and holocaust, well known by the North American audience, to render the horrors of the historical event. Mosley's distance from the original version is already visible in the historical "post-it" I have analyzed earlier, since he describes more explicitly the triangular slave trade and names the various regions of the Americas that have imported slaves from Africa. To me, in Mosley's perspective, the ecopoetical metaphors of the tsunami and the earthquake are a strategy of avoidance, and are useless for the didactic purpose of the film, hence his desire to move away from the poetic tone of Chonville's and Chamoiseau's narration. I see Mosley's use of the terms "genocide" and "holocaust" at the beginning of the film as a way to create a parallel between two systems of dehumanization: the Holocaust and slavery. It sets the preconditions that are necessary to unravel amnesia and craft a process of individual and collective healing in a post-Civil Rights U.S. society that has not yet put an end to the racial divide but has reconfigured it.

CLOSING SCENE

Original Version

Child, is it still time to search for who was responsible? Was the kingdom of France more to blame than the kingdom of Abomey? Is Africa that has lost its population for no profit more innocent than Europe that made all the profit? When there are too many culprits, you should fear that justice shall never be rendered in the tribunal of humans and that responsibilities shall be dissolved between wave and wind like letters of indulgence, leaving on our lips only the taste of salt and bitterness.

Mariner, the first of your dreams, the one no one ever remembers, will forever be haunted by an accursed slave ship. The crew is not made up

of European sailors, but of disheveled negroes who raise to the skies their broken chains. They have massacred the crew and not knowing how to sail, they wander aimlessly onto the ocean of your nights.

Mosley's Narration

Child, is this time to seek out who is to blame for this monumental crime? Should the criminals and their beneficiaries be given amnesty? Or should the guilt be shared by the European slavers, the New World nations, and by the kings of Africa who betrayed their people and their continent? There are no innocents here except for those millions of souls lost at sea or enslaved in foreign lands, those born into servitude without knowledge of their ancestors or their gods. And there are the children of the children of slaves born into the world of their grandsires' masters robbed of the light we knew. The victims of these crimes call out for justice. Their silent cries echo throughout the world on the bitter desiccated lips of the dead and in the impoverished hovels and cold prisons that house the descendants of slavery and attempted genocide. Will justice ever be done in the courthouse of humanity? Or will all responsibility evaporate on the waves and the wind, like letters of indulgence, leaving nothing on our lips but the taste of salt and bitterness? Until this dark history has been brought to light, our world will be haunted by an ill-fated slave ship. On that ship, the crew is not made up of European sailors, but of bushy-haired Negroes raising their broken chains to the sky. With no knowledge of sailing, they roam endlessly on the ocean of our eternal night.

In the section addressed to the mariner, Chamoiseau and Chonville anchor the duty of memory in a metonymic perspective. The concept that is brought forward is that of the European *sailor* haunted by a cursed slave ship taken hostage by captives wandering on "the ocean of [his] nights" (the sailor's). Using such a referent, the *part* (the sailor) evokes and questions the *whole* that is us, a you that each viewer of the film is in need to identify. However, the word *sailor* is not present in Mosley's text. So, the camera lens moves from a metonymic focal point toward a whole, identified as the world ("our world will be haunted by a slave ship . . . roaming endlessly the ocean of our eternal night"). Mosley's narration is like an apocalyptic ultimatum declaimed in front of the entire world. One can feel urgency in his text. If dark history is not brought to light, the world will be plunged into an eternal night. By contrast, the rhetoric proposed by Chamoiseau and Chonville remains poetic while keeping the text within the context of sailing, of the Middle Passage. In that particular frame, the mysterious mariner is the one who is called to witness, which is not the case with Mosley's

text. So, as far as the act of contrition of the peoples responsible for the slave trade is concerned, the rhetoric of the metonymy works on the viewers' minds differently from the non-poetic discourse chosen by Mosley.

Paying close attention to the specific distinctions between Mosley's narration and Chamoiseau's and Chonville's text, one notices that in the first sentence, Mosley recasts the idea of "*responsabilités*" [responsibilities] present in the original script, into that of a "monumental crime." He insists on the idea of criminality by wondering whether criminals and their beneficiaries will be given amnesty, thus adding a question and using two terms, "criminals" and "amnesty," that are not used in the original text. Furthermore, while the HBO version ignores the direct reference to the kingdom of Abomey as one of the major locations of the slave trade, it makes it a point to bring together all who participated in the slave trade: the kings of Africa, the European slave traders, as well as nations of the New World.[18] In Mosley's text "the slave-trading African kings who betrayed their people and their continents," the words "betrayal," "criminality," "amnesty," "robbery" and "attempted genocide" not only constitute a whole range of meaningful terms that are not part of the vocabulary used in the French version, but also inscribe the HBO version in clear opposition to the original poetic rumination, and Deslauriers's smooth cinematic approach. In addition, the HBO version is more explicit on the necessity that justice be rendered, and on the need for the boy to observe the repercussions of the slave trade on the descendants of slaves, at the economic, social and psychological levels (this passage does not appear in the original version).

When considering the two versions, it is important to point to the fact that the public targeted by the HBO version is a North American English-speaking public, while the targeted audience for the original version is primarily Caribbean, Franco-French, European, and ultimately global. Could therefore the two versions complement each other as a double narrative that calls on two types of viewers coming from different post-slavery dynamics in order to build a memory of the slave trade and slavery?

The end of the original text invites the viewer to consider a peaceful process of re-appropriating memory; using a different text as a detour, with the intention of nourishing in different ways the memory of the boy to whom the film is addressed, as well as the memory of the viewer, Walter Mosley modifies the original meaning of the film by short-circuiting the rhetoric of a poetic serenity present in the original version. Then one can say that Mosley not only explicitly fills in the blanks of history, but also what he perceives as the blanks of what remains implicit, incomplete, unsaid in the original text. The reasons why Chamoiseau and Chonville approach the situation with a rhetoric that is different from Mosley's have to be apprehended in a socio-historical context that is specific to each society where the

cultural heritage is not the same and the psychic ramifications, the consequences, and repercussions of slavery, are intertwined differently in the collective unconscious and inscribed in dynamics that reveal postcolonial and post-segregationist interferences. As a result of these two different contexts, the approach to the deconstruction of mainstream discourses that reflect each post-emancipation mentality differs significantly. While Mosley puts in place an aggressive counter-discourse that takes place within a post-segregationist North American nation, Chonville and Chamoiseau choose a poetic and symbolic path within the framework of a Martinican society in a situation of postcontact with regards to the French nation. In order to give substantial meaning to the story of the captive in the film, and in order to build a post–Civil Rights memory of slavery in the U.S., Mosley feels the need to shun the poetic rhetoric of the original version of the film. This is because the twenty-first century descendants of the captives of the Middle Passage still inhabit the scars left by slavery. For Mosley, a pattern of disenfranchisement of African American communities is the key after-effect of slavery in the United States, and the conclusion of the film is the ideal space to address this issue. In Mosley's narration, "impoverished hovels" refers to government-sanctioned racial oppression, supporting race-based segregation, racial profiling, and a high unemployment rate. Similarly, the phrase "cold prisons that house the descendants of slavery and attempted genocide" refers to the disproportionate incarceration of African American males that Michelle Alexander metaphorically calls the New Jim Crow. Indeed, for Alexander, "a facially race-neutral system of laws has operated to create a racial caste system" (201). In Mosley's perception, this is what the conversation between the young boy and the captive narrator in the film needs to focus on. As the correlation between the slave ship and the cruise ship does not sufficiently trigger the emotional states to remember the slave trade, for Mosley a specific post–Middle Passage narration, with specific excess in the narration, is necessary for the post-victim of the slave trade.

A TIDALECTICAL CINEMA

I would like to return to the notion of "transmissibility" discussed above to articulate some concluding remarks on the dis/similarity between the 1999 and 2003 versions of *Passage du milieu*. A key paradigm in Trauma studies, the concept of transmissibility has generated insightful debates among trauma theorists, and the major question that stands out in this debate is whether or not trauma can accurately be represented, and how. In other words, these debates question the way literary or cinematic narratives, with their aesthetic specificity and original-

ity, fictionalize and transform the historical events and the traumatic experience they represented for the real victims who were the first to be affected.

Indeed, in his critical perspective on "elucidating trauma" and its after-effects in cultures and on people, Dominick LaCapra observes that using "concepts derived from psychoanalysis should not obscure the difference between victims of traumatic historical events and others not directly experiencing them" (*Writing History, Writing Trauma* ix). Commenting on LaCapra's observation, Irene Visser remarks that in "obscuring differences and collapsing distinctions the broad usage of transmissibility risks the trivialization of trauma" (275). She further states that to avoid the confusion between direct and indirect victims, trauma should be defined as "the memory of an overwhelming and violent wounding directly incurred as a first-hand experience in order to differentiate it from secondary or vicarious traumatization" (275).

Differentiating between direct and indirect victims for LaCapra, or discussing how, according to Cathy Caruth, the moving and sorrowful *voice* is released through the wound, are critical positionings that Deslaurier's film insightfully invites us to revisit. Similarly, Caruth's criticized[19] discussion of latency that consists not in the forgetting of a reality that can hence never be fully known, but in an inherent latency within the experience itself (*Unclaimed Experience* 17), leads me to contend that these debates in Trauma studies are at the core of *Passage du milieu*. They help to unravel the subsequent tidalectical conversation between Mosley, Deslauriers, Chamoiseau and Chonville who carve out the adequate rhetorical strategies and methodological tools to represent the horrors of the slave trade, from their own mindset.

Transmissibility and the unforgettable history of colonization are the fundamental epistemological task at the core of the field of Postcolonial studies since, by historicizing the Sea, it has articulated its specific discussion on memory and trauma. By constantly reworking the unforgettable, Postcolonial studies have indeed encapsulated the Middle Passage—"the packed cries, the bone soldered by coral to bone, . . . the bones ground by windmills, . . . the drowned women," (Walcott, "Sea is History")—as the foundational locus of memory from where to re-craft a Black Atlantic imaginary. Such an historicization of the Atlantic may have certainly fueled the imagination of many, including myself, who automatically related Jason de Caires Taylor's first underwater sculpture park "Vicissitudes"[20] located off the coasts of Grenada, to the Middle Passage.

When Aimé Césaire pairs memory to blood in the following stanza, his poetic intention in 1939 is a significant prelude to the epistemological weight of trauma in Postcolonial studies:

> How much blood in my memory, how many lagoons! They are
> covered with death's-heads. They are not covered with water lil-
> ies. Lagoons in my memory. No sashes of women on their banks.
> My memory is circled with blood. My remembrance is girdled with
> corpses! (*Return to my Native Land* 90)

Thus, Toni Morrison's notion of rememory that helps her characters in *Be-
loved* to problematize the recovery of the past, and the difficulty of processing
the opacity that lies underneath the acts of interpreting, concealing, avoiding,
healing, and crying, directly speaks to Aimé Césaire's blood-stained memory. The
multilayered grammatical dimensions of Morrison's rememory (a noun and verb
in *Beloved*) and its extension through the verb "to disremember," when they are
excavated from the context of Morrison's novel and applied to the problematics
I deal with in this study, work on the unconscious. They allow me to interrogate
the after-effects of slavery from diverse angles, that of the young boy in the film
standing on the wharf and looking at the cruise ship, or walking on the beach
and gazing at the horizontal line of the sea, but also that of any viewer from the
African Diaspora or from any communities in the world. Morrison's rememory
is a circular grammar of a conscience that tackles the opacity of trauma and the
entangled movements of healing and remembering 400 years later, and as such
"rememory" sits within Marianne Hirsch's larger paradigm of postmemory. It
is significant to remark that even though Hirsch conceptualizes postmemory
from the context of the Holocaust and from personal experience, she invites us,
as cultural theorists, to disseminate postmemory into various opaque trauma
realities where the "generation after" relates to and remembers the collective and
personal trauma experienced by the previous generation. The relational process
is actualized by an "imaginative investment, projection and creation," and for
Hirsch, "all of us share certain qualities and symptoms that make us a *postgen-
eration* since "postmemory reflects an uneasy oscillation between continuity and
rupture" (4–6).

Therefore, when Irene Visser remarks that trauma theory is "increasingly
critiqued as inadequate to the research agenda of postcolonial studies," and
when she argues for developing "possible directions in which to expand trauma's
conceptual framework in order to respond more adequately to postcolonial ways
of understanding history, memory and trauma" (270), she overlooks Hirsch's
incisive bridging between some of the tenets of trauma theory and postcolonial
theory. As Hirsch recalls, postmemory "shares the layering and belatedness of
the other posts" (postmodernism, poststructuralism, postcolonial, which does not
mean the end of the colonial but its troubling continuity), and "aligns itself with

the practices of citation and supplementarity that characterize them" (5). Thus Visser's and LaCapra's discussion of the necessary differentiation between first-hand experience of trauma and vicarious traumatization, and Visser's call for "the openness of trauma theory to non-western and non-Eurocentric models of prolonged and cumulative traumatization," can find in postmemory, "a structure of inter- and transgenerational return of traumatic knowledge and embodied experience" (6). Hirsch's postmemory astutely dialogues, then, with Françoise Lionnet's and Shuh-mei Shih's intellectual project that they label the "creolization of theory" where the anthropological and sociolinguistic concept of creolization becomes essential to rethinking modes of theorizing cultural, literary, political and historical issues.[21]

Similarly, Visser omits a discussion of how postcolonial studies, through the work of psychiatrist and postcolonial thinker Frantz Fanon, had already pioneered the necessary interconnectedness between Trauma studies and Postcolonial studies. In his analysis of the psychological effects of colonization, racism, and colonial wars, while dislocating Eurocentric psychoanalysis and ethnopsychiatry, he tackles essential disorders such as individual and collective alienation, *lactification, éréthisme affectif* (affective erethism) or pathological hypersensitivity, neurosis, psychological splitting, to name a few. One might be tempted to wonder whether Fanon is more a Trauma theorist than a postcolonial theorist; nevertheless, I think that the most accurate remark to be made is that Fanon's work has insightfully showed the necessity to bridge both fields in critical analyses of the after-effects of slavery.

At the end of *Black Skin, White Masks*, as Fanon, with a Sartrean and existentialist tone, seeks "endlessly to create himself in the world he's heading for," and as he disputes the relevance to "ask today's white men to answer for the slave traders of the seventeenth century," he declares:

> I am a black man, and tons of chains, squalls of lashes, and rivers of spit stream over my shoulders. But . . . I have not the right to admit the slightest patch of being into my existence. I have not the right to become mired by the determinations of the past. I am not a slave to slavery that dehumanized my ancestors. (204–5)

This now famous declaration "I am not a slave to slavery" encompasses harassing, yet fundamental questions: how to inherit from a horrific historical past, how to fight against cultural collective amnesia, and carve out critical awareness and radical agency in order to fruitfully manoeuver around the ghosts of Manichean categories such as slave-masters, colonizers-colonized.

To me Fanon's 1952 pioneering discussion for an interconnectedness between what would later become Trauma studies and Postcolonial studies is central to the ongoing criticism of Western Trauma theory for having shaped a critical apparatus that is too Eurocentric, that refers heavily to the Holocaust, that does not acknowledge the sufferings of non-Western and minority groups, and as Stef Craps argues, that "has failed to live up to the promise of cross-cultural ethical engagement" (46). Craps contends that because founding figures of Trauma theory such as Caruth, Felman, Hartman, LaCapra, or Laub "tend to take for granted the universal validity of definitions of trauma and recovery that have developed out of the Western history of modernity . . . trauma theory risks assisting in the perpetuation of the very beliefs, practices, and structures that maintain existing injustices and inequalities" (46). Craps's assertions echo Roberto Beneduce[22] and Michela Borzaga's critiques of PTSD (Post traumatic stress disorder), the widely used formulation elaborated by the American Psychiatric Association upon which trauma theorists heavily rely, and that does not consider the daily aspects of trauma in the life of disenfranchised, persecuted, tortured, and disempowered people. While Beneduce strongly argues that PTSD is "an hegemonic category that linearizes, rationalizes and domesticates what often belongs to the realm of the incomprehensible and the chaotic" (*Archeologie del trauma* 29), Tariana Turia, former New Zealand member of Parliament and co-leader of the Maori Party, proposes the term "postcolonial traumatic stress disorder," and Alvin Poussaint and Amy Alexander craft the term "post-traumatic slavery syndrome."

In Deslauriers's film the symbolic interaction between the child and the captive-narrator embodies these zones of entanglements discussed above. The boy whom we assume is Martinican, interrogates and revises through his individual narrative what he has been told about slavery, and what he has ultimately internalized. The geography, the beach, the harbor, and the cruise ship sustain the boy's narrative, and although they do not contain any visible traces of trauma, they are elected by Deslauriers as the perfect spaces that trigger the meanders of memory. Caribbean nature has camouflaged the painful traces of the transatlantic slave trade, and Deslauriers builds a lucid eye for his camera and for the boy. These eyes are transgenerational in the sense that they need serenity and inquisitiveness to see beyond the visible reality.

Yet, these seascapes do not correspond to Mosley's geography, and when he re-appropriates Deslauriers's film and makes it his own, his lucid eye needs to rely on another type of transgenerational memory. That is why the "impoverished hovels and cold prisons that house the descendants of slavery" are important in his mindscape. At the beginning of the film, when Mosley re-appropriates

and expands the term "holocaust," I see how he echoes Hirsch's assertion that "Holocaust can no longer serve simply as a conceptual limit case in the discussion of historical trauma, memory, and forgetting," and how her discussion of postmemory is "in dialogue with numerous contexts of traumatic transfer" (18).

Drawing from Brathwaite's remark that in the Caribbean "our psychology is not successfully dialectical in the way Western philosophy has assumed people's lives should be, but tidalectic" (34), I contend that the triangular structure—horror, victim, viewer—(Kaplan and Wang 10), the multiple layers of memory and historical consciousness that the horrors of the slave trade require, the crosscutting techniques often used in the film to bridge the present and the past, collectively carve out a tidalectical conversation between the 1999 and the 2003 versions of *Passage du milieu*. Both versions interrogate the unwarranted comforting cure at the end of the film, the vicariously traumatized experience of the viewers, and their key position as witnesses who ultimately carve out an agency in order to be transformed by the film.

CONCLUSION

The film is dedicated to "Africa the Crucified, to the slaves of yesterday, and their descendants of today in Mauritania, Sudan and elsewhere . . ." With the mention of Mauritania and Sudan, the original version insightfully links the tragic fate of a global community of modern slaves to that of the slaves transported across the Atlantic Ocean from the sixteenth century onward. Thus the film is inscribed within this immediacy and this contemporaneity that may be necessary, as I suggested at the beginning of this study, in order to disentangle the thick temporality of slavery that would make it an event that happened too long ago to remember. Walter Mosley did not connect the Middle Passage to contemporary and ongoing modes of modern slavery "in Mauritania, Sudan and elsewhere . . ." His dedication says: "To Africa, the Crucified . . . To the slaves of yesterday, and their descendants today . . ."

The specificity of Deslaurier's film is that the voice-over and the cinematic effects poetically complement each other. Thus, when Mosley rewrites the narration of the captive, can we conclude that we have ultimately two different films? Since the images and the cinematic techniques have not been modified, the film keeps its aesthetic particularity. However, the poetic vein that characterizes it, that is maintained until the very end of the film, and reinforced through the heartrending a cappella chorus that one hears as the film's credits unfold, is at odds with the tense tone of the narration reconfigured by Mosley.

Nevertheless, the "process of intergenerational transmission" (Hirsh 18) and the tidalectical conversation that is at play in the film between the Martinican and American artists, between the viewers and the victims of the Middle Passage, are to me an astute case study in our effort to be transnational producers of a "convincing theory" of the cinema of slavery, and in our constant efforts to refine our analysis of trauma, "rememory," "disremembering," and silence in this era of memory.[23]

Notes

1. Olivier Barlet, *Africultures* 23, December 1999.
2. Esther Iverem, founder and editor of SeeingBlack.com remarks that Deslauriers "treats the action on the ship in a fairly benign way, and that for such a visceral experience, there is an odd and somber detachment in the film." She further observes that "the poetic meditation lends an air of calm to the story and a sense of passivity to the captives who seem to offer their wrists to be shackled." Along that same vein, for Wendy Knepper, while "the concept of the film is intriguing, it fails to rise to the challenge of depicting events that have become part of the collective trauma of history because the film's plodding pace and strangely pacific tone are at odds with the representation of the horrors and violence of enslavement." The meditative reverie, she explains, does not create any strong effect on the screen, but projects on the contrary, a distancing effect (188).
3. Mosley is the author of a mystery series, science fiction novels, and political monographs.
4. Bureau pour le développement des migrations intéressant les départements d'Outre mer [Bureau for the development of the migrations of people from the French Overseas Departments]. For an analysis of this migration phenomenon in a documentary film, see my article "Utopies du BUMIDOM: Construire l'avenir dans un là-bas postcontact," [Utopia of the BUMIDOM: to Build a Future in a Postcontact Overseas].
5. Here I refer to Marianne Hirsch's expansion of Rosalind Morris's suggestion that in this era of "posts," ("postcolonial," "posttraumatic," "postsecular," "postracial") the post "functions as a Post-it that adheres to the surface of texts and concepts, adding to them and thereby transforming them in the form of a Derridean supplement" (*The Generation of Postmemory* 5). My use of the term "post it" insists on the value of the text that appears on the screen, and reinforces the strong meaning of the complex layers of memory that are meshed in the film's subjective account of the slave trade, through the memory of an imagined dead slave-captive.
6. The excerpts quoted throughout my study are the English subtitles from the French original version.

7. I refer here to the U.S. and French slave trade since Deslauriers, Chonville, Chamoiseau, and Mosley reconfigure a memory of the slave trade from these two different dynamics. Although France had occasionally transported slaves across the Atlantic from 1643 to 1669, a massive uninterrupted slave trade started in 1670. For the USA in 1645 and in 1650 a small number of slaves were transported, and a steady trade started in 1678. One should bear in mind that illegal slave trade considerably supplied the plantation system, since the slave trade was officially abolished in 1817 for France, and in 1807 for the USA.

8. Toni Morrison's concept of rememory will be examined later in my analysis of Deslauriers's film.

9. www.raphia.fr/images/films/passage.html last accessed January 2015. (French and English versions of the background notes).

10. Articles 1 and 2 of Decree # 2006–388 of March 31, 2006 stipulate that the ceremonies will be organized "in Paris and in each metropolitan department at the initiative of the prefect as well as in the *lieux de mémoire[sites of memory]* of slavery and the slave trade."

11. http://memorial.nantes.fr/en/le-memorial/une-volonte-politique/ last accessed April 2015.

12. In September 1991, the statue of Empress Joséphine was beheaded in La Savane, a city park in Fort-de-France, Martinique. No one has claimed responsibility for the beheading, the head has never been replaced, and the event continuously generates compelling debates among intellectuals, contemporary artists, politicians, and the general population of Martinique. While some Martinicans see Joséphine as the pride of the island as the Empress of the French, many remain vehemently critical, and associate her solely with her supposed role in the reinstatement of slavery in 1802. Thus, the beheading of the statue, and its various symbolic defacements relocate Joséphine within the entanglements between the repressed memory of slavery by official History, and the need to reconfigure this official History. For a thorough analysis, see my article, "Of Naked Body and Beheaded Statue: Performing Conflicting History in Fort-de-France."

13. It would be relevant to do a comparative analysis of how the museum ultimately inscribes these historical events in the city's memory and Caryl Phillips's reflections in *The Atlantic Sound* where Liverpool is described as "a place where history is so physically present, yet so glaringly absent from people's consciousness." Phillips observes: "But where is it any different? May be this is the modern condition, and Liverpool is merely acting out this reality with an honest vigour" (117).

14. The Cap 110 Memorial at Anse Caffard, inaugurated in 1998 in the town of Diamant on the southwestern coast of Martinique, The Ark of Return, inaugurated in Washington DC in 2015, and the Memorial ACTe inaugurated in Pointe-à-Pitre, Guadeloupe in 2015 are meaningful loci of memory.

15. "Le point de vue des captifs." Interview of Guy Deslauriers by Olivier Barlet, *Africultures* 8, mars 1998. Translations are my own unless otherwise indicated.

16. To this effect Gerima observes: "To me, if I indulged in graphically filming the rape scene, I would be going against my purpose. I think I did not shoot that scene graphically. I shot it to show that white men's relationship to black women was like an outright treatment of an animal. It's not this love story. I wanted to show that he rapes her the way he would rape a cow or an animal. He was not having a human relationship with this African woman. And so, to me, I don't see it as graphic. Graphic, to me, is going into the elements of sex. For example, in that scene I don't even show him; I don't even care to show him. I only show the map of the idea of what I wanted to express.

17. Similarly after its debut on HBO, *The Middle Passage* was "screened at various museums which included the Apex Museum in Atlanta, Dusable Museum in Chicago, South Dallas Cultural Center in Dallas, California African-American Museum in Los Angeles, the Anacostia Museum in Washington, DC, and the Studio Museum of Harlem in New York City. Furthermore, through a sweepstakes, consumers were given the opportunity to win a trip for two to the African continent by answering trivia questions on HBO programming." http://www.prnewswire.com/news-releases/hbo-commemorates-black-history-month-with-journey-to-today-campaign-75586347.html last accessed February 2016.

18. Here, I may question Steven Spielberg's vision in *Amistad* in which the kings of Spain were more to blame than American slavers.

19. For example, see Alan Gibbs, *Contemporary American Trauma Narratives*. Edinburgh: Edinburgh University Press, 2014.

20. "Vicissitudes" represents a circle of children of diverse ethnic groups holding hands. After the sculpture was interpreted as being anchored within the tragedies of the Middle Passage, Jason de Caires Taylor subsequently explained that it was not his intention to relate "Vicissitudes" to the transatlantic slave trade. "I am very encouraged how it has resonated differently within various communities and feel it is working as an art piece by questioning our identity, history and stimulating debate." For an interesting discussion about this palimpsestic reading of the sculpture, see Davide Carozza's post: https://sites.duke.edu/blackatlantic/sample-page/depictions-of-the-middle-passage-and-the-slave-trade-in-visual-art/levitate-windward-coast-and-vicissitudes-curatorial-statement/jason-de-caires-taylor-vicissitudes/ last accessed February 2016.

21. For Lionnet and Shih, as a notion that has embodied since the fifteenth century the rigid borders but also the fissures between hegemonic, subaltern groups and ethno-classes, creolization contains the flexibility and porosity that are necessary to disarticulate our academic division of labor that generally fails to account for

the degree to which our politics of knowledge, the genealogies of our specialized disciplines, and our disciplinary formations are mutually constituted.

22. Roberto Beneduce, a psychiatrist and medical anthropologist, founded in 1996 and currently heads the Frantz Fanon Center in Turin. A leading center in ethnopsychiatry, it "provides support services, counseling, psychotherapy and psychosocial support to immigrants, refugees, victims of torture, asylum seekers, foreign women victims of trafficking and sexual exploitation and unaccompanied minors."

23. Hoffman, Eva. 2004. *After Such Knowledge: Memory, History, and the Legacy of the Holocaust*. New York: Public Affairs, (203).

Works Cited

Alexander, Michelle. *The New Jim Crow. Mass Incarceration in the Age of Colorblindness.* New York: The New Press, 2010/2012. Print.

Beneduce, Roberto. *Archeologie del Trauma: Un'Antropologia del Sottosuolo*. Roma-Bari, Laterza Edizioni, 2010. Print.

Borzaga, Michela. "Trauma in the Postcolony: Towards a New Theoretical Approach." *Trauma, Memory, and Narrative in the Contemporary South African Novel: Essays*, edited by Ewald Mengel and Michela Borzaga. Amsterdam, New York: Rodopi 2012. Print.

Brathwaite, Kamau. *ConVERSations with Nathaniel Mackey.* Staten Island, NY: We Press & Xcp; Minneapolis: Cross Cultural Poetics, 1999. Print.

Caruth, Cathy. *Unclaimed Experience: Trauma, Narrative, and History.* Baltimore: Johns Hopkins University Press, 1996. Print.

Césaire, Aimé. *Return to my Native Land.* Translated by Emile Snyder, Paris: Présence Africaine, 1971. Print.

Césaire, Suzanne. "Alain et l'esthétique." *Tropiques* vol. 2, July 1941, pp. 53–61. Print.

Craps, Stef. "Beyond Eurocentrism: Trauma Theory in the Global Age." *Beyond The Future of Trauma Theory: Contemporary Literary and Cultural Criticism*, edited by Gert Buelens, Sam Durrant, and Robert Eaglestone. New York: Routledge, 2014, pp. 45–61. Print.

Curtius, Anny Dominique. "Construire une mémoire postcoloniale de l'esclavage dans *Passage du milieu*." *Images de soi dans les sociétés postcoloniales*, edited by Patricia Donatien. Paris: Editions Le Manuscrit, 2006, pp. 529–43. Print.

———. "De cuerpos desnudos pintados y de estatuas decapitadas: La historia interpretativa de Fort-de-France." *Revista de Crítica Literaria Latinoamericana*, "Francia en Latinoamérica/Latinoamérica en Francia," vol. 39, no. 78, 2013, pp 175–94. Print.

———. "Of Naked Body and Beheaded Statue: Performing Conflicting History in Fort-de-France." *Critical Perspectives on Conflict in Caribbean Societies of the Late 20th and Early 21st Centuries*, edited by Patricia Donatien and Rodolphe Solbiac. Newcastle upon Tyne: Cambridge Scholars Publishing, 2015, pp. 9–30. Print.

————. "Utopies du BUMIDOM: Construire l'avenir dans un là-bas postcontact." *French Forum*, vol. 35, no. 2–3, Spring/Fall 2010, pp. 135–55. Print.

Fanon, Frantz. *Black Skin, White Masks.* Translated by Richard Philcox. New York: Grove Press, [1952], 2008. Print.

Hirsch, Marianne. *The Generation of Postmemory. Writing and Visual Culture After the Holocaust.* New York: Columbia University Press, 2012. Print.

Iverrem, Esther. "A Dry Middle Passage." http://www.seeingblack.com/x022102/middlepassage.shtml. Accessed 1 April 2015.

Kaplan, Ann, and Ban Wang (eds.). *Trauma and Cinema. Cross-Cultural Explorations.* Hong Kong University Press, 2004. Print.

Knepper, Wendy. *Patrick Chamoiseau: A Critical Introduction.* Jackson: University Press of Mississippi, 2012. Print.

LaCapra, Dominick. *Writing History, Writing Trauma.* Baltimore & London: Johns Hopkins University Press, 2001. Print.

Lionnet, Françoise, and Shu-mei Shih (eds). *The Creolization of Theory.* Durham: Duke University Press, 2011. Print.

The Middle Passage. Dir. Guy Deslauriers. HBO Films, 2003. DVD.

Morrison, Toni. *Beloved.* New York : Alfred A. Knopf, 1987. Print.

Passage du milieu. Dir. Guy Deslauriers. Kreol Productions, 1999. DVD.

Phillips, Caryl. *The Atlantic Sound.* New York : Alfred A. Knopf, 2000. Print.

Poussaint, Alvin F., and Amy Alexander. *Lay My Burden Down : Suicide and the Mental Health Crisis Among African-Americans.* Boston: Beacon Press, 2000. Print.

Stewart, Rhonda. "Walter Mosley: The Hardest Working Writer in the Publishing Business. An interview by Rhonda Stewart." *The Crisis,* January/February 2006, p. 49. Print.

Turia, Tariana. "Tariana Turia's speech notes." Speech to NZ Psychological Society Conference, August 29, 2000, Waikato University, Hamilton, New Zealand. http://www.converge.org.nz/pma/tspeech.htm/ Accessed May 2016.

Visser, Irene. "Trauma Theory and Postcolonial Studies." *Journal of Postcolonial Writing,* vol. 47, no. 3, July 2011, pp. 270–82. Print.

Walcott, Derek. "Sea is History." *The Star-apple Kingdom.* New York: Farrar, Straus, and Giroux, 1979. Print.

Woolford, Pamela. "Filming Slavery. A Conversation with Haile Gerima." *Transition,* vol. 64, 1994, pp. 90–104. Print.

Mulattos and the Challenges of the Third Space in *Roble de Olor / Scent of Oak*

Mamadou Badiane

R ace and racialism are two sides of the same coin, both supported by junk science that attempts to demonstrate the primacy of a world hierarchy and to objectify a collective race. Race and racialism allow for the acceptance of the "other" only with great reluctance and then only if the other's status can be justified by being a product of *mestizaje*. This is precisely the message communicated by the film *Roble de Olor* (*Scent of Oak*), a Cuban film starring Cuban actor Jorge Perugorría and Dominican actress, Lía Chapman, now residing in Spain. Lía plays the freed black daughter of a wealthy Frenchman who left Haiti for Cuba in the nineteenth century. While researching the figure of the mulatto in nineteenth-century Cuban literature and film, I became familiar with the film *Roble de Olor* whose world premier by the ICAIC was held in the Charles Chaplin room in Havana on October 20, 2003. The film was presented in celebration of Cuban Culture Day. In this article, I examine some of the challenges faced by the mulatto character in this film, obstacles that lead to the emergence of a new hybrid identity, a third space that straddles the conventional categories of black and white that structured the social reality of the time. According to Guadalupe Mejía Núñez:

> The *Mulatta* emerges from an act of *mestizaje* initiated during colonization, the mixing of two races that results in a stereotyped beauty

and sensuality constituting a source of inspiration in the artistic currents of Hispanic America. Her value is placed in the context of pleasure (she is a lover or a prostitute), but she is not considered as the wife of either a white or black man, nor is she included in Christian religious practices, given that her beauty and attractiveness have been associated with the diabolic. The fusion of two bloods and two cultures have given this woman an exuberant sexuality described in Hispano-American poetry and narrative through images and metaphors that associate her with a paradisiacal space.[1]

Certainly, this sensualized and "paradisiacal space" between two opposing entities is what Homi Bhabha and Frantz Fanon have referred to either as a "third space" (in the case of Bhabha) or an "impossible ontology" (in the case of Fanon).

Of course, the third space implies the existence of a first and second space, categories used to order and categorize colonial society. As Homi Bhabha affirms, "The productive capacities of the third space have a colonial or postcolonial provenance" (38). Frantz Fanon, among the first theoreticians to describe racial liminality argues that:

> As long as the black man is among his own, he will have no occasion, except in minor internal conflicts, to experience his being through others. There is of course the moment of "being for others," of which Hegel speaks, but every ontology is made unattainable in a colonized and civilized society. It would seem that this fact has not been the question. In the Weltanschaung of a colonized people there is an impurity, a flaw that outlaws any ontological explanation. (109–10)

One of the most significant problems created by racial subjugation is that it stifles the creation of new ontological possibilities that move beyond fixed notions of identity. Even the mulatto, though clearly neither totally white nor black, is unable to be categorized as a third entity. His/her ambiguous status has not gone unnoticed, however. In *Falsas crónicas del sur*, for example, the obstacles confronted by the emergence of mulattos are brought into focus with the rhetorical question posed by Miss Florence: "How is it possible to have so much beauty and so little compassion in the same face? Could it be, as Mr. Lind says, that this hybrid island race (mulatto) has been born without a soul?" (26). In this case, the female mulatto's in-between status is resolved by eliminating her from the category of the human at all. She has no soul and therefore no ontological status in the realm of mankind. It is this process that Anny Curtius refers to as "désontologisme" in her article "Désontologisme et Réontologisme des esclaves

et des marrons (runaway slaves)." In nineteenth-century slave society, the mulatto is stripped of his/her humanity.

As is well known, in all spaces where people have been the victim of certain kinds of subjugation, the first cultural space is the one occupied by the native who is able to move easily and freely through his/her indigenous habitat. A second space is superimposed on the indigenous territory by the dominant colonial structure. The occupying force does not allow the indigenous population to articulate an authentic identity in an independent way. Finally, there is a third space created by a hybridized culture combining elements of both the indigenous and the occupying identities. This mestizo identity struggles to find a voice and legitimacy in a society where those of the first and second space are each already vying for supremacy. This phenomenon has been defined by Néstor García Canclini as "Sociocultural processes in which structures or discrete practices that exist in a separate form, combine to generate new structures, objects and practices."[2] These new forms can, though praised as progressive in some parts of the world, create a sense of unease for members of the first and second space. In the absence of authorization by the cultural elite, these hybrid forms can lay no claim to any legitimate status. However, it bears noting that it is not only the cultural elite that distrusts these hybridized realities. They are also resented by subjugated races who see them as a distracting presence that only serves to exacerbate the already high tensions between the first and second space.

The encounter between these different cultural forms (first, second, and third space inhabitants) turns out to be fairly difficult. Bhabha points out that "it is very difficult, even impossible and counterproductive, to try and fit together different forms of culture and to pretend that they can easily coexist" (Rutherford 209). The process of hybridization "gives rise to something different, something new and unrecognizable, a new area of negotiation of meaning and representation" (211). Some of these difficulties are discussed in my research on the emergence of a third space in the novel *El baúl de Miss Florence* by Ana Lydia Vega. In my analysis of this novel, I tried to show "the way in which Ana Lydia Vega reflects on the birth of a conflicted third identity, nourished in the veins of the various civilizations present in Puerto Rico in the mid nineteenth century."[3]

In the film *Roble de Olor*, the birth of this third entity is represented by the main character, Úrsula Lambert. Her race and religion will be the cause of her arrest, imprisonment, and death. Other manifestations of hybridity can be found in the film's music and also in the more humane plantation that she and her husband founded. In the film, we witness the creation of a new musical rhythm that contrasts sharply with the classical music embraced and valued by the host

and music master, the great Enrique Goetz. The coffee plantation that Lambert and her husband founded, where blacks are not mistreated, also causes concern in that it departs from conventional Cuban practices towards slaves.

Úrsula Lambert is a mulatto woman from Haiti with both money and slaves. In 2005, filmmaker Rigoberto López sent a letter to sociologist Guenther Roth, in which he admits "the movie is fictional and does not tell the actual biography of Cornelio Souchay and Úrsula Lambert. It is, however, inspired by the actual love relationship of the couple in the first half of the nineteenth century and by the coffee plantation Angerona, founded by them, the ruins of which everybody can still visit. Thus, the movie is historical fiction, a metaphor." He adds that if the fabled romantic relationship between a German man and a Haitian mulatto woman has endured to this day, it is surely because the "oral tradition in the region has preserved the legend of the love between the German Cornelio Souchay and the Haitian Úrsula Lambert" (1). According to Guenther Roth, Úrsula is "a free mulatta from Haiti, who fiercely defends her Afro-Caribbean religious and revolutionary heritage at her trial for witchcraft and abolitionism" (1). Although fictionalized, the story of Úrsula's loves and struggles personifies the painful emergence of the third space in nineteenth-century Cuba.

In a recent article, "Nicolás Guillén en el laberinto del mestizaje cubano," I point out the risks associated with practicing any non-Catholic form of religion during the colonial period. In *Los cultos Afrocubanos*, Miguel Barnet highlights this aspect of Cuban culture:

> Forced by the repressive imposition of the Catholic Church, which frequently throughout history recognized only its own preeminence, the black African produced one of the most complex sociological phenomena by syncretizing their divinities with the Catholic saints. It was a give and take of elements and attributes that, nevertheless, could not alter the basic concepts transplanted from Africa.[4]

Úrsula, for her part, refuses to deny her strongly held non-Christian religious beliefs. During the trial concocted by Havana officials intended to imprison her for the rest of her life, she affirms that "my spirits accompany me."[5] Úrsula remembers the glorious past of her parents and grandparents who defeated the French in a wave of successive revolutions in nineteenth-century Haiti that culminated in 1804 with the declaration of independence of the first black republic in the Americas. Úrsula believes that she is helped, accompanied, and guided by the spirits. She reminds the tribunal during the proceedings that Napoleon Bonaparte invaded Haiti and Spain, but that it was the Haitians who defeated

the French troops. The film director acknowledges this in an interview with Sandra del Valle Casals:

> Although for some, the Haitian movement could mean simply the "validation" of a race, one must consider that the Haitian Republic was the result of the first great revolution for independence in the Americas, which introduced a new conception of independence for man, making it a real phenomenon established in social circumstances. Before the Haitian movement, this concept had a limited philosophical use, as it was employed by the *encyclopédistes* (Voltaire, Diderot ...) who spoke of the independence of man in relation to the concept of God and the monarchy: these were philosophical speculations regarding individual liberty which could not be detached from a political concept of independence. It is the Haitian Revolution that introduces this concept in our day, because blacks, precursors to the wars of independence on the continent, struggled not only for their own liberty from slavery, but also for the independence of the totality of the country.[6]

It is thus perfectly understandable why Úrsula would ask herself, "Where are the demons that they [the white prosecutors] talked about?" When she declares in her defense that "I will never stop being what I am. No one and nothing will make me deny what I am,"[7] it becomes evident that society cannot accommodate her identity, thereby revealing the necessity of a third space wherein she might find acceptance. At a ceremony where illustrious Cuban families were gathered, the white women mocked Úrsula for being "black but different." When confronted by these insulting comments, Úrsula re-writes their assessment by claiming she is "different but black." The labyrinth of identity is complicated further in this dialogue because the mulatto woman is identified by the other women as a descendent of a French father and a Haitian mulatto mother. Úrsula is clearly torn between her pride of race and the knowledge that she is nevertheless different from her counterparts. This is analogous to Anibal Quijano's general comments on Latin America's socio-political situation:

> This is obviously a relationship of social hierarchy, of "superiority" and "inferiority" between "whites," "Blacks," "Indians" and mixed race "mestizos," which during the second half of the 19th Century also came to include "Asians," the "yellow" and the "olive-skinned." Since the 18th century, the increase of mixed race people led to a more complex and difficult hierarchy of "colors" and tones, to discrimination among the castes it generated. This social scale remained in place until well into the 19th Century. (25)

These linguistic conflicts should come as no surprise given the fact that the film is set in Cuba during the first half of the nineteenth century. During this time, slavery was a vigorous economic, social, and political institution. Nevertheless, the Haitian revolution had important ramifications for the rest of the Caribbean. As David Patrick Geggus notes in his book, "In the period between the American and the French revolutions, Saint Domingue produced close to one-half of all the sugar and coffee consumed in Europe and the Americas as well as substantial amounts of cotton, indigo, and ground provisions" (5). After the Haitian revolution, the French empire lost one of its Caribbean jewels, and Haiti declared itself the first black republic in the Americas.

Haiti's success undoubtedly had serious economic and political repercussions for the rest of the Caribbean. The revolution in Haiti exposed their economic risks, and this, according to many critics, had a negative impact on the wars of independence in Cuba. Ada Ferrer notes that, "After the Haitian Revolution, Cuba replaced colonial St. Domingue as the world's largest producer of sugar" (2). Also, as a consequence of the defeat of the French in Haiti, a large part of the racially diverse French population fled to Cuba because they no longer found acceptance in Haiti. Úrsula Lambert, the black woman who would fall in love with the young German Cornelio Souchay, came from a prominent Haitian family, now scorned in post-revolutionary Haiti. This fear of a racial uprising in Cuba similar to that of Haiti has been thoroughly explored by Aline Helg in her widely read book *Our Rightful Share: The Afro-Cuban Struggle for Equality, 1886–1912*. Discussing the fears that certain Cubans had toward men of color she writes that:

> The first fear was that of the Haitian Revolution and, related to it, the fear of an Afro-Cuban uprising and an Afro-Caribbean conspiracy to make Cuba a black republic. It addressed Cuba's whole white population and implied that any separate Afro-Cuban organization could evolve into a Black dictatorship and a massacre of whites. Dating back to the Haitian Revolution, this fear had legitimated the annihilation of slave rebellions and of the Conspiracy of La Escalera in the first half of the nineteenth century. (17)

The fear of a Haitian-style revolution in Cuba is prominently in evidence in *Roble de Olor*. The film revives an ideology of fear already developed by José Antonio Saco with regard to the proportion of blacks to whites. One of the major landowners in the area warns Don Souchay of the danger during a visit to Angerona. The sugar baron was surprised by "a more human version of slavery

in which blacks outnumber whites three to one. And they also know how to play
the violin and direct an orchestra. If today they are their own masters, perhaps
tomorrow they will be our masters and rulers of our island."[8] This hostile attitude
prevailed in the literature of the time. Elsewhere I have examined this fear that
was prevalent in a certain segment of the Cuban population in the nineteenth
century.[9] The director of *Roble de Olor* also acknowledges the far-reaching impli-
cations that the Haitian Revolution had on Cubans in an interview with Sandra
del Valle Casals published by La *Jiribilla*:

> The Haitian Revolution isn't only about that country nor what mo-
> tivated the triggering forces of this great event, rather as an historic
> and political event, it transcends these frameworks to become a
> substantial, fundamental point of reference for the modern world.
> (Casals n.p.)

In the film, the Cuban ruling class in the first half of the nineteenth century was
well aware that Úrsula Lambert fled to Cuba with her slaves and that she had an
enormous amount of money. This is what allowed her to start what would become
the second most important coffee plantation on the island. Bertha Martínez
Páez, in her article "Una Pequeña crónica para Úrsula Lambert: la diosa negra
del cafetal Angerona en *Indice*," notes

> This coffee plantation became the second on the island according
> to Reverend Abiel Abbot during his visit in 1838, with more than
> 750,000 coffee plants, and by 1839 it was first with a million coffee
> plants according to Salas and Quiroga. This same year Cirilo Vil-
> laverde would spend two days there, as he relates in the last chapter
> of his book, *Excursión a Vuelta Abajo*. Many visitors, famous people,
> intellectuals, painters, and so on, spent time at the plantation admir-
> ing its magnificence and documenting it in chronicles, paintings, and
> so on. Nevertheless, Úrsula's presence is not reflected in any of these,
> so prevalent was the social and racial discrimination: because we
> consider that this relationship must have been an "open secret" given
> that his family arrives from Germany somewhere around 1835, and
> even their most intimate friends knew of her presence and position
> at the plantation, as attested in many official documents.[10]

The first half of the nineteenth century is depicted in the film as a time
of tragedy, enigma, and suffering for the simple reason that it coincided with
slavery, an institution that naturally forbade marriage between a white man and

a black woman.[11] This is perhaps what explains why a statue of Angerona, the Roman goddess of silence and fertility, was erected in honor of the plantation. This symbolic sculpture was the only way Úrsula could be recognized for her efforts. Bertha M. Páez explains that:

> Yes, she is the other goddess of Angerona Coffee Plantation. Possibly to honor herself and the silent love that she and plantation master Don Cornelio Souchay had, the white marble statue was installed. She is the roman goddess of silence and fertility of the fields over which she still presides and welcomes people to these blessed lands which are simultaneously enigmatic and majestic ruins lest later generations forget the beautiful story of an intelligent German protagonist, a beautiful Haitian woman, more than a hundred African slaves and their descendants, as well as the rest of the white family, in other words, Angerona is to us: the union of three continents Africa, Europe, and America and of four cultures: the African, German, Haitian, and Cuban. Each brought the best of itself so that today, almost two centuries later, this great story is still alive.[12]

The forced encounter between different cultures in such a limited geographical space engenders the racial and identity clashes that dominate the film, *Roble de Olor*. It bears noting, however, that, the hundreds of well-treated slaves depicted in the film contradict the harsh reality of slavery in Cuba. Racism and intolerance condemn love between two different races—a white gentleman from Germany, and a mulatto woman from Haiti—to brutal failure. But the film also highlights the difficulties the mulatto in general confronts in nineteenth-century slaveholding society. As Ulises Rodríguez Febles correctly notes,

> *Roble de olor* is the song of the impossible, unrealizable love between cultures and human beings from different horizons.... It is the contradictory history of the region, an analysis from the drama of man, the power of ideologies, breaking down the nature of the human being and individual and collective liberty.[13]

The failure of the relationship between Úrsula and Souchay typifies how difficult it is to establish a space beyond the binary divisions of black and white, a third space represented by the distinctiveness of the mulattos in nineteenth-century Cuban society. The mulattos' situation in the film depicts many of the obstacles that hinder the emergence of a third space, especially when one small but dominant group establishes the rules of the game and constructs an official social hierarchy within a multicultural society. As Bertha Páez bitterly notes, the slave-

holding system looked down on Úrsula for the simple fact of her being a woman of color in an age characterized by the rigid categories of slavery. The third space shatters at Úrsula's feet. Both her presence and integration into high society of nineteenth-century Cuba is denied, despite her being Don Souchay's economic superior. Her participation in the coffee plantation's success is visible and noted in various testimonies, but mainstream Cuban society refuses to acknowledge her contributions. This is the absence lamented by Bertha Martínez Páez.

It is important to remember that Cuban colonial society was rigidly structured in order to control all possible alliances. Verena Martinez-Alier has thoroughly examined these restrictions in her book *Marriage, Class and Colour in the Nineteenth-Century Cuba*:

> In 1776, the Spanish Crown enacted a Pragmática Sanción aimed
> at preventing unequal marriages resulting from the allegedly ill-
> understood freedom of marriage. Parental consent to marriage was
> made a formal requirement for those under twenty-five years of age
> and/or living under parental tutelage. (1)

The importance of controlling marriages is underscored during the trial of the young Úrsula when Souchay, accused by the prosecutor of having a relationship with the mulatto girl, admits that he was not legally married to her. The priest of the local church who was present calls her a "Concubina!" [Concubine], thus identifying her as a morally transgressive female. In this environment, the need to control marriage is underscored when Úrsula, a third entity in that she is neither wife nor concubine, nor black or white, nor slave or master, is ultimately defeated. Just after winning the award at a social gathering for "best mask of the new year" (perhaps an allegorical reminder of the mulatto's need to mask her identity to find acceptance) and after being applauded warmly by her guests, she begins to dance with her husband before the adoring crowd. This symbolic union was meant to signify the public acceptance of her marriage in the eyes of the townspeople. However, just at this moment, the guards enter to arrest Úrsula. The whole celebration was orchestrated to publicly expose her downfall and humiliate her. Accused of witchcraft and abolitionist intentions, she and her husband risk also losing their property. Even the young couple's lawyer, Don José Álvarez, warns them of society's capacity to do harm. According to the young lawyer:

> The ills of nineteenth-century Cuban society are lies and envy. The
> lie is the body of this country. Lies and envy are her pains and nerves.
> Intransigence and intolerance are her blood. Her face is hypocrisy.
> Two faces, two images, two morals.[14]

In the face of such opposition, Souchay responds with a question that establishes his rebellious commitment to his partner: "Do you know what love is?"

Souchay had not realized how threatening Cafetal Angerona was in the eyes of the Cuban ruling class. The economic, social, and historic success of a racially mixed couple raised fear and suspicion on the part of the white population of the period. This likely explains the numerous fires on the plantation that were set by the self-defense brigades. The racially mixed couple is attacked not only in the courts, but also physically, on their plantation. Various elements combine to augment the mulatto woman's failure. The consequences of Úrsula's downfall extend well beyond the individual's specific circumstances, and find expression in a wide variety of nineteenth-century literary texts.

Cecilia Valdés and *El otro Francisco* are two novels that were turned into films and brought to the big screen the eternal problem of the non-integration of the mulattos into nineteenth-century Cuban society. These filmic examples suggest how difficult it was for female mulattos to construct an individual identity. The first few pages of *Cecilia Valdés* illustrate the mulatto young girl's ambiguous status:

> To which race does this girl belong? It's difficult to say. Neverthe-less, an expert eye would notice that her red lips have a dark border or edge and that the glow of her face ends in a kind of darkness where her hair emerges. Her blood was not pure and one could be certain that somewhere in the third or fourth generation there was Ethiopian mixed in.[15]

This phenotypic confusion is reflected also in the abstract, almost antithetical, description provided by Cecilia's grandmother: "mariposa sin alas" [a butterfly without wings] (80). Perhaps the grandmother foresees the sad fate that will befall mulattos during slavery, their inability to escape (sin alas) their hybrid status ("de la raza híbrida e inferior" [from a hybrid and inferior race] *Cecilia Valdés*, 108). This status of inferiority would hound many until their death.

The mulatto woman tended to be a victim of her skin color, a distinction that provided her with a more sexualized role in slaveholding society as is pointed out by Vera Kutzinksi: "Of particular importance about the sexual and racial stereotype of the mestiza or mulata, . . . are its intricate and contradictory ties to the ideological construction of that imagined community called Cuba. . . . In the case of the mulata, high symbolic or cultural visibility contrasts sharply with social invisibility" (*Sugars' Secrets* 7). The outsider status of Úrsula Lambert in *Roble de Olor* can undoubtedly be explained by her situation as a mulatto woman, a racial category that she embraces with great pride, but one that is feared by

her counterparts. Through her efforts, the third space is proudly affirmed, but nevertheless defeated.

Úrsula is distinct from her land-owning Cuban counterparts not only physically, but also as a result of her religious beliefs. She publicly recognizes her gods and her syncretic spirits. This leads her principal accuser, Souchay's cousin Miss Hesse (played by Raquel Rubí who won the Premio Caricato in 2003 for best supporting actress in a film), to affirm that Úrsula was transforming into something, morphing into an unknown entity. As a consequence of Miss Hesse's false accusations, Don Souchay pushed her to the ground and insisted that she "pídele perdón a esta tierra" (Ask this land to forgive you). This passage recalls the Real Maravilloso of Alejo Carpentier's *El reino de este mundo* where Mackandal transforms into several beings in order to attack slave owners. In an interview that appeared in the *Afro-Hispanic Review*, Rigoberto López, the film's creator, concedes that "the film is very Caribbean as it moves in the poetry of magical realism and is inspired by a story of real love on which is constructed the fictitious discourse."[16]

It is this fictional discourse that explains perhaps the more "humane" nature of slavery in the film. More realistic films focus on the documented mistreatment of slaves. However, the common and cruel types of punishment meted out to slaves in films such as *El otro Francisco*, *La última cena*, or *Cecilia Valdés* are toned down in *Roble de Olor*. The primary type of suffering depicted in this film is emotional rather than physical. The theme of impossible love, so prevalent in the Romanticism of the nineteenth century, constitutes the primary source of Úrsula and Don Souchay's suffering. At the beginning of the film, the transport of a few injured slaves alludes to the mistreatment and suffering of slaves in colonial societies, but beatings, lynching, the use of shackles, mutilations, whippings, and other forms of corporal punishment are not depicted graphically in the film. The few times that Don Souchay raises his voice to slaves are in response to his German cousin's false accusations of sexual abuse that were brought against an elderly slave. Anyone watching the film will be struck by the scene where the racist cousin of the German succumbs to "tropical magic" and surrenders herself up to a sweaty and muscular slave. This incident constitutes yet another stereotype about blacks and peoples of African descent, and the scene is in stark contrast to another scene in the film where a white man, that is to say, a supposedly civilized and enlightened man, seduces the "black woman," i.e., Lambert. In the later scene, the camera lingers on the more civilized and more Europeanized *mestiza* woman, an object and symbol of pleasure and voluptuousness/sensuality. The scene depicts in detail the sexual encounter that has the potential to produce hybrid identities. Later scenes reveal a sexual encounter between Lambert and Souchay

while riding a horse. In contrast to the scenes depicting love-making by a white man, the sexual encounter between a black man and white woman is portrayed as uncivilized and lascivious. Rather than focus leisurely on the encounter, the camera avoids it altogether, thereby allowing omission to suggest what the film dares not depict. Indeed, Miss Hess invited the young slave to her room with the intention of convincing Don Souchay that it was impossible to "civilize blacks."

The slaves of Angerona plantation are as a-typical as the protagonist and constitute a third space of their own. They work as if they were employed by any typical industrial factory. Their weekends were free, they could go to the clinic whenever they fell ill, they worked regular hours, and they even created an orchestra under the direction of the great mulatto director Juan de la Cruz. While it is true that work in the nineteenth-century sugar cane fields was much more difficult than on coffee plantations, the freedoms afforded to slaves at Angerona are nevertheless unusual and difficult to understand. During a visit by colonial authorities to the coffee plantation, Mr. Crisóstomo (a sugar baron) was quite surprised to learn that runaway slaves were not a problem on the plantation's operations. Another guest was bewildered by the "limitless" freedom of Angerona's slaves. On this subject, Guenther Roth has noted that:

> In movie, romance, commentary and news items, and also some historical accounts, fiction, fact and misinformation have been mixed up with one another. While filmmakers and literary writers have poetic license, historians search for the facts, which include, however, the cultural and political impact of fictions. Movie and romance proceeded from some facts to imaginative invention. (2)

It is quite possible that director Rigoberto López took some artistic license to make us live in a world completely removed from reality. One must, however, note that even these more humanely treated slaves were never given the possibility to gain freedom.

Nevertheless, the famous Angerona coffee plantation, named by a mestiza in honor of a Latin goddess of silence, is a legendary achievement. The hardships endured by hybridized people in the film illustrate the strict hierarchical status of Cubans that characterized colonialist society and underscore the limited social/ cultural space in which people with black skin were confined. Beyond work on the plantation, their only other activity depicted is making music. The limited access to higher intellectual pursuits by blacks is also depicted in the Antillean and Caribbean worlds found in Maracas' *La Ópera de Illán Bacca*, Carpentier's *Los Pasos Perdidos*, and Wilson Harris's *The Palace of the Peacock*, wherein black

people are assigned mastery over the folk arts while the hard sciences are cast as the province of whites who kept these intellectual endeavors for themselves. The mulatto figure serves ostensibly as a bridge between the world of the free whites and the black slaves. Rigoberto López envisions this hybridized figure as a mestiza woman with a noticeable African phenotype, but who is presented as progressive and "civilized" (Europeanized), a forerunner of the contemporary Afro-Caribbean ideal. In the music of the film as well, the emergence of a third space can be found in the confrontation between Juan de la Cruz (a mulatto musical director) and a master of European classical music, the great Handel.

The film offers a common fictionalized representation of racialized perspectives that combines a loose interpretation of history with moralizing dialogues to communicate a subjective propagandist message. The end of the film could not be more idealistic: a mulatto musician extols sensitivity as the only path to liberation and happiness, a conclusion quite appropriate for an age that failed to sufficiently denounce its racialist hypocrisy. *Roble de Olor*, after attempting to show a gentler kind of Cuban Revolutionary film, also ends with the same predictable racialism, that is to say, the defeat of the non-white "other."

Notes

1. "La *Mulata* surgió de un activo mestizaje iniciado durante la Colonia, la mezcla de dos razas dio por resultado un estereotipo de belleza y sensualidad que constituyó una fuente de inspiración en las corrientes artísticas de Hispanoamérica. Su valorización se ha dado dentro del contexto del placer; es amante o prostituta, no se la concibe como esposa del blanco ni del negro, tampoco se la incluye dentro de una práctica religiosa-cristiana, ya que su belleza y su atractivo han sido asociados a lo diabólico. La fusión de dos sangres y dos culturas han dado a esta mujer, una exuberante sexualidad que se describen en la poesía y la narrativa hispanoamericana a través de imágenes y metáforas que la asocian dentro de un espacio paradisíaco." Unless otherwise indicated, translations are mine.

2. "procesos socio-culturales en los que estructuras o prácticas discretas, que existían en forma separada, se combinan para generar nuevas estructuras, objetos y prácticas" (14).

3. "la manera en que Ana Lydia Vega reflexiona sobre el nacimiento de una conflictiva tercera entidad, que se nutrió de las venas de las varias civilizaciones presentes en Puerto Rico a mitad del siglo xix" (Badiane, "Tempranos choques," 883).

4. "Forzado por la imposición represiva de la Iglesia Católica, que en períodos históricos frecuentes no reconocía sino su preeminencia, el negro africano produjo uno de los más complejos fenómenos sociológicos al sincretizar sus divinidades con los santos

católicos. Toma y daca (give and take) de elementos y atributos que, sin embargo, no pudieron alterar los conceptos básicos trasplantados de África" (39).

5. "mis loas me acompañan"

6. Aunque para algunos el movimiento haitiano pudiera significar simplemente la 'validación' de una raza, hay que pensar que la República de Haití fue resultado de la primera gran revolución de Independencia de América, que introdujo una nueva concepción de independencia para el hombre, convirtiéndolo en un fenómeno real, asentado en las circunstancias sociales. Antes del movimiento haitiano, este concepto tenía un valor limitado a lo filosófico, tal y como era manejado por los enciclopedistas (Voltaire, Diderot . . .) quienes hablaban de la independencia del hombre frente al concepto de Dios y de monarquía: eran especulaciones filosóficas en torno a la libertad individual, de lo cual no se desprendía una interpretación política del concepto de independencia. Es la Revolución de Haití la que introduce esa noción en el pensamiento de nuestros días, porque lo negros, precursores de las guerras independentistas de nuestro continente, lucharon no solo por su libertad como esclavos, sino por la independencia total de su país.

7. "nunca dejaré de ser lo que soy. Nadie ni nada me hará negar lo que soy."

8. "una versión más humana de la esclavitud" and that "los negros están en proporción de tres a uno en relación con los blancos. Y no sólo saben tocar el violín y dirigir una orquesta. Si hoy son dueños de ellos mismos, tal vez mañana sean dueños de nosotros y de nuestra isla."

9. *The Changing Face of Afro-Caribbean Cultural Identity: Negrismo and Negritude.* Lanham, MD: Lexington Books, 2010, p. 16.

10. "Este cafetal se convierte en el 2do de la isla según el reverendo Abiel Abbot en su visita en 1838, con más de 750 000 cafetos, y ya en 1839 según Salas y Quiroga era el primero con un millón de cafetos. En ese mismo año también Cirilo Villaverde pasa 2 días en él, así lo relata en el último capítulo de su libro *Excursión a Vuelta Abajo*. Muchos visitantes, personalidades, intelectuales, pintores, etc., pasaron por este cafetal, admirándolo en su magnificencia, dejando constancia en crónicas, grabados, etc. Sin embargo, la presencia de Úrsula no aparece reflejada en ningún relato. Cuánto aún pesaba la discriminación social y racial: porque consideramos que esa relación debió ser "un secreto a voces," ya que desde la familia de él que llega de Alemania alrededor del año 1835, hasta los amigos más allegados conocen de su presencia y posición en el cafetal, así consta en muchos documentos oficiales."

11. The French Colonial System also applied the same rules in its colonies. The *Code Noir* (1685) had articles that dealt specifically with marriage between Europeans and blacks. Article XI stated clearly: "Défendons très expressément aux curés de procéder aux mariages des esclaves, s'ils ne font pas apparoir du consentement de leurs maîtres. Défendons aussi aux maîtres d'user d'aucunes contraintes sur leurs esclaves pour les marier contre leur gré" (13). (We forbid priests from conducting weddings between

slaves if it appears that they do not have their masters' permission. We also forbid masters from using any constraints on their slaves to marry them without their wishes).

12. "Sí, ella es la otra diosa del Cafetal Angerona. Posiblemente en honor a su persona y a los amores que en silencio mantenían ella y el dueño de la hacienda Don Cornelio Souchay, se instaló la de mármol blanco, la diosa romana del silencio y la fertilidad de los campos que aún preside y da la bienvenida a esas tierras benditas y también a las enigmáticas y a la vez majestuosas ruinas para que no olviden las generaciones precedentes, la bella historia que allí protagonizaron un inteligente alemán, una hermosa haitiana, más de un centenar de esclavos africanos y su posterior descendencia, así como el resto de la familia blanca, o sea, lo que para nosotros es Angerona: la unión de tres continentes África, Europa y América y la de cuatro culturas: la africana, la alemana, haitiana y cubana. Cada una aportó lo mejor de sí, para que llegara a nuestros días, casi dos siglos después, su gran historia."

13. "*Roble de olor* es un canto de los imposibles, el amor irrealizable entre culturas y seres humanos de horizontes diferentes. . . . Es la contradictoria historia de la región, un análisis desde el drama del hombre, del poder de las ideologías, abatiendo lo que concierne a la naturaleza del ser humano y a su libertad individual y colectiva" (Casals).

14. "Las enfermedades de la sociedad cubana del siglo XIX son la mentira y la envidia. La mentira es el cuerpo de este país. "La mentira y la envidia son sus penas y sus nervios. La intransigencia y la intolerancia son su sangre. Su rostro es la hipocresía. Dos caras, dos rostros, dos morales."

15. "¿A qué raza, pues, pertenecía esta muchacha? Difícil es decirlo. Sin embargo, a un ojo conocedor no podía esconderse que sus labios rojos tenían un borde o filete oscuro, y que la iluminación del rostro terminaba en una especie penumbra hacia el nacimiento del cabello. Su sangre no era pura y bien podía asegurarse que allá en la tercera o cuarta generación estaba mezclada con la etíope" (73).

16. "la película es muy caribeña, que se mueve en la poética de lo real maravilloso y está inspirada en una historia de amor real que el pretexto a partir del cual construyó un discurso ficcionado" (38).

Works Cited

Badiane, Mamadou. *The Changing Face of Afro-Caribbean Cultural Identity: Negrismo and Negritude.* Lanham, MD: Lexington Books, 2010. Print.
———. "Nicolás Guillén en el laberinto del mestizaje cubano." *El Atlántico como frontera: Mediaciones culturales entre Cuba y España,* edited by Damaris Puñales Alpízar. Madrid: Verbum, 2014, pp. 219–32. Print.
———. "Tempranos choques culturales y de género en 'El baúl de Miss Florence' de Ana Lydia Vega." *Revista Iberoamericana,* vol. 79, no. 244–45, 2013, pp. 883–98. Print.
Barnet, Miguel. *Cultos afro-cubanos: La Regla de Ocha, La Regla de Palo Monte.* La Habana: Ediciones Unión, Princeton, 1995. Print.

Bhabha, Homi K. *The Location of Culture*. London & New York: Routledge, 1994. Print.

Casals, Sandra del Valle. "Haiti: Imagen documental y ficcional desde lo Real-Maravilloso. El cine de Rigoberto López." *La Jiribilla*. Online vol. 140. http://www .lajiribilla.co.cu/2004/n140_01/140_12.html

Curtius, Anny. "Désontologisme et réontologisme des esclaves et des marrons." *Au visiteur lumineux. Des îles créoles aux sociétés plurielles. Mélanges offerts à Jean Benoist*, edited by Jean Bernabé, Jean-Luc Bonniol, Raphaël Confiant, and Gerry L'etang. Pointe-à-Pitre: Ibis Rouge, 2000, pp. 103–14. Print.

Fanon, Frantz. *Black Skin, White Masks*. Translated by Charles Lam Markam, New York: Grove Press. 1967. Print.

Ferrer, Ada. *Insurgent Cuba: Race, Nation, and Revolution, 1868–1898*. Chapel Hill: University of North Carolina Press, 1999. Print.

García Canclini, Néstor. *Culturas híbridas: estrategias para entrar y salir de la modernidad*. Buenos Aires: Editorial Grijalbo, 2001. Print.

Geggus, David Patrick. *Haitian Revolutionary Studies*. Bloomington: Indiana University Press, 2002. Print.

Helg, Aline. *Our Rightful Share: The Afro-Cuban Struggle for Equality, 1886–1912*. Chapel Hill: The University of North Carolina Press, 1995. Print.

Hewitt, Julia Cuervo. *Aché, presencia Africana: tradiciones Yoruba-lucumí en la narrativa cubana*. New York: Peter Lang, 1988. Print.

Kutzinski, Vera. *Sugar's Secrets: Race and the Erotics of Cuban Nationalism*. Charlottesville: University Press of Virginia, 1993. Print.

Martinez-Alier, Verena. *Marriage, Class and Colour in Nineteenth-Century Cuba: A Study of Racial Attitudes and Sexual Values in a Slave Society*. Ann Arbor: The University of Michigan Press, 1989. Print.

Mejía Núñez, Guadalupe. "La *Mulata* en la expresión artística." *Sincronía:* Otoño, 2002. http://sincronia.cucsh.udg.mx/lamulata.htm

Páez, Bertha Martínez. "Una pequeña crónica para Úrsula Lambert: la diosa negra del cafetal Angerona." *Indice*, vol. 22, 1997. http://www.vitral.org/vitral/vitral22 /memcul.htm

Quijano, Anibal. "Of Don Quixote and Windmills in Latin America" *Estudos avançados* vol. 19, no. 55, 2005, pp. 1–24. Ejournal.

Roth, Guenther. "Angerona: Facts and Fictions about Cornelio Souchay and Ursula Lambert's Cuban Coffee Plantation." www.guentherroth.com

Rutherford, Jonathan. "The Third Space. Interview with Homi Bhabha." *Identity: Community, Culture, Difference*. London: Lawrence and Wishart, 1990, pp. 207–21. Print.

Vega, Ana Lydia. *Falsas crónicas del sur*. San Juan: Editorial de la Universidad de Puerto Rico, 1991. Print.

Villaverde, Cirilio. *Cecilia Valdés*. Mexico D.F.: Porrúa, S.A., 1986. Print.

(Dis)Figuring the Plantation

Discourses of Slave Space in Lars von Trier's *Manderlay*

Edward R. Piñuelas

Perhaps the best way to approach Lars von Trier's 2005 film *Manderlay* is to begin with the end. The film's final sequence is a montage of iconic images depicting racial oppression, violence, and ongoing inequalities in the post-bellum United States, set to David Bowie's "Young Americans." The montage begins with a wide photograph of a Ku Klux Klan meeting, and moves into images of white anti-integration protesters, National Guardsmen with bayonet-tipped rifles pointed at civil rights protesters, stills of the Rodney King beating, a series of photos depicting black men on the ground (some bleeding), surrounded by armed police, sharecroppers, burning crosses, urban slums, shoe shiners, chain gangs, riots, hungry children, homeless men and women sleeping on sidewalks, George W. Bush, the World Trade Center, Vietnam, Desert Storm, funerals for black children, Martin Luther King in his coffin, Malcom X dead on a stretcher, the whip-scarred back of a slave, and lynch mobs of smiling men, women, and children, posing in front of black bodies hanging from nearby trees like background for a family portrait. In this rather lengthy end-credit sequence, von Trier performs a condensed version of the visual and spatial history he traces throughout the film. The images come out of sequence, fluctuating between the contemporary and the historical, antebellum and post-bellum, Jim Crow and the war on drugs. They tell a situated yet decontextualized history of racial violence in the U.S., of the expendable, exchangeable black body in slavery and its

legacies—what Saidiya Hartman describes as the "fungibility" that renders the slave body "an abstract and empty vessel vulnerable to the projection of others' feelings, ideas, desires, and values" (21). The sequence denies a teleological progression, a "that was then, this is now" foreclosure in which blackness may evolve from an object of destruction to an agent of change, from expendability to uniqueness.

It is strange that, given this loaded (if over-simplified) visual history of black bodies in subjection, von Trier's film is often viewed not as a commentary on structural racism and socio-economic disenfranchisement, or on the continuing effects of failed Reconstruction, but rather as a critique of Bush-era interventionism and nation-building. Within this model, the film is said to warn of the lasting responsibilities of forced liberation, of the ethical exigencies of spreading democracy in an utterly foreign context. While von Trier remains cryptic regarding the film's political commentary, this scholarship is certainly warranted, given von Trier's prior political positioning and the film's historical context. And yet, to bypass the Danish director's figuration of North American plantation slavery is to perform an all-too familiar rhetorical gesture that employs the black body as a mere signifier, a text that mediates meaning, but that is itself not meaningful. This gesture can be traced back to the writings of proslavery physicians who textualized the slave body into what William Etter calls a "rhetorical abnormalization of black [bodies]" (91). It can also be traced to abolitionist authors who, though well-intentioned, employed the slave body as a site of hyperembodied suffering, an object of rhetorical empathy that, as Hartman reminds us, reinforced the "thingly quality of the captive body by reducing the body to evidence" (19). In bypassing von Trier's construction of North American plantation slavery, in assuming slavery's role in the film as essentially symbolic and representational, one takes for granted the institution as already static and significative, a background to a performance rather than a performative gesture. By overlooking how von Trier's film reanimates slavery, one in turn overlooks how the peculiar institution frames the very notions of freedom, injustice, and violence that allow the film to operate as a critique of American politics and culture to begin with.

In an effort to reframe *Manderlay* in the context of slavery's performative gesturing, I read the film not as an ethical commentary on American exceptionalism or neo-liberal interventionism, but as a work of neo-slave fiction. In doing so, I wish to interrogate how von Trier, a Danish filmmaker who has never visited the United States, let alone a southern plantation, recreates the world of slavery, and how his construction modifies and at times rejects many of the figurative gestures of slave narrators, historical and contemporary. My primary concern here is how

von Trier constructs a highly stylized, abstracted plantation space, focusing on the modes of relation and violence attached to the spaces his characters inhabit, as well as the boundaries they obey and defy. I argue that von Trier crafts what I refer to as a figural geography that does not aim to re-create slavery on the screen, but to deconstruct its visual history. Von Trier builds both on Post-Brechtian ethical and aesthetic abstractions and on the figural legacies of the slave narrative and its contemporary forms, to employ figural geography as a medium for critiquing contemporary structures of violence in the United States.

Manderlay is the second film in von Trier's yet-to-be-completed "USA: Land of Opportunities" trilogy, a highly controversial set of films in which the Danish director, who, due to a fear of flying, has never visited the United States, critiques elements of North American politics and culture. Set in the 1930s, the trilogy follows the experiences of Grace, the daughter of a powerful crime boss, as she attempts to reject her birthright in an effort to live a morally virtuous life—an attempt that is both driven and thwarted by the places and people she encounters along the way. In the trilogy's first film, *Dogville*, Grace runs away from her father's home and settles into the small Colorado town of Dogville. As she attempts to ingratiate herself to the townspeople by making herself useful to them, Grace slowly falls prey to their exploitation and eventual scapegoating. The film ends with Grace's return to her father, as she orders his henchmen to burn Dogville to the ground and slaughter its inhabitants.

Manderlay takes up where *Dogville* leaves off, beginning with Grace's fleeing Dogville with her father and his caravan of gangsters, travelling east through the U.S. South. While stopped in a nameless Alabama town, the group happens upon a still functioning slave plantation: the Manderlay Plantation. Outraged at the plantation's very existence some seventy years post-emancipation, Grace immediately takes action, once again intervening against her father's plea to leave the "local matter" alone. Driven by a paternalistic sense of responsibility for the slaves' condition ("It's our abuses made them what they are," as she puts it), Grace sets out to liberate the slaves. She orders her father's henchmen to disarm the slave family, though all they find are a "shotgun and an old toy pistol"; she confronts the plantation mistress, Mam, at her deathbed, and righteously chastises her for her moral crimes; she opens the plantation's main gate, declaring its slaves free to "come and go as they please" and "enjoy the same freedoms as any other citizen of this country."

In short, Grace re-enacts U.S. emancipation, from armed confrontation, to surrender, to proclaiming freedom. Satisfied at the moral and ethical error corrected, the de facto and de jure aligned, Grace returns to her father's car,

preparing to leave the Manderlay Plantation that was to be only a brief stop on a journey eastward, when she is hit with the next link in her performance's logical chain: Reconstruction. As Grace is slowly sobered by her father's reminders of post-slavery reality (promises of reparation betrayed, legal reckoning deferred), Wilhelm, an elder slave community leader, approaches the car to invite Grace back to the plantation so that the slaves might "thank [her] properly for what [she has] done." Grace was longing for this; she happily agrees.

After being, as the film's narrator explains, "conducted through the wretched living quarters bestowed upon the slaves, with their pitiful leaking cabins," confident that what she has done "would comprise an unconditional enrichment of these people's lives," Grace enters the plantation's common building to meet a group of uncertain faces. Rather than graciously praise and thank her, as Grace had hoped, the newly freed men and women sit silently, worried looks on their faces, all but Timothy, whose "strangely exotic" voice cuts the silence:

> *Timothy*: When we were slaves, we were not required to offer thanks for our supper. Or for the water we drank and the air we breathed.
> *Grace*: Nobody needs to say thank you, but . . .
> *Timothy*: But what? You mean there's something we ought to be thankful for?
> *Grace*: I didn't mean *but*, I mean *and* . . . *and* there's no reason to be grateful for anything as natural as your freedom. I'm the first to apologize for everything you and your people have been subjected to. You see, those gates should have been unlocked seventy years ago.
> *Timothy*: Only seventy years ago? And before that, of course, they were completely justified.
> *Grace*: No . . . no, no you misunderstand me . . . uh, what can I say?
> *Timothy*: You need say nothing at all. (Takes a seat). We've heard of your kind: a society lady who spends her time rescuing wretched niggers. (Leaves the room)

What follows Timothy's harsh criticism and exit is a series of revelations about the other freed men and women that causes Grace to realize that Wilhelm had not invited her back to thank her, but to force her to account for the struggles of mere nominal emancipation. After the plantation's former owners enter with exploitative "free" labor contracts, Grace is decisively sucked into the ethical responsibilities of liberation. So, after successfully requesting that her father leave behind his lawyer to write a legal contract transferring ownership of the Manderlay Plantation to its newly freed slaves, along with a few of his henchman to maintain order, Grace

commits to remaining on the Manderlay Plantation until she deems its inhabitants properly established in their freedom, and the film unfolds.

POST-BRECHTIAN AESTHETICS
IN THE POST-SLAVERY SOUTH

Though both completed films in von Trier's "USA: Land of Opportunities" trilogy employ different actors and locales, they all share a common cinematic style: a minimalist mise-en-scène in which all action is filmed on a bare stage. Onto this stage are painted white outlines indicating the settings' various locales. Rather than construct the film's geography visually, then, von Trier does so textually, as the absent edifices and landmarks are replaced with written labels such as "Mam's House" and "Chicken House." More important, though, are the performative aspects that define the Manderlay Plantation's spatial code. Within *Manderlay*'s bare staging, which is constructed in an isolated airplane hangar in Trollhattan, Sweden, actors perform a form of absent geography, blinded by the empty walls, using the invisible passageways to manage or obstruct entrance and exit, honoring the spaces deemed dangerous, sacred, or otherwise off-limits—limits the film's audience cannot see.

Both of von Trier's "Land of Opportunities" films are set not visually, but performatively. They are also set sonically, with ambient noises coming from just outside the frame, though never in a way that allows one to fully suspend the imagination—the invisible walls never feel quite in place, the echoes bouncing off the hangar's walls never allow one to think of anything as existing far outside the frame. This sonic enclosure is particularly emphasized in *Manderlay*. While in the trilogy's first film, *Dogville*, von Trier works with what he calls the "idea of landscape," in *Manderlay* that idea is gone, as "at no point do you get the feeling that there is an outside," for "after all Manderlay is a prison" (von Trier/Nicodemus). Adding a further cinematic layer that merges the sonic and the textual, the film's narrative is carried forward by an omniscient narrator, voiced by actor John Hurt, who reveals characters' motivations and concerns, and provides context for the film's setting and actions. The film's austere staging is thus far from empty: rather than privilege a particular aesthetic or narrative tradition, von Trier merges and mixes the visual, performative, sonic, and textual in a way that leaves the frame open, denying any illusion that its story, and the history attached to that story, is somehow contained within the screen.

Through these austere staging elements, *Manderlay* builds on what Drama theorist David Barnett identifies as the Brechtian tendency to employ the

"tableaux as a way of articulating contradiction," a contradiction that "does not preclude interpretation on the part of the spectator but asks for an involvement which goes beyond mere rational comprehension" (345). Rather than allow viewers to make sense of the film's strange and unfamiliar elements and actions, von Trier suspends the rational and irrational to activate a constantly shifting dialectic between sense and nonsense. This shifting dialectic activates both an ethical and an epistemological relation between audience and performance. As Angelos Koutsourakis shows us in his extensive interrogation of the Danish director's work, von Trier's "ascetic aesthetics," combined with his often overly simplistic social and ethical tableaux, forces his audience to engage with social and aesthetic norms they might otherwise take for granted. According to Koutsourakis, in activating these engagements, von Trier in turn forces audiences not to suspend imagination for the sake of narrative clarity, but to wrestle with the underpinning logic of narrative itself—and the social and political relations tied to that logic (Koutsourakis 152). In the case of *Manderlay*, viewers are further pushed to reflect on the connections between space and the continuing history of racial violence in the United States. Rather than construct a plantation fully formed, the film presents a collapsed plantation geography, forcing viewers to experience its space through the relationships that allow slavery to function, even in the post-slavery world. Those relations are extracted from their proper places, then, in order to reveal their continuing presence.

Viewed through the Post-Brechtian lens of Barnett and Koutsourakis, *Manderlay* becomes a film not so much about slavery or even post-bellum race-relations, but about the idea of slavery, and the ethical material slavery engenders. It becomes, in other words, an invitation to engage with the underpinning logic of the chattel principle divorced of its particular juridical domain. This rupture occurs at multiple levels: the Manderlay Plantation exists outside its own socio-historical context; the film's actions and conflicts often register as critiques of neo-liberal nation-building rhetoric not entirely connected to race and racial slavery. Perhaps this is why so many have viewed the film as a critique of the George W. Bush administration, and of North American interventionism in general, and not as a reflection of the lingering effects of slavery in the present.[1] My reading is not in contrast to these interpretations, but in concert with them: I argue that in the film slavery provides a lens for viewing not only violent American legacies, but also the ways those legacies (and their continuing manifestations) themselves underwrite the notions of freedom, democracy, and citizenship that condition how contemporary audiences relate to the film, and to each other through the film. This slight turn is a familiar one for those who

study the slave narrative genre and early African American literature, and by placing African American studies in conversation with film studies critiques of the film, we can better grasp how von Trier manipulates the generic conventions of slave narrative, creating those conventions into instruments for unearthing the institution's lingering legacies.

CELLULOID MAPS

In the second chapter of his original 1845 *Narrative*, Frederick Douglass paints an ethnographic portrait of the southern plantation on which he "received [his] first impressions of slavery" (46). Having departed his narrative through the metaphorical "blood-stained gate, the entrance to the hell of slavery" that was the brutal whipping of his Aunt Hester (45), Douglass now describes the quotidian of plantation life through the spaces that largely defined his slave experience. He details a written geography of the Maryland estate that served as his first home, from the tobacco and corn that dictated the plantation's labor and ecological make-up, to the Great House Farm that "wore the appearance of a country village" (49) and served as a place of governance for neighboring farms, to the space that separated the Great House Farm from the slave quarters, whose "dense old woods" slaves would regularly make "reverberate with their wild songs." Folded into this figurative mapping are several scenes of social and economic intercourse: social hierarchies among slaves, sales of crops and goods in a nearby Baltimore market, sales of slaves at that same market. In short, Douglass figuratively maps not only the various spaces that define his experience as a slave, but also the nexus of relations that both shaped and were conditioned by those spaces. He constructs, that is, a figural geography from within which his white abolitionist readership could orient itself, walking his audience through a domain rarely experienced firsthand, a domain that was to stand for the slave condition at large.

Douglass's depiction set in motion a figurative model that would extend throughout the slave narrative tradition: that of mapping the social, political, and psychic spaces of slavery in order to recreate the slave's world for non-slave (white) audiences. While for Douglass this map unfurls to primarily reveal the field and the Big House, other slave narrators extend it into further reaches of slave geography, spaces at times beyond the plantation boundaries, and at times folded deeper into them. Solomon Northup, for example, reveals the liminal spaces between slavery and freedom, from the coffle to a slave pen "within the very shadow of the Capitol" (23). As Miranda Green-Barteet has recently argued, Harriet Jacobs folds this form of liminality into the domestic space absent even

in Douglass's map of the Big House. Focusing on the physical and metaphorical space of the garret in which Jacobs hides while awaiting rescue, as well as the rhetorical space of her narrative, Green-Barteet asserts that "Jacobs uses the interstitiality of the garret to recreate herself according to her own terms, a process she completes by envisioning her slave narrative as an interstitial text" (56). In other words, while Northup figures a liminality from outside the plantation's boundaries, though inside the very political fabric of the nation, Jacobs crafts spaces, figural and physical, of resistance—and in doing so creates of her narrative a liminal medium for asserting her humanity in a context that throws it into jeopardy. Collectively, these foundational slave narratives not only crafted modes of relating the spatial relationships that largely defined life in bondage; they also created modes of figuring space in ways that animated and critiqued the social and political material that held those relationships together.

We should not take it as a coincidence that Douglass's (1845), Northup's (1853), and Jacobs's (1861) narratives were published in and, in Douglass's case, very close to a period William Gleason identifies as a moment "not only in which architecture came of age professionally in the U.S. but also in which ideas about architecture became a prominent part of broader conversations about American culture, American history, American politics, and (although we have not always understood this clearly) American race relations" (26). Viewing the figural mapping these and other slave narratives employ in their foundational texts as modes of materializing social relations both inside and outside of slavery's juridical domain allows us to see how critical space has been to the emergent African American ethos. That is, much in the way mapping not only offers a program for navigating an unfamiliar space, but indeed shapes one's relationship to that space, the figural geographies presented in slave narratives offer more than a picture of slave life: they offer a medium for orienting oneself in the institution and its many legacies. By moving figural mapping to the foreground, then, one opens a window into how space serves as a medium for experiencing and expressing racial violence in the United States—a tradition that motivates von Trier's collapsed, staged plantation.

Long after Douglass's famous second chapter, the map continues to unfurl itself. The figurative mapping that both partly defines the slave narrative genre and extends beyond the genre plays a vital role in films set in slavery—from *Gone with the Wind* to *Django Unchained*. In visually and aurally reanimating slave space, many of these films perform problematic endeavors to materialize slavery, moving beyond the figural depictions of first-hand narratives in order to reify phenomena absent from historical record. In doing so, they perform a powerful role not just

in representing the institution, but in recasting its ethical and political material. As Michael Ralph argues regarding contemporary slave films, these films often go so far as to aestheticize slavery in order to "grappl[e] with the economic and political matrix in which the peculiar institution was enmeshed and the economic and political trajectories that have emanated from it" (154). Vital though these materializing and aestheticizing efforts are to bringing contemporary audiences into a world often forgotten, they come at a cost: in materializing the plantation, they risk casting its socio-spatial order to the background, containing it within the frame and foreclosing its movement beyond the screen.

Lars von Trier forgoes materialization in *Manderlay*, forgoing in turn the very "aesthetics of slavery" Ralph identifies. Rather than reconstruct the plantation as a concrete and complete domain that frames his narrative, as is the norm in films set in slavery, von Trier denies any sort of figural territoriality that might suggest a plantation geography already in play. He does not establish a concrete, embodied plantation to serve as the background for slave performance, but rather figures the plantation as a performative space in itself—one not bound to a particular territory or, in the case of this film, period, and therefore de/re-territorializable outside the antebellum context. It is not the spatial markers and architectural structures that condition the Manderlay Plantation's geography (though throughout the film these markers are treated as real by the film's actors), but the daily socio-spatial practices of its inhabitants—both enslaved and enslaving.

In reanimating slave space while refusing to materialize it, von Trier returns to the sorts of materializing motifs of the slave narrative and its many manifestations—both historic and contemporary—yet consistently denies the reifying

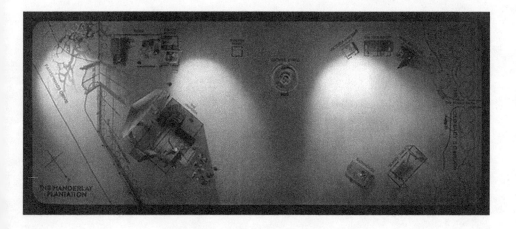

powers of his medium. He crafts a slave domain based not on re-construction, but on absence, setting his plantation on a white stage surrounded by a darkness broken by spots of artificial light, a stage on which structures are defined by black outlines, their names written in generic text, like a condensed blueprint of a nineteenth-century cotton plantation.

Within this collapsed domain, actors obey the rules the abstract boundaries and invisible walls enforce. In doing so, the film's characters (who never quite escape the artifice of play-acting) enact a performative spatiality that defines the film's plantation geography. In the absence of visual geographic markers, that is, these characters map the plantation through action, conjuring a socio-spatial order not contained in any particular place. In this sense, von Trier employs the forms of Post-Brechtian aesthetics described by Koutsourakis and Barnett to create an ethical tableau of the slave condition, a tableau built upon the de/re-territorializable racial dynamics of slavery removed from its proper place.

The spatial figuration that frames the film's events and relations is not defined by the presence of historicized markers of antebellum society, but by the absence of any such marker. Von Trier gestures to this absence—this lack of an underlying or overarching political domain that indeed conditions Manderlay's existence—from the film's very beginning. The film opens with a map of the United States, a map that fills the frame with a white background onto which state lines and names are minimally shown, with no markers of terrain, no city names, no bodies of water; just a black outline on a map without borders, a purely abstract domain within which all events and places are situated throughout the film. It is only when the image expands beyond the frame that this abstraction becomes more focused, as the edges darken to call attention to the caravan of cars travelling over the state lines and, presumably, through the territories these lines represent. In a sense, the film opens by announcing a peculiar collapse of social, political, and representational domains. As the caravan traverses borders fraught with contested notions of American territoriality (the frontier of the West, the mass migration of the Dust Bowl, the Jim Crow South), it does so in the absence of any such context, on a map that flattens territoriality into abstract iconography.

By stripping the cinematic frame of the visual markers of plantation geography, von Trier layers his slave space with myriad meanings and contexts. Rather than supply his viewer with a visual representation of a history easily accessed as a fastened, museumified object, von Trier employs a darkness and abstraction that defies any particular historical orientation. In denying the plantation as a static background, fully constructed as the backdrop to historical processes already complete, von Trier offers a model of the plantation as a performative domain,

a space enacted by social relations and conventions that might reappear at any moment—a dynamic carried out in his final montage. The Manderlay Plantation is thus not a pathological space, even though it appears at the surface as an aberration, but an embodiment of what Frank Wilderson calls the "the presence of the twentieth-century Slave estate in contradistinction to the presence of civil society," a site in which the ethical relations of slavery boil to the surface of contemporary social and political structures (*Red, White, and Black* 119). Von Trier begins his entry into slavery not by locating the institution within a particular place, but by dislocating it from any particular place and time, rendering it plastic and reterritorializable. Not only does it make sense, then, that the Manderlay Plantation should exist some seventy years following the Emancipation Proclamation, but it could not exist otherwise—lest the slave condition be entombed within the already framed territories of the antebellum United States.

Within this bare abstraction, von Trier constructs, spatially and temporally, the socio-ethical order of the Manderlay Plantation. This order, strangely, begins from without. As Grace and her accompanying band of gangsters stand in the darkness that remains throughout the film, a black woman (not yet a slave within the film's narrative) runs out from an open section of the plantation's bordering fence and pleads with Grace to stop an impending whipping of a man named Timothy (not yet a slave). When the confused Grace asks why Timothy was to be whipped, the woman gives an answer than sets in motion the film's neo-slave narrative framework:

> *Woman*: "That's how they do with slaves."
> *Grace*: "Slaves?"
> *Woman*: "Yes, mam. Surely you heard of slaves. That's what we
> is at Manderlay, this godforsaken place."

Upon saying these final lines, the now slave woman grabs Grace's hand and leads her through the empty section of the fence. What pulls Grace into this slave space—a space both within the socio-political domain of the post-bellum South and yet utterly outside this domain—is a call for white salvation, a salvation activated by impending black suffering. Indeed, it is this very suffering and exigency that allows the plantation to be penetrated—by both the drove of (white) gangsters and the cinematic gaze—as the yet unnamed, self-identified slave woman informs Grace/us that the passageway through which she/we enter is a section of the plantation's outer fence taken out solely for the purpose of whippings.

Through the Manderlay Plantation's own "blood-stained gate," through an impending violence on the black body, von Trier initiates his plantation performance, incarnating a relationship inherent to the abolitionist movement—a plea for help from privileged white outsiders. It is fitting, then, that our introduction into the slave condition on Manderlay is a whipping, fitting that the slave woman pleads not to the armed gangsters, but to the finely dressed woman whose visage conjures the high society leaders of the nineteenth-century abolitionist movement. The scene then moves from a wide shot of the open gate to a close shot of a shirtless man fastened to the section of fence, arms tied outstretched. Here, von Trier constructs a scene almost too familiar, a tableau in which the flesh of the slave body promises to signify—whether that signification be of value (as would be consistent with the chattel principle), fungibility (following Hartman), or sentimentality (as in the abolitionist tradition). But this signification is interrupted, as Grace takes the whip from the overseer and orders Timothy untied. Von Trier constructs this scene based on the fundamental power to subjugate the slave body through physical violence, only to disrupt it, and in doing so disrupts the intimate pleasures that Christina Sharpe argues are "reenacted and recirculated in national consciousness through the staging and interpretation of slavery and its excesses, in everyday relations of terror, in literary texts, visual arts, museum exhibitions, and memorials" (112). Von Trier thus frames the scene only to de-frame it, and works to de-frame similar scenes of plantation order and disorder throughout the film—a dynamic largely played out through the film's figural geography.

This act of de-framing slave space intensifies once the white authority of the Manderlay Plantation collapses. After the whip is forcibly removed, at gunpoint, from the overseer's hand; after the mistress of the house dies; after the previous slaveholding family is ordered to labor in place of the newly freed slaves (until Grace "consider[s] that [their] understanding of the worth of other human beings has reached the desirable stage") and the slaves are formed (by Grace) into a democratic body; Grace is shocked to find that, rather than taking responsibility for their newly possessed land, these newly freed men and women resort to idleness. When Grace is alerted that the planting season is rapidly passing, this idleness comes front and center. After consulting with Wilhelm, the de facto leader of Manderlay's slave community, about the planting, Grace learns of the document that details the plantation's management, and in turn shapes the film's socio-spatial framework: Mam's Law—a book detailing the Manderlay Plantation's management, from slave treatment and punishment to daily routines.

Available only to the mistress and her family, Mam's Law provides the film both a socio-spatial blueprint and a narrative paradigm, coding authorized and

transgressive spatial actions and rendering those actions legible. While this coding plays out throughout the course of the film, the scene depicting Grace's discovery of the book performs this dynamic, both visually and spatially. The scene opens by returning us to the blood-stained gate, now closed. Grace stands in a blotch of light revealing only her and, faintly, the Big House's leading Roman columns—by far the largest structures in the film's sparse staging. As the high angle shot tilts upward (and outward), the home is slowly illuminated, first the columns, then the two-story interior previously invisible.

The Big House thus revealed is the most detailed locale of the film—the only one with non-essential furniture and aesthetic embellishments, the only one with an actual door (to Mam's bedroom), the only one with visual depth—yet the most socially empty, as after Mam's death it is rarely occupied. It is a space defined by excess, at least in relation to the film's motifs, and social absence—a tomb of the antebellum era.

After passing through the film's only physical door into Mam's room, Grace finds Mam's Law beneath the old mistress's bed; and the plantation, much like the Big House now exposed, unfolds—an unfolding at once textual, spatial, visual, and social. As Grace lies on Mam's bed reading through the book of what the film's third-person narrator describes as "bizarre and viscous regulations," she begins to see how "Mam's Law revealed it all." As the narrator utters these words, the camera now moves from its bird's eye view of the book upward (and outward) on a vertical axis, rotating and opening the frame to the entire plantation, returning to the mapping motif established in the film's opening scene. Just outside the Big House, the formerly enslaved stand on their assigned numbers written as a grid on the ground just north of the home (an orientation granted

by the compass on the bottom-left-hand corner of the frame), shaded from the stage lighting by the adjacent Big House wall. To the map's southwest corner lies the barn, and on the west end of the plantation are the slave quarters and the bathhouse and meeting room, separated by the cotton field. Finally, to the far west is the "Old Lady's Garden," which serves as the plantation's border.

Mam's Law provides something of a shadow map of the plantation, a palimpsest that imposes a social and psychic code over the Manderlay Plantation's bare and anachronistic space. The book itself prescribes a social order based on roles, assigning each slave a number corresponding to type ("clowning nigger," "losing nigger," "pleasing nigger," "proudy nigger," and so on), and detailing the social and labor roles each is to play, in addition to the psychological approaches to his or her management and treatment. Though previously unaware of this code, Grace finds this page "strangely familiar," feeling that "somewhere, [she] had seen something similar for sure." Upon the narrator's revealing this sense of strange familiarity, the frame opens (as the camera ascends and rotates) to reveal the former slaves standing over their respective numbers on the grid just outside the Big House balcony.

Grace's sense of uncanny familiarity is vital to the film's reconstruction of slave space, as well as its connection of that space to racially coded psychic, social, and political structures of the contemporary the United States. As Frank Wilderson points out, these structures underwrite the film itself, as in materializing what the film's narrator calls "[b]ondage, even through psychology," von Trier both "help[s] us clarify relations of power" and "comments on the

non-black unconscious" inherent in American socio-political structures ("The Lady with the Whip"). While I depart from Wilderson's assertions that these psychic-social relations connect to Orlando Patterson's theory of social death (I would instead argue that what von Trier presents is more akin to a corrupted/corrupting social life, a life of the persisting socially undead, as it were), his connections between racially coded power relations and the non-black unconscious are vital to understanding how von Trier exposes the uncanny presence of slave history in the present. Rather than ossifying the anti-black unconscious that conditions social relations on and beyond the Manderlay Plantation, von Trier maintains the tension between the unconscious desires and pleasures that, returning to Hartman, direct the gaze toward the hyperembodied suffering black body, and modes of denying these pleasures—as in the film's opening whipping scene.

Extreme and stereotypical though they may be, the social categories detailed in Mam's Law complete the film's already abstracted and bare ethical tableau—a tableau that extends from the "ascetic aesthetics" of von Trier's post-Brechtian staging. Viewed as part of this tableau, Mam's Law does not offer a representation of antebellum or post-bellum racial casting, but a medium for reading the anti-black unconscious that, stripped down to an almost comical extreme (much like the Manderlay Plantation itself), continues to haunt the film's post-bellum setting. It is fitting, then, that the book should be written not by the plantation mistress, but by Wilhelm, the slave community's de facto leader, who seems to parody the anti-black unconscious in ways both disgusting and familiar. Perhaps what is so shocking about the revelation that Wilhelm authored Mam's Law is not merely that a slave would choose slavery over freedom, nor that he should write such a viciously racist social code, but that the code functions so well—that it should follow a logic undeniably folded into to the post-bellum world of its protagonist (and audience).

The pivotal scene in which Grace encounters Mam's Law epitomizes von Trier's visual cartography throughout *Manderlay*: von Trier maps the plantation outward not simply from the Big House, the architectural symbol of authority and power, but from the text—an unbounded, plastic code that defines spatial practices and subjectivities on the Manderlay Plantation, a code that structures an order the scenery does not, and makes the invisible walls and doors block and allow passage. And yet, even Mam's Law as a text cannot contain that code, for the "bondage . . . through psychology" in question is not the result of the book, but is its condition. Much like the film's staging, then, in which bare abstraction

denies a historicized and therefore contained plantation geography, the social logic that guides the Manderlay Plantation exceeds any situated context—Mam's Law functions not because it is written, but because it doesn't have to be.

The revelation that Wilhelm authored Mam's Law, and that the slaves on the Manderlay Plantation choose to live in slavery, unravels Grace's fantasy of white liberation. She decides to flee Manderlay, but before she can escape the confines of the Manderlay Plantation, into the illusory post-slavery world that would register Manderlay as a pathological space rather than a manifestation of the anti-black unconscious permeating North American social life, she must return to the tableaux that she originally encounters on the plantation: Timothy's whipping. While Grace initially stages the whipping to evade Wilhelm's attempt to keep her hostage on the plantation, using the removed section of the gate as a means of escape, Timothy once again pulls her out of her paternalistic illusion. As she derides Timothy for his dishonesty and trickery, and curses Manderlay's slaves for their weakness and betrayal to their race, Timothy reminds her of something she said upon first encountering the plantation: "Aren't you forgetting something? You made us." Though she never intended to harm Timothy, Grace grabs the whip from the ground, saying nothing, savagely whips him, and leaves the Manderlay Plantation, as she entered it, through the "blood-stained gate."

After Mam's death, when the Big House loses its status as the symbolic source of power on the plantation, becoming instead a site of transgression (Grace's unveiling of Mam's Law, her eventual sexual encounter with Timothy), and even after Mam's Law is itself revealed as a sham, slavery's psychic, social, and ethical relations continue on. Ultimately, Grace is incapable of escaping this truth: that the social and psychic mechanisms of slavery are not bound by law or geography, that those mechanisms in fact shape law and geography. After crossing the plantation's threshold, she passes a final reminder of slavery's unbounded presence: the lynched body of Burt, the one slave who chose to leave the plantation upon learning of slavery's end. But Grace fails to notice Burt's body hanging outside Manderlay's walls, and runs in panic from the plantation, across the white space of the abstracted U.S. map, and into von Trier's final montage.

Note

1. There are some notable exceptions to this tendency. Ruth Doughty, for instance, has written an article viewing the film as a "passing" narrative, while Frank Wilderson has remarked on the film's employment of social death as a fundamental trope. See Doughty (2007) and Wilderson (2013).

Works Cited

Barnett, David. "Toward a Definition of Post-Brechtian Performance: The Example of In the Jungle of the Cities at the Berliner Ensemble, 1971." *Modern Drama*, vol. 54, no. 3, 2011, pp. 333–56. Print.

Doughty, Ruth. "Manderlay (2005): Lars von Trier's Narrative of Passing." *New Cinemas: Journal of Contemporary Film*, vol. 5, no. 2, 2007, 153–61. Print.

Douglass, Frederick. *Narrative of the Life of Frederick Douglass, an American Slave.* 2nd ed. Boston: Bedford Books of St. Martin's Press, 2003. Print.

Etter, William M. *The Good Body: Normalizing Visions in Nineteenth-Century American Literature and Culture, 1836–1867.* Newcastle: Cambridge Scholars, 2010. Print.

Gleason, William A. *Sites Unseen: Architecture, Race, and American Literature.* New York: New York University Press, 2011. Print.

Gleiberman, Owen. "Manderlay." *Entertainment Weekly*, 862/863, 2006, p. 114. Print.

Green-Barteet, Miranda A. "'The Loophole of Retreat': Interstitial Spaces in Harriet Jacobs's Incidents in the Life of a Slave Girl." *South Central Review*, vol. 30, no. 2, 2013, pp. 53–72. Print.

Hartman, Saidiya V. *Scenes of Subjection: Terror, Slavery, and Self-Making in Nineteenth-Century America.* New York: Oxford University Press, 1997. Print.

Koutsourakis, Angelos. *Politics as Form in Lars Von Trier: A Post-Brechtian Reading.* New York: Bloomsbury Academic, 2013. Print.

Northup, Solomon. *Twelve Years a Slave.* New York: Penguin Random House, 2013. Print.

Ralph, Michael. "Theoretical Ramifications of Django Unchained." *American Anthropologist*, vol. 117, no. 1, 2015, pp. 154–61. Print.

Sharpe, Christina Elizabeth. *Monstrous Intimacies: Making Post-Slavery Subjects.* Durham, NC: Duke University Press, 2010. Print.

Von Trier, Lars. "I Am an American Woman: An Interview with Lars von Trier about Sexual Fantasies, the Pope, America, Slavery and His New Film *Manderlay*." Interview by Katja Nicodemus. *Die Zeit.* 17 Nov. 2005. Web.

———. "Lars von Trier: Anti-American? Me?" Interview by Emma Bell. *Independent.* 21 Oct. 2005. Web.

———. "Torture Is Fine: On Pain, Guilt and Violence, Black Presidents, Toy Helicopters, and a Seriously Misbehaving Björk. An Interview with Filmmaker Lars von Trier at Zentropa Film Studios in Copenhagen." Interview by Stefan Grissemann. *FilmComment.* Jan. 2006. Web.

Wilderson, Frank. "The Lady with the Whip: Gendered Violence and Social Death in Manderlay and Django Unchained." Barnard College. 2013.

———. *Red, White, and Black: Cinema and the Structure of U.S. Antagonisms.* Durham, NC: Duke University Press, 2010. Print.

Exploring the Ugly Truth

Cinema of Integration, Slavery, and the Poetics of Beauty in *El cimarrón*

Nemesio Gil

Mirerza González–Vélez

Among the few available Puerto Rican films representing slavery, *El cimarrón* (2006) stands out as a technical achievement at the threshold of the impending transition from traditional film stock to digital HD cinema of the motion picture industry in the Caribbean.[1] The first Puerto Rican film shot and exhibited entirely in HD (Panasonic VariCam), it garnered awards for best film and best director at the 2007 Tulipanes Latino Art and Film Festival in Michigan and also competed to represent Puerto Rico in the first round of the Academy Awards for Best Foreign Film that same year. Written and produced by Iván Gonzalo Ortiz and directed by Iván Dariel Ortiz, the father-son team embarked on a motion-picture adventure that took them to the harbors of slavery in the Caribbean in the historical epoch that saw the rise of Toussaint Louverture and the Haitian Revolution. Set in the island of Puerto Rico in the nineteenth century (1810–1815), *El cimarrón* tells the story of two African newlyweds who are separated and sold as slaves to Caribbean merchants, and who later meet again to fight for their love and freedom from the hands of their vicious overseer. The main character is based on Marcos Xiorro, the celebrated black Puerto Rican slave who became a maroon and defied the forces of the Spanish empire in order to initiate a revolution in the island for the manumission of his enslaved counterparts.

El cimarrón was partially successful in Puerto Rico if we take into consideration that small-scale local films only stay in movie theaters for an average of one to four weeks. It survived a month in movie theaters usually plagued by Hollywood blockbusters. In the history of Puerto Rican cinema, the romantic drama *Linda Sara* (dir. Jacobo Morales, 1994) and the wild comedy *Broche de Oro* (dir. Raúl Marchand Sánchez, 2012) are two films that broke audience attendance records for local theater showings of more than six months. In addition, the Dominican/Puerto Rican co-production *Domirriqueños* (dir. Eduardo Ortiz, 2015), another comedy, recently became the most financially successful film in the history of local films by harvesting more than a million dollars in ticket sales—a considerable amount of commercial receipt for local cinema. *El cimarrón* was selected among other films to be the possible contender for the coveted Academy Awards for Best Foreign Film at the time. However, the coming-of-age sexy comedy *Maldeamores* (dir. Carlos Ruíz Ruíz and Mariem Pérez Riera, 2007) was finally chosen by the Puerto Rico Film Commission Committee to represent the island. And yet, it did not make the final cut among the five international selections for the Oscars. *El cimarrón*, for its part, became available for purchase or rental in video stores. With the closing of big chain video stores in the island in the last few years, now it is part of Amazon's online streaming service.

Very few local films stir heated debate in Puerto Rico due to their short life span in theaters. For those which last more than a month, newspaper reviews and television interviews may accompany its success. *El cimarrón* is not the exception. Despite its subject matter, debate was confined to specialized university forums or radio shows. Scholars, college students, and filmmakers were its main audience engaging in academic or simply aesthetic discussions. Nevertheless, there has always been on the island general excitement for the achievement of Puerto Rican filmmakers battling to make films despite difficult local circumstances.

The fact is that slavery films in Puerto Rico, including *El cimarrón*, resonate so far as they represent Hollywood's grand scale production value. Even a film such as *12 Years a Slave* was received cautiously due to its graphic portrayal of torture methods, though also praised for its directing and acting. The Hollywood blockbuster overshadows local taste and film attendance across the island. Even in the town of Loíza where the highest concentration of black Puerto Ricans is located, audiences were no larger for *El cimarrón* despite the film's subject matter. Regardless of the fact that a film on slavery or the historical presence of Africans in the island does resonate in the fine arts and intellectual circles where *El cimarrón* was seen and discussed, in reality it did not translate immediately

to attracting audiences by representing the interests of the black population, as in the case of the residents of this coastal zone. Though actively immersed in the perpetuation of its African roots and culture, the black community of Loíza may have found the director's beautification of the image and story of Xiorro's life as not being representative of the Afro-Puerto Rican experience elders narrate and transmit across generations through their autochthonous art and music. Generally speaking, Loíza's movie-going audience is mostly lured by big spectacle Hollywood productions.

CINEMA, FANTASY, AND THE ENSLAVED SUBJECT

If we are to explore the director/producer's interest in making this film as a love story, as well as its unique treatment of slavery, we must accept that the traditional theoretical approaches to the study of films, Lacanian film theory in particular, fall short in assessing how audiences receive and experience film texts. In order to demonstrate that *El cimarrón* provides a viewing experience that depends on the context of the viewer, we deploy Todd McGowan's (2007) concept of the *real gaze* and propose that the film is an example of what he considers the *cinema of integration* movement (19).

In traditional Lacanian film theory the gaze is a complex term that suggests a didactic communicative experience that entails looking at something while being looked at. In such a communicative experience, anxiety arises from one's acknowledgment that real material conditions are still in place even in moments of desire and fantasy. Traditional Lacanian film theory usually portrays the idea of gazing as a totalizing cinematic experience for all spectators, who become the subject of the gaze and render all possible agency. McGowan's concept of *real gaze* deploys a reinterpretation of the traditional Lacanian gaze by relocalizing it as an embodiment of the object. He argues that

> the Lacanian real is the indication of the incompleteness of the symbolic order. It is the point at which signification breaks down, a gap in the social structure. By stressing the importance of the real, Lacan doesn't proclaim an ability to escape language and identify what is really actual; instead, he affirms the limitations of language— language's inability to say it all or speak the whole truth. (3)

In this sense, McGowan's intention is to rescue *the real* by affirming that it gets silenced in the psychoanalytic film theory of the 1970s, resulting in a lack of

research on how spectatorship relates to the structural vulnerability of representing ideology.

In other words, McGowan promotes a reassessment of the Lacanian idea of the gaze by locating the gaze within the objectivity of the film text, a realm of *the real*: "as an object, the gaze acts to trigger our desire visually, and as such it is what Lacan calls an *objet petit*, or object-cause desire" (5). McGowan relates spectators' interest in watching a film with a subtle power of enjoyment encoded in the gaze, the power "to excite spectators and bring them into the cinema" (12). Such a reconfigured notion of the gaze, the *real gaze*, allows McGowan to suggest a typology for films based on their different relations to the gaze: the cinema of fantasy, the cinema of desire, the cinema of integration and the cinema of intersection (19). The cinema of integration refers specifically to "films that incite desire only to resolve it into a fantasy scenario that provides a screen through which the spectator can experience the gaze without its attendant trauma" (19).

McGowan's intervention allows Lacanian film theory to expand its scope into areas related to the particular material conditions of the filmic experience, such as "film texts, viewers and viewing conditions" (Ayers 58). We agree with this statement and argue, accordingly, that the peculiarities of the visual narratives used by *El cimarrón* provide for a visual text on slavery and blackness that appeals to viewers, whose viewing experiences are, consequently, contextualized by Caribbean identities that are both complex and ambiguous. In that sense, we suggest that in order to analyze the aesthetics of the film's visual narrative, close attention has to be given to the role that both nature and the black body play in the film text as signifiers.

Nature and the black body are, in effect, the main tools of *El cimarrón*'s visual narrative, which normalizes the trauma of the enslaved subject by the use of fantasy and desire. This type of cinematic experience resembles Hollywood films that suggest fantasy and desire are both fulfilled by the attainment of the object of desire. *El cimarrón* is portrayed by its director as a love story that confronts the cruelty of slavery. The film also narrates how the enslaved men and women fight for their freedom as the white slaver imposes on them the horrors of the plantation economy to attain financial and sexual gains. These contradictory desires are experienced by viewers who at the end of the film confront a sort of happy ending where the enslaved man and woman attain freedom, one by means of death, the other by becoming *el cimarrón/maroon*: in other words, someone who had escaped from bondage. As explained by J. L. Chinea (2002), in the case of the colonial Hispanic Caribbean, more particularly Puerto Rico (1700 to 1800), the local Spanish colonial government allowed the entry of slaves who had escaped

from nearby islands under British, Danish, and French control. Many of these people were enslaved again in Puerto Rico by means of the "agregados" system, a type of legalized coercion of free citizens (Mintz 1974) that provided for labor control (Rodríguez-Silva 2012). This, however, is not the maroon experience portrayed by *El cimarrón* as the main character is already located in Puerto Rico. Ortiz's depiction of the maroon might be related to a different aspect regarding slavery in Puerto Rico, one that relates the traumas of slavery with the black body. It is worth noticing that the increased number of maroons coming to Puerto Rico prompted the growth of the non-white population, and anxieties on the generalization of blacks bodies, a phenomenon that jeopardized the control of the White Iberian population (Chinea 2002, 179). Worries of having very few families of proven Iberian "pure" blood resulted in the welcoming of the 1815 immigration decree *Cédula de Gracia*, "a major boost to White immigrants and slave owners" meant to promote the "whitening" of Puerto Rico (196). Racial tensions have been part of the Puerto Rican imagination, as well as the lack of social narratives on blackness and the role that African heritage plays in the production of a metanarrative of the nation. *El cimarrón*'s storyline and visual structure seems to resound with these ideas. By the beautification of a difficult and violent historical period, Ortiz's film provides viewers with an enjoyable cinematic experience that resonates with a long historical tradition of silencing the brutality of slavery. In other words, the film mediates the ugly truth of slavery through the poetics of beauty, providing audiences an undisruptive enjoyment of the horrors of slavery as an historical reality in Puerto Rico. *El cimarrón* mobilizes both nature and the black body as visual tools that provide for a pleasurable experience that integrates fantasy and desire into the cinematic viewing experience for local audiences.

NATURE AS BEAUTY

The film starts with a white-lettered title card on a black screen that reads, "In the epoch of slavery over fifteen million Africans were brought to the Americas to serve as slaves. Within their pain and anguish . . . they loved." Then, fading into the very first image of the film, a flaming dawn—at the top of the screen frame—overlooks the thick and dark vegetation below that seems to be trying to touch the few scattered clouds in the orange sky. We are in Africa. Another title card indicates this, superimposed on the fireball image, but then dissolves into two or three additional images of what the Europeans coined the "Dark Continent."

The human factor mingles with Nature in *El cimarrón*. Indeed, Africans seem to become one with its luscious and fruitful landscape. In expressing this

symbiotic view of nature, the director displays a group of African women stand-
ing in a slowly flowing river. Within this group, a young maid (Femi, played by
Dolores Pedro), half naked, is being prepared for her wedding as if in a ritual. On
the left side of the screen, the greens, reds, and earth tones blossom in the plants
on the very edge of the river. These plants sit there, quietly, as true spectators on
Nature's "bleachers" overlooking the African women whose red and brown head
turbans, and beige long robes, match the lush vegetation's color scale. Everything
is drenched with a medium-soft golden light that gives the image a sense of
warmth, peace, and inherent sensuality. The cinematography and its palette of
saturated gold, chocolates, beiges, and greens are consistent as a visual reference
throughout the film. This description is hardly "embellished": the first images
of *El cimarrón* are simply a pictographic statement of a paradisiacal Africa that
shone for its apparent beauty and tranquility before the European conqueror
disrupted it in search of slaves for the colonial trade enterprise.

Cutting from medium shots to medium-close ups, the African mothers and
aunts baptize Femi in a delicate stream of golden water. Next, there is a straight
cut to the next shot showing the bridegroom (Marcos Xiorro, played by Pedro
Telemaco) surrounded by three older male members of the community who also
perform the preparatory ritual for the union of the African lovers. Bare-chested
and wearing the African kilt that distinguishes the Dagaaba people of Ghana,
they are in the same river, probably not too far from their female counterparts,
as the forested area in the background of the shot well indicates. José "Pepe"
Ojeda's original harp, strings, and ever-present synthesizer musical score, both
romantic and nostalgic, permeates these non-dialogue short scenes and each
encounter between the soon-to-be distraught lovers. All the scenes were filmed
in Puerto Rican locations.

Kneeling down to receive the blessing of one of the members of the ceremo-
nial group, the viewer immediately notices Marcos's muscular body.[2] Though
it is considered commonplace (and to many, a cliché) that among the features
attributed to men of African descent is their alleged muscularity and strong
anatomy, such features have been at the center of multiple theoretical debates
on black masculinity (e.g., Stuart Hall). The scene at hand particularly stresses
this element of blackness as visual component in the construction of the image
of Marcos Xiorro, *el cimarrón*. The transitional cut-in shot finds him kneeling
down in front of the Ghanaian "baptizer." Xiorro supports himself with one
knee on the soil of the river and the other one straight up to keep his bal-
ance. His pose reminds us of European kings crowned by authoritative divine
mandate.

THE BLACK BODY, FANTASY, AND DESIRE

Pedro Telemaco's body certainly reproduces the physique preferred in the Puerto Rican film industry. This industry, although very much influenced by Hollywood cinema and television (despite its continuous—and many times, successful—attempts to disassociate itself from it), articulates a complex, paradoxical image of the black male body. In this image, the imposing black body is the object of both idolization and fear.[3] One of the promotional posters of the film shows Marcos Xiorro with bare torso, exhibiting six-pack cut abs and flexed arms and chest whose definitions are emphasized by the strong key light that falls upon

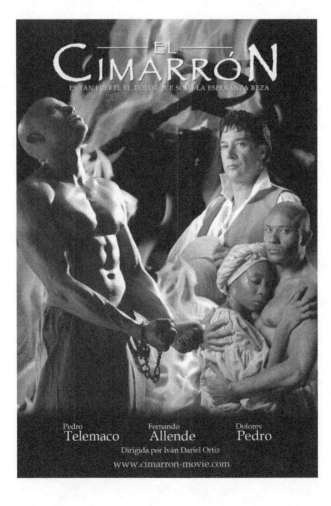

EL CIMARRÓN (2006), PROMO- TIONAL FILM POSTER.

them. In the background, an intense-looking overseer observes him. On the right, below the overseer, Xiorro appears again in protective and loving embrace with his beloved.

The golden light that falls on Xiorro's body and the ¾ angle chosen for the full and medium shots favor the optics of the muscular, hyper-masculine black body. Curiously, somewhere during the crosscutting from the first sight the viewer has of Xiorro's naked back and torso to the last shot smoothly dissolving into Femi's equally naked chest, the actor stretched his muscularity to its limits with his pose appearing even more forcefully unnatural. It reminds the viewer of a fashion model's pose. This sequence ends with another shot of both African lovers in the same river as the community's priest joins them in matrimony in the middle of the river whose golden light radiates to its fullest intensity from its shallow waters as well as from the burning sky above. The image certainly supports the director's "poetics of beauty" and the positioning of the film as cinema of integration as it represents a love story within the confines of the brutal existence slaves survived in a Puerto Rican plantation.

It is crucial to emphasize that the physiognomy of the black subject has historically—and categorically—been celebrated (or despised) in literature and the visual arts from colonial to contemporary discourses on blackness and the male body. For example, Richard Ligon, a seventeenth-century British Royalist, architect, and travel writer who visited the Caribbean after escaping civil unrest in his native England, paid particular attention to the physiognomic characteristics of black male slaves he encountered at his arrival. He writes,

> I have been very strict, in observing the shapes of these people; and for the men, they are very well timbered, that is, broad between the shoulders, full breasted, well filleted, and clean legged and may hold good with Albert Dürer's rules, who allows twice the length of the head, to the breadth of the shoulders, and twice the length of the face, to the breadth of the hips, and according to this rule these men are shaped. (102)

Ligon claims his authoritative and legitimate power of observation and rendering. The portrait he paints of the black men he sees is as systematic and structured as any of his architectural designs. He assembles his aesthetic subjects by enumerating parts of the body, modifying them with nouns ("timber," "filet," "breast," "leg") that can also be adjectivized adding "-ed," and by declining the adjectival nouns, thus accentuating them. Ligon therefore presents these men as if they were architectural structures, both evaluated and praised for their

physique. In addition, by enumerating the parts of the body, he is systematically fragmenting the whole of the black individual's physiognomic elements and identity. The body of the black subject is then a colonized landscape not only conquered but also disassembled, beautified, and rebuilt at will.

Considering the human body and its significance in the history of visual culture, Nicholas Mirzoeff confirms that "[it] has been the principal subject of Western art since the Renaissance" (2). The trajectory that the "body" has had as dominant focus in the figurative and representative arts elevated it to a complex and fascinating status in which anatomical scientists would take a leading role in the eighteenth and nineteenth centuries, especially as they attempt to categorize the physiognomy of the black subject at the lowest level of the Chain of Being by setting it in contrast with that of his white European counterpart. The former is a grotesque creature; the latter, attractive and desirable. It is thus through the "beautification" of the black figure, as seen, for example, in the previous Ligon excerpt that the traditional negative image of the black subject is counterbalanced even more under the auspices of a profitable imperial enterprise during the Atlantic slave trade. The figure of the African subject is elevated to a pedestal of beauty, desire, and acceptance, if momentarily, though his condition of slave remains unchanged. His place in the sugar-making machinery is justified and valued since the strongest and most beautiful Africans are the most profitable in the Caribbean plantocracy. Ligon's "timber-like" black slaves are thus praised for their anatomical power as moneymaking machines that are also beautiful to the gaze. Along the same lines (excluding the imperial venture, of course), Iván Dariel's gaze upon the bodies of his "slaves" in *El cimarrón*, via the cinematic lens, also operates under a visual "beautifying" discourse in which the black body is aesthetically pleasant to behold. Through a cinematic lens that gives the director "power" to gaze at what had been legitimized as "ugly" in the history of African slavery, he transforms that precise "ugliness" into a "poetic beauty" supplemented by a romantic story. As Ligon did in his colonial report, Iván Dariel also "fragments" the whole of his slaves into anatomical parts as the camera focuses on their faces (close-ups) and body parts (in full and medium shots panning down from Xiorro's muscular torso dissolving into Femi's countenance to continue its trajectory down her bare breasts under the sun) in the first scene. The filmmaker paints their bodies with the brush of his cinematic lens. The black naked figures are turned into aesthetic objects instead of denigrated bodies, providing for the progression of the love story from Africa to Puerto Rico.

In fact, contemporary anthropologists, ethnographers, and visual culture scholars have come together with art historians in an interdisciplinary attempt

to inquire on the presence and representation of Africans and other dark-skinned individuals in the visual arts in Europe and the rest of the world to better understand their impact in the lives of the Empires before, during, and after the Atlantic slave trade. Several contemporary authors have opened doors into the query and their works should be noted: Eric Bindman and Henry Louis Gates, Jr. edited *The Image of the Black in Western Art, Vols. I–V* (2010–2014), a monumental survey in five encyclopedic volumes subdivided in ten parts that explore thousands of fine arts artifacts representing the black subject from the Pharaohs to the Renaissance to the U.S. Civil War, and onward to the 1960s; T. F. Earle and K. J. P. Lowe's *Black Africans in Renaissance Europe* (2005) compiles research from art historians, anthropologists, and literature scholars enquiring into the presence and impact of Blacks from different social classes in the political, social, and historical life of fifteenth- and sixteenth-century Europe; Marcus Wood's detailed study on eighteenth- and nineteenth-century visual representations of slavery in English and American paintings, engravings, and other art artifacts. In cinema studies, Natalie Zemon Davis's *Slaves on Screen* (2002) and Richard A. Gordon's *Cinema, Slavery, and Brazilian Nationalism* (2015), among others, take a look at the representation of slavery in motion pictures and the aesthetic qualities that makes the Seventh Art a perfect counterpart to retell its history.

Following the wedding in *El cimarrón*, on the very evening of their honeymoon, the two African newlyweds are captured by slave traders. Moments before, the viewer had a better look at the countenance of the black protagonist. He is a man of cinnamon-like skin tone with facial features that in the Puerto Rican physiognomic cartography of African descendants lean toward the "negro fino" category. In Puerto Rico, traditional racial discourse developed in the form of linguistic "beautification" as when a black man is called a "negrito lindo" (good-looking black man), "negrito inteligente" ("intelligent black man"), or "negro de salón" (salon black man), which makes reference to the European custom of meeting in salons to enjoy the lively discussion of intellectual, literary, and artistic matters of the day, as it was done in France in the seventeenth and eighteenth centuries. The lexicon "negrito" possesses two denominatives: negr- which indicates race and "-ito" which is a diminutive and therefore turns the word into a term of endearment very common in Puerto Rican contemporary language. Therefore, there has been a historical preoccupation with how non-blacks refer to a black person, i.e., by not using "offensive" language that in turn becomes a euphemism for the racial and denigrating attributive traditionally inherent in the word "negro."

Once in the Caribbean, Femi is separated from Xiorro and sold on the auction block. The lovers reunite after Xiorro makes an unsuccessful attempt

to escape to become a *cimarrón* (a *maroon*). It is precisely during the auction block scene that *don Pablo*, a slave owner (played by Fernando Allende), first appears as a counterpart to the "beautiful" black male figure. It is already 1809 and the small unidentified Puerto Rican town in which the story takes place is thriving as a slave market. The shot that introduces don Pablo is a medium shot of a preacher's hand holding a Bible in the foreground (on the right side of the screen frame) and an elderly townswoman in the middle ground (on the center of the screen frame), who listens intently to the zealous preacher's sermon. The scripture delivered comes from 2 Timothy 3:1–5, warning against arrogant and blasphemous men: "This know also, that in the last days perilous times shall come. For men shall be lovers of their own selves, covetous, boasters, proud, blasphemers . . ."[4] In that very instant, the camera pans to the left of the screen frame to reveal don Pablo arriving in full nineteenth-century gentleman's attire, followed by his immediate assistant overseer, Santiago (played by Teófilo Torres). Don Pablo is white, of European descent, and considerably wealthy. A tall dark top hat (tilted to the side), pompous white linen shirt with pleated cravat, vest, chocolate brown multi-buttoned long-sleeve coat, dark beige waistcoat, breeches, and knee high overseer boots are complemented by firm and overconfident steps as he surveys the town's market followed by his assistant who behaves like the king's wine taster as he approves of the provisions bought at the market. An elegant and self-assured don Pablo points at everything with a cane that, in his hand, is more like a king's scepter; his tilted top hat, the king's orb. Don Pablo, is the epitome of the notorious nineteenth-century dandy whose pictorialized image in visual artifacts and literature of the time visualized him as "disengaged and indifferent, too superficial to espouse a political cause and too self-absorbed to care about society" (Amann 2). However, the director and the screenwriter did involve don Pablo in the political turmoil of the times in which Puerto Rico was at the threshold of revolution as the neighboring Haiti saw its fulfillment in the hands of Toussaint Louverture. Don Pablo is also highly interested in the financial and sexual objectification of the slaves.

Fernando Allende is a well-renowned film, theater, and television actor among the multiplicity of male celebrities in Latin America, the Caribbean, and the United States. His career spans over thirty years of continuous work in the entertainment industry. From the very start of his acting career, Allende was considered an extremely handsome man whose Spanish facial features and lean, clean, and elegant body type represented the "best breed" of the European and Latin American genetic blend. At 53 years of age during production, he had surprisingly not lost the dandy-allure that has characterized him as one of the

leading *galanes* in the Spanish-speaking world of *cine y telenovelas*.[5] It is indeed with an ever-present allure of dandyism that Allende plays don Pablo. As such, both *galanes* are face to face in what appears to be a caged-fight between the black and the white man in search of freedom, land, and male prowess.

Nevertheless, and despite Allende's long-established industry curriculum, his affected, histrionic diction and tone of voice in most of his scenes in *El cimarrón* are extraordinarily exact as he delivers every line of dialogue with a stamina and precision that inevitably recalls soap opera performances. This contrasts entirely with, for example, Dolores Pedro's *tour de force* performance which, even if mostly in complete or partial silence, relies on the character's internal emotional turmoil to flesh out a woman who has been forcefully separated from both her motherland and her beloved husband. Telemaco, for his part, engages in a similar internally drawn effort in which he tries to distance himself from a previous soap opera acting history. His enigmatic presence and "exotic" Caribbean physiognomy (cinnamon-like skin tone, clear eyes, and "refined" facial features) were for the delight and acceptance of mainstream audiences. For Telemaco does not resemble the stereotype of a Sub-Saharan West African, and yet, a Latin American star such as Fernando Allende in the role of the cruel don Pablo adds certain sophistication and intensity to the picturesque canvas of this beautified version of the Xiorro saga.

In an interview with the director of the film by the authors for the present chapter, Ortiz nonetheless claimed that casting Telemaco and Allende was not expressly done with the purpose of taking advantage of an expected success in ticket sales due to their attractiveness and stardom as male figures in Latin American film and television industries. The producers of the film had other actors in mind for the protagonist roles but the choices for professionally trained black actors in Puerto Rico were (and are still today) limited. In fact, very few attended the casting sessions for these and other additional roles for the rest of the slave community in the Puerto Rican plantation represented in the film. As for actresses they even considered at first a black Colombian actress. They had already cast a Puerto Rican actress that was living in Los Angeles, but SAG (the Screen Actors Guild of America) did not let her accept the offer because *El cimarrón* was obviously a non-SAG production. Dolores Pedro, a Cuban actress and longtime resident on the island, was the third actress considered who in the end was selected to play Femi. Interestingly, Telemaco was offered the role from the start. The director even avows that it was expressly written for him; still, he asserts, main actors were selected for their acting abilities and not for their "attractive looks" or box-office pull.

However, the casting of Telemaco and Allende is certainly an element that goes beyond simply the acting talents both possess. It has connotations of a visual discourse on "blackness" and "whiteness" that permeates and contextualizes the outlook of the story and further supports the beautification of its characters. The casting, one could argue, nurtures the film's gazing "poetics of beauty," by integrating fantasy and desire. *El cimarrón* basks in the sumptuousness of its HD digital cinematography and, again, in the choice of "beautiful" actors such as Allende and Telemaco to incarnate the main characters in this romantic story of slavery. Both performers correspond to a specific view of the master/slave binary opposition that seems to stand as a strategic aesthetic element in this stylized cinematic version of gazing the "ugly" truth about the black man and his white owner in nineteenth-century Puerto Rico.

Another revealing visual element that adds to the production value of the film as one of integration and preoccupation with "beautifying" the diegetic world of the Puerto Rican plantation in the early 1800s is that of the wardrobe chosen for the slaves. As any other film depicting a specific historical era, the color palette that complements *El cimarrón*'s art direction and costume design displays its earth tones in yellows, greens, light and dark browns, and tones of orange already evident in the first sequence of the film. The director specifically chose these hues that, according to his research, formed part of the gamma of fabrics in the epoch at hand. The island being so far from Europe, fashion would reach the Spanish-settled Caribbean island much later than expected. Therefore, it was already "outdated" by the time it arrived on the island. There were no "pure" white fabrics; the range leaned more towards beige. In the film, the clothing worn by actors portraying slaves was embroidered by hand. If there were any suits or coats seamed with sewing machines—such as the ones worn by those playing nobility and politicians—they were not put together using the type of detailed and tight needlework seen in contemporary fashion. And yet, the majority of the costumes worn by slaves or characters of lower status in the film (e.g., a market vendor, the baker's wife, and so on) appear in front of the cinematic lens as particularly "new" and "bright." There are no stains, unstitched hems, any type of discoloration or creased fabrics for slaves and townspeople who did nothing but work all day long, under a scorching sun lifting, cleaning, and even walking on muddy roads. The cinematic image and its components (art director, set decoration, costumes, and the like) are peculiarly impeccable. One of the reasons for the quality of the fabrics that seemed to shine all the more under HMIs (light sources for illuminating large spaces) in scenes shot in exteriors might be that the director's gaze upon these troublesome times in the Caribbean was conceived as a cinematic "fable," as he very well argued.

El cimarrón was released on November 2006. From development to filming the process took around three years of pre-production. Unlike other directors that might have watched prior films on slavery such as *Roots* (1977), *Glory* (1989), and *Amistad* (1997), Iván Dariel decided not to watch any films related to the subject. Instead, he relied on local paintings of the era for background research. *Cimarrón's* director Iván Dariel Ortiz affirms,

> We read the only two books available in Puerto Rico on the subject of Marcos Xiorro, one by Luis Díaz-Soler and the other by Guillermo Baralt. The thing is that history has always been written by those who win the war. And in that era, blacks could not read nor write. So, who wrote [their] history ... ? White men. So I started to look at some visual medium of the epoch, among them many paintings.... [Painters] would render slaves in the Caribbean cane fields, send the paintings to Europe, but [they depicted] slaves ... cutting cane wearing hats ("pavas") and shoes.[6] Slaves did not have shoes! Even their faces have a smile on them. So they are sending these paintings to Europe and everybody is thinking: "Hey, they are being treated very well [down there in Puerto Rico]." (Ortiz, "Interview")

In addition, he visited a small museum of slavery in San Juan to draw inspiration for his visual interpretation of the era. His visual style was certainly influenced by films that were not necessarily about slavery. For example, some of the film's cinematography was inspired by the Chinese sword drama [*House of*] *Flying Daggers* (2004); *A Little Princess* (1995) and *A Walk in the Clouds* (1995) also served as vivid visual references; the latter two films were directed by renowned Latin American directors. *El cimarrón*, according to its director, is a production about the crude reality of slavery in the Caribbean that relied on paintings from the era and other films that had nothing to do with the subject for the purpose of the "beautification" of a slave romantic "fable." For a film production at a budget of $500,000 and 20 days of shooting, the film employed around 200–300 people including extras, actors, and technical crew on any given day. Compared to other local productions, this corresponds to a medium-sized to large motion picture crew trying to make ends meet with a limited budget for such a historical drama.[7]

Post-production of any film (whether a low- or big-budget production) always exceeds the producer's assigned budget. *El cimarrón's* crew asked, practically begged, three different companies for help to finish the editing/sound process of the film since at the time there were not many experts on the new digital HD that could accommodate this type of production. From Estudios Churubusco

in Mexico to minimal post-work in Los Angeles and then on to New York, the completion of the full HD process tested their patience. Today all major cinema houses in Puerto Rico are fully equipped with digital projectors as the days of film stock seem close to reciting its farewell. However, the producers of *El cimarrón* rented and installed a surprising total of 12 digital projectors available at the time in 12 cinemas houses around the island. *El cimarrón* is thus both the first production fully shot and exhibited in digital HD in Puerto Rico, and probably in the Caribbean. This constituted in itself a significant technical-historical moment in the history of Puerto Rican cinema. Furthermore, representing a time in history tainted with the inhuman treatment of Africans in the Atlantic world of slavery through a story that elevates the dignity of the enslaved within a romantic storyline, separates it from other equally admirable renditions in which the main focus is the representation of violence. The director asserts,

> I don't think there can be any film that could represent how difficult it was for the slaves. No film can represent what really happened. It must have been a thousand times worse. So, that there was violence we already know. But that these people in fact LOVED is a different story. (Ortiz, "Interview")

When asked, "What inspired you to embark in the visual representation of these specific historical times and characters?" he revealed that he had always had great interest in the subject because his grandfather (on his father's side) was a black man. He was "del color de un teléfono."[8] By contrast, his grandmother was extremely fair ("white"). Most interestingly, his grandfather's grandmother, as far as the family knows, had been a slave on the island prior to abolition in 1873. Therefore, there was the need to come to terms with a past that was more than just a distant historical episode commemorating emancipation in Puerto Rico every March 22nd.

EL CIMARRÓN AS CINEMA OF INTEGRATION

Jason Nichols (2015) notes that multicultural democracy is the dominant narrative that mediates racial formations in Puerto Rico, the Hispanic Caribbean, and Latin America. This post-racial discourse is very prevalent among Puerto Ricans and among some other Latino groups, "who have always acknowledged that they have African ancestry, but it is habituated to the idea that the people are a perfect blend of the African slave, proud and noble Spaniard, and the humble

native Taíno. This conception is problematic because it is a convenient way to deny institutional and in some cases individual racism" (n.p.).

Although *El cimarrón* relies on the beautification of an historical period in the Caribbean where violence inflicted upon Africans and its subsequent trauma are at the axis of its driving force, *the film* still works as one possible interpretative gazing at the ugly [historical] truth of slavery through a lens that beautifies its content with romance and an embellished landscape as tapestry. As an example of what McGowan calls the cinema of integration, *El cimarrón* provides a cinematic experience where the gazing of the horrors of slavery is based on the object's contextual elements: the film texts, the viewers experience, and the viewing conditions. Moreover, there is not—and there should not be—one unique approach to cinematic representations of slavery. A film such as *12 Years a Slave* (2013) displays a painful spectacle of violent torture while the French vehicle *Case Départ* (2011) opted for the comedy—whether to the dismay or admiration of critics and audiences. In the meantime, Quentin Tarantino's *Django Unchained* (2012) employs a combination of both raw violence and dry humor, as it is typical of this controversial filmmaker.

Within the contemporary Puerto Rican historical context, Iván Dariel Ortiz's choice of a beautified version of the brutalities of slavery and Xiorro's heroic story presented in glorious HD might definitely correspond to a treatment of these events with a certain delicacy and caution. As the subject of race and racism on the island has always been a "veiled" reality, not necessarily directly and openly discussed in public, euphemisms such as "negrito lindo, fino, inteligente" ("dear beautiful, refined, intelligent black man") are part of the everyday language when addressing or referring to dark-skinned individuals. Therefore, the need to present a feature film on the subject of slavery could be said to also correspond to a social and racial decorum toward the black community. In addition, Iván Dariel avows his admiration for Hollywood cinema and its tendency toward embellishing the image of films containing romantic themes even when the storyline might take place during wartime. This is evident in his treatment of a stylized cinematography, the overly dramatic music that at times seems to overpower the image itself, and the attention to the sculpted bodies of Xiorro and his love interest in *El cimarrón*. The latter parallels the Puerto Rican tradition of telenovelas in which the protagonists are visualized, admired, *and* desired for their physical attributes. After all, the main actors (Pedro Telemaco and Fernando Allende) are always remembered and celebrated as the quintessential *galanes* (i.e., leading men) of the now-defunct Puerto Rican telenovelas.

Notes

1. The other two films are *El Resplandor* (DIVEDCO, 1962) and a short film, also titled *Cimarrón* (1978) but with no direct connection to the 2006 version presented here.
2. Based on the director's notes, the specific instructions of the director to his actor were to arch his back pushing out his chest while keeping his arms to the side, slightly bent, closer to his torso, and letting the back and arm muscles exert all their fibrous tissues and filaments.
3. Later in the film, don Pablo (Fernando Allende) comments on the physiognomy of Xiorro (Pedro Telemaco). He tells his assistant: "This Negro has features of a white man," to which the assistant replies: "My master, you know that Europeans had relations with the African 'negras' during their trips to that continent. That's the result."
4. "Biblegateway" Online King James Version.
5. The *galán* is the leading man (always handsome and fit) of the *telenovelas* (Latin American soap operas).
6. The "pava" is a typical Puerto Rican large straw hat in which the straws on its rim are left "wild" creating a wavelike effect around it. It is also the icon of humble, hardworking countrymen and women (*jíbaros*) and a symbol for one of the island's political parties claiming: "Bread, Land, Freedom."
7. The Puerto Rico Film Commission (the governmental entity in charge of authorizing and promoting local and international film productions) financed the project in the form of a government loan, which has to be repaid. Films are declared sole property of the PRFC if the producers fail to pay the production loan in full for a limited period of five years.
8. He is making visual reference to the traditional household rotary dial telephone in Puerto Rico in the 70s and 80s, which was jet black.

Works Cited

Amann, Elizabeth. *Dandyism in the Age of Revolution: The Art of the Cut.* London: U of Chicago Press, 2015. Print.

Ayers, Drew. "The Real Gaze: Film Theory after Lacan. Review." *The Velvet Light Trap*, vol. 61, 2008, pp. 57–59. Print.

Carnegie, C. V. *Postcolonialism Prefigured: Caribbean Borderlands.* New Brunswick, NJ: Rutgers University Press, 2002. Print.

Chinea, J. L. *Race Labor in the Hispanic Caribbean: The West Indian Immigrant Worker Experience in Puerto Rico, 1800–1850.* Gainesville: University Press of Florida, 2005. Print.

Díaz Soler, Luis M. *History of Black Slavery in Puerto Rico.* San Juan: Editorial de la Universidad de Puerto Rico, 1981. Print.

Figueroa, Luis A. *Sugar, Slavery and Freedom in Nineteenth-Century Puerto Rico.* Chapel Hill: The University of North Carolina Press, 2005. Print.

Garraway, D. L. "Toward a Creole Myth of Origin: Narrative, Foundations and Eschatology in Patrick Chamoiseau's 'l'esclave Vieil Homme et le Molosse.'" *Callaloo*, vol. 29, no. 1, 2006, pp.151–67. Print.

Gil, Nemesio. *The Black and the Beautiful: Strategies of Depiction and Visualisation in Richard Ligon's "A True and Exact History of the Island of Barbados" (1657).* Diss. U of Puerto Rico, 2015, pp. 6–7, 266–68. Print.

Glissant, E. *Caribbean Discourse.* Translated by J. Michael Dash, Charlottesville: University Press of Virginia, 1989. Print.

Hall, Stuart. "The Spectacle of the Other." *Representations: Cultural Representations and Signifying Practices.* London: Sage Publications and Open University, 1997, pp. 225–93. Print.

Ligon, Richard. *A True and Exact History of the Island of Barbados*, edited by Karen Ordahl Kupperman. Amazon: Hackett Publishing, 2011 (1657). Kindle Edition.

McGowan, Todd. *The Real Gaze: Film Theory After Lacan.* Albany: State University of New York Press, 2007. Print.

Mintz, Sidney M. *Caribbean Transformations.* Baltimore and London: Johns Hopkins UP, 1974. Print.

Mirzoeff, Nicholas. *Bodyscape: Art, Modernity and the Ideal Figure.* London, New York: Routledge, 1995. Print.

Nichols, Jason. "La melaza que llora: How to Keep the Term 'Afro-Latino' from Losing its Power." Web. http://www.latinorebels.com/2015/10/16/la-melaza -que-llora-how-to-keep-the-term-afro-latino-from-losing-its-power/. Accessed 12 May 2016.

Rodríguez-Silva, I. *Silencing Blackness: Disentangling Race, Colonial Regimes, and National Struggles in Post-Emancipation Puerto Rico (1850–1920).* New York: Palgrave Macmillan, 2012. Print.

Case départ

Slavery in Martinique through the Lens of Comedy

Gladys M. Francis

The comic demands something like
a momentary anesthesia of the heart.

—HENRI BERGSON

If you want to tell people the truth,
make them laugh, otherwise they'll kill you.

—OSCAR WILDE

Every act of communication is an act of translation.

—GREGORY RABASSA

Bearing in mind the limited number of French films on slavery that have been produced in the past decades, there is no overstatement in arguing that French filmmakers have a tendency to circumvent subjects related to slavery and colonization. Though factors underlying this trend are manifold, they nonetheless commonly involve a significant ambivalence on slavery as seen in mainstream print capitalism, history books, schoolbooks, or official discourses concerned with the construction, propaganda, or representation of the French Nation.[1] These inconsistencies and contradictions do not, however, reflect the extensive dealings of France in the slave trade during a period that spans over two

centuries until the abolition of slavery in France in 1848. In order to better probe representations of identity, bodily pain, race, class, sexuality, and gender in *Case départ* (2011), a French comedy that depicts slavery in colonial Martinique, we must first understand its cultural, historical, and socio-political context. Without this context, it would be difficult to understand the reactions that emerged when it was announced that the film *Case départ* would conjoin a colonial backdrop and the comedy genre. Not unlike conventional discourses, very few French films discuss France's colonial and slavery era,[2] just as there are very few Black actors in the French cinematic arena. Flouting this cinematographic trend, in the summer of 2011, two French actors (of Cameroonian origin) Fabrice Eboué and Thomas N'Gijol co-starred in and brought to the big screen (with co-director Lionel Steketee) *Case départ*, a full-length film set for the most part in 1780 colonial Martinique. Beyond presenting a contextual framework, I find it important to observe the representations of the Black body in pain and its agency as defined by the gaze of *Case départ*'s directors. I analyze to what extent the comedians allow the viewers to understand, identify, contextualize, and interpret that pain through laughter. Indeed, what substantial understanding or awareness about slavery survives the comedy and the irony?

THEN AND NOW: FRANCE'S BEARINGS TOWARD SLAVERY, COLONIZATION, AND RACE

During Napoleon III's Second Empire (1852–1870) and the Third Republic (1870–1940), also a period famous for its creation of "National Education" curricula, many history textbooks adopted in primary and secondary schools did not shy away from analogies between the Roman occupation of France and this country's own imperial presence in Africa and the Caribbean. Gustave Hervé and Gaston Clemendot's popular French history book (1904) parallels, for instance, France's conquest of Africans to that of the Romans over the Gauls, ultimately providing a narrative of power and domination coupled with the romanticization of a civilizing mission: "Two thousand years ago, the beautiful country we live in [was called] Gaul. Its inhabitants, the Gauls, lived the same as the savages of Africa live today" (5).[3] The authors add:

> In sum, our Gallic ancestors were savages hardly more advanced than are, at present, many negroes in Africa. . . . Today, when French or English soldiers fight against African negroes, they always end up defeating them because they have the advantage over them of having

better arms. Similarly, the Romans soldiers who invaded Gaul could not but defeat the Gauls because they were much better armed.[4]

Throughout history, the French have maintained methodical patterns through which historical figures, events, or facts are retrieved, mythologized, reframed, or disregarded to quench the construction of nationhood.[5] As Benedict Anderson argues, national myths of an origin and the nation-building mythology are rather functionalist terms (190–210), or in other words, they are constructed narratives and stories, "imagined communities"—more than they are real. The statement by Ernest Renan (1823—1892) that a Nation is "an everyday plebiscite"[6] puts forth the idea of a collective identity nourished by shared memories and people's *will/desire* to belong to a nation. It also implies a communal contribution to the creation of the Nation as opposed to major implications of race, locality, or religion. Renan's "spiritual principle" approach to nationalism, summarized in the German term *Willensnation* ("nation-by-volition"), reveals similar ambivalence in official discourses concerned with positing France's sense of identity and nationhood. Renan further affirms that

> forgetfulness, and [even] historical error, form an essential factor in the creation of a nation; and thus it is that the progress of historical studies may often be dangerous to the nationality. Historical research, in fact, brings back to light the deeds of violence that have taken place at the commencement of all political formations, even of those the consequences of which have been most beneficial. Unity is ever achieved by brutality.... But the essence of the nation is, that all its individual members should have things in common;[7] and also, that all of them should hold many things in oblivion. No French citizen knows whether he is a Burgundian, an Alan, or a Visigoth; every French citizen ought to have forgotten St. Bartholomew, and the massacres of the South in the thirteenth century. (277)

Renan overlooks the weight conceded to learning mechanisms in an epoch during which the dissemination of knowledge, learning, and *remembering* occurred within state-run schools chartering selective nation-building mythologies and discourses. As Anderson points out, the French state continued to preserve certain bodies of knowledge that "needed to be forgotten" in order to sustain the national identity (199–201). We cannot but ask "what is the process by which one does indeed get one's history wrong in order to get one's national or communal identity right?" (Mazrui 9). In addition, Renan's concepts of "nation-by-volition" and shared memory (and forgetting) reflect, as Tzvetan Todorov stresses, an

idealist conceptualization and "a failure" (304–5),[8] one initial reason being that constructions of memory and identity are essentially built on "otherness." In fact, the creation of identity remains closely intertwined with the constructions of zones of differentiations with the "Other," a process that partakes in the production of memory and remembering. Furthermore, official discourses filled with (material and symbolic) dominant positivist trends on France's past, nationhood, or "civic nationalism," reveal ambivalent nationalist modes of thinking more than the expressions of social reality.

These historical and ontological praxes as well as such empirical discourses (concerned with the *practical* integrity of national imaginings and imaging) complicate the comprehension and discussions on issues of race, slavery, and colonization. Displaced under "positive" configurations (as seen in the selfless, difficult, and necessary civilizing program of the "uncivilized" Africans), the realities, inhumanity, and consequences of slavery and colonization of Africans and their descendants become ineffectual. These particular dispositions of the state have stifled efforts of recognition, commemoration, recollection, and reparations vis-à-vis the transatlantic slave trade and slavery. This conventional stance continues to play an important role in the amnesia and misunderstanding on this segment of French history.

Our twenty-first century reveals the extent to which this ambivalence on slavery remains patent as seen in the public statements made in 2007 by Nicolas Sarkozy, who at the time was the President of the French Republic:

> The European dream needs the Mediterranean [i.e., the Maghreb] dream. [That] dream that was not so much a dream of conquest as a dream of civilization. Let us stop blackening the past. [The] majority of those who left for the South were neither monsters nor exploiters. Many put their energies toward building roads, bridges, schools, and hospitals. Many wore themselves out cultivating a bit of thankless land that none had farmed before. Many went only to heal or teach. [One] must respect the men and women of goodwill who meant, in good faith, to work beneficially for an ideal of civilization in which they believed. [If] France has a moral debt it is above all toward them. [A] politic of civilization, it is what the Mediterranean prompted us to do [and] nothing has ever been mediocre over there [in the Mediterranean].[9] (2007a)

A month later, Sarkozy reiterated his nostalgia of such a French civilizing model, insisting that France's dedication was to civilize more than it was to exploit, which he concludes, stands as a unique and rare disposition among all of the

other European colonial powers. In another speech, Sarkozy went on to assert France's virtuous past through an implicit reference to Germany, affirming that France never committed genocide or any crime against humanity (2007b).[10] Such discourses have nurtured tense environments in which the representativeness and experiences of slavery, colonization, and issues of race and racism are very difficult to tackle within the governmental framework. In fact, Sarkozy's comments were delivered six years after the French government passed the commemorative "Taubira Law" (*La loi Taubira* n. 2001–434) recognizing the Atlantic slave trade and slavery as a crime against humanity. It was not until 2001, exactly 163 years after the abolition of slavery, that such a law was implemented, after the due efforts of Christiane Taubira. Born in French Guiana (a former French colony and now an Overseas Department of France), Taubira is the former Justice Minister of France. Five years after the passing of the Taubira Law, May 10 was declared "a national day of memory for the slave trade, slavery and their abolition." In 2012, a memorial dedicated to slavery and its abolition was built in Nantes (the largest slave trade port in France during the colonial period). It was only as recently as May 10, 2015 that The Mémorial ACTe, a cultural center dedicated to the memory, history of the slave trade and struggles of bondage in the Guadeloupe Islands, opened its doors on the former sugar cane factory site of Darboussier, in the city of Pointe à Pitre.

Lately, various overt forms of racism, xenophobia, and homophobia have shed light on detrimental socio-political facets of France. In 2013, Taubira defended and led the passage of France's same-sex marriage and adoption law (whose supporters commonly named *Le mariage pour tous*). She subsequently became a target of opponents to the law who aimed racist affronts at her. Anne-Sophie Leclère, a National Front[11] candidate, published a picture on Facebook comparing Taubira to a monkey (Stille 2013). The following week, during a protest by "*La Manif*[12] *pour tous*,"[13] a child waved a banana at Taubira chanting "ugly ape, eat your banana!"[14] (Rotman, Faure 2013). These incidents were echoed in the headline of the French far-right newspaper *Minute*: "Maligne comme un singe, Taubira retrouve la banane." "Retrouver la banane" literally means getting back/ recovering a banana; so the headline translates as "Crafty as a Monkey, Taubira Gets Her Banana Back" (Willsher 2013). The second half of the headline also evokes a French expression that means to smile (or to be happy). With this interpretation, the entire headline could be read as: "cunning as a monkey, Taubira is as happy as a clam (or sandboy)." These ongoing "violent racist comments denying [Taubira's] appurtenance to the human race" (Bonaventure 2014) are similar to the racist slurs and monkey screeches frequently hollered at French

soccer players of color in stadiums across France. In a statement following the legal penalties against *Minute* for their racist treatment of Taubira, the paper's staff declared themselves without regret, claiming to have practiced not racism, but only satire, which is not a crime (Jean-Marie Molitor interview for *Minute*, in *Le Monde* 2013).[15] If humor (comedy, irony, satire) can be a powerful tool in the communication of ideas, the comedic process can also carry its own pitfalls in its efforts to challenge one's assumptions, subjectivities, views, and orthodoxies. In fact, comedy can be informative, deceptive, influential, or dangerous (as the events surrounding *Je suis Charlie* can attest).

CASE DÉPART, "THE MOVIE OF SHAME"? WHEN LAUGHTER MEETS MORALITY AND ETHICS

Prior to the film's release date, various individuals ranging from bloggers, socio-cultural associations/clubs, or scholars (speaking predominantly from an African Diaspora perspective) expressed their outrage on social media platforms. They were shocked that three producers of African ancestry would find the linking between the comedy genre and slavery to be an appropriate approach in France, a country that rarely addresses its colonial past. A Facebook page was created, titled "Let's boycott *Case départ*: the movie of shame." During this period of promotion and marketing, Eboué and N'Gijol responded to the heated commentaries asserting that the film was not a comedy on slavery, but a comedy that unites people to make them understand issues of identity in contemporary France (Hermer 2011). Asked why the film was not shot in Martinique, they stated their original desire to film in Martinique, but "being too sensitive to their colonial past, Martiniquans were resistant toward the idea of *Case départ* being filmed on their island" (Allociné);[16] the duo claims in an interview with *Commeaucinéma*, that it was the local whites, or *békés*,[17] who particularly opposed the filming in Martinique.[18] As a result, the decision was made to film in Cuba.[19] These heated discussions and negative attention that took place during the film's pre-launch period probably boosted the film's promotion. Once released in July 2011, *Case départ* became the leading box office comedy in France, earning over $15 million in the few months following its opening. The Cannes Festival's positive reactions to the film and the abounding box office sales (close to 1.8 million tickets sold) affirmed its success, weakening or silencing the virulent criticisms on social media. Those who disapproved of the film were often reminded that it was not a historical piece and that they probably lacked a sense of humor. Those entertained by the film could hardly be blamed, for it is laughter that *Case*

départ makes permissible. It was not new to the film industry to examine difficult topics such as fascism, anti-Semitism, or slavery through the lens of comedy.[20] However, the presentation of issues surrounding the topic of slavery through the lens of comedy was a new approach within the French film industry; *Case départ's* slant was utterly novel to French cinema.

The film's title, *Case départ*, translates as "back to square one," meaning to start from the beginning, the point of departure. In the colonial context of the French Antilles, "case" also alludes to the wood shack in which slaves lived. Nowadays, it is still common to use the term "case (créole)" to refer to a small wooden house.[21] In this context, the title can be interpreted as a *case (créole)* serving as the characters' point of departure toward their colonial past. *Case départ's* plot centers on two Parisian half-brothers whose Antillean father is dying in his home, in Martinique. As they visit him prior to his passing, they are transported back to slavery by the magic powers of an old aunt[22] who is infuriated to see them destroy the sole piece of inheritance left to them by their father: the certificate declaring the free status of their grandparents during the French colonial era (the brothers had destroyed the document for they did not find any financial value in it). *Case départ* uses the ambiguity of time and space with the characters propelled into the past while maintaining their twenty-first century gaze. As we know, cinema can make present what is absent, and *Case départ* gives a vivid presence to colonial Martinique. In fact, most of the film is set in colonial times, with costumes, décor, actions, plot, and jokes that are all relevant and coherent to the depicted slave system. It is also worth noting that while *Case départ* is by no means a historical film, to make it pertinent to the slavery era, the actors consulted historians to ensure projecting realistic atmospheres through the costumes, the depiction of eighteenth-century eating practices, and ballroom scenes, for instance.

The comedy genre probably lends itself more readily than other genres to the analysis of class relations and to the nexus between order and disorder. Comedy is still a big tradition in Europe, especially in France, where half of the film industry's production is comedy. As a genre, comedy deliberately goes against the demands of realism and prides itself on being an arena where repressed tensions can be released in a safe manner. Accordingly, *Case départ's* icons act out class distinctions (signified by certain cultural referents such as dress codes, linguistic registers, working and living environments), using stereotypes on class, race, and national prejudice that are often meant to foreground or parody such stereotyping. *Case départ*, in essence a "buddy" adventure film, centers on two Black French men distinctly incognizant of their Caribbean roots. Each embod-

ies certain stereotypes; Régis, the wealthy mulatto who denies his Black roots and lacks compassion for the needy, is a "yes-man" to his Caucasian boss and is married to a white woman. The second character, Joël, is a dark-skinned Muslim who harasses a girl for her canteen money (in front of his daughter) so he can pay a bus fine, he also does not want to work, has been to prison for robbing an elderly woman, and systematically blames his problems on racism. In a French context, Régis is thus the bourgeois while Joël represents the scum (*la racaille*). Purposely parochial, the jokes are meant to foreground stereotypes and social class differences internalized within race issues. The film captures class, not just as economic relations but also as power relations with dominant/dominated dichotomies or ideologies. Playing on stereotypes, the directors aim to ridicule behaviors prevalent in contemporary France and to show how current stereotypical discourses used by Black, White, and Jewish people are made irrelevant when shifted into the colonial era:

> *Monsieur Henri* (the slave overseer): Get to work, you Negro
> with your big [*he is interrupted by Joël's interjection*]
> *Joël*: You racist!
> *Monsieur Henri*: What?
> *Joël*: You say that because I'm Black!
> *Monsieur Henri*: Evidently! [*Laughs (long giggle)*][23]

Displaced in colonial times, we see how Joël and Régis are forced to re-negotiate the economics of their now enslaved selves. In fact, as slaves, they are now a fungible property, underprivileged, and forced to provide free labor while enduring the deprivation of all personal or economic benefits (wages, property, freedom of full mobility, and human rights). Chris Bliss reminds us that best comedies and satires have the ability to "circumvent our ingrained perspectives," and to generate critical thinking or greater understanding within an individual, potentially leading to real change: "as the philosopher's stone, [comedy takes] the base metal of our conventional wisdom and transforms it through ridicule into a different way of seeing and ultimately being in the world" (2011). Bliss adds that in comedy,

> there is this mental delight that is followed by the physical response
> of laughter, which, not coincidentally, releases endorphins in the
> brain. And just like that, you have been seduced into a different way
> of looking at something because the endorphins have brought down
> your defenses. This is the exact opposite of the way that anger and

206 SLAVERY IN MARTINIQUE

fear and panic, all of the flight-or-fight responses, operate. Flight-or-fight releases adrenalin, which throws our walls up sky-high. And the comedy comes along, dealing with a lot of the same areas where our defenses are the strongest—race, religion, politics, sexuality—only by approaching them through humor instead of adrenalin, we get endorphins and the alchemy of laughter turns our walls into windows, revealing a fresh and unexpected point of view. (4)

Given a French context in which slavery is rarely discussed, as a comedy, *Case départ* carries double-edged implications. While it has the potential to challenge viewers by making them gaze at issues scantily addressed in the socio-political arena, it can also faultily rely on an "assumed" awareness of meaning on these issues on the part of the viewers. In the latter case, the viewers' ability to respond depends on not only their sense of moral and ethical responsibility, but also their basic critical thinking.

> *The priest:* Negroes need simple food because they are simple people.
> *The son-in-law:* As a matter of fact, be careful! By getting too close to them, it might be you that they will end up eating.
> *Madame Jourdain:* Are African Negroes really cannibals?
> *The priest:* Of course! All the more so as if you're lost in the bush, you can hardly escape from a Negro. Their large nostrils confer them a sense of smell much superior than ours. They can smell you from miles away.
> *The son-in-law:* Should they not start to smell themselves?
> [*Everybody laughs at the dinner table*]
> *Madame Jourdain:* The worst part is that some white people beget children with these Negro women. Well, should we consider these mixed-bloods as humans?
> *The priest:* When a horse fornicates with a donkey it never results in a horse but a stupid and sterile mule.
> *Joséphine Jourdain:* What about this gigantic sex of theirs?
> *The priest:* . . . It helps them cling to branches like opossums.
> *Madame Jourdain:* . . . These Negroes have legs for hands!
> *The son-in-law:* And hands for legs like any monkey
> [*Everybody laughs at the dinner table*]

Filled with racist comments, this comedic scene reminds us of the French far-right newspaper *Minute*'s portrayal of Christiane Taubira as a monkey. In fact, if it is true that "every act of communication is an act of translation" (Rabassa

2005), *Case départ*'s comedy adds a complex layer to the depictions and inter-
pretations surrounding the slavery era through deliberate misdirection, ironic
stances, tricky verbiage, and provoking depictions (what comedy usually entails).
It also reminds us that many people still believe in such fallacies and stereotypes.

The film also takes historical liberties that both confirm and deny common
stereotypes of the Jews. In 1685, the *Black Code* (Le code noir)[24] ordered the
Jews out of France's colonies, but in *Case départ*, the directors trigger the contro-
versy surrounding the Jews' alleged involvement in the transatlantic slave trade
through the depiction of a problematic caricaturized Jewish character. In the
film, Isaac,[25] a stereotyped Jewish merchant, is seen participating in the slavery's
economic system by providing luxury goods to the plantation owner, while also
being very sympathetic to the two enslaved brothers whose escape from the
same plantation he facilitates. He is later seen feeding the brothers at his house
before they continue their escape. In their interview with *Commeaucinéma*, the
directors expressed being aware of the controversy on whether or not the Jews
were Black slaves' traffickers, to which they contended "finding [this debate] so
surreal" querying "how can [one] reasonably debate to know who between the
Jews or the Blacks suffered the most?"[26] (*Commeaucinéma* "Interview Croisé"
2011). Subsequently, in the film, Eboué and N'Gijol put in place a humoristic
and arbitrary debate on this topic, between the two brothers who come from
the future and the Jewish man whose reality is that of 1780, having no idea of
the Holocaust and anti-Semitism his people will endure:

> *Régis:* Why are you doing all of this for us?
> *Isaac:* Because I am a Jew. Do you know what the Christians used
> to call the Jews? The Negroes of Europe! Your people and mine
> lived the same sufferings.
> *Régis:* Well, anyway, thank you!
> *Joël:* You suffered, but it's not preventing you from causing hurt in
> Palestine!
> *Isaac:* What about Palestine?
> *Régis:* You idiot! How do you expect him to know about this?
> *Isaac:* What's happening in Palestine?
> *Joël:* Don't worry about it. It's a tense debate; let's not get into it.
> *Isaac:* In any event, we must stand together. Two peoples suffered
> throughout History, first the Jews, then the Blacks.
> *Joël:* First the Blacks, *then* the Jews!
> *Régis:* Oh no! We suffered more than you did!
> *Joël:* I'm sorry, but the enslavement of Black people is the biggest
> suffering of this century!

> *Isaac:* What? We were the first to suffer mass slavery in Egypt un-
> til Moses freed us, then it was inquisition, and *we* the number
> *one* of suffering.
> *Joël:* I'm sorry but I just can't let you say that.
> *Régis:* . . . the Blacks did suffer more.
> *Isaac:* I disagree!
> *Joël:* Later, when Adolph Hitler comes into the picture, we will be
> able to talk about it some more.
> *Isaac:* Who's Adolph? . . .

Case départ's humor is thus essentially sustained by a series of anachronisms that ultimately force the viewers to revisit issues of racism, labor, identity, and sexuality within satirical and controversial perspectives. In an interview, Eboué explained:

> [During slavery], racism wasn't considered racism. It was a way of
> thinking. [In the film], our goal was also to say that today, when you
> are Black, you have a choice, a choice to try to integrate, advance,
> or to be a rebel, whereas [during colonial times] we were Negroes
> without any choice. [The goal] was also to go back in History.[27]
> (*Commeaucinéma* 2011)

Although comedy intends primarily to make the viewers laugh, it can neverthe-less be misinterpreted by those who are not equipped with sufficient contextual knowledge to critique what is being presented to them. When ironic racist jokes are added to the mix, the results can be disastrous. Based on their comments, the directors believe that to some extent all the characters are portrayed as immoral, whether they be Black, Jewish, or White. By engaging all the characters in racist or ironic comments, they aim to put all of them at a similar level of despicability. The viewers are thus invited to adopt the characters' positions to get the jokes. Such undertakings constitute one of the potential pitfalls of comedy, since they tend to downplay considerations of privilege, locality, historicity, gender, and class stratifications (among others) that shape moral values and interpretations.

 Case départ might not make fun of slavery. As a comedy, its puns are not declarative (to express what is known to be the case in reality) but they certainly do push boundaries and touch the irrepressible. Yet, not all satire is funny or accurate. Ted Cohen's and Tanya Rodriguez's research on moral psychology and race theory offers interesting examinations on the aesthetics and ethics of humor. They explain that a joke is not good just because it is inappropriate; con-versely, that it is inappropriate does not necessarily mean that a joke is not funny (Cohen 84). But appreciating ironic racist humor could involve a lack of empathy

toward the reality and horror of slavery. As Rodriguez explains, ironic jokes on race may be acceptable to an audience that already rejects racism (12), and more specifically in the case of *Case départ*, an audience that understands the horror and implications surrounding slavery. But as Rodriguez insists, audiences are comfortable with such jokes precisely because as individuals they feel self-assured in their own rejection of genuine racism and possess an understanding of their space of privilege (12). The problem is that this does not (and should not) apply to all viewers. As Henri Bergson argues: "The comic demands something like a momentary anesthesia of the heart" (5). It is understood that through ironic racist jokes, the film can unwittingly create a "forsaking of empathy" (Rodriguez 14), given that the viewer can distance him or herself from the feelings of those affected by slavery, lashings, and colonial domination. The viewer could become in such a case a spectator complicit in the horrors of slavery.

Most of the negative press associated with *Case départ* focused on its abject moral and ethical essence because it "made fun of slavery." Such criticisms might reside in the fact that the filmmakers insisted to have only used slavery as a secondary backdrop, when in reality the colonial setting stands as the core of *Case départ*. In fact, their simplified depiction of slavery can hardly be measured as a meek background. It is within such aesthetics and positioning that the directors present complex issues of identity, class, racism, gender, and sexuality in both colonial Martinique and contemporary France. These issues are without doubt relevant to the socio-cultural tensions we continue to witness in France and between France and its former colonies. Humor, as I argued, can offer efficient and safe methods to address such issues, which is why *Case départ*'s humoristic alternative could stand as suitable. Yet, this diluted presentation of bondage might prevent the audience from experiencing the empathy toward the condition of slavery that is essential to the brothers' identity formation. It is, however, inaccurate to argue that *Case départ* makes fun of slavery *per se* (as I propose to further explain in my next section of study). Rather, it sells laughter and mockery regarding selfhood, immigration, and racism and, as such, the directors attained their goal, just as the entertained viewers probably got the laughter they expected and purchased.

SLAVERY THROUGH DEPICTIONS OF BUSINESS AND ECONOMIC TRANSACTIONS

The directors received harsh criticisms for their buffoonish interpretation of Black people within the colonial setting of their film. These comments are rooted

in the flawed narratives found in mainstream discourses. They are also rooted in a desire to correct and/or revise historical misrepresentations and exaggerations via a shift in representations and commemorations of blackness—as resistance, nobility, and magnificence. Indeed, *Case départ*'s negative criticisms also derive from apertures, *lacunae*, and urgencies to develop a shared consensus and a truer face to admittedly negative features of French colonial History. In addition, because Fabrice Eboué and Thomas N'Gijol are of African descent, this certainly brought other sets of expectations. Named "Uncle Toms," "bounties,"[28] "Black faces," and "a disgrace to their Black ancestors," most negative remarks found on social media condemned the fact that two *Black* men were insensitive and found humor to be an appropriate choice to bring the French colonial era—an era largely characterized by the presence of slavery—to the main screen. *Case départ*'s controversy reflects the unaddressed chapters of a French colonial history in relation to which humor seems inappropriate.

In *Case départ*, we also observe a blurring between business acumen and the economics of slavery, which is best illustrated when Régis uses the talents he gained as a twenty-first century mayor's office employee to please his plantation white master and negotiate for certain privileges or his choice of corporal punishment. For instance, he avoids the torture of lashing, not knowing that branding would be the alternative. It is often Régis who negotiates on behalf of Joël. Furthermore, we witness their negotiation with the plantation owner, regarding the reallocation of the certificates of freedom they received for rescuing his son Victor, who almost drowned in a river. The child's name is a direct reference to Victor Schoelcher, as stated by Eboué and N'Gijol in various interviews. Named France's Undersecretary of the Navy and the Colonies in the nineteenth century, Victor Schoelcher headed a commission charged with drafting a decree abolishing slavery in the French Caribbean. Schoelcher is habitually depicted in monuments and mainstream historical narratives as the heartfelt white man and beneficent savior who liberated an entire Black people from bondage. In recent years, French Caribbean union-run education groups and associative movements (of descendants of slaves) have started to de-patronize and de-reify Schoelcher's figure in a creole slogan "*A pa Schoelcher ki libéré nèg*" (It is not Schoelcher who freed enslaved people). The process stands for an acknowledgement of the considerable and active roles that slaves and Maroons played in achieving their own freedom. In *Case départ*, Régis and Joël position themselves as those who inspire Victor's propensity and largesse regarding slaves and their freedom.

Among their fellow slaves only Régis and Joël seem capable of participating in political intrigue. We also observe a lack of communication between the two

men and the other slaves. As a result, the characters' identity formation (claimed to be necessary through a return to slavery) is not built on the slaves' sense of solidarity and community building. The latter are unique facets of slaves' capacity to survive (and rebel) in the stifling dynamics of the slave trade and slavery. There is therefore no clear resistance from the two men against slavery as an institution. In fact, *Case départ* itself does not challenge this institution and probably never intended to.

Case départ's narrative device of time travel serves as a means to carry out an investigation into identity as well as a mechanism for observing certain social values. The fade/dissolve effects created by the smoke coming from the pipes of both the old mysterious aunt and that of Monsieur Henri ("the overseer") respectively bring Joël and Régis to 1780 and back to the twenty-first century. Their return to events of the past is hermeneutically determined for it produces, in the end, an elucidation. Thus, Joël and Régis' transportation to the slave era is supposed to bring truth (on their sense of self) and shed light on issues of class and race. Slavery is personalized and seen through the eyes of the main characters. The ideological and nationalistic implications of the return to the past are evident. By framing history as an individual experience and because the film is a return to colonial times, history can become didactic: a moral lesson. Alternatively, it can lead to identification with a national ideal. As a matter of fact, back in contemporary France, the brothers seem to have gained a better understanding of their identity, which contributes to their better fit in the French national landscape. This renewed look at the present via the past is what we see at the end of the film.

In the film, the classism within colonial society writ large is clearly based on slave workers alienated from the commodity produced, a commodity that is destined for the market and for the profit of white people. In the twenty-first century, Joël, having reached a new sense of identity, is now working on a construction site and getting his minimum wage check. His work still contributes to the profit of others, based in part on the repression within his wages of the profit margin. While Joël fusses about his minimum wage paying job, he most importantly chooses to stay employed. As such, *Case départ*'s *dénouement* presents Joël and Régis as being redeemed. In this fashion, Joël's work ethic mirrors that of Régis, who for his part seems to have lost his "béni-oui-oui" (yes-man) attitude toward his white boss and gained some of Joël's rebelliousness. This is observed when Régis demands that his white boss respect him by showing him a Fleur-de-Lys hot-ironed on his buttock (the brand he received when he was enslaved):

> *Boss:* Hello my lil' Régis! How was your trip to the Caribbean?
> *Régis:* It went well thank you.
> *Boss:* Were they on time for the funeral? [*Laughs*] What?! It's a
> joke! Did you leave your sense of humor in the Caribbean?
> *Régis:* No it's just that coming from your mouth I don't find this
> funny.... I'm not your nigger, I'm not your servant, alright?
> *Boss:* But, what's wrong with you Régis?
> *Régis:* Let me show you something.
> *Boss:* What do you want to show me?
> [*Régis pulls down his pants and shows his behind*]
> *Boss:* What the fuck!
> *Régis:* So from now on, you'll have to learn to respect me, okay?
> Have a good weekend.

The estranged and troubled half-brothers are finally companions, complementing and better understanding each other. Once the characters return from slavery, they are mythologized into "better, improved Black men." They are portrayed as better sons, fathers, and romantic partners (in the case of Régis with his wife).

Django Unchained (see relevant essay in this volume), the comedic spaghetti Western directed in 2012 by Tarantino regarding antebellum Mississippi, maintains an unflinching (and controversial) exposition of slavery's horrors. Indeed, the violence against enslaved Blacks is real and raw in *Django Unchained* through the various paraphernalia of slave torture (among other things). This does not happen in *Case départ*, in which lashings, for instance, are barely shown on screen. Instead, during acts of torture, the camera focuses on the masters and their mundane discussions. In parallel, the comedic intention of a scene like this one disembodies the cruelty of the lashing, preventing both the heroification or the potential of defiance by the Black individual, just as the scene removes the victimization of slaves or the Black body in pain as an object of interest (or shock) to the viewers' gaze. Although the slave owners' idiocy is captured through a silly and grotesque parody of European aristocratic society, the gags—nonetheless—hardly capture the politics of exploitation, brutality or resistance that are part of the economics of colonial and post-plantation systems that still affect descendants of slaves today. Similarly, the film's depictions of the Maroons muffle the militant, abolitionist, revolutionary movements, and resisting Blacks in colonial Martinique. We observe this process in the scene that follows the brothers' second escape, when a group of Maroons frees them from the slave hunters and invites them to their secret site in the woods. As they gather and rally to express their resistance and actions to eradicate bondage (massacre all

the White people that indulge in slavery), Régis refuses to offer his collaboration noting the extremism of their agenda. As a result, the Maroons evict the brothers from their group. During the scene, the caricaturized Maroons are epitomized as savages and their verbiage of resistance presented as simplistic, and in which their principles of freedom are revealed as frivolously sectarian. For example, to welcome Régis and Joël, the leader intends to rename the brothers with free African names, but foolishly chooses to rename Régis with an enslaved name "Jean Moulin." The scene could be interpreted as the Maroons being estranged to their own African history and traditions. Although the directors believe they used a colonial past to clarify present attitudes and offer some moral reasoning, colonial Martinique becomes in the film an ambivalent metaphor that comments on contemporary times, rather than being a space of critical reflection on past, present, and future. Built on ersatz politics, the film's colonial journey seems out of touch with the estranged performances of awareness and self-consciousness provided in the end. Such politics are too narrowly construed to effectively suggest comprehensive interpretations on culture and identity formation within colonial and modern praxes.

REPRESENTATIONS OF PAIN, SEX, GENDER, AND POWER

Case départ emphasizes the perspective of the slaves' white overseer, Monsieur Henri. We are also put in the presence of white slave hunters depicted as sociopaths and sadists who seem to prefer inflicting pain rather than producing profit (their sadistic desires are however never fully acted upon in the film). Under their control, the Black slaves are physically and psychologically abused more for pleasure and leisure than for their labor. In another scene on a sugarcane field, the camera angle reflects Joël's perspective as he witnesses what he perceives as the act of fellatio between two male slaves; he proceeds to videotape the act on his cellphone. The scene is comedic because in reality the two men are resting: one (a slave named Isidore)[29] is seated and eating some sugar cane while talking and facing another fellow slave who is leaning against a pole. In the spotless and romanticized plantation, depictions of slave labor seem secondary and parodic. The slavery of the film, then, can be perceived as socially acceptable and benign. Such a representation could suggest the efforts of the filmmakers to produce a marketable commodity. The dominance of Monsieur Henri's male subjectivity is a gaze that seems motivated by a fear of castration or obsession with Black slaves' overpowering sex size, which nourishes both his desire to control/punish

Black men as well as their "big cock." When Régis is promoted from a domestic slave to slave overseer, Monsieur Henri violently grasps and corners him while yelling: "Listen to me you Negro, it's not the size [of your cock that counts], you understand, do you understand? It's not the size that counts!" Consequently, when he punishes them, he always voices controlling their "big cock." In addition, a slave hunter in the film is depicted as having a fetish for cutting slaves' feet. The fulfillment of this pleasure eliminates the politics of his profession within the system of Economic Slavery. Furthermore, the role of women merits attention. Joël's mother is hyper masculinized (as seen in the scene when she beats him up and tells him that she will kill him), while the half-sisters are noticeably silent and quite paralytic. We only hear them cry of sadness at their dad's bed and they have no say in their inheritance. Rosalie,[30] the enslaved grandmother (depicted in the film's colonial era as a young woman), has little narrative presence of her own. She is essentialized, while male characters are constructed and conceptualized in greater detail. Patriarchy is therefore valorized and Rosalie is a socially sanctioned object of the erotic gaze.

Thinking that Isidore their grandfather is homosexual (since Joël believed seeing him performing fellatio on another male slave), Régis and Joël trust that they must "fix this error" since their family line would be destroyed and they would never get a chance to be propelled back into the twenty-first century. For the two brothers, resolving Isidore's (mistaken) homosexual problem amounts to the film's dramatic quandary. They use rum to intoxicate Rosalie and Isidore (who do not know that Régis and Joël are, absurdly, their grandchildren). In a murky barrack located on the plantation, the viewers are presented with what is likely the most shocking scene of the film. Laying-down on the ground, Régis and Joël are sandwiching the inert bodies of Rosalie and Isidore (Joël positioned behind Isidore and Régis behind Rosalie). Joël masturbates Isidore to get him to an erection. Upon Régis' directions "Okay it's good now, put it down!" we see Joël's discomfort with the entire situation. After inquiring on the reason why he has to be the one "taking care of Isidore" (to which Régis replies, facetiously, that he does not trust him with their grandma), Joël barks at Régis to stop staring at him and breathing so hard. During this whimsical dialogue, Régis himself becomes sexually aroused and seems eager to start maneuvering his body against that of Rosalie. While masturbating against Rosalie, Régis drives Rosalie toward Isidore, while Joël pushes Isidore toward Rosalie. As they facilitate the sexual intercourse between Rosalie and Isidore, Joël stops partaking in the act, while Régis, on the other hand, gets completely carried away, slapping Rosalie's buttocks, moaning, moving faster and faster behind her, until the camera moves

outside of the shack. We then notice Monsieur Henri standing in the distance, looking toward the woodshed as he hears loud screams of jouissance. Off-screen, the apex of pleasure heard from the perspective of Monsieur Henri and that of the viewers, maintains some level of ambiguity for it is not clear if the long moaning of pleasure comes from Isidore or Régis. Whether cast in terms of voyeurism, rape, or the incestuous-like ménage à quatre, the sexual act is great potential controversy in that the representation of rape is displaced from the white master/overseer to the slaves. Régis and Joël take away agency from Rosalie and Isidore; they also clearly emasculate Isidore. The lack of empowerment is a recurring motif in the film and heteronormativity seems frequently sought after. Empowerment on the part of Régis and Joël, by taking the "gay away" from Isidore, equals a genetic correction that would simultaneously correct the historical/temporal fabric. This sexual transaction embodies the film's title; the *case* (the woodshed) becomes the lieu of the sexual intercourse that permits the birth, the *départ*, the point of departure, the square one, the beginning for Joël and Régis (in the post-slavery era).

The ending of *Case départ* reveals—similarly to *Django Unchained*—a problematic vision of resistance and Black agency on the part of its directors. In *Case départ*, it is through individual achievement that the characters articulate and obtain freedom. They give Rosalie and Isidore their freed-slave papers because in the end, what matters to them, is not the collective suffering brought about by slavery, but rather, their own predicament. Collective agency is substituted for them by making a (supposedly) gay man have sex with a woman. As such, the end of the film carries a neoliberal message that reflects the privileged zone from which the directors are conceptualizing "minority" positioning. The neoliberal happy ending shows racial hierarchy and difference dissolved into economies of interpersonal and individualized transactions.

CONCLUSION

As Rodriguez argues, there is a difference between *feeling for* and *feeling as*: "Empathic identification, which allows us to feel what a character feels, is the strongest form of emotional engagement" (7). Aesthetic identification is imaginative. It puts us in the position of the *other*, we see through that individual's eyes. *Case départ* dehistoricizes past and present politics that affect Black (Caribbean) people. By transforming political economy and social relations into individual quests and transactions, they risk whitewashing slavery and its legacy. In fact, it is not the comedic undertaking of *Case départ* that disturbs most, since that

approach could have bluntly and critically exposed issues of identity, class, race, and gender. It is rather the fact that *Case départ*'s gags tend to replace the actual relations of exploitation central to the colonial and postcolonial systems it describes. This creates an emotionlessness that could forestall empathy and impede ethical and moral questioning on the part of typical (i.e. non-academic) viewers.

Cinema as a cultural artifact often serves hegemonic purposes. Similarly, *Case départ*'s problematic lack of focus on the resisting and collective body, and its interest in non-redemptive and unempathetic laughter fail to challenge the homogeneous western gaze on the Black body.

In addition, discourses based on satire, ironic racist jokes, stereotyped behaviors, and a diminishing of Black agency within the context of slavery can impede the viewers' ability to empathize with that context. With its narrative of hegemonic individual overcoming, the film fits the ideology of a mass entertainment industry, and as we are fully aware, "the production and consumption of mass culture is [often] thoroughly embedded in capitalist material and ideological imperatives" (Reed 6). In terms of a French film industry so reluctant to finance projects concerned with a colonial past, we could applaud the directors of *Case départ* for using comedy to bring this past to the big screen. In a socio-political sphere filled with amnesia, forgetting, timid remembering, and blurred facts and knowledge on the colonial era, *Case départ* does not quite challenge the masses and could be perceived as a simple piece of entertainment.

Most of *Case départ*'s negative criticisms fixated on Eboué and N'Gijol's African heritage, as if being French natives with African lineage should have implicated more sensitivity on their part in their filmic representation of slaves and slavery. Yet, their Cameroonian origins do not inherently position them within sympathetic and unfailing assessments of the experiences lived by African slaves during their bondage—in the Americas. Just as it should not be assumed that their Cameroonian origins infer that they fathom French Caribbean people of African descent's intricate and multifarious emotional and psychological dealings with two centuries of bondage. The same can be said of their understanding of the vestiges of dominance that continue to affect "French citizens (from the Antilles)" in contemporary France. As a result, the film's meek representations of bondage, just as its ideological perspective in which Black men of Caribbean origins are policed in ways that require them to become "good" integrated citizens, can be perceived as privileged or condescending. *Case départ* does not intend to be a film *about* slavery. Instead, and regrettably, the film merely uses slavery as a tool to explore issues of "Black" identity in terms of a *Westernized* African Diaspora perspective.

Notes

1. Among these works: Madame de Saint-Ouen (1827); G. Beleze (1841); G. Bruno (1877); A. Dubois (1884); E. Vauche (1885); F. Mahon (1882); E. Bonnemère (1882); Edgar Zevort and E. Burle (1886); E. Lavisse 1913; and few years after the end of the Third Republic: H. Guillemain and l'abbé Le Ster (1943).

2. *Le passage du milieu* by Guy Deslauriers in 1999; *1802 l'épopée guadeloupéenne* in 2005 by Christian Lara (2,557 tickets sold); the mini TV-series *Tropiques Amers* by Jean-Claude Barny in 2007 (4 million viewers); *Le pays à l'envers* by Sylvaine Dampierre in 2009 (2,960 tickets sold); *Case départ* by Thomas N'Gijol, Fabrice Eboué, and Lionel Steketee in 2011 (1.8 million tickets sold); and in 2012 the TV-program *Toussaint Louverture* by Philippe Niang (2.9 million viewers).

3. "Le beau pays que nous habitons [s'appelait] il y a 2000 ans [la Gaule]. Ses habitants, les Gaulois, vivaient comme vivent aujourd'hui les sauvages d'Afrique."

4. "En somme, nos ancêtres gaulois étaient des sauvages aussi peu avancés que le sont, à l'heure actuelle, beaucoup de nègres en Afrique ... Aujourd'hui, quand les soldats français ou anglais se battent contre des nègres africains, ils finissent toujours par les vaincre, car ils ont sur eux l'avantage d'avoir de meilleures armes. De même, les soldats romains qui envahirent la Gaule devaient finir par battre les Gaulois, car ils étaient beaucoup mieux armés" (10–13).

5. Similar ambivalences are found in the cultural, political, literary, historical, and an-thropological interpretations, relations, and representations of ideologies surround-ing the Gallic myth of "Our ancestors the Gaulles." There are various recuperations and interpretations on the fall of the Gauls. Often, their major defeat against the Romans is replaced by a glorification of their resistance against the glorious enemy. Other historical narratives emphasize the Gauls' military *prouesses*, their patriotism (through the figure of Vercingétorix, who proudly died in his fight against Caesar during the battle of Alésia), as opposed to the Druids' barbarism, misery, pagan, and blood-rites. Vercingétorix was an imperial propaganda for Napoleon III, who in 1866, built a seven-meter high statue of Vercingetorix with traits resembling his. We can also use the example of Charles de Gaulle who stated that for him the History of France begins with the first Christian King Clovis and not with the "pre-historic" Gallo-Roman era: «Pour moi, l'histoire de France commence avec Clovis, choisi comme roi de France par la tribu des Francs, qui donnèrent leur nom à la France. Avant Clovis nous avons la préhistoire gallo-romaine et gauloise. l'élément décisif pour moi c'est que Clovis fut le premier roi à être baptisé chrétien. Mon pays est un pays chrétien et je commence à compter l'histoire de France à partir de l'accession d'un roi chrétien qui porte le nom des Francs» (Pognon 1970, 30).

6. This is a paragon expression symbolizing the civic nationalism born in France as a result of the 1789 French Revolution. The statement was delivered during a lecture

at a conference that took place at the University of Sorbonne. In French: "l'existence d'une nation est … un plébiscite de tous les jours, comme l'existence de l'individu est une affirmation perpétuelle de vie" (1882).

7. " … l'essence d'une nation est que tous les individus aient beaucoup de choses en commun, et aussi que tous aient oublié bien des choses."

8. "Tout oppose ces deux conceptions, la nation comme race et la nation comme contrat : l'une est physique, l'autre morale, l'une naturelle, l'autre artificielle, l'une est tournée vers le passé, l'autre vers l'avenir, l'une est déterminisme, l'autre liberté…. La tentative la plus célèbre pour le faire, celle de Renan, est un échec : on ne peut se contenter d'ajouter, l'un à la suite de l'autre, deux « critères », alors que le second annule le premier" (508–9).

9. "Le rêve européen a besoin du rêve méditerranéen. [Ce] rêve qui ne fut pas tant un rêve de conquête qu'un rêve de civilisation. Cessons de noircir le passé … la plupart de ceux qui partirent vers le Sud n'étaient ni des monstres ni des exploiteurs. Beaucoup mirent leur énergie à construire des routes, des ponts, des écoles, des hôpitaux. Beaucoup s'épuisèrent à cultiver un bout de terre ingrat que nul avant n'eux n'avait cultivé. Beaucoup ne partirent que pour soigner, pour enseigner. [On] doit respecter les hommes et les femmes de bonne volonté qui ont pensé de bonne foi œuvrer utilement pour un idéal de civilisation auquel ils croyaient. [Si] la France a une dette morale, c'est d'abord envers eux…. Faire une politique de civilisation, voilà à quoi nous incite la Méditerranée [où] rien ne fut jamais médiocre."

10. "Au bout du compte nous avons tout lieu d'être fiers de notre pays, de son histoire, de ce qu'il a incarné, de ce qu'il incarne encore aux yeux du monde. Car la France n'a jamais cédé à la tentation totalitaire. Elle n'a jamais exterminé un peuple. Elle n'a pas inventé la solution finale, elle n'a pas commis de crime contre l'humanité, ni de genocide … La vérité c'est qu'il n'y a pas eu beaucoup de puissances coloniales dans le monde qui aient tant oeuvré pour la civilisation et le développement et si peu pour l'exploitation. On peut condamner le principe du système colonial et avoir l'honnêteté de reconnaître cela."

11. The "Front National" (FN) is a right-wing French political party.

12. "Manif" is the abbreviation of "manifestation" (a demonstration/gathering of people in a public space to make known and defend their opinion).

13. *La manif pour tous* comprised groups opposing *Le mariage pour tous*.

14. "La guenon, mange ta banana!"

15. "Nous ne sommes pas du tout racistes, cette Une est de mauvais goût mais c'est de la satire, ce n'est pas un délit" Jean-Marie Molitor, *Minute*.

16. "Le tournage a duré 44 jours et s'est déroulé entre Paris et Cuba. Au départ, les réalisateurs souhaitaient tourner en Martinique, mais la population était très réticente, en partie à cause du lien complexe qu'elle entretient avec l'histoire de l'esclavage."

17. The term *Béké* is a Creole word used to describe a descendant of the early European (French) settlers in the French Antilles. Nowadays, the *békés* represent a small minority in the French Caribbean but they control much of the local industry. The class difference that exists between the *békés* and the predominantly Black majority population of French Caribbean societies is quite striking. For more on the topic, consult the documentary "Les derniers maîtres de la Martinique" (2009).

18. In *Commeaucinéma*: [Interviewer -] Vous avez tourné à Cuba ... Lionel—Et à Paris pour les scènes en Métropole. Au départ, nous voulions tourner en Martinique, mais certains békés—les descendants des grands propriétaires de l'époque—n'ont pas voulu qu'on tourne le film dans leurs propriétés. Les blessures sont toujours ouvertes. Nous n'avons pas eu le choix, et nous nous sommes tournés naturellement vers Cuba, où nous n'avons eu aucun problème. Fabrice—Le paradoxe est intéressant : pour des histoires de susceptibilité, nous n'avons pas pu tourner un film dans ce qui est censé être une des grandes démocraties de cette planète et on a été obligés d'aller le tourner dans ce qui est censé être une des dernières dictatures ...

19. Cuba's natural beauty, iconic colonial architecture, coffee plantations, and National Parks continue to draw (since the end of the Cuban Revolution) various filmmakers shooting movies on slavery.

20. For instance *Duck Soup* in 1933, *The Great Dictator* in 1940, *Il Federale* in 1961, *La vita e bella* in 1997, and shortly after *Case départ*, *Django Unchained* in 2012.

21. For more information on this topic, consult the "cases créoles" illustrations and critical analyses in the volume *Sexe, Amour, Genre et Trauma dans la Caraïbe francophone* by Gladys M. Francis (2016).

22. Played by Isabel del Carmen Solar Montalvo.

23. In this essay, all translations of *Case départ*'s quotes (from French to English) are mine.

24. The "Code noir" is a decree originally passed by France's King Louis XIV in 1685. It outlined the conditions of slavery in the French colonial empire; for instance, it limited the activities of free Negroes, prohibited the practice of any religion other than Roman Catholicism, and indicated the types of corporal punishments runaway slaves should be subjected to.

25. Played by Michel Crémadès.

26. Il y a quantité de polémiques sur les Juifs qui auraient été des esclavagistes ou pas mais nous, on trouve ça tellement surréaliste. ... Comment est-il possible de débattre raisonnablement pour savoir qui des Juifs ou des Noirs a le plus souffert? (http://www.commeaucinema.com/interviews/case-depart,188592).

27. Fabrice—À l'époque, le racisme n'était pas considéré comme étant du racisme. C'était un mode de pensée. Le but, c'était aussi de dire qu'aujourd'hui, quand on est noir, on a le choix, le choix d'essayer de s'intégrer, d'avancer, ou d'être un rebelle, alors qu'à

l'époque, on était un nègre et on n'avait aucun choix. C'était aussi l'intérêt de remonter en arrière dans l'Histoire.

28. The Bounty Bar is a coconut filled chocolate bar that is brown on the outside and white on the inside. The term "bounty" is used to refer to someone Black in a derogatory manner. The ethnic slur describes a Black individual criticized for being an assimilated French citizen (*un intégré*) or an "indigenous of the French Republic" (*un indigène de la République*). The insult insinuates that the "bounty" behaves like white people and/or adopts white people's politics, betraying as a result the Black community.

29. Played by Eric Ebouaney.

30. Played by Stéfi Celma.

Works Cited

Allociné. "Case départ. Tournage: Secret de tournage sur Case départ." www.allocine. fr/film/fichefilm-182097/secrets-tournage/. Web. Apr. 2015.

Anderson, Benedict R. O'G. (1983) *Imagined Communities: Reflections on the Origin and Spread of Nationalism*: London: Verso, 1991. Print.

Bergson, Henri. *Laughter: An Essay on the Meaning of the Comic*. Translated by Brereton and Rothwell, New York: Macmillan, 1914. Print.

Bhabha, Homi. "The Commitment to Theory." *Questions of Third Cinema*, edited by J. Pines and P. Willemen. London: British Film Institute, 1989. Print.

———. *The Location of Culture*. London: Routledge, 1994. Print.

Bliss, Chris. "Comedy is Translation." TedxRainier. Dec. 2011. Film.

Bonaventure, Lionel. "'Taubira retrouve la banane': le directeur de Minute condamné pour sa Une." *l'Express.fr avec AFP.com*, 30 Oct. 2014. Web. Apr. 2015.

Case départ. Fabrice Eboué, Thomas N'Gijol, and Lionel Steketee. Perf. Fabrice Eboué, Thomas N'Gijol, Eriq Ebouaney et Stéfi Celma. Légende Film, 2011. Film.

"Case départ 2011." http://www.commeaucinema.com/interviews/case-depart -comedie,188592. Web. Apr. 2015.

Cohen, Ted. *Jokes: Philosophical Thoughts on Joking Matters*. Chicago: University of Chicago Press, 1999. Print.

Commeaucinéma. "Interviews croisées de Lionel Steketee, Fabrice Eboué et Thomas Ngijol: *Django Unchained*. Dir. Quentin Tarantino. Perf. Jamie Foxx, Christoph Waltz, Leonardo DiCaprio and Kerry Washington. Sony Pictures and The Weinstein Company, 2012. Film.

Edmond Pognon, De Gaulle et l'histoire de France : Trente ans éclairés par vingt siècles. Paris: Albin Michel, 1970. Print.

Ferguson, K. M. "Beyond Indigenization and Reconceptualization: Towards a Global, Multidirectional Model of Technology Transfer." *International Social Work*, vol. 48, no. 5, 2005, pp. 519–35. Print.

Gilroy, Paul. (1993) *The Black Atlantic: Modernity and National Consciousness.* London/ New York: Verso, 1995. Print.

Hayward, Susan. *Cinema Studies: The Key Concepts.* London/NY: Routledge, 2001. Print.

———. *French National Cinema.* London/New York: Routledge, 1993. Print.

Hermer, Pascal. *Case Départ le film interview croisée Thomas Ngijol et Fabrice Eboué.* 19 Jun. 2011. telexvar.com.

Hervé, Gustave et Gaston Clemendot. *Histoire de France, cours élémentaire et moyen.* Paris, Bibliothèque d'éducation, 1904. Print.

Jullian, Camille. "Vercingétorix." *La Revue de Paris.* 1er avril 1901.

Mazrui, Ali Al'Amin. *The African Predicament and the American Experience: A Tale of Two Edens.* Westport: Praeger Publishers, 2004. Print.

Rabassa, Gregory. *If This Be Treason: Translation and Its Dyscontents, A Memoir.* NY: New Directions Books, 2005. Print.

Reed, Adolph. "*Django Unchained,* or, *The Help*: How 'Cultural Politics' Is Worse Than No Politics at All, and Why." 25 Feb. 2013. Nonsite.org.

Renan, Ernest. *Qu'est-ce qu'une nation?* Conférence faite en Sorbonne, le 11 mars 1882. Collection électronique de la Bibliothèque Municipale de Lisieux, pp. 277–310.

Rodriguez, Tanya. "Numbing the Heart: Racist Jokes and the Aesthetic Affect." *Contemporary Aesthetics*, vol. 12, 2014, pp. 1–16. Web. Apr. 2015.

Rotman, Charlotte et Sonya Faure. "La parole est à la discrimination." *Libération*, 5 Nov. 2013. Web. Apr. 2015.

Sarkozy, Nicolas. Speech delivered at the "meeting de Toulon." *Sarkozy.fr.* 7 février 2007a.

———. Speech delivered at the "meeting de Caen. *Sarkozy.fr.* 9 mars 2007b.

Senghor, Leopold Sédar. Discours de réception à l'Académie française. Le Monde, 30 mars 1984, p. 15. Print.

Siéyes, Emmanuel Joseph. *Qu'est-ce que le Tiers état?.* Editions du Boucher. 2002. E-book.

Stille, Alexander. "The Justice Minister and the Banana: How Racist is France?" *The New Yorker*, 14 Nov. 2015. Web. Apr. 2015.

Todorov, Tzvetan. *Nous et les autres: Le réflexion française sur la diversité humaine.* Paris: Editions du Seuil, 1989. Print.

Willsher, Kim. "French magazine faces legal inquiry over racist slur against politician." *The Guardian*, 13 Nov. 2013. Web. April 2015.

Young, Lola. *Fear of the Dark: 'Race,' Gender and Sexuality in the Cinema.* London/NY: Routledge, 1996. Print.

Django Unchained

Slavery and Corrective Authenticity in the Southern

Dexter Gabriel

The release *of Django Unchained* in the waning days of December 2012 saw a new addition to the genre of the slavery film. The film tells the story of a slave, Django (Jamie Foxx) acquired by the enigmatic Dr. Schultz (Christoph Waltz), a German bounty hunter in need of assistance in identifying several white fugitives. Offered his freedom, Django eventually becomes Schultz's protégé: a black bounty hunter in the antebellum slave South, killing—under the protection of federal warrants—nefarious whites. This unlikely duo, former slave and murderous mentor, devise a plan to find and rescue Django's wife, Broomhilda (Kerry Washington) from the fantastically named plantation "Candie Land," owned by the sadistic and ever-smiling Southern gentleman Calvin Candie (Leonardo DiCaprio).

Diverging from sweeping Hollywood epics like *Glory* (1989) and *Amistad* (1997), *Django Unchained* did not bill itself as a faithful aesthetic recreation of the past. It was instead a pastiche of Spaghetti Westerns and Blaxploitation set in an antebellum South that boldly eschewed historicity. Part revenge story and part slave narrative, *Django Unchained* inaugurated a new genre that its director Quentin Tarantino termed the Southern. In commentaries upon its release historians largely dismissed the film as absurd: a fantasy divorced from the realities of slavery.[1] Film critics in contrast reveled in its absurdity, reminding that the film was entertainment and not a historical drama.[2] But if *Django Unchained*

222

was not history, it also aimed for more than frivolity. In repeated interviews Tarantino made clear that the purpose of his film was to offer a window into the American past: a corrective to images previously presented throughout slave cinema, and a form of authenticity more real than history itself.

To understand this attempt at correcting the past through fiction, *Django Unchained* must be situated within Tarantino's vision of the Southern. It is a genre whose origins are rooted in the director's aversion for Hollywood's take on slavery, the revenge narratives of Italian Spaghetti Westerns, and the graphic imagery and rebellious masculinity of Blaxploitation. Tarantino argues that the Southern must be portrayed through the lens of the storyteller rather than the Historian (with a capital H), allowing for a more authentic window into the past. But to achieve this corrective authenticity, the Southern is dependent on the very Hollywood past it seeks to correct: appropriating, subverting, and recreating longstanding cinematic stereotypes and presenting them with the plausibility of realism. The Southern thus exists as a paradox: an attempt to correct our popular myths of slavery that in the end manages to both preserve and reinvent them.

THE MAKING OF THE SOUTHERN

Historians have never functioned as the sole architects of our collective memory. From D. W. Griffith's *Birth of a Nation* (1915) to present day, film has become a primary vehicle through which the larger public is informed about the past. In Tarantino's estimation, Hollywood's depiction of that past when it comes to slavery has long lacked legitimacy. Even Alex Haley's *Roots* (1977), for Tarantino, falls short of the mark. "When you look at *Roots*, nothing about it rings true in the storytelling, and none of the performers ring true for me either," he complained in a 2012 interview days before the release of *Django Unchained*. "I didn't see it [*Roots*] when it first came on, but when I did I couldn't get over how oversimplified they made everything about that time. It didn't move me because it claimed to be something it wasn't." African American filmmaker, and co-producer of *Django Unchained*, Reginald Hudlin agreed, calling many aspects of the iconic 1970s miniseries "Bulls—t" (Samuels).

For Tarantino and Hudlin, *Roots*'s failure at authenticity reflected Hollywood's unwillingness to confront slavery's reality on a human level. One scene proved poignant to both men, where the character Chicken George (Ben Vereen), when given a chance to mete out punishment upon his former master, refuses to take his vengeance. "No way he becomes the bigger man at that moment," Tarantino balked. "The powers that be during the '70s didn't want to send the

message of revenge to African-Americans. They didn't want to give black people any ideas. But anyone knows that would never happen in that situation. And in *Django Unchained* we make that clear" (Samuels).

Django Unchained's exploration of this innate human desire for vengeance derives in great part from the Spaghetti Westerns that emerged in the 1960s. Spaghetti westerns themselves existed within a cultural milieu, reinventing the American Western through an Italian-European lens melded with the morally ambiguous anti-heroes of Japanese Samurai cinema. Italian filmmaker Sergio Leone is recognized as the auteur of this style with the 1964 *A Fist Full of Dollars*, cementing the bounty killer as a staple of the genre.[3]

In 1966, fellow Italian filmmaker Sergio Corbucci entered his own take with *Django*, a film centered on a Civil War veteran drawn into a war between rival villainous forces as he seeks revenge for the murder of his wife. Corbucci's film spawned scores of unofficial "sequels" in which Django took on different roles and faces. This adaptability gave birth to a type of pop-culture "Djangoism," creating what filmic scholar Bert Fridlund terms "a trans-story hero." What tied together these disparate characters was their break with dichotomous definitions of right and wrong, as they crossed restrictive moral boundaries to achieve their ends. In doing so, each becomes more human and thus more relatable to audiences searching for more flawed definitions of heroism. *Django Unchained* follows in this trend, this time recasting the trans-story hero as the vengeful rebel slave (Fridlund).

Tarantino outlined his intention as early as 2007 to create a new genre of Spaghetti Western that would present this more human face of American slavery. He termed it "a Southern":

> I want to explore something that really hasn't been done. . . . I want to do movies that deal with America's horrible past with slavery and stuff but do them like spaghetti westerns, not like big issue movies. I want to do them like they're genre films, but they deal with everything that America has never dealt with because it's ashamed of it . . . (Hiscock)

This new Southern was to be both entertainment and a provocative tool of historical and cinematic introspection, which Tarantino believed Hollywood intentionally erased from its lens. "I was always amazed so many Western films could get away with not dealing with slavery at all," he charged. "Hollywood didn't want to deal with it because it was too ugly and too messy" (Hiscock).

This was not Tarantino's first allusion to the power of film to better translate American slavery into public memory. In previous interviews he expressed his desire to make a film on the radical abolitionist John Brown, whom he named one of the "biggest heroes of all time." Tarantino's purpose was again corrective: to subvert popular negative depictions of Brown in earlier Hollywood films, most noticeably Michael Curtiz's *Santa Fe Trail* (1940). This was not to be a biopic, however, but instead a film on Brown's violent reprisal upon slavery. Biopics, Tarantino griped, were "musty" affairs: "showcases for actors" that disallowed "story-tellers or directors" to display their creativity in a way that could reach audiences.[4]

This interplay between the storyteller, creativity, and authenticity comes together for Tarantino in the exploitation film. The reliance on pulp fiction and exaggerated visual violence is easily visible throughout his body of work, from *Reservoir Dogs* (1992) to the *Kill Bill* series (2003, 2004). For Tarantino, Blaxploitation has proved especially impactful, appearing in films such as *Pulp Fiction* (1994) and *Jackie Brown* (1997). The exploitation subgenre was popularized with director Melvin Van Peeble's *Sweet Sweetback's Baadasssss Song* (1971) and for almost a decade featured a cast of larger-than-life heroes and heroines.[5]

While most Blaxploitation films were set in gritty urban environments, the subgenre as well played a critical role in altering the landscape of American slave cinematography. Films like *Slaves* (1969) and *The Legend of Nigger Charlie* (1972) were refutations of the Hollywood plantation epics, with displays of vengeful, rebellious, and nearly always masculine anger mirroring the fires of Watts and Detroit. Most famous of these was Richard Fleischer's *Mandingo* (1975), based on the lurid "slave-breeding plantation" novels of writer Kyle Onstott. Fleischer's *Mandingo* mingled Blaxploitation with the gratuitous scopophilia of director Russ Myer's Sexploitation to produce a sexually charged, violent take on slavery. In a 1996 interview Tarantino singled out the film for particular praise, calling it one of the few times in the last twenty years that a major studio has made a "full-on, gigantic, big-budget exploitation movie."[6]

Django Unchained emerges out of this blending of cinematic styles: a vengeful hero of the Spaghetti Western; a rebel slave molded more on Blaxploitation's Shaft than Nat Turner; and a landscape of human bondage borrowed from the graphic, the salacious and the shocking. This for Tarantino is the making of the Southern, where the filmmaker exists as the purveyor of authenticity. This is history removed from superfluous academic discourse and given to the masses, a populist form of engagement with the past in which the filmmaker as storyteller becomes the "anti-Historian."

THE FILMMAKER AS ANTI-HISTORIAN

Tarantino defined this differentiation in 2012: "When slave narratives are done on film, they tend to be historical with a capital H, with an arms-length quality to them. I wanted to break that history-under-glass aspect, I wanted to throw a rock through that glass and shatter it for all times, and take you into it."[7] This conflict between historians and cinema is not new, as numerous media theorists have examined this continuing dialectic. All historical films are inherently alternative fiction, rearranging the past in order to fit a visual narrative. Tarantino takes this a step further, however, by imbuing his history with exploitation tropes that verge on the fantastic and the grotesque, part of what film critic Roger Ebert calls a "gutlevel" understanding of turning the patently absurd into the plausible.[8]

This is perhaps most visible in the 2009 film *Inglourious Basterds*, in which Tarantino radically alters history in his retelling of Jewish soldiers enacting vengeance on the Third Reich. For Tarantino the historical record, while offering inspiration, proved an impediment to the most important role of the filmmaker—to tell a story that best engaged audiences:

> Well, on this movie there's one real big roadblock, and that's history itself. And I expected to honour that roadblock. But then at some point, deep, deep, deep into writing it, it hit me. . . . What happens in this movie didn't happen in real life because my characters didn't exist. But if they had, this could have happened in real life. And from that point on, it simply had to be plausible. . . .

In this attempt at authenticity, history is malleable. What "characters" may have done in real life is less important than how the storyteller believed they might have behaved. For Tarantino, historical cinema's only requirement is its ability to sell plausibility.[9]

This perception of the filmmaker as the historian of authenticity can be traced to the dawn of cinema. D. W. Griffith, director of the epic *The Birth of a Nation* (1915), predicted that in the near future history would be told not with books but carrels of boxes whereby a person could simply "press the button and actually see" historical events. "If it is right for historians to write history," Griffith mused, "then by similar and unanswerable reasons it is right for us to tell the truth of the historic past in motion pictures" (Lenning 1).

Griffith's attempt "to tell the truth of the historic past" was in the end a revisionist retelling of the Civil War and Reconstruction, centered on fallacies

of Lost Cause ideology. But it was a form of populist engagement with history that (white) viewers found personally accessible through this new medium of film, which offered a degree of realism unattainable by previous mass media. With its ability to influence senses through visual perceptions, lighting, and sound, *The Birth of a Nation* allowed for a personal engagement with what was viewed as history.

White audiences, drawing on the contextual racial biases of their age, saw the screen depictions as "truth" and an authentic recounting of the American past. Immediate reactions were visceral: from attacks upon African Americans to the advent of the Second Ku Klux Klan. When white audiences viewed scenes of white men in blackface chasing young white women, they reacted with hisses; in one Florida theater gunfire reportedly erupted as someone took aim at the nefarious character Gus the Renegade on the screen. *The Birth of a Nation* for white audiences was not just a two-dimensional drama; it was history as it had actually happened, more authentic in its moving imagery and storytelling narration than previous mediums of history (with a capital H) could convey.[10]

Similar to Griffith, Tarantino purports an interest in contributing to not just cinematography, but the public memory of the past. Further, like Griffith, there is for Tarantino a continued theme of rescuing history from elite academics and reshaping it to offer a greater accessibility to the masses. "We all intellectually 'know' the brutality and inhumanity of slavery," Tarantino related in 2012, "but after you do the research it's no longer intellectual any more, no longer just historical record—you feel it in your bones. It makes you angry, and you want to do something."[11]

Tarantino's call to action speaks to his belief in the inability of past cinematography like *Roots*, as well as academic historians, to translate the historical record of slavery into a form of populist engagement. As anti-Historian Tarantino offers a more entertaining and authentic history: a storyteller for the masses not bound by the limitations of historical veracity.

Django Unchained revels in this intentional temporal ambiguity, rearranging events, characters, and time into an alternate history. The story begins in Texas in 1858, described as "two years before the Civil War," even though the war started three years later in 1861. It creates a scene of anachronistic Klan members in the antebellum south, when in reality the Klan would not be formed until 1865. The dubious historicity of "Mandingo Fighting" is presented as part of a realistic past, and made a centerpiece of the story. While slaves trudge along in the wake of masters and overseers, rapper Rick Ross's voice laments his need for "100 Black Coffins" to a bass-heavy track. As with *Inglourious Basterds*, where

history provides a roadblock, Tarantino works around it, creating a more authentic alternative past through the fictitious, the fantastic, and even the absurd.[12]

THE SUPERBUCK AS REBEL SLAVE

This subversion of history to create authenticity becomes most relevant in Tarantino's creation of the vengeful slave rebel and the landscape of slavery so profoundly important to the Southern. In 2013, Reginald Hudlin gave insight into this process, particularly the inspiration for the character Django:

> Over a decade ago, Quentin and I were talking about movies about slavery and I brought up my frustration with most of them. I had no interest in seeing yet another movie about noble suffering. I wanted to see foot to ass. There were all kinds of Black people who stood up and fought back, including members of my own family. I wanted to see stories about them.

Hudlin's assessment lies at the heart of Tarantino's Southern. As a corrective, it challenges not only the academic historian's hegemony on the past, but also the erasure of black rebellion in previous Hollywood films. If slavery is to be presented with a more human face, for Hudlin and Tarantino it should be a rebellious one—the most human of responses to inhumanity.[13]

Underlying this theme of vengeance and rebellion in the Southern is how, within this all-subjugating environment, a slave might regain manhood. It is a trope perhaps best defined in Frederick Douglass's repositioning of the master-slave dialectic in his battle with the slave breaker Covey, and his own semi-fictitious essay of black rebellion in *The Heroic Slave.* In these instances, republican notions of masculinity are achieved through the physical confrontation of the slave system whose domination makes the attainment of honor impossible for most slaves. Only a few slaves, through rebellion, are able to rescue their manhood from the slave regime. "You have seen how a man was made a slave," Douglass proclaims about his fight with Covey, "you shall see how a slave was made a man."[14]

It is a definition of black masculinity extolled by African American dramatists and writers in the 1960s, creating masculine slave characters that typified the era's oppositional stance to white patriarchal hegemony. Black manhood was presented as phoenix-like: capable of enduring adversity through slavery but emerging stronger and dignified from oppression through struggle, reminiscent of Douglass's claim that his fight with Covey had "rekindled the few expiring embers of freedom, and revived within me a sense of my own manhood."[15] Hol-

lywood appropriated this rebel slave in Blaxploitation films like *The Scalphunters* (1968) and the slave Western *Boss Nigger* (1975). It was a subversion of the familiar Buck stereotype of the earlier plantation epics, depicted as strong and loyal black men utterly subservient in their bondage. Blaxploitation transforms this earlier stereotype into the "Super Buck:" his physical strength and sexuality now empowered to almost superhuman heights and turned against the slave regime. In Django, this atypical heroic rebel slave finds cinematic life once again (Bogle 10–17, 231–42).

From the outset, Django (Jamie Foxx) is portrayed as special—"that one in ten thousand nigga" who stands up to the slave institution, the "Super Buck" incarnate.[16] Django's inherent insubordination is marked into his flesh by a runaway brand on his cheek and whip scars along his back. In a flashback scene his former owner Old Man Carrucan (Christopher Garza) declares with grudging admiration, "You got sand, Django." The term "sand" here is slang for courage, used by Southerners since Mark Twain.[17] For Django it marks his masculine defiance, anathema to a slave system where the Buck, even in his strength, was denied honor—a foundational stone of white manhood. In slavery Django is an anomaly, out of place and without purpose within an institution founded on black subservience. "I got no use for a nigger," Old Man Carrucan chides, "with sand."[18]

Django is rescued from slavery by the German dentist-turned-bounty-hunter, Doctor Schultz (Christoph Waltz). It is Schultz who inducts Django into the fraternity of bounty killers so common to the Spaghetti Western trope, instilling within him an ethos on the morally ambiguous use of violence in the struggle of good versus evil. This trope of white mentors and slave resistance is not new in slavery cinema or the historical record. The most comparable case is Italian director Gillo Pontecorvo's *Burn!* (1969), a loose retelling of the Haitian Revolution and a follow up to Pontecorvo's groundbreaking postcolonial drama *The Battle of Algiers* (1966). In *Burn!*, the interestingly named English mercenary William Walker (Marlon Brando) instructs and mentors the slave José Dolores (Evaristo Márquez) on leading a slave rebellion.[19] The theme shares elements of common slaveholder folklore, which blamed white agitators for rebellious slaves—thought to be too docile or intellectually incapable to act on their own.[20]

Tarantino denied this dynamic, comparing the Django-Schultz binary instead to the Western cliché of the veteran gunslinger and the young "cowpoke." Reginald Hudlin remarked in fact that one of the film's goals was to move away from such portrayals, which he criticized in historical film dramas like Steven Spielberg's *Glory* (1989). "I liked the black characters in *Glory*," Hudlin told

interviewers. "Didn't see the point of the white ones. The true story was the slaves in the film. They should have been the main focal point of the entire plot. But somehow no one figured that out."[21]

Yet for all these attempts at subversion, Django is as much a creation of his white liberator as he is of Tarantino's imagination. Like José Dolores in *Burn*, Django manages to come into his own as the film progresses; but like *Glory* before him, he is tied to his white benefactor.[22] As an outsider, Schultz is a person who deplores American slavery and, despite his own casual use of violence, is horrified by the brutality of the South's peculiar institution. Schultz's influence as a white agent provocateur goes beyond his young protégé. At one point, while searching for Django among a slave coffle, Schultz places a loaded shotgun into the hands of a bewildered slave. Only after he suggests the possibility of attaining freedom, however, providing step-by-step instructions, do the gathered slaves turn the weapon on their captors. Schultz, it turns out, is the elusive white agitator of slaveholder conspiracies: a John Brown archetype for the Southern.[23]

Schultz's conversion of Django from slave to bounty hunter subverts and reverses the system of commodification in Tarantino's Southern. Here, dead white bodies are made into wealthy commodities, a system that Schultz notes is not unlike slavery. With his newfound authority, Django fantastically struts about pulling white men off horses, sitting at their tables and insulting them at will. He exudes the "swagger" of a hip hop icon: so cool that even his horse dances. At his most daring, the angry rebellious lyrics of the late Tupac Shakur echo out on a track amid scenes of murderous slave vengeance. In his temporal ambiguity, Django is rendered as an ideal of modern black masculinity thrust through time: a type of fantastic "black Terminator," sent back to correct the cinematic wrongs of Hollywood past.[24] But if the fictional Django is to be cast in the image of the exceptional rebel slave, the slave communities in which he exists must by nature be a diametric opposite, if only to enhance his singular peculiarity.

SLAVERY IN THE SOUTHERN

One of the first slaves with a speaking role in *Django Unchained* is Betina (Miriam F. Glover), the property of the flamboyant plantation owner "Big Daddy" (Don Johnson), whose tongue-in-cheek name plays on notions of sexuality. Betina, with her high-pitched voice and airy demeanor, bears a striking similarity to the character Prissy (Butterfly McQueen) from *Gone with the Wind*, whose similar infantile nature became immortalized in the lines, "I don't

know nothin' bout birthin' babies!" Both channel aspects of the Pickaninny, a well-established caricature which depicted slaves as mischievous children or inherently child-like. This is part of the paradox of Tarantino's archetype of the exceptional rebel slave in the Southern: it relies on a slave community reproduced from older familiar stereotypes of the cinematic past—the Mammy, the Tom, the Pickaninny, and the Jezebel.[25]

Throughout the film, Django violently assaults slave masters, overseers, and any whites who threaten his "unchained" status. In contrast, most slaves serve as background characters: shocked, immobile, and often silent. The historical record contradicts such simplistic dynamics. Rather than acts of singular masculine daring, insurrections throughout the institution of slavery were often communal efforts. Added to this were numerous acts of individual violent resistance, not to mention the innumerable ways in which slaves challenged their status in daily acts including sabotage, running away, feigning illness, work stoppages, tainting food, and other activities disruptive to the slave regime.[26] To overcome these historical "roadblocks" that might upset Django's exceptional, and inherently masculine, place in the Southern, Tarantino instead reproduces the full range of slave stereotypes popularized by Old South nostalgia and Hollywood, all with their own degrees of loyalty and subservience to the slave regime.

Like Betina, the roles of black women in *Django Unchained* are mostly based on slave era stereotypes: Mammy and her opposite, the wanton and sexualized Jezebel. The latter appears twice, as the suggestively dressed Coco (Danièle Watts) at the Cleopatra Club and the more visible Sheba (Nichole Galicia), a slave mistress who seems to relish in her status. Tarantino's use of names appears as a satirical take on the Jezebel: Coco, a common Blaxploitation character; Sheba, a sexualized Biblical figure; and Cleopatra, an Egyptian queen associated with sexuality and power. The underlying issue of sexual exploitation towards these women is never explored, and instead treated with a casual, almost playful, disregard. This is in stark contrast to films like Steve McQueen's *12 Years A Slave* (2013), where slavery's dehumanizing rape culture is central to the narrative. Even the well-placed black Mistress Shaw (Alfre Woodard) in *12 Years A Slave* pronounces apocalyptic judgment on the Southern planter class, declaring God will handle them all.[27]

In *Django Unchained* the most prominent slave woman is Broomhilda Von Shaft (Kerry Washington). As a character, she is neither Mammy or Jezebel. As a house slave she is even well-educated, able to speak German. Yet if Broomhilda defies common slave stereotypes, it is only to become the Hollywood trope of the damsel in distress. For most of the film she is a ghost from Django's memory

rather than a solid persona with substance. In this shadowy existence, audiences are treated to glimpses of her resistance to the slave system as a runaway—nicknamed "Little Troublemaker" by Django. But she appears lost in the role of her namesake, and is relegated to mostly whimpers and screams as she awaits her Sigfried.[28]

It is the slave men in the end against whom Django must pose an oppositional existence of masculinity within the Southern. Most of these play the role of subservient Bucks, in the mold of Big Sam of *Gone with the Wind*, whose massive strength is forever in service of his mistress. In *Django's* fictionalized slave society, whites have complete control over these men, both body and mind. Tarantino drives this home in a scene where the sadistic slave owner Calvin Candie (Leonardo DiCaprio) forces two "Mandingo" fighting men to brawl to the death. The audience is treated to graphic imagery of hand-to-hand blood sport, as grappling black bodies, drenched in sweat and stripped to the waist, engage in murderous blood sport for white amusement. It does not end until one slave gouges out the eyes of the other, and then caves in his head with a hammer.[29]

The scene is a recreation from Fleischer's *Mandingo* (1975), where the "Mandingo" fighting slave Mede (Ken Norton) similarly struggles in deadly gladiatorial combat against another slave before a cheering white crowd, with Mede ultimately using his teeth to tear open his opponent's neck. There is scant evidence from the historical record of such gory events, but as mythology these scenes serve as metaphor on slavery's brutality and its ability to render human beings into commodities. For the directors, even if such things did not exist, they display the utter control slave owners held over black existence, black life, and, ultimately, black death. As with *Mandingo*, the gladiatorial slave culture depicted within *Django Unchained* is reflective of Tarantino's driving ethos towards authenticity: it is the storyteller's aesthetic vision which must be given prime importance—the spirit of slavery over its substance.[30]

The cinematic endurance of such mythology may be illustrative of its power. Similar to audiences who watched *Mandingo* in 1975, *Django Unchained's* slave fighting scene created a persuasive impression of authenticity on modern viewers—enough so, that a spate of news articles followed upon the film's release attempting to ascertain its historicity.[31] Historian Gregory Kaster compares this cinematography, even in its fictive devices, to the depiction of the "suffering slave" common to abolitionist imagery of the nineteenth century. Indeed, *Mandingo* treats viewers to scenes of naked black flesh repeatedly beaten, whipped, prodded, abused—even boiled. It is trope in exploitation and sexploi-

tation that Tarantino appropriates with fervor, fulfilling his penchant for visual violence. In one scene Django is left hanging fully nude, with genitals exposed under the threat of castration (the ultimate emasculation for a film steeped in masculinity), a recreation of a similar scene of torment in *Mandingo* where a male slave is hung upside down and bloodily paddled on his bare buttocks (Kaster).

But if such fictive creativity excels at dramatizing the horrors of slavery, it must concurrently do so by diminishing its victims. Tarantino's "Mandingo fighters" are mindless brutes, disturbingly similar to the feral blacks of *The Birth of a Nation*. Although sympathetic as suffering slaves, they are rendered incapable of asserting any act of self-will or control, committing fratricide at an order. This is a divergence from even Fleischer's *Mandingo*, which in its myth-making still offered complicated depictions of slaves and the slave community. In *Mandingo*, two other male slaves continuously warn the black fighter Mede against becoming a "white man's fighting animal." After the murderous match, an elder slave chastises the young fighter, telling him, "Congratulations, it's not every day a black man gets to kill another black man." Despite its salacious and lurid imagery, *Mandingo* managed to present slaves with a semblance of autonomy, existing within a community set apart from their masters and aware of their mutual oppression. It is the "world the slaves made," even in the midst of desperate circumstances.[32]

In contrast, most slaves of Tarantino's *Django Unchained* appear to have about as little recognizable community as they do dialogue. Viewers are treated to scant instances of their thoughts, voices, or perspectives. They exist mostly as extensions of their owners, silent backdrops to the story as white men, and Django, speak and interact. In one disturbing scene a slave woman plays idly on a swing, either uncaring or oblivious, as another slave is brutally whipped just feet away. The only slave who appears to show any initiative or self-concern, the runaway D'Artagnan (Ato Essandoh), pleads for his life before being torn apart by dogs. If the 1970s gave us rebellious slaves, conspiring slaves, and a collectivist interacting slave community, Tarantino's post-millennial Southern creates slaves (with the exception of Django) utterly beneath the thrall of white hegemony.

In a poignant scene, slave owner Calvin Candie holds forth on the nature of slave docility. Invoking the nineteenth-century pseudoscience of phrenology, Candie ruminates on the inherent inferiority of blacks, declaring them biologically fitted for subservience. As evidence he uses the skull of a former slave, who shaved his father each day with a razor and never once attempted to slit his throat. It is an ahistorical perspective, belied by the existence throughout the antebellum South of a plethora of arms, patrols, local militias, and federal garrisons,

all necessary to the maintenance of slavery. Nor does it confront the very real and unequal power dynamic that would have mitigated against fantastic rebels like Django. But Candie's monologue allows for only one answer in rebuttal: Django as the "one in ten thousand" heroic slave, a unique aberration molded by Tarantino to subvert the plantation regime.

SUBVERSION AND PRESERVATION

Subversion is used throughout *Django Unchained* to upend popular cinematic depictions of slavery. To achieve this, the Southern appropriates familiar images and tropes, only to distort them. It is a style borrowed in part from *Mandingo*, where it is most readily perceived in the portrayal of the slave mansion. In Fleischer's film, the opulent manor so common in plantation epics is instead depicted as dismal and dilapidated, its exterior draped in faded moss and its interior a series of dark, shadowy, empty corridors. It is imagery that evokes what critic Robert Keser terms the "moral darkness" and corruption of the slave system: a scene of barbarism and decay that undermines Hollywood's earlier depictions (Keser).

Similarly, the plantation Candie Land is both the opulent mansion of Southern nostalgia and a house of horrors. Its name, like the boyish smile of its owner Calvin Candie, is a falsehood steeped in sadism and human annihilation. In the end it reveals its true self: a gory scene of blood and death that must be utterly destroyed. In this act of subversion, Tarantino destroys (quite literally) one of the most ubiquitous symbols of slavery cinema. Among the slave population, however, subversion relies not only on appropriation and distortion but also preservation. This is most pronounced in the only other slave character, beyond Django, who is allowed to subvert the stereotypes of the celluloid past: the faithful Tom recast as a diabolical mastermind in the form of Stephen (Samuel Jackson).

Described by Jackson as a figure that will make him the "most hated black man" in cinematic history, Stephen is the elderly black slave caretaker of Candie Land and the quintessential Tom.[33] Like his counterpart Mammy, the Tom has origins in Southern reminiscence and transferred early to the screen, portrayed usually by white men in blackface. In *Confederate Spy* (1910), Uncle Daniel is a faithful slave who turns spy for the Confederacy. Sacrificing his life before a Northern firing squad, he dies content, knowing that he "did it for massa's sake." In *For Massa's Sake* (1911) the faithful Uncle Joe volunteers to be sold back into slavery to pay off his master's debts. In later Hollywood plantation epics the Tom was equally pervasive. Now played by black men, he appeared as Uncle

Billy (Billy "Bojangles" Robinson) alongside Shirley Temple in *The Little Colonel* (1935) and *The Littlest Rebel* (1935), and the dutiful Uncle Peter (Eddie "Rochester" Anderson) in *Gone With the Wind* (Bogle 4–6, 47–52, 86–94).

After the 1960s however, the Tom underwent a dramatic cinematic transformation. In *Slaves* (1969), Ossie Davis's take on the Tom, named Luke, in the end joins an insurrection. In *Mandingo*, the slave Agamemnon (Richard Ward) puts on the face of the humble Tom; but within the protective space of the slave community he slips his mask, revealing a bitter figure that chafes at bondage, in the end killing his owner. In *Roots* the seeming faithfulness of the slave Fiddler (Louis Gossett, Jr.) is depicted as a ruse that allows him a cunning advantage over whites.[34]

Django Unchained's Stephen is none of these. He is instead a new take on the classic Tom, the faithful Uncle of *The Birth of a Nation* (1915) who remains loyal to his owners and takes up arms in their defense. He is the "Uncle Tom" epithet of African American socio-political folklore: the house slave who betrays his race to curry favor with whites. The notion of "traitorous" blacks in fact is a common theme in *Django Unchained*, first introduced by the "black slaver" who Django is forced to imitate as a ruse to free his wife. "Ain't nothin' lower than a black slaver," Django relates to Schultz. "A black slaver is lower than the head house nigger, and, buddy, that's pretty fuckin' low." In the black slaver and treacherous house slave, Tarantino depicts antebellum American slavery as a system that both whites *and* blacks maintain. In their subservience and passivity, even the larger slave community is complicit in this conspiracy.[35]

Through Stephen the classic Tom is subverted, imbued with intellect, guile, and a sadistic streak. However, his intelligence is placed at the service of the slave system and his power is wielded upon the other blacks about him. As a Tom, Stephen is incomprehensibly evil, shuffling about with his staff and spitting vitriol at other blacks, making "nigger jokes" and laughing heartily with whites. Stephen in fact is revealed as the brains behind Candie Land, a villainous "Nigger Jim" to his Calvin Candie's Huck Finn. His collusion is not merely a self-serving one, but a willing acceptance of the tenets of white supremacy.

By the climax of the film, Stephen emerges as Django's prime nemesis, setting up a plot based on the "house versus field slave" dichotomy. Popularized by Malcolm X to criticize contemporary black politics in the 1960s, this theory purports that house slaves were inherently tied to their owners due to proximity. Receiving better treatment and food, house slaves allegedly took on the personality of their masters, internalizing their oppression and wielding it against the black community.

The slave record does not allow for easy generalization of slave experiences, and is in fact riddled with house slaves who suffered some of the worst abuses and could lash out in violent retribution. Ex-slave Ida Henry for instance recalled how the mistress of the house stabbed a female cook in the eye with a fork and put it out, because a potato was not fully cooked. Ex-slave John Rudd claimed that rather than surrendering to a whipping, his mother chased her mistress through the house with a knife.[36] Despite this complexity, the popular image of the house slave remains one-dimensional and derogatory in much of popular black political discourse: the opposite of the field slave, who was certain and unapologetic in his black identity. It is as well a contest of young versus old, as Stephen's hatred of Django is seemingly rooted in the latter's defiance as an "uppity nigger" (Malcolm X).

Stephen lives up to this role, undoing Django's plans and aiding in his capture. In his irrational self-hate he is the Uncle Ruckus of Aaron McGruder's *Boondocks* and the cinematic embodiment of modern urban mythologies such as the Willie Lynch forgery.[37] While Django allows other slaves to flee his final vengeance, Stephen suffers the fate of the whites he so faithfully serves. Left to die in the plantation, he is incapable of redemption. His last breath is spent declaring his eternal loyalty as Candie Land explodes around him. Through Stephen, the old Tom, once thought dead and buried with the 1960s, has made his triumphant return to cinema. He is the faithful slave both subverted, preserved, resurrected, and refashioned for modern audiences who can easily recognize him within the modern landscape of black folklore.

CONCLUSION

By early January 2013, *Django Unchained* had unleashed a plethora of write-ups: some in praise, criticism, or deconstruction. Amid this flurry was added a new twist. The National Entertainment Collectibles Association (NECA), in tandem with the film's producers, was placing a line of dolls on the market. Django, Broomhilda, Dr. Schultz, Calvin Candie, and even Stephen, were now boxed and up for sale. Tarantino's films *Kill Bill* and *Inglourious Basterds* had used dolls in the past. But the act of buying and selling replicas of slaves proved controversial enough to have the dolls pulled from the shelves. This was a momentary setback, and they quietly returned soon after as collectibles.[38]

The clash over the commodification of slave dolls was reminiscent of the clash over Steven Spielberg's intent to create an *Amistad* Learning Kit to accompany his film and distribute it to classrooms. Historians decried the act as a step too far, noting the numerous historical inaccuracies in the film. In a *New York Times*

opinion piece, Eric Foner called the move "not appropriate" and suggested the film's producers should instead "direct students to the local library" (Foner).

Though *Django Unchained* never made its claim to historicity in the same tenor as Spielberg's *Amistad*, Quentin Tarantino has repeatedly made clear his film's intent to enter into the contested arena of our national past. Collectible dolls are not the same as a learning kit, but in its attempt at correcting popular conceptions of slavery *Django Unchained* blurs the already porous boundaries between history and cinematic fiction. It is in this nebulous blurring that the Southern exists: myth, metaphor, absurdity, and alternate history translated as visual authenticity. In doing so, Tarantino's genre both subverts and yet preserves conceptions of slavery based on past of cinema and our popular memories—two interdependent modes of understanding.

Slavery remains a topic for which our society still struggles to negotiate a useable language of discussion. Into this vacuum film has come to serve as both surrogate teacher and interlocutor. In this way, Tarantino's Southern is simply the latest salvo in an ongoing dialectic between historicity and film. But as bell hooks reminds, films give us reimagined and reinvented reflections of the real world, not the real world itself (hooks 1–9). Cinematic depictions are based on how we choose to remember the past—a selective process that changes with the social and political temperament.

Notes

1. Daina Ramey Berry, "Quentin Tarantino's Django Unchained (2012)," *Not Even Past,* 1 Jan. 2013, accessed 5 July 2015; Jelani Cobb, "Tarantino Unchained," *The New Yorker,* 2 Jan. 2013; Lonnie Bunch, "What Django Unchained Got Wrong: A Review from National Museum of African American History and Culture Curator Lonnie Bunch," 14 Jan. 2013, Smithsonian.com, accessed July 5, 2015.
2. Scott Foundas, "Django Unchained Upends the Western," *The Village Voice,* 19 Dec. 2012; David Denby, "Django Unchained: Put-On, Revenge, and the Aesthetics of Trash," *The New Yorker,* 22 Jan. 2013.
3. Arianna Mancini, "The New Spaghetti Western: The Southern," *Iperstoria. Testi letterature linguaggi* Numero 2, ottobre 2013. Web. Accessed July 20, 2015; Christopher Frayling, *Spaghetti Westerns: Cowboys and Europeans from Karl May to Sergio Leone,* New York: Saint Martin's Press, 2006, pp. 141–91; *Yojimbo.* Akira Kurosawa. 1961; Sergio Leone, *A Fist Full of Dollars* (1966).
4. Quentin Tarantino. Interview by Charlie Rose. "A Conversation With Filmmakers Quentin Tarantino And Robert Rodriguez About Their New Double Feature, 'Grindhouse,'" 5 Apr. 2007. Accessed 7 July 2015. Michael Curtiz's *Santa Fe Trail* (1940)

depicts John Brown as a fanatic who is thwarted by the heroics of George Custer and the future Confederate general Jeb Stuart.

5. On Blaxploitation, see Sulee Jean Stinson, *The Dawn of Blaxploitation: Sweet Sweetback's Baadasssss Song and it Audience* (Cambridge: Harvard University, 1992); Novotny Lawrence, *Blaxploitation Films of the 1970s: Blackness and Genre* (New York: Routledge, 2008).

6. Quentin Tarantino and Gerald Peary, *Quentin Tarantino: Interviews* (Jackson: University Press of Mississippi, 1998), 172; Russ Myers, made famous with his 1965 film *Faster, Pussycat! Kill! Kill!* and 1969's *Vixen*, was known for his exploitative use of violence and sexuality. Scopophilia, literally translated as the "love of watching," is a Freudian term of analysis adopted by feminist film critics to identify the predominantly male gaze of Hollywood cinema, which turned women into objects of sexual voyeurism. See Laura Mulvey, "Visual Pleasure and Narrative Cinema," *Screen*, vol. 16, no. 3, 1975, pp. 6–18.

7. Andrew Pulver, "Quentin Tarantino defends depiction of slavery in Django Unchained," *The Guardian*, 7 Dec. 2012. Accessed 16 July 2015.

8. Roger Ebert, "Faster Quentin: Thrill! Thrill! Thrill!" *Chicago Sun*, 7 Jan. 2013. Accessed 10 July 2015.

9. Tarantino and Peary, *Interviews*, 172, 177–78.

10. John Hope Franklin, "Birth of a Nation: Propaganda as History," *The Massachusetts Review*, vol. 20, no. 3, 1979, p. 431; David Rylance, "Breech Birth: The Receptions to D. W. Griffith's 'Birth of a Nation,'" *Australian Journal of American Studies*, vol. 24, no. 2, December 2005, pp. 3–6. For more on *Birth of a Nation's* links to the formation of the Second Klan, see David Mark Chalmers, *Hooded Americanism: The History of the Ku Klux Klan* (North Carolina: Duke University Press, 1965). For more on the Lost Cause, see Gary W. Gallagher and Alan T. Nolan Carl, eds., *The Myth of the Lost Cause and Civil War History* (Bloomington: Indiana University Press, 2000).

11. Pulver, "Quentin Tarantino," 2012. Accessed 16 July 2015.

12. Adilifu Nama locates *Django Unchained* with its "historical discontinuities," less as a speculative Spaghetti Western but instead as a type of Gothic Horror film. For this alternative analysis, see Adilifu Nama, *Race on the QT: Blackness and the Films of Quentin Tarantino* (Austin: University of Texas Press, 2015), pp. 106–20.

13. Reginald Hudlin. Interview by Gil Robertson. "Oscar-Nominated Producer Reginald Hudlin Talks 'Django Unchained,'" *Ebony*, 17 Jan. 2013. Accessed 26 July 2015.

14. Frederick Douglass, *Narrative of the Life of Frederick Douglass, an American Slave. Written by Himself* (Boston: Anti-Slavery Office, 1845), pp. 65–66; Cynthia S. Hamilton, "Models of Agency: Frederick Douglass and 'The Heroic Slave.'" Proceedings of the American Antiquarian Society Volume 115, Part 2 (October 2005), pp. 87–135.

15. Douglass, *Narrative of the Life of Frederick Douglass*, 76; William L. Van Deburg, "From Slave to Citizen, 1861–1965," *Slavery and Race in American Popular Culture*

(Madison: University of Wisconsin Press, 1984), pp. 149–51. The use of masculine here should not be construed for essentialism, reduced to a set of easily identifiable stable characteristics. As Judith Butler has shown, gender is "tenuously constituted in time, instituted in an exterior space through a stylized repetition of acts . . . a constructed identity" and "a performative accomplishment." See Judith Butler, *Gender Trouble: Feminism and the Subversion of Identity* (New York: Routledge, 1999), p. 179.

16. *Django Unchained*. Dir. Quentin Tarantino. 2012.

17. Django Unchained; Mark Twain, *Mark Twain's Adventures of Tom Sawyer and Huckleberry Finn: The Original Text Edition* (Montgomery: NewSouth Books, 2012), p. 426.

18. For the ways in which honor functioned as a ritual component of white antebellum southern masculinity and its comparisons to black masculine emasculation, see Kenneth Greenberg, *Honor and Slavery: Lies, Duels, Noses, Masks, Dressing as a Woman, Gifts, Strangers, Humanitarianism, Death, Slave Rebellions, The Proslavery Argument, Baseball, Hunting and Gambling in the Old South* (Princeton: Princeton University, 1996).

19. *Burn!* Dir. Gillo Pontecorvo. 1969.

20. In French Saint-Domingue (Haiti), planters told tales of whites in blackface, who they were certain incited slaves to rebellion. Nat Turner's 1831 insurrection in Southampton, Virginia was blamed on white Northern abolitionists; colonial authorities in Jamaica singled out white Christian missionaries as leading conspirators in the 1831–1832 "Baptist War." See Scot French, *The Rebellious Slave: Nat Turner in American Memory* (New York: Houghton & Mifflin, 2004), p. 110; Laurent Dubois, *Avengers of the New World: The Story of the Haitian Revolution* (Cambridge: Harvard University Press, 2004), p. 103; David Brion Davis, *Inhuman Bondage: The Rise and Fall of Slavery in the New World: The Rise and Fall of Slavery in the New World* (New York: Oxford University Press, 2006), pp. 219–20.

21. Quentin Tarantino. Interview by Henry Louis Gates. "Tarantino 'Unchained,' Part 3: White Saviors." *The Root*, 25 Dec. 2012. Accessed 25 July 2015; Nicholas Robinson, "Quentin Tarantino says 'Roots' was inauthentic," *Rollingout*, 24 Dec. 2012. Accessed 25 July 2015.

22. Ibid.

23. *Django Unchained*.

24. Literary critic Regina Bradley calls the use of Hip Hop in *Django Unchained* a sonic representation of the American South as a site of racial trauma, with rappers like Rick Ross and Tupac Shakur (2Pac) symbolizing calls for black masculine violence and revenge. See, Regina Bradley, Sonic Borders Virtual Panel: Regina Bradley, "I Like the Way You Rhyme, Boy: Hip Hop Sensibility and Racial Trauma in *Django Unchained*," *Sounding Out*, 28 Jan. 2013. Accessed 14 Aug. 2015.

25. *Django Unchained*; David O. Selznick, *Gone with the Wind* (1939); Bogle, *Toms, Coons, Mulattoes, Mammies and Bucks*, pp. 3–9; Deborah Gray White, *Ar'nt I a Woman?*

Female Slaves in the Plantation South, rev. ed. (New York: W. W. Norton & Co, 1985), pp. 27–46, 46–61.

26. The historiography on slave rebellions and slave resistance in American slavery is vast: Joseph Carroll, *Slave Insurrections in the United States: 1800–1865* (New York: Negro Universities Press, 1938); Herbert Aptheker, *American Negro Slave Revolts* (New York: Columbia University Press, 1943); Stephen B. Oates, *The Fires of Jubilee: Nat Turner's Fierce Rebellion* (New York: Harper Collins, 1975); Eugene Genovese, *From Rebellion to Revolution: Afro-American Slave Revolts in the Making of the Modern World* (Baton Rouge: Louisiana University Press, 1979); Gary Y. Okihiro, ed., *In Resistance: Studies in African, Caribbean, and Afro-American History* (Amherst: University of Massachusetts Press, 1986); Douglas R. Egerton, *Gabriel's Rebellion: The Virginia Slave Conspiracies of 1800 and 1802* (Durham: University of North Carolina Press, 1993); John Hope Franklin and Loren Schweninger, *Runaway Slaves: Rebels on the Plantation* (New York: Oxford University Press, 2000); Stephanie Camp, *Closer to Freedom: Enslaved Women and Everyday Resistance in the Plantation South* (Durham: University of North Carolina Press, 2004); Walter C. Rucker, *The River Flows On: Black Resistance, Culture and Identity Formation in Early America* (Baton Rouge: Louisiana State University Press, 2006); Gerald Horne, *The Counter-Revolution of 1776: Slave Resistance and the Origins of the United States of America* (New York: New York University Press, 2014)

27. *Django Unchained*; *Twelve Years a Slave*. Dir. Steve McQueen. 2013.

28. *Django Unchained*. Tarantino has hinted at a larger role for Broomhilda that was edited out of the final film. Drew Taylor, "From Script to Screen: The 12 Biggest Deleted/Unfilmed Scenes From 'Django Unchained,'" *Indiewire*, 18 April 2013. Accessed 12 Aug. 2015.

29. Ibid.

30. *Mandingo*. Dir. Richard Fleischer. 1975.

31. Aisha Harris, "Was There Really 'Mandingo Fighting,' Like in Django Unchained?," *Slate*, 24 Dec. 2012. Accessed 26 July, 2015; Max Evry, "Django Unexplained: Was Mandingo Fighting a Real Thing?" *Next Movie*, 25 Dec. 2012. Accessed 26 July 2015.

32. *Mandingo* (1975).

33. Samuel Jackson. "Samuel Jackson Talks About Playing the Most Hated Black Man in America in the Film Django Unchained." *VibeTv*, 21 Dec. 2012. Accessed 4 Aug. 2015.

34. Herbert J. Biberman *Slaves* (1969); *Mandingo* (1975); *Roots* (1977).

35. *Django Unchained*.

36. Ida Henry, "Ida Henry. Age 83. Oklahoma City, Okla.," Interview. *The WPA Oklahoma Slave Narratives*, vol. 13, 1937, p. 135. [collection-online] Library of Congress; John Rudd, "Told by John Rudd, an ex-slave," Interview by Lauana Creel. *The WPA*

Indiana Slave Narratives, vol. 5, 1936–1938, pp. 170–71. [collection-online] Library of Congress.

37. Aaron McGruder, *All the Rage: The Boondocks Past and Present* (New York: Three Rivers Press, 2007), 242; William Jelani Cobb, "Willie Lynch is Dead (1712?–2003)" *Afro-Netizen* (originally posted on Africana.com), 29 Sep. 2003. Accessed 18 Aug. 2015.

38. Karu F. Daniels, "Django Unchained: Selling Slaves as Action Figures," *The Daily Beast*, 6 Jan. 2013. Accessed 10 Sep. 2015.

Works Cited

Bogle, Donald. *Toms, Coons, Mulattoes, Mammies and Bucks: An Interpretive History of Blacks in American Films*. New 3d ed. New York: Continuum Publishing Company, 2000.

Foner, Eric. "Hollywood Invades the Classroom." *New York Times*, 20 Dec. 1997. Accessed 10 Sep. 2015.

Fridlund, Bert. *The Spaghetti Western: A Thematic Analysis*. Jefferson: McFarland & Company, 2006, pp. 93–121.

Hiscock, John. "Quentin Tarantino: I'm Proud of My Flop." *The Telegraph*, 27 April 2007. Web. Accessed 14 July 2015.

hooks, bell. *Reel to Real: Race, Sex and Class at the Movies*. New York: Routledge, 1996.

Kaster, Gregory. "Django and Lincoln: The Suffering Slave and the Law of Slavery." *Django Unchained: The Continuation of Metacinema*, edited by Oliver C. Peck. New York: Bloomsbury Publishing, 2014, pp. 75–90.

Keser, Robert. "The Greatest Film About Race Ever Filmed in Hollywood: Richard Fleischer's Mandingo." *Bright Lights Film Journal*, 14 July 2014 (original publication Feb. 2006). Accessed 16 Aug. 2015.

Lenning, Arthur. "Myth and the Fact: The Reception of the Birth of a Nation." *Film History*, vol. 16, no. 2, April 2004, p. 1.

Malcolm X. "Message to Grassroots." Speech to the Northern Negro Grass Roots Leadership Conference, King Solomon Baptist Church, Detroit, Michigan, on November 10, 1963. *Teaching American History*. Accessed 18 Aug. 2015.

Samuels, Allison. "Quentin Tarantino on Django Unchained and the Problem with 'Roots.'" *The Daily Beast*, 10 Dec. 2012. Accessed 7 July 2015.

Telling the Tula Slave Revolt

A Creolizing Affair with Neo-Colonial Implications

Daniel Arbino

utchman Jeroen Leinders's 2013 motion picture, *Tula: The Revolt*, is a
fictional representation of the 1795 slave rebellion in Curaçao. The film,
which is the first Dutch film about slavery, depicts the uprising from its begin-
ning as an argument between slave and master to its violent ending when the
Dutch colonial government sentences the leader of the slave insurrection, Tula,
and three of his closest comrades to death. This article examines Leinders's at-
tempt to complicate the rebellion beyond a Black-White dichotomy to articulate
moments of ambivalence and creolization. I look to cultural theorist Édouard
Glissant to define the latter: "an unceasing process of transformation" (142) that
"as an idea means the negation of creolization as a category, by giving priority
to the notion of natural creolization" (141) and thereby demonstrates that "it is
no longer valid to glorify 'unique' origins that the race safeguards and prolongs"
(140). By ambivalence I refer to Homi Bhabha's definition that posits a dialogistic
relationship in which moments of slippage disrupt colonial authority. I argue
that three White members of the colonial enterprise participate in moments of
slippage in the film, whether intentionally or not, that unsettle a clear-cut colonial
hierarchy. Leinders, who spent parts of his childhood living on the island, uses
these moments to posit the slave revolt as a creolizing affair in which post-racial
affiliations are made based on constructions of cultural sameness in the film.
Race, then, in Leinders's view, becomes secondary to the relationship between

the colonizer and the colonized. To that end, the film portrays colonial Dutch-men, represented by slaveholders, a council headed by a governor, and an army as agents of oppression. At the same time, other colonial subjects struggle with their liminal position within the colonial enterprise: as members of the plantocracy and Church they contribute to the colonial system and yet throughout the film they subvert their own affiliation to the colonizer based on their acts in defense of the slaves. Leinders ultimately postulates a post-slavery Curaçaoan identity based on reconciliation at the expense of the colonizer, and this is literally seen when a White woman of the upper class offers her house to the slaves without enduring racial anxiety, a metaphor for an autonomous unity (they are of the same house) in the face of the colonial power. Meanwhile, the film portrays a largely pacific approach to revolt, one in which Tula, the leader of the rebellion, demands nonviolence of his followers. These moments strengthen Leinders's project towards reconciliation between Whites and people of color, but are problematized by what Matthew Hughey identifies as the White Savior trope. To conclude the chapter, I argue that Leinders's film paradoxically reinscribes neo-colonial relationships: that is, a White Dutch director exploits the story of an Afro-Curaçaoan for fame and commercial gain at the expense of the chance for Curaçaoans to tell their own story.

LEINDERS AND THE APPROPRIATION OF AMBIVALENCE

In "Of Mimicry and Man: The Ambivalence of Colonial Discourse" (1985), Homi Bhabha discusses the effects of mimicry and ambivalence on the colonial subject. He claims that as the colonized subject becomes indoctrinated with discursive knowledge, s/he ultimately blurs the line between colonizer and colonized through mimicry and mockery of the colonizer (129). Herein Bhabha points to a divide, or lack thereof, between colonizer and colonized. Yet what happens when members of the colonial enterprise, the very ones invested in producing colonial subjects who reproduce colonial ideas, values, and mindsets, partake of their own unsettling through mockery? Here we might find Bhabha's use of liminality to be helpful. In *The Location of Culture* (1994), Bhabha elucidates liminality as a constant negotiation of cultural identity across race, gender, class, and cultural traditions:

> It is in the emergence of the interstices—the overlap and dis-placement of domains of difference—that the intersubjective and

collective experiences of nationness, community interest, or cultural value are negotiated. How are subjects formed "in-between," or in excess of, the sum of the "parts" of difference (usually intoned as race/class/gender, etc.)? How do strategies of representation or empowerment come to be formulated in the competing claims of communities where, despite shared histories of deprivation and discrimination, the exchange of values, meanings and priorities may not always be collaborative and dialogical, but may be profoundly antagonistic, conflictual and even incommensurable? (2)

Bhabha asserts that race, class, and gender do not come with pre-determined affiliations. On the other hand, we constantly define ourselves in terms of cultural difference. This cultural difference suggests that terms such as "colonizer" and "colonized" are often blurred, creating a liminal space.

Tula: The Revolt portrays a complex racial hierarchy that undermines a Black slave-White master binary. Although the slaves are of African descent and the slave-owners are of European descent, Leinders frustrates this dichotomy on more than one occasion. Black soldiers fight on the side of the colonial army. The priest's helper, Jantsi, is an Afro-Curaçaoan male devoted to the Western religion. Even the man who assists the colonial government in capturing Tula is a former slave who originally joined the revolt. These moments show that in *Tula* race is secondary to other affiliations, whether they are religious, economic, or personal. In these complexities, Leinders reveals one of his objectives of the film: to expose the atrocities of slavery and begin a process of reconciliation. By showing Whites who undermine the colonial enterprise, Leinders attempts to unify White and Black under the guise of morality, justice, and a shared Antillean experience. This objective becomes clearer in a response to a criticism he received for being a White director filming a movie about a slave revolt. In an effort to move beyond racial affiliations, he explains,

wouldn't it be better to agree that the key word here is people? Can we agree on the fact that injustice has been done to people? Can we both look back at the period of slavery and conclude that this is something that is despicable? Does it matter what color you are to come to this conclusion? (Leinders)

As I show below, Leinders highlights three moments of ambivalence in the film in which members of the colonial enterprise blur the lines between colonizer and colonized, thereby deemphasizing race.

The first instance of ambivalence is in fact what sets the events of the rest of the film in motion. Tula's future wife Speranza, a house slave, overhears master Willem speaking with a colonial administrator about how the Dutch republicans, with the help of the recently established French Republic, have taken control of the Netherlands. This left the Netherlands, then renamed the Batavian Republic, as a vassal state of France, operating under the French Republic's ideology of equality and freedom (Oostindie, "Slave Resistance" 9). Indeed, France abolishes slavery in all of its possessions in 1794.[1] The transition to French rule thus informs the slaves of what they perceive to be their new rights to emancipation. Moreover, Speranza also hears the two men discussing the recent successful slave revolution in Haiti. The nearness of Haiti serves as a symbol of hope for the enslaved on Curaçao. That night, Speranza relays the message to Tula and others, who celebrate only to find themselves called to work the next day, which happens to be a Sunday.[2] When Tula confronts master Willem on the recent political developments, declaring that "The French beat the Dutch and they outlawed slavery. We should be free by law. The French are here master; now you got somebody to obey. We all just waiting for you to obey," Master Willem reestablishes his power by sending Speranza as a gift to a nearby plantation. Tula regroups his thoughts and the next day again demands an explanation as to why he must continue to work, when the French have declared him free. Master Willem, seeing himself outnumbered by a group of angry slaves, sends Tula and his men to speak to the Governor, claiming that "If you are right, the governor may just give you an audience. . . . You are free to go talk to the Governor. . . . Go plead your case, with my blessings" before he flees on his horse.

I point to this scene as a moment of ambiguity because master Willem belies his duties within the colonial enterprise. Although unintentional, the permission that he gives Tula and the other men (with his "blessings") is the spark that begins the revolt. Rather than putting the uprising down, he unwittingly encourages it. Granted, the conversation is between him and approximately twenty angry slaves, but he allows his power to be doubted and, ultimately, relinquishes his authority. In part this is because he wants to procure his own survival. With the events in Haiti fresh in his mind, Willem quickly removes himself from a position of authority, telling the men to speak with the Governor instead. In so doing, he escapes his possible death. Also at play here is his deep dissatisfaction with the Netherlands, which has fallen to the French. He bemoans this loss in his earlier conversations. He cannot answer Tula's question nor force the slaves to work because, in part, he no longer knows in what colonial enterprise he participates and his affiliation is untethered. Does he align with a transforming

and remote Dutch state? A French Republic that he has already denounced? The island of Curaçao in particular as a tenable home amidst transformation? These uncertainties and doubts provide the space for his unintentional complicity in the revolt and the subsequent shunning that he receives from the Governor and the colonial court. To be clear, Willem's participation in the revolt stops here, but his own ambivalent feelings towards events in Europe create a slippage in his authoritarian role because they directly affect his relationship to the colonial enterprise.

The second moment of ambivalence takes place on another plantation just outside of Port Marie, where Tula and his growing band of dissenters (which includes once again Speranza) are greeted by Ms. Lesire's houseboy and invited to her home. In her exchange with Tula, Ms. Lesire assures Tula that though she cannot be seen with him in public, she would do everything she could to help. At that point, Ms. Lesire makes a literal and symbolic gesture to Tula: "Use what you'd like here, but look after my home. It is yours as long as you need it." To avoid any suspicion of conspiracy, she then leaves. The offering of the house here has two related meanings. Literally, she is offering the rebels shelter, clothing, and food. In fact, Tula and Speranza sleep in the master bedroom that night. On a figurative level, the Big House, historically a site of racialized power and violence, is reconfigured into an open home (Russ 168).[3] Indeed, the house serves as a metaphorical crossroads: an acknowledgment that hierarchical change is in action. With Tula and Speranza inhabiting it together, Leinders reveals a certain discourse: the heterosexual and peaceful couple (one Black, one described as "Yellow" because she is multiracial) are appropriating the land that they have worked relentlessly without ever being able to call it their own. In addition, they presumably conceive their son (also named Tula) here; this bio-reproductivity ensures a family lineage. Yet it is because Ms. Lesire, a White woman, allows them to do so. The intersection of race and gender is quite visible here: Ms. Lesire's civil status as a single woman who still resides in the upper echelon of a paternalistic society distinguishes her empathy from someone like master Willem.[4] She understands the inequality that the slaves face because she too faces it, albeit in very different ways. Having Ms. Lesire as a metaphorical bridge between the two societies on Curaçao facilitates Leinders's telling of the story as one of post-racial affiliations. Ms. Lesire's occupation of the Plantation house (the Big House) followed by that of Tula and Speranza de-authorizes the house as a site of White patriarchy, thereby taking the "racial house," in the words of Toni Morrison, and turning it into a "nonracist home" (Morrison 5). Nevertheless there are certainly limits to this change: the house is ultimately

Ms. Lesire's and she has every intention of reclaiming it. In that sense, the Big House demonstrates the anxieties that Ms. Lesire embodies as a member of the colonial enterprise who recognizes slavery's injustice: she must secure her place on the island with regards to either outcome of the revolt.

The final scene of ambivalence that this article addresses involves the priest, Father Jacobus Schinck, who, after being granted the opportunity to mediate between the colonial government and the slaves, begins his journey to the Port Marie plantation in Ms. Lesire's carriage, who again serves as an intermediary between the colonizers and the colonized. The exchange between Father Schinck and the colonial government is heated in regards to dealing with the uprising: Father Schinck affirms his allegiance to the colonial government, declaring that "freeing the slaves would be every bit of a mistake as killing them is" and that "I believe that by [God's] grace, we have all been prescribed our place on this earth." His role as mediator then is not to negotiate a compromise between the two sides, but rather to recommend that the slaves return to their position. However, he already has a history of ambivalence. When bringing communion out to the field slaves early in the film, he answers a question posed by one of the field slaves, Shinishi: "Now you see father, master got us workin' on Sunday. I just wanna know, who go to hell for it?" The priest responds: "I think you'll be okay." This muddled answer suggests that in the eyes of the Catholic Church, the slaves are not in the wrong, which is to imply that the master is. Here Church and State come into conflict: the Church believes that in order to indoctrinate the slaves, they must be treated like Catholics. That is to say, the slave-owner should not force them to work on Sundays so that they may observe the Sabbath. The State, dependent upon the slaves' work for crop exportation, is more concerned with economic prosperity. In the scene in which he serves as mediator, Father Schinck approaches the plantation singing in Papiamentu, a language that, in 1795, was more typical among Afro-Curaçaoans than Dutch coloniz-ers.[5] After a brief discussion with Tula in which the Father acknowledges that though their struggle is a worthy one, it is a struggle that they will not win, he is asked to accompany Mama Pretu (Mother Black) in leading the dissenters in prayer. Here Father Schinck's position becomes liminal because the ensuing scene is not one of Christian orthodoxy, but rather a syncretic Afro-Curaçaoan prayer conducted by the dissenters in Papiamentu, and one that yields to tambú, a drum-based music and dance form popular throughout Curaçao, Aruba, and Bonaire. Mama Pretu incorporates Father Schinck into the scene by calling on "every god we know, old and new, to protect our path, as we march for our freedom." At this point, Father Schinck leads an alternating prayer in English

in which he names various relevant figures of the Christian pantheon while two women interrupt him in Papiamentu to plead for mercy, presumably to the figure the Father evokes. In linguistic terms, Schinck's prayer in English follows the goal of the film to reach a wider audience; its juxtaposition with Papiamentu implies that he would have spoken Dutch in this historical moment. Interestingly, Leinders decided not to provide translation to the few times that Papiamentu is used in the film, rendering it incomprehensible to those in the audience who do not understand it. When Father Schinck finishes calling on Mary, Saint Rose, Saint Peter, and Jesus, Mama Pretu then pleads for the guidance of Papa Legba, Yoruban deity of the crossroads. This is the one scene in the film that highlights Papiamentu and tambú as forms of resistance to Dutch colonization and yet a participant in all of it is a man who earlier in the film states that the Church and the State must be inseparable. Father Schinck's role in all of this is surprising: does he say nothing about the rebels' blending of religions because he feels that their cause is a lost one? Is he calling on all gods in an effort to compel the slaves to peacefully return to their plantations? Or is this how he has been preaching all along? These answers are not clear in the film. Rupert notes that "by the early nineteenth century, there is ample evidence that the local Roman Catholic Church was preaching regularly in Papiamentu" (216), but did they also allow the praises to Legba and the ritual dancing? In any case, in the film Father Schinck takes part in what Cuban anthropologist Fernando Ortiz termed "transculturation." Similar to creolization in the fusing of at least two heterogeneous cultural elements, an important distinction of transculturation is that the subordinate class takes elements from the dominant culture and appropriates it for their own benefit (Ortiz 93–94). Here the rebels use Christian prayer, blended with equally relevant other beliefs, in a revolt against a colonial Church and State invested in their defeat. Therefore, the Father's role in guiding that prayer puts him in an ambiguous position between his congregation and the enterprise he aims to protect.

"THE SAVIOR TROPE" AND THE TERMS OF RECONCILIATION

In *The White Savior Film* (2014) Matthew Hughey identifies the genre and its trope as "a white messianic character [who] saves a lower- or working-class, usually urban or isolated, nonwhite character from a sad fate" (1). He continues that "terms such as 'noble savage,' 'manifest destiny,' 'white man's burden,' and 'great white hope' refer to previous iterations of the complex relationship be-

tween the tropes of the white savior and the dysfunctional and dark 'other' in need of saving," presented along the lines of "intercultural friendships and the humanistic struggle to overcome daunting odds (usually 'based on a true story,' to boot)" (8). With the exception of *Amistad* (1997), Hughey examines post-slavery films such as *Gran Torino* (2008), *The Blind Side* (2009), and *The Help* (2011). Of principle interest to this article is that the recent amount of films about slavery relationships aim to trouble binaries by showing a White protagonist aiding the struggle of people of African descent. While I do not discount that this happened throughout history, I argue that films that rely on the White savior trope under the guise of "based on a true story" reproduce harmful images: the great White benefactor and the dependent Black. The popularity of these films is becoming all the more evident and has crossed into the realm of the slave narrative: Steve McQueen's *12 Years a Slave* (2013), Amma Asante's *Belle* (2013), Thomas Phillips's *The North Star* (2015), and even Quentin Tarantinto's *Django Unchained* (2012), which features easily the most rebellious character of the aforementioned films, all utilize a White character that facilitates the struggle. Why are these types of films made while the story of the Haitian Revolution goes largely untold in cinema?[6] Do White audiences need a White character with whom to identify? Or is it, as I argue, an anxiety about slavery in the Americas and an interest to promote historical events as complex and post-racial so as to promote multicultural communities? In an interview with Temple University Press, Hughey agrees:

> The danger is when many defend the supposed lack of ideological slant or racial politics in these films, by referencing that they are based on actual, historical events. The "based on a true story" phrase may seduce audiences into an uncritical appraisal of these films. These films subtly rewrite historical events so that white colonizers, paternalistic controllers, and meddling interlopers seem necessary, relevant, and moral. ("Author Interviews")

The White savior trope is useful to think about ways in which these films attempt to forge a multiracial community, but ultimately rely on antiquated images that the audience consumes. As Hughey notes, the audience often overlooks the ideological slant in favor of praise. Such was the case in positive reviews of *Tula*. The film received nominations at multiple film festivals, including the 2014 San Diego Black Film Festival (where it won "Best Film"), The Pan African Film Festival (where it won "Best First Feature"), the London Film Awards (where it was awarded the "Grand Jury Prize"), and was an official selection at the

Social Justice Film Festival in Seattle and the Trinidad and Tobago Film Festival, among others. The African Diaspora International Film Festival recognized the film's uniqueness for being the first movie "on the essence of slave resistance" ("Tula The Revolt—Black History Month"). Local film critic Mario Kleinmoedig calls the film a "beautiful story" that is "recognizable" (Kleinmoedig). Additionally, members of the Curaçaoan parliament were so impressed with the film that they allowed free screenings for school children (Salvaran). However, Leinders's intent towards a post-racial film risks these very same antiquated images described above in its desire towards racial reconciliation on the island. The film proves to be timely in that aspect as 2012 council elections in Curaçao drudged up colonial relationships and their lasting legacies on race, identity, and sentiments of who belongs and who does not, as I will discuss below. In an effort to deemphasize race, Leinders uses a variety of techniques that minimize racial violence and bloodshed in favor of questions of morality. In an interview with Dick Drayer, Leinders comments on the possibility of his film: "We just made a short film. Anyone who looks at it is gripped by emotion and compassion for the tragedy of the slave. And in that emotion you unite your people; there is no revenge to arise from: everyone finds [slavery] terrible." Dutch film critic Shelley Eimers points out that the film "follows both Tula and the Dutch oppressors and tries to make it clear that on both sides, not everyone is good or bad." When Tula asks Ms. Lesire why she is helping them, her response is ethical: "because it's right." Yet Leinders's moments of ambivalence, in his efforts towards post-racial affiliations, point to a reconciliation that maintains a *status quo* of racial power and promotes the role of the White Benefactor. The aforementioned scenes of ambivalence suggest that the slave revolt would not have occurred without the help of White colonizers, particularly Ms. Lesire. When contrasted with Tula, who Leinders portrays in a constant moral quandary about how to lead a revolt he did not want to lead, Ms. Lesire is, as Surinamese historian Sandew Hira puts it, "the one who encourages blacks to fight for their rights. She is the fearless fighter for the freedom of black people." Hira's condemnation of the film is certainly not minced, but the scholar raises a valuable point as he questions the "accuracy" of Ms. Lesire's portrayal in the film as someone who *openly* sympathizes with the revolt when historical records indicate that she denies any sort of knowledge of the revolt. Dutch critic Steffan Hofland is in agreement. His review acknowledges that the film is "very romanticized" and that while "this simplification makes the film narrative much more exciting, it slightly offsets the historical relevance." Perhaps more useful questions to ask for the purpose of this study is why do filmmakers, such as Leinders, continue to utilize White

characters (real or otherwise) as catalysts towards emancipation? What does it say about films on slavery to show these multiracial collaborations? How does it change the way that the viewer thinks about slave rebellion? In the specific case of *Tula*, how much of Ms. Lesire's role parallels that of Leinders's own desire to be a catalyst to tell this story with the hope of sparking racial reconciliation and a post-racial world?

This continues to play out in how racial violence is (and is not) portrayed in *Tula: The Revolt*. The director never shows the death of Tula, opting instead to show his sentencing in a cyclical fashion to bookend the film. Leinders reproduces the historical sentence of Tula's death: "He should be taken to the place of execution and bound on a cross and from head to feet broken upon the wheel, then scorched in the face, while the head should finally be cut off and put on the gallows" (Paula 26). In that aspect, Leinders does not lessen the sentence, but in never showing the grim execution or even a slave master beating a slave, the excessive violence found in slavery and racial difference is minimized. If Leinders showed Tula's death on screen, it would undo his objective of a post-racial reconciliation, but herein lie the limits of post-racial ideologies such as creolization: they often reduce racial difference to promote cultural sameness, thereby minimizing racialized violence.[7] Leinders ultimately follows this formula: the film ends on an optimistic note for the future with Speranza and her newborn son Tula walking along the beach. Tula the father is replaced by Tula the son, a symbol of a new generation and a more just world. In part this is because Leinders's film, according to the official website, is "an action movie, but at the same time a character movie, giving the audience the insights of a reluctant leader, his hopes, his fears, his values, his love, his faith, but also his inevitable destiny" (tulathemovie.com). However, by omitting Tula's death, Leinders silences the horrors and atrocities of slavery, repeating colonial models of master narratives for one side, and erasure for another. Ironically, in an effort to reconcile Blacks and Whites, the film's (lack of) ending denies descendants of slaves the chance to process their history.

NEO-COLONIAL IMPLICATIONS

In spite of Leinders's ability to create a film that complicates racial binaries during a slave revolt in an effort towards resolution, positions of power based heavily on race, a colonizer-colonized paradigm, and socioeconomic status influence the making of this film. In effect, the film is rife with neo-colonial implications after paradoxically trying to overcome them in the film. My definition of

neo-colonialism hews closely to that of Bill Ashcroft's in that neo-colonialism "refers to any and all forms of control of the ex-colonies after political independence" (177) and Robert Young's belief that this control is advanced via "development and dependency theory" (the non-Western world's inability to escape Western discourses on development and economic growth) and later, "critical development theory" (the incorporation of culture, gender, society, and politics) that ultimately leads to exploitation and intentional under-developing on multiple levels (49–56). At the crux of this argument is the fact that two White Dutchmen (Leinders and film producer Dolph van Stapele) from Curaçao's former colonizer, the Netherlands, are on the island (after giving serious thought to filming *Tula* in South Africa [Roos]) to shoot a film about a slave revolt against the Dutch. The film is shot in English with Dutch subtitles, according to Leinders, "to reach a large audience" and broaden "the possibilities in the field of actors and actresses" ("Q&A").[8] Yet one cannot deny that a film in English, replete with famous Dutch actors (including the revered Jeroen Willems in his final performance) as well as Danny Glover, would garner more income in an international market. The few times that Papiamentu (the language most commonly spoken in Curaçao) is spoken, there are no translations, rendering it incomprehensible to the majority of the international audience. Why not provide subtitles for it? The film's musical score is epic, orchestral, and Hollywood-like; there is no autochthonous music. Moreover, none of the main actors or filmmakers, though multinational, are Curaçaoan. Even the actor playing Tula, Obi Abili, is a British citizen of Nigerian descent with no apparent relationship to Curaçao; the screenwriter is an African American from the United States. I highlight all of these details to demonstrate the minimal participation that the island and its residents had in the making of this film. In Leinders's defense, local actors were cast in the film's smaller roles and both actors and the director provided workshops to aspiring actors and filmmakers (Gibbs).

Paradoxically, the official site states this about Tula and the slave revolt: "As many slaves were transported and traded through the Caribbean transit harbors like the one on Curaçao, this story belongs to them and to their descendants. It deserves to be told, for it is an important part of history, identity and in the end, of our society today" (tulathemovie.com). The contradiction, as I outline above, is that Curaçaoans had very little input into how their story would be told, who would tell their story, to whom it would be told, and in what language it would be told, while the film is consumed by younger generations of Curaçaoan school children. For all of the reconciliation and complicated affiliations that Leinders posits in the film, the way that he made it affirms a neo-colonial relationship of

power, commercial exploitation (were the local actors and crew a way to involve the community or find cheap labor?), master narratives, and cultural imperialism. I say neo-colonial because of his position as a Dutchman, an identity acknowledged by Leinders himself, Curaçaoans, and the larger public as the Trinidad and Tobago Film Festival awarded him the prize for "Best Caribbean Film by an International Director" ("Awards Announced"). This is how *Tula* and its director differ from the aforementioned slavery films in which directors are either of African descent or grew up in the Americas. Leinders, even as a Dutchman who spent parts of his youth in Curaçao, did not experience the intimacies and legacies of slavery in the same way. In the eyes of Curaçaoans, that relegates him to an outsider. What is more, due to Curaçao's recent contentious relationship with the Netherlands, Curaçaoans have contextualized the film and its director under the umbrella of neocolonialism. This is evident in Curaçaoan culture critic Jermain Ostiana's harsh critique of the film:

> On the website www.tulamovie.com they are talking about: "A story representing centuries of conflicted relations between black and white the effects of which still haunt us today." And it does as the two Dutch white privileged filmmakers cold-heartedly or extremely naively kidnap the opportunity of Afro-Curaçaoans or at least Curaçaoans to tell the tales of freedom-fighting Tula. (Ostiana)[9]

Ostiana's larger concern here is that as of 2011, the Netherlands curtailed Curaçaoan cultural development by never opening a film school on the island so that Curaçaoans can tell their own cinematic version of Tula, leaving it in the hands of the former colonizers to do so.[10] Certainly this is not Leinders's fault, but because of his project and position at a time of tense racial relations, he receives the brunt of the criticism. Gert Oostindie points out in *Postcolonial Netherlands* (2012) that the Netherlands showed little enthusiasm in commemorating slavery in the Dutch Antilles (150). Leinders's well-intentioned efforts raise awareness about Tula, the history of slavery on Curaçao, and an important revolt in Caribbean history and are therefore a significant attempt to move beyond these erasures in Dutch society and promote dialogue between the Antilles and the Netherlands. In many cases, these efforts are overlooked.

Leinders's film and its reception breach issues of representation as elucidated by Linda Alcoff in her seminal essay "The Problem of Speaking for Others" (1991). Therein Alcoff details the gravitas of when a person in a privileged position speaks for and/or about marginalized groups. She considers factors such as the location of the speaker, the location of the interlocutor, and the location of the

subject in question while also giving attention to content and how it is viewed as truth (5–15). One of the repeated discourses surrounding this film is that Leinders spent part of his childhood growing up in Curaçao while van Stapele has worked there for over a decade. In fact, the biographies on the film's official website seem more determined to emphasize that the two White Dutchmen share some sort of insider status on the island than establishing their background in film production and how their interest in the film developed. Hendrik Hendrichs's review of the film notes that "as a writer and documentary maker in Holland [Leinders] was amazed to find that nobody knew Tula's story, so he decided he had found a worthy subject for his first feature film" (118). Leinders's personal website acknowledges that he has a background in marketing and advertising with prior experience working for NGOs like Amnesty International (jeroenleinders.com). His commercials, trailers, and short films can be readily accessed on internet sites such as Vimeo and range from advertisements for Shoestring Adventure Travel and the Dutch online dating site *Relatieplanet* to aftercare for Breast Cancer victims and his next focus (*Jeroen Leinders's Videos*), the Dutch anti-violence film *Wanneer de mieren schreeuwen* [When the Ants Cry] (2016) which is based on a true story about the tragic murder of a thirteen-year-old boy who was shot in the head (*Voor Een Miljoen*). Yet the Tula website does not showcase Leinders's extensive background in film production. On the other hand, the site states that "the project's initiator and director Jeroen Leinders is no stranger to Curaçao. He spent a large part of his youth on the island and has been regularly living and working there during the past five years." Meanwhile, van Stapele's biography begins with the following: "Being the co-owner of Fisheye Media Productions co-initiator Dolph van Stapele has been working from Curaçao as a director of photography for the last decade." Van Stapele's goes on to vaguely mention that he brings years of experience in editing, short film, and documentary making (tulathemovie.com). This anxiety about belonging and who can and cannot make a film about the Tula revolt (as well as the credentials to do so) was similarly shared by island residents, as has been noted by Ostiana and Hira's concerns of historical inaccuracies and silencing. As Dutch film critic Dick Gilsing points out, the fact that Leinders did spend time in Curaçao was not enough to afford him an insider status amongst the residents: "*Amid critical reception of the film's production in Curaçao*, Leinders and producer Dolph van Stapele, two White Dutchmen with the intent to tell the story of slaves, had to consult with local historians" (my emphasis).[11] Gilsing's comment on critical reception would suggest that Curaçaoans could not overlook Leinders and van Stapele's location as White Dutchmen, reminders of a colonial period that problematically ended in 2010.[12] Anti-Dutch sentiment flared up once again in the summer of

2012 when the Netherlands placed Curaçao under "guardianship" due to a rising budget deficit ("Schotte").[13] One might argue that the focus on these two men's location as White Dutchmen is an example of what Alcoff terms a "charge of reductionism," that is, "[reducing] evaluation to a political assessment of the speaker's location where that location is seen as an insurmountable essence that fixes one" (16). The aforementioned biographies on the film's official website insinuate Leinders and van Stapele's commitment to bypass this problem, but due to the nearness of Curaçao's transition from colony to autonomous state within the Kingdom of the Netherlands coupled with glaring issues in the film, the two men cannot do so successfully.

Herein lies the next paradigm of Leinders's film. Depending on the school of thought, Leinders's retelling of the Tula slave revolt is either accurate or over-simplified. Hendrichs's positive review of the film states the following:

> [*Tula*] is a good example of public history. It points to half-forgotten or neglected sources, it provides teachers with material that is emo-tionally moving as well as intellectually dependable, and it tells the general public—not only the descendants of enslaved persons—the story of a fight for human rights against the (literally) crushing power of the Dutch slave holding elites. (120)

Meanwhile, Hira's opinion piece for the Curaçaoan newspaper *Antillians Dagblad* [Antillean Newspaper] outlines a number of perceived glaring historical inac-curacies. Hira, who has co-authored a book on the Tula Slave Revolt titled *Tula, de slavenopstand van 1795 op Curaçao* [Tula, the Slave Revolt of 1795 on Curaçao] (2011), takes umbrage with Tula's representation in the film:

> How did Jeroen Leinders portray Tula? As a watered-down, weak man who did not want a revolt or a revolution, but only an interview with the governor. He had established no organization, but was sur-prised by people who just offered to join the rebellion. Throughout the whole movie this Tula moans about how he still wants a conver-sation with the governor instead of a revolt or revolution. Nothing about independence. No organization. No well-prepared uprising. ... [Leinders] chose the colonial story of Tula. ... His Tula had no greater vision than to request a meeting with the governor. (Hira)

Although one could argue that Tula's portrayal as "weak" is better thought of as reflective, peaceful, and poised throughout, Hira also underscores that Tula wanted a full-on revolt similar to that of Haiti, with the ultimate goal being

complete independence and a government ruled by Black men (Hira). What is more, Tula's band intentionally razed estates and poisoned wells and cisterns of White colonials in an effort to imitate the successes of the Haitian Revolution (Hoyer 8). In the film, only the Dutch colonists committed such atrocities. Those Antilleans who are familiar with and follow this version of history have found Leinders's film underwhelming. Others, such as Curaçaoan journalist Mario Kleinmoedig, have absolved Leinders of any blame: "The tragedy is that I think that *Tula* corresponds quite well with the 'official' history of Curaçao. So, if this Tula is historically incorrect, then the problem is not Leinders." When asked about the portrayal of Tula in separate interviews, Leinders and van Stapele gave different answers. The director, opting for a multivalent postmodern approach, stated, "There are many different Tulas. If you look at the White vision that there was about Tula, he was a criminal and troublemaker who was to be arrested as soon as possible, but in the eyes of the locals Tula was a great warrior. If you delve into it, there is no other possible conclusion than that both stories can be correct" (Thomas). Meanwhile, citing budgetary issues and an effort not to reinvent history in response to criticisms of the film's superficiality, van Stapele responds that "we really followed the story of Tula for the film. We have not deviated from there. As a result, we did not go deep. It had been a very clear choice. Perhaps if we possessed ten times the budget, if we had the story in a broader historical context ... but we did not think about that" ("Belangrijk dat het er is"). Both men agree that they followed historical detail, but only Leinders suggests that there is more than one version of that history, which allows for multiple interpretations and eschews responsibility if he misrepresents Tula. With objectives to portray a "revolt on Curaçao that was meant to be won by words, rather than arms" (tulathemovie.com) and post-racial allegiances built around understanding and reconciliation, Leinders becomes so enveloped in presenting Tula as nonviolent that he erases some of what little historical fact does exist about the rebel. What history tells us, as shown in Rupert's study, is that Tula had a co-conspirator from a different plantation which suggests that the revolt was planned (208).[14] Slaves also sang French freedom songs (Rupert 209) and though it is not mentioned in the film, Tula takes the last name Rigaud in honor of Haitian General Benoit Joseph Rigaud (Benjamin 76). Due to Tula's knowledge of contemporary events in the region coupled with his affinity for Haiti, some scholars, such as Charles Do Rego, have argued that a larger Caribbean conspiracy was in the works (24). However, by removing this sort of organization and premeditation, in the film only Ms. Lesire's words of encouragement push Tula forward and Leinders rewrites Curaçaoan history, a salient sign of cultural imperialism.

CONCLUSION

Jeroen Leinders's first motion picture *Tula: The Revolt* is an ambitious effort to tell the history of the 1795 slave revolt in Curaçao. However, Leinders falls into many of the trappings that he aims to undo in the film: a reinscription of colonial stereotypes that posit a great White benefactor; a manipulation of history for the sake of a master narrative; and post-racial commentaries shrouded in reconciliation at the expense of showing racialized difference and violence. The complicated reception of the film (the Curaçaoan government endorsed it while film and cultural critics largely criticized it) in many ways echoes larger postcolonial issues of elevating the former colonizers (what V. S. Naipaul would call Mimic Men) or rejecting them; of promoting a post-racial community or acknowledging historical violence amongst different racial sectors on the island. Put into the current context of racial tensions and diplomatic tensions between Curaçao and the Netherlands, the film and its critical reception in Curaçao ultimately raise questions about who can and cannot make slavery films as well as how history is told and remembered. In Leinders's case, he was able to call attention to the Tula Revolt, but he also told another people's story. In sum, it is not that a White director made a film about slavery. This has been, and will be done countless times with varying degrees of success. The issue here is that a member of the former colonizer (who was the colonizer just a year before production began) came to the former colonized state and amidst heated postcolonial tensions, tried to tell the people their own history.

Notes

1. Napoleon reinstated slavery in 1802.
2. In an effort to teach slaves Christian principles, slave masters were expected to allow slaves to observe the Sabbath by providing this day to rest.
3. Russ's study refers to Toni Morrison's novel *Paradise*. However, I find her ideas of the "open home" to be fitting here.
4. It should also be pointed out that as part of her distinction from others in the colonial enterprise, Ms. Lesire seemingly only has the one house slave; the viewer does not see any field slaves which suggests that she does not have any or very few.
5. Indeed, Linda Rupert's study of Curaçao in the early modern Atlantic world, notes how "Father Schinck . . . was chosen to mediate with the rebels in part because he was fluent in Papiamentu" (216).
6. It should be noted that Danny Glover acted in this film in the role of a sort of elder statesman. Of greater interest perhaps is that he has been unsuccessfully

trying to have a film on the Haitian Revolution greenlighted for several years. Was his participation in *Tula* a way to garner further interest in Caribbean slave revolts in hopes that one on Haiti come to fruition or an acquiescence that it may never?

7. See Amar Acheraiou's *Questioning Hybridity, Postcolonialism, and Globalization* (2011) for a study on this phenomenon.

8. To be fair, Leinders re-screened the film in November 2015 (one year after the original version of this article) with subtitles in Papiamentu. According to the film's Facebook page, the re-screening was to meet popular demand and the inclusion of Papiamentu subtitles was the recognition of "an important asset for Curaçao. . . . It will make the film accessible for a much larger group of the Curaçao population."

9. In the director's defense, Leinders invited Ostiana to join him on the set and aid in the film's production, though Ostiana declined.

10. I refer to the following statement: "In 2011 there is no film school here—if you want to learn cinematography you will have to go study abroad" (Ostiana).

11. These two advisors are Venancio "Pacheco" Domacassé and Charles do Rego. Interestingly, Domacassé, whose formal background is as a director and actor for theater, film, and television, wrote and directed a 1971 play about the Tula revolt in Papiamentu titled *Tula, e rebellion di 1795: un drama historiko* [Tula: The Rebellion of 1795: A Historical Play]. It should also be noted that do Rego's background is in human geography.

12. I say "problematically" because Curaçao is a country with internal autonomy within the Kingdom of the Netherlands. This suggests that theoretically Curaçao is an equal partner in the Kingdom with the Netherlands, though the former still relies on the latter for defense and foreign policy. Moreover, the Netherlands administers a majority of the Kingdom's affairs.

13. In fact, that October Curaçao held general elections for The Estates of Curaçao, an island council. Helmin Wiels, a pro-independence leftist of the Pueblo Soberano party who was later assassinated (in 2013), won while supposedly threatening to put any Dutch administrators who tried to interfere with Curaçao in "body bags" ("P.V.V.").

14. Angelie Sens confirms that Tula later admitted to this.

Works Cited

Acheraiou, Amar. *Questioning Hybridity, Postcolonialism, and Globalization.* New York: Palgrave MacMillan, 2011. Print.

Alcoff, Linda. "The Problem of Speaking for Others." *Cultural Critique*, Winter 1991–1992, pp. 5–32. Print.

Amistad. Dir. Steven Spielberg. DreamWorks Pictures, 1997. Film.

Ashcroft, Bill, Gareth Griffiths, and Helen Tiffin. *Post-Colonial Studies: The Key Concepts.* New York: Routledge, 2013. Print.

"Author Interviews." Web. 2 Jun. 2015. http://www.temple.edu/tempress/authors/2263
_qa.html

"Awards Announced For 2013 Trinidad + Tobago Film Festival." Web. 21 May 2015.
http://www.ttfilmfestival.com/2013/09/awards-announced-for-2013-trinidadtobago
-film-festival/ "Belangrijk dat het er is." *Knipselkrant Curaçao.* 19 Jul. 2013. Web.
21 Jan. 2015. http://www.kkCuraçao.info/?p=32251

Belle. Dir. Amma Asante. Fox Searchlight Pictures, 2013. Film.

Benjamin, Alan F. *Jews of the Dutch Caribbean: Exploring Ethnic Identity on Curaçao.*
London: Routledge, 2002. Print.

Bhabha, Homi K. *The Location of Culture.* London: Routledge, 2004. Print.

———. "Of Mimicry and Man: The Ambivalence of Colonial Discourse." *October,*
vol. 28, Spring 1984, pp. 125–33. Print.

The Blind Side. Dir. John Lee Hancock. Warner Bros. Pictures, 2009. Film.

"Danny Glover's Haiti Film Lacked 'White Heroes,' Producers Said." *Domini-
can Today.* 26 Jul. 2008. Web. http://www.dominicantoday.com/dr/people/2008
/7/26/28807/Danny-Glovers-Haiti-film-lacked-white-heroes-producers-said.
22 Apr. 2015.

Django Unchained. Dir. Quentin Tarantino. The Weinstein Company, 2012. Film.

Do Rego, Charles P. *Sklabitut i rebellion 1795.* Curaçao: Asosiashon Promoshon
Konsenshi Istoriko, 1983. Print.

Domacassé, Pacheco. *Tula, e rebellion di 1795: un drama historiko.* Willemstad: n.p., 1975.
Print.

Drayer, Dick. "Het werd tijd dat dit verhaal verteld werd." *NRC.* 30 Nov. 2012. Web.
http://www.qracao.com/index.php/dit-is-een-artikelen/4306-het-werd-tijd-dat
-dit-verhaal-verteld-werd. 22 Jan. 2015.

Eimers, Shelley. "Recensie: *Tula: The Revolt* (2013)." *Cinemagazine.* 3 July 2013. Web.
http://cinemagazine.nl/tula-the-revolt-2013-recensie/. 30 Dec. 2014.

Gibbs, Natasja. "Acteurs 'Tula the Revolt' geven workshop acteren." *Qraçao.* 19 Nov.
2012. Web. http://www.qracao.com/index.php/ouder/4056-acteurs-tula-the-revolt
-geven-workshop-acteren. 16 Feb. 2015.

Gilsing, Dick. "*Tula: The Revolt*—recensie." *Movie Scene.* 3 July 2013. Web. http://www
.moviescene.nl/p/148126/tula_the_revolt_-_recensie. 30 Dec. 2014.

Glissant, Édouard. *Caribbean Discourse: Selected Essays.* Translated by J. Michael Dash,
Charlottesville: UP of Virginia, 1989. Print.

Gran Torino. Dir. Clint Eastwood. Warner Bros. Pictures, 2008. Film.

The Help. Dir. Tate Taylor. Walt Disney Studios, 2011. Film.

Hendrichs, Hendrick. "A Children's Book and a Soap Opera as Public History? Two
Dutch Films on Slavery." *The Public Historian,* vol. 36, no. 2, 2014, pp. 117–21. Print.

Hira, Sandew. "Tula de mislukking." *Antillians Dagblad.* 24 Jul. 2013. Web. http://www
.antilliaansdagblad.com/index.php/Curaçao/opinie/7149-tula-de-mislukking.
6 Jan. 2015.

Hofland, Steffan. "Tula: The Revolt." 3 Jul. 2013. Web. http://www.filmtotaal.nl
/recensie.php?id=31941. 28 May 2015.

Hoyer, Willem. *A Brief Historical Description of the Island of Curaçao*. Willemstad: n.p., 1947. Print.

Hughey, Matthew W. *The White Savior Film: Content, Critics, and Consumption*. Philadelphia: Temple UP, 2014. Print.

Jeroen Leinders Film Director. Web. 10 Apr. 2015. http://www.jeroenleinders.com/

Jeroen Leinders's Videos. Web. 25 Jun. 2015. https://vimeo.com/user6184880/videos

Kleinmoedig, Mario. "Tula Rewritten." *Amigoe*. 29 Jul. 2013. Web. http://www.amigoe .com/ingezonden/30-ingezonden/159215-tula-rewritten. 7 Jan. 2015.

Morrison, Toni. *Home*. New York: Alfred A. Knopf, 2012. Print.

The North Star. Dir. Thomas K. Phillips. Luckpig Pictures, 2015. Film.

Oostindie, Gert. *Postcolonial Netherlands: Sixty-five Years of Forgetting, Commemorating, Silencing*. Amsterdam: Amsterdam UP, 2012. Print.

———. "Slave resistance, colour lines, and the impact of the French and Haitian Revolutions in Curaçao." *Curaçao in the Age of Revolutions, 1795–1800*, edited by Wim Klooster and Gert Oostindie. Leiden: KITLV Press, 2011, pp. 1–22. Print.

Ortiz, Fernando. *Contrapunteo cubano del tabaco y el azúcar*. Caracas: Ayacucho, 1978. Print.

Ostiana, Jermain. "*Tula* Will Decolonize Curaçao Cinematography." 15 Aug. 2011. Web. https://triunfodisablika.wordpress.com/2011/08/15/tula-will-decolonize -Curaçao-cinematography/. 21 Jan. 2015.

Paula, Alejandro F. *From Objective to Subjective Barriers: A Historico-Philosophical Analysis of Certain Negative Attitudes Among the Negroid Population of Curaçao*. Willemstad: Curaçaosche Courant, 1967. Print.

"P.V.V.: Press Charges Against Wiels." *Curaçao Chronicle*. 25 Oct. 2012. Web. http:// Curaçaochronicle.com/judicial/p-v-v-press-charges-against-wiels/. 22 Dec. 2014.

"Q&A with Jeroen Leinders the Director of Tula—The Revolt." *Hope Road Publishing*. 1 Sep. 2013. Web. https://hoperoadpublishing.wordpress.com/2013/09/01/qa-with -jeroen-leinders-the-director-of-tula-the-revolt/. 8 Dec. 2015.

Roos, Ilja. "'Tene Tula na Kòrsou.'" *Versgeperst*. 17 Apr. 2012. Web. http://www.versge perst.com/lifestyle/151437/%E2%80%98tene-tula-na-korsou%E2%80%99.html. 21 Jan. 2015.

Rupert, Linda M. *Creolization and Contraband: Curaçao in the Early Modern Atlantic World*. Athens, GA: UP of Georgia, 2012. Print.

Russ, Elizabeth. *The Plantation in the Postslavery Imagination*. Oxford: Oxford UP, 2009. Print.

"Schotte: The People Want Me." *Curaçao Chronicle*. 15 Oct. 2012. Web. http:// Curaçaochronicle.com/politics/schotte-the-people-want-me/. 27 Dec. 2014.

Sens, Angelie. " Curaçao Slave Revolt (1795)." *The Historical Encyclopedia of World Slavery* Vol. 1, edited by Junius P. Rodriguez. Santa Barbara, CA: ABC-CLIO, 1997, pp. 204–5. Print.

Sulvaran, Glenn. "Tula the Revolt movie. E konseheronan di Jardim a yega na un bon akuerdo ku e management i donjonan di The Cinemas. Kier men ku e kos ta bai

door. Den siman ku ta bin nos lo informa pueblo riba e detayesnan e.o. dianan di funshon, orarionan i unda por bai tuma e karchinan Mi kier a yama publikamente danki na Minister Jardim, su konseheronan, The Cinemas i tur ku a apoya e inishativa." *Facebook.* 20 Jul. 2013. Web. https://www.facebook.com/glenn.sulvaran /posts/695240830490844?fref=nf. 12 Jun. 2015.

Thomas, Otti. "Leinders verdedigt 'zijn' Tula." *Knipselkrant Curaçao.* 6 Aug. 2013. Web. 21 Jan. 2015. http://www.kkCuraçao.info/?p=33837

Tula: The Revolt. Dir. Jeroen. Fisheye Feature Films, 2013. Film.

"Tula The Revolt—Black History Month." Web. 20 May 2015. http://nyadiff.org /tula-the-revolt-black-history-month/

Tula The Revolt—Facebook Page. Web. 30 Aug. 2017. https://www.facebook.com/Tula .TheRevolt/?fref=nf

Tula The Revolt—Home. Web. 21 Jan. 2015. http://www.tulathemovie.com/home/

12 Years a Slave. Dir. Steve McQueen. Fox Searchlight Pictures, 2013. Film.

Voor Een Miljoen Kunnen Wij Het Doen. Web. 20 May 2015. http://www.vooreen miljoenkunnenwehetdoen.nl/

Young, Robert. *Postcolonialism: An Historical Introduction.* Oxford: Blackwell Publishers, 2001. Print.

This Film Called My Back

Black Pain and Painful History in *12 Years a Slave*

Janell Hobson

> It never looked as terrible as it
> was and it made her wonder
> if hell was a pretty place too.
> Fire and brimstone all right,
> but hidden in lacy groves.

—TONI MORRISON, *BELOVED* (1987)

In Toni Morrison's *Beloved*, the main character Sethe recalls the glorious splendor of the trees on Sweet Home, the farm where she spent time as a slave, even if she could not recollect the faces of the men hanging from those trees. This vivid "rememory" echoes cinematically in Steve McQueen's film *12 Years a Slave* (2013) far more astutely than was captured in the Oprah Winfrey–produced and Jonathan Demme–directed 1998 film adaptation of *Beloved*. Whereas Beloved-the-film sought to recreate the surface-level narrative of the novel, McQueen's film instead plunges to the depths of black pain and trauma, thus becoming the cinematic version of the "unspeakable" subtext of Beloved-the-novel. In filming the "unwatchable," McQueen explodes the subtlety of Morrison's language—which functions much like a "lacy grove" hiding the grotesque scene of lynching—by producing stark and harrowing visuals. Fire and brimstone all right, a "pretty place" sure enough, but the gruesome scene[s] will be candid.

Undeniably, McQueen dwells on the scene of hell and refuses to look away (meaning we, the audience, cannot look away). In one unforgettable scene, he focuses his shot on Solomon Northup (played brilliantly by Chiwetel Ejiofor) hanging all day from one of those gorgeous trees, barely standing on the tips of his toes to keep himself alive, all while the moss in the trees glides in the Southern breeze and the enslaved and enslavers go about their daily routines. After all, this punishment is "routine" for those African Americans who dared to assert their humanity.

I had the privilege of viewing this much-acclaimed film before its wider release. Adapted from Solomon Northup's 1853 narrative of his experiences as a free black man kidnapped from Saratoga, New York in 1841, when he is drugged and later sold away from his family as a slave in Louisiana, the screening for this film that I attended was part of a fundraising event for our local Underground Railroad History organization in upstate New York, with Northup's descendants in attendance. This is definitely a film to be experienced in community.

Before his film's premiere, McQueen exhibited an artistic photograph, "Lynching Tree," featured as the backdrop to Kanye West's "Blood on the Leaves" performance at the 2013 MTV Video Music Awards show. This popular-culture framing of McQueen's art, placed in the context of West's own commentary on "New Slaves" for his 2013 album *Yeezus*, with his remix of Nina Simone's rendition of Billie Holiday's anti-lynching song "Strange Fruit," highlights how contemporary racial politics are mired in the history of chattel slavery and Jim Crow racism. We keep harking back to the same racial hurt because we have not dealt with that historical trauma. Or, when we do, we often rely on sentimentality—with the cinematic examples of *The Birth of a Nation* (1915) and *Gone with the Wind* (1939)—or on satire, as more recently dramatized in Quentin Tarantino's 2012 film *Django Unchained* and in the unfortunate launching of Russell Simmons' *All Def Digital* YouTube channel with the universally panned and later removed "Harriet Tubman Sex Tape" (All Def Digital 2013).

With such controversial and hyperbolic narratives revisiting chattel slavery, the timing for a more serious engagement with the issue came in the form of McQueen's adaptation of Solomon Northup's slave narrative, premiering—just one month after the Tubman sex tape scandal—at the 2013 Toronto Film Festival and subsequently winning its Audience Award. The myths that we have been telling ourselves about our nation's history are constantly undermined by scenes of hanged bodies, mixed-race progeny of rape and centuries of exploited-labor-turned-commodity. Perhaps more than in any other film, McQueen details the

unending toil of cane-cutting, tree-chopping, and cotton-picking. This is the nation literally built on the whipped and tortured backs of bondspeople.

Despite these historical truths, there is still an over-reliance on what Saidiya V. Hartman calls "scenes of subjection," or the "constitution of blackness as an abject and degraded condition" (Hartman 22), which necessarily aggrandizes the narrative of black pain and suffering. While we might recognize the anti-slavery political impetus for such narratives during the mid-nineteenth-century era—not just in Northup's but also in the bestselling novel *Uncle Tom's Cabin*, which debuted the year before his (and to which he dedicated his own narrative to its author Harriet Beecher Stowe), as well as in the tropes of black suffering, from Frederick Douglass's whipped female relatives in his 1848 narrative to the 1863 photograph of Gordon, "a typical Negro," whose scarred back in *Harper's Weekly* became iconic—we may well ask what the political apparatus might be for a film in our own millennial era when we reproduce these visual and literary tropes to address our own contemporary problems with race and racism. In the so-called "postracial" era of the United States, under the presidency of a black man, Barack Obama, what is the effect of having a film like *12 Years a Slave*, and do we get new narratives about history, about black pain and suffering, or even about the possibility of black representations in cinema? This is the central question guiding my critique in the subsequent pages.

THE FILM "NO ONE WAS MAKING"

With more than 200 slave narratives in existence in our cultural history, it is astounding that Solomon Northup's is the first to receive big-screen adaptation. Granted, Northup's story had already received small-screen treatment with Gordon Parks' 1984 *Solomon Northup's Odyssey*, featured on PBS's American Playhouse. However, the way McQueen tells it, his film was the one that "no one was making . . . it's one of those things where there's just a huge hole in the canon of cinema" (quoted in NPR News 2013). Such commentary seems to ignore cinema's routine treatment of chattel slavery; after all, even more recently than the early period in cinema of revisionist Southern history, and the blaxploitation-era of 1970s films like *Mandingo*, are the late-twentieth-century films as seen in such melodramatic Hollywood fare as Steven Spielberg's 1997 *Amistad* or in the black nationalist sensibilities of Haile Gerima's time-travel magical realism in his 1994 independent film *Sankofa*. Additionally, there is the aforementioned satirical *Django Unchained*, which premiered a year before *12 Years a Slave*. However, when McQueen states that "no one was making a film"

on slavery, he more than likely is referring to the lack of realist storytelling that he offers so candidly in his film adaptation on the topic.

We are perhaps fortunate to have McQueen's honest eye and take-no-prisoners approach to filmmaking on this subject, not to mention the willingness of Brad Pitt, doubling as "white savior" in both his minimal role in the film and his role as a film producer, to finance it. Moreover, as McQueen confided to Henry Louis Gates, Jr. (the literary historian with whom he consulted on the story), his film "wouldn't have been made if Obama wasn't president" (Gates 2013). McQueen's comments are not unlike Hollywood studio chief Harvey Weinstein's remarks on an "Obama effect" in cinema, which references the presence of an African American president who is presumably "erasing racial lines" (Waxman 2013). That McQueen also shares in this cinematic and political optimism reinforces the ways that such symbolic representations are given more weight over the realities of racial and economic oppression that still shape the lives of African Americans—from state violence and police brutality to housing and educational discrimination to mass incarcerations. The "success" of a black film like *12 Years a Slave* winning a Best Picture Academy Award, along with the success of having an African American in the White House, recalls what Patricia Hill Collins terms the "politics of containment," which relies on the hypervisibility of successful African Americans "to generate the *invisibility* of exclusionary practices" (Collins 1998, 14; emphasis in original).

Indeed, some critics have faulted *12 Years a Slave* for advancing a particularly individualist storyline—in which Northup develops tunnel vision, focused solely on his survival while ignoring the tragic fates of other slaves around him: most notably enslaved women like Eliza and Patsey, whose characterizations will be discussed further. As writer Kirsten West Savali lamented, the film *12 Years a Slave* may have pushed this individualist perspective because its screenwriter John Ridley advances individual success over collective freedoms, best reflected when he infamously wrote a self-loathing critique of African Americans in a manifesto that blamed racial ills on individual behaviors versus systemic racism. Criticizing the rewriting of Northup, Savali suggests the following:

> Solomon Northup became an abolitionist who risked his life to free others still bound by slavery. Ridley had a different vision, whereupon Solomon's story ended when he was saved by white men. His story ended when he jumped into the back of the carriage, leaving behind the filth and grime of the "niggers" on the plantation—each mile putting more distance between him and the unrelenting carnage. For

Ridley, once Northup was safely ensconced in the bosom of respect-
ability, it was time for the credits to roll. (Savali 2014)

Certainly, Savali and others seeking particular political narratives on racial justice would treat with suspicion any film on slavery that is critically acclaimed and meets with little controversy from a white-majority institution like the Academy of Motion Picture Arts and Sciences. After all, McQueen downplayed any specific parallels between the history of chattel slavery and the contemporary scene. One exception occurred during his Oscar Best Picture acceptance speech in 2014, when he reminded audiences of the issue of "modern-day slavery," a label used to describe the global phenomenon of human trafficking. Interestingly, some feminists debate the usefulness of the term "slavery" to qualify sex work and sex trafficking, which obfuscates the complex choices that women make when engaging in mobility and "illicit" sexualities, as such scholars as Kamala Kempadoo, Mireille Miller-Young, and Erica Lorraine Williams have argued when addressing issues of black women in the global sex industry. However, in the context of McQueen advancing this contemporary parallel with *12 Years a Slave* he can obscure the racial politics of both the past and the present by instead reframing his film for a "universal" narrative. This is worth considering when comparing the reception of his film to Ava DuVernay's *Selma* the following year. DuVernay, by contrast, failed to receive the same accolades with her politically astute *Selma*, which unequivocally referenced the current Black Lives Matter movement (both on-screen and during post-film promotion) while also shifting the focus from the individual heroism of Dr. Martin Luther King, Jr. to collective freedom struggle with her inclusion of various actors in the Civil Rights movement.

Despite these different responses, we might recognize that, for McQueen, the particulars of certain racial cultural shifts and economic opportunities—including Pitt's production company, Plan B, expressing interest in McQueen after seeing his first film, *Hunger*—aligned at the right time. Indeed, as a film auteur with only two previous feature films, McQueen had already carved out a particular directorial approach to his films—precise, unflinching, and fixated on the body in pain. His first film, *Hunger* (2008), focused on IRA prisoner Bobby Sands (portrayed by Michael Fassbender, an actor who appears in all of McQueen's films) who carried out a hunger strike at Britain's Maze prison in 1981. Interestingly, his second film from 2011, *Shame* also starring Fassbender, might seem to focus us on the opposite of the body in pain—the body in pleasure—yet, the protagonist's struggle with sex addiction is given similar treatment: the body is pushed to its limits (or excesses) as it undergoes severe punishment while it struggles for control, a battle it ultimately loses.

However, in *12 Years a Slave*, Northup's body is completely stripped of any attempts at political resistance (as with Bobby Sands's starving body) or self-destructive impulses (as with the sex addiction portrayed in *Shame*). All destructive forces on the body are external, and—slowly but surely—we understand the process of dehumanization as we watch freeman Northup descend slowly into the appalling conditions of slavery, from being chained, whipped, and caged, to being sold at auction to narrowly escaping lynching. While en route by riverboat to Louisiana, Northup learns from the other enslaved men what it means to resist (fight back and lose one's life, as occurs with Robert, a character [played by Michael Kenneth Williams] who is quite literally chomping at the bit to fight his oppressors) or survive via submission (as the character Clemens [played by Chris Chalk] strongly advises before he visually demonstrates to a stunned Northup how to play a childlike "Sambo" in the presence of his master). The humiliation of slavery will be unwatchable, and yet McQueen's camera unflinchingly bears witness to this "unspeakable" history—as Morrison has described it. Scenes of mutilated naked bodies on display at auction, along with the violent ripping apart of Eliza's family, whose children are sold away, unfold as if we were watching a horror story, and we the audience, like Northup, experience his enslavement as a culture shock.

WOMAN, THY NAME IS "PATHOS"

If the enslaved men teach Northup to "keep his head down" in order to survive, the enslaved women of this story seem to exist as his emotional catharsis, as a conduit in which to externalize his sufferings. In one of the few scathing reviews against *12 Years a Slave*, film critic Armond White derisively suggested the long-suffering enslaved character Patsey (played by newcomer Lupita Nyong'o in what would become her Oscar-winning role) should instead be called "Pathos," in what he viewed as a film that reduces its women to "human whipping posts—beaten, humiliated, raped for our delectation" (White 2013). However, as biting as this review seems to be, there is a kernel of truth that can be gleaned here. His critique is not unlike bell hooks's who takes black male filmmakers to task for their failure of imagination when telling a black woman's story in slavery (cited in Obenson 2013).

Hooks was similarly critical of Gerima's *Sankofa*, where the heroine in that film is also subjected to physical and sexual violence—branded, whipped, stripped, and raped (hooks 1996, 128). *Sankofa* opens with this character oblivious to the history of the slave trade, posing as a fashion model for a white photographer on the Cape Coast Castle of Ghana, before she ventures through one of

the "doors of no return," suddenly transported back to the past and reminded of her historical slave status. Before our heroine in *Sankofa* can amend her ways in the present day, she is severely punished in the past for daring to conform to (and seek sexual and aesthetic affirmation from) a white male gaze. Instead she is disciplined by the filmmaker's black nationalist male gaze.

However, McQueen's politics are by no means rendered in the same limited nationalistic lens; indeed, he must be given credit for including women's stories, which are given as much screen time alongside Northup's in an attempt to offer a holistic view of the collective slave experience. The women of *12 Years a Slave* also happen to be the most interesting characters in the story. This may be due to the film's links to the conventions of the slave narrative, conventions that highlighted the brutalities of slavery through the black female body; audiences then and now seem more comfortable with abject suffering visited upon women. The slave mother Eliza (played by Adepero Oduye) is inconsolable when she is separated from her children on the slave market, and Patsey is preyed upon by an obsessive batterer, Edwin Epps, Northup's second owner (portrayed chillingly by Michael Fassbender). Epps's behavior is a classic study of sexual violence and power, from the way he routinely violates the personal spaces of his slaves—which includes waking them up from their beds at night to dance for him—to the way he threateningly sneaks into a slave's room or, worse, coddles a little slave girl while walking around shamelessly without pants. This violence, ingrained in sexuality, shapes the enslaved woman's experience in this narrative, so we have the abject victim represented by Patsey, whose excruciatingly lengthy whipping scene serves as the climax to this draining visitation of the dark ordeal of our collective history.

There are subtle moments of resistance, captured in Eliza's refusal to stop wailing for her lost children; in Mistress Shaw (Alfre Woodard), the black mistress of a plantation owner who has capitalized on her being "favored" by her master; or even in Patsey refusing to play the sexual temptress for Epps. However, I found myself wanting more of these subtleties. I am struck by the story of Patsey, who is "prized" by Epps. As stated earlier, many of the slave narratives, written or dictated by formerly enslaved African American men, highlight the utter sufferings of black women. I think of this especially in the way film audiences were audibly sobbing during the climactic scene in which Patsey is excoriated in the unbearably long whipping scene. Her punishment is for daring to leave the plantation without Epps's knowledge, an action that emerged from a simple desire to keep her body clean: she borrows some soap from Mistress Shaw on the neighboring plantation since Epps's wife (portrayed icily by Sarah Paulson), out of jealousy, had deprived her of these basic neces-

sities. Despite Patsey finding "favor" from her owner (if we want to categorize *rape* as such), despite her ability to out-pick any other enslaved worker when it comes to daily pulling in "500 pounds of cotton," there is no safety for being a "good worker" or "finding favor" in the enslaver's eye. To drive this point further, McQueen's camera redirects us to the piece of soap that caused such grave injustice. Patsey's back becomes the foundation on which to comprehend black suffering. She is literally "this bridge called my back," to recall that edited collection by Gloria Anzaldúa and Cherríe Moraga, linking us back to an unspeakable and unwatchable past.

If we believe Northup's narrative, Patsey was an actual woman who presumably existed and who did not escape from slavery—unless she lived long enough to be emancipated (the story ends with Northup's rescue from slavery in 1853, just ten years prior to the Emancipation Proclamation). It is possible to interpret Northup's published narrative as part of the longer battle to end slavery, which ultimately occurred with the Thirteenth Amendment and which could have had the effect of eventually rescuing enslaved subjects like Patsey. However, within the cinematic story, Patsey, along with Eliza and Mistress Shaw, are juxtaposed against the dichotomous portrayals of both Northup's wife—who encapsulates respectable free black womanhood—and the unnamed, light-skinned slave woman who appears in the film's opening scene, as she assertively initiates a sex act with Northup sleeping next to her, before she disappears altogether from the story. During post-screening discussions, certain audience members expressed discomfort and discomfiting interpretations about this scene. Solomon is quite reluctant but eventually complies, bringing temporary relief for the woman and heartbreaking sadness for Solomon, who then flashes back to his earlier life with his wife and children back in Saratoga, before he was kidnapped into slavery.

What for me was a scene that McQueen created to capture these bonded people's deepest (and most human) cravings for love and desire, others in the audience saw as a perpetuation of black sexual stereotypes. One audience member, invested in preserving Northup's legacy, was offended that this scene would be included since it undermined what to her was the "truth" of Solomon's fidelity to his wife. Another audience member thought it was significant that the woman in the scene was a "mulatto," thereby suggesting the stereotype of the lighter-skinned black woman as "sexual temptress" for both the white and black man. The public forum, in which silence greeted both statements, certainly indicated our reluctance to discuss sexual politics or to challenge respectability politics.

Perhaps this is why no one discussed the rape scene between Epps and Patsey, a scene that was mostly framed through the extreme close-up shot on Epps's orgasmic yet pained face, while we barely see Patsey's own facial expression, except

at the end when she is laid bare like a lifeless doll. We certainly get no close-up on Patsey. Indeed, the focal point for much of Patsey's suffering—including the infamous whipping scene—is on her body, from scarred back to disfigured eye (at the hands of her mistress). Patsey's body is the object of our horror and pity, while her internal reflections remain hidden.

VIOLENT RECOVERIES, EROTIC (IM)POSSIBILITIES

As brilliant as this film is, and as important as it was for both McQueen and screenwriter John Ridley to include Patsey's story alongside Solomon's, I find it curious that McQueen did not delve further into their intimate lives (nor are the other bondspeople given much of a voice except through songs). What if McQueen had taken artistic license and inserted a "romance" between Patsey and Solomon, for instance, even if only to create desire, love, intimacy—necessary emotions to contest dehumanization? What if Patsey had been that unnamed woman in the opening sex scene? Could she have later emerged as the martyred heroine that she quickly became in post-film discussions?

Patsey does not desire Edwin Epps, and in maintaining a platonic relation-ship with Solomon, she transcends "sexual temptress" status by serving only as Epps's victim. What sexual agency does Patsey have, or Solomon for that matter? What does Solomon's "fidelity" to his wife mean in a system where neither en-slaved women nor men controlled their own sexuality, where their owners could couple and separate lovers on a whim? Where, indeed, Epps—who was ready to battle Solomon like a bull territorializing his sexual ownership over Patsey because Solomon exchanged more than two words with her—would obsessively undermine such a budding romance, if they were so inclined. Would such a "romance" represent resistance if they did pursue it, or would we—the audi-ence—also be invested in respectability politics: in which we demand Solomon Northup's faithfulness to his wife, despite his twelve-year-absence from her, and in which we demand Patsey's sexual virtue?

In maintaining a faithful adaptation of Northup's narrative, McQueen missed some fruitful developments of subtext that a Victorian moral sensibility muted; a contemporary artist needed to fill in the gaps and silences of a narrative that Northup produced under the white abolitionist gaze and out of respect for his family. Because of this, we still encounter simplistic divides between an unpreju-diced "Free North" and a racially oppressive "Slave South," along with virtuous heroes and martyrs. The film is extremely stark and powerful, but outside of the brutal picture of slavery, McQueen needed to dig deeper into the interior lives of bondswomen and men. Patsey's story still needs to be more fully realized: where

she is more than an abject victim and a woman with agency enough to carve out her own path for survival. Her characterization is of sheer passivity, so much so that viewers project onto her stoic resistance and emotional suffering. I think of this when comparing her to the other enslaved women in the story—the unnamed woman, Eliza, and Mistress Shaw—the latter two who admit complicity in their sexualized roles as mistresses to their white slaveowners.

Eliza and Mistress Shaw are fascinatingly more complex in their roles, but it is Patsey that we remember. I want to suggest that we remember Patsey, not so much because Nyong'o's performance is stronger but because her sexuality is more *legible* to us. Nineteenth-century stereotypes and narratives have passed down to contemporary audiences two basic tropes of enslaved black female sexuality: the Jezebel and the Rape Victim, which are part of the larger "Controlling Images" that Collins references as integral to the systemic framework of stereotypes used to control black women's lives (Collins 1990). Since neither Eliza nor Mistress Shaw fits neatly into the hypersexual and "lascivious" label (as slaveowners and traders often mislabeled enslaved women), they are less recognizable to us, in the way that Patsey the rape victim is. Indeed, the sexual violence visited upon her body positions her within a politics of respectability since she is devoid of sexual desire. And it is this respectability that propels Nyong'o forward from slavery film role to red-carpet fashion queen and gracious Oscar award winner.

Had McQueen filmed the rape scene with Epps in such a way that allowed Patsey to evoke even a quiver of pleasure, her character would have become *illegible* to us, and perhaps talk of awards and acclaim (not to mention the audience response) might have taken a different turn. I say this, not to erase the historical reality of slave rape, but considering how both McQueen and Fassbender spoke of the rape scene in the context of Edwin's complex "love" for Patsey (George 2013; Vineyard 2013), we must question why Patsey was not afforded the same complexity and agency—and reducing Patsey to "she was a slave" is not a compelling answer. This merely speaks to what Sharon P. Holland has observed as the treatment of "nearly three hundred years of chattel slavery in the Americas as a historical volume unworthy of sexuality's theorizing" (Holland 2011, 92).

While Holland specifically critiques here the relative absence of queer theories on sexual histories during this era, other scholars such as Omise'eke Natasha Tinsley mobilize black queer imaginings at the origins of chattel slavery—on the slave ship itself—where "Africans became fluid bodies under the force of brutality. Tightly or loosely packed in sex-segregated holds ... unnamed rebellions took place not in violent but *erotic* resistance, in interpersonal relationships enslaved Africans formed with those imprisoned or oozing beside them" (Tinsley 197–98; emphasis in original). This historical description of tightly packed bodies forming

erotic bonds on slave ships is not unlike the opening scene of Solomon Northup and the unnamed woman, thus suggesting McQueen's interest in "theorizing sexuality." However, this woman's subsequent disappearance, along with Patsey's under-developed sexual narrative, leaves us with an unfinished portrait of black female sexual subjectivity.

In their work on enslaved women's histories, Treva B. Lindsey and Jessica Marie Johnson suggest that we place black female sexuality at the center of our methodologies if we are to rediscover fully fleshed-out human beings with erotic lives, feelings, and agency. As they argue, "To find intimate encounters beyond the dialogic of slave-owner power is to envision enslaved and free black female sexuality as a thing beyond the Encounter, *a thing belonging to itself*" (Lindsey and Johnson 180; emphasis in original). This is in keeping with what Hortense Spillers identifies as the silence on black female sexuality in which our "New World, diasporic plight marked the *theft of the body*—a willful and violent . . . severing of the captive body from its motive will, its active desire" (Spillers 67; emphasis in original). Even then, given the work of feminist historians in repositioning enslaved women beyond the hypersexual label and in exposing the institutional practice of sexual violence in slavery, just showing a quiver of pleasure could set us back hundreds of years. The dilemma presents itself: to experience pleasure is to erase the realities of institutionalized sexual violence in chattel slavery, perhaps even to minimize what Angela Y. Davis characterizes as "the terroristic use of rape" by slave owners to "remind the women of their essential and inalterable femaleness" (Davis 24). However, to experience only rape and suffering is to reproduce the abject victim, the woman as "pathos," as object, as chattel and property. Somewhere in this history is a more complex rendering and understanding of black female sexuality—one that necessarily exists beyond Northup's narrative and McQueen's film.

Despite these limitations, McQueen must be commended for daring to present these issues—black pain and suffering, sexual violence, near-lynching—in a film on chattel slavery. *12 Years a Slave* especially serves as a counter-narrative to the softened and romanticized narratives that previously existed in cinema. Even the casting of darker-skinned Lupita Nyong'o presents a significant challenge to the standard trope of the Jezebel/Rape Victim as only embodying lighter-skinned or mixed-race black womanhood in interracial sexual encounters.

Such cultural shifts in cinema are sometimes overlooked in wider debates about racial politics and representations in media. For instance, it was not lost on some that, seventy-five years after Hattie McDaniel became the first African American to win a Best Supporting Actress Oscar, Lupita Nyong'o would become the sixth black woman to win that same Oscar—and for playing the same

type of role as McDaniel, a slave. If we juxtapose McDaniel's Mammy in *Gone with the Wind* alongside Nyong'o's Patsey, however, we might realize that, apart from being slaves, their characters are nothing alike. Indeed, from a historical and cinematic context, Mammy, a different "controlling image," is the mask that pro-slavery apologists used to erase the existence of the Patseys in slavery. Such stereotypes conveniently negated the prevalence of sexual violence in chattel slavery through an emphasis on a desexualized and defeminized figure whose loyal devotion to her white slave-owning family cemented her inferior status in this raced, classed, and sexual economy.

12 Years a Slave removes the masks from *Gone with the Wind*, and we recognize this through the very different depictions of Mammy and Patsey. We can instead bask in the afterglow of Lupita Nyong'o's Oscar win—the climax to a whirlwind awards season in which we witnessed Nyong'o's transformation "up from slavery" to red-carpet fashion and beauty icon for darker-skinned women, her coloring once negated by caricatures of Mammy. We might call this cinematic progress, which is a mere glimpse into a painful history that technicolor tried to distort and which we can now watch with the realism that McQueen insisted was needed to fill in the gaps of cinema.

CONCLUSION: TOWARD A BLACK ATLANTIC NEO-SLAVE NARRATIVE

More than attempting to redress the "huge hole" in cinematic history, Steve McQueen, who developed his technical skills first as a video artist, provides us with a unique artistic vision of black pain and suffering, one that does not obscure or repress its visualization. The gaps in cinema are best represented by those films which often sentimentalize or suppress the subject of chattel slavery for the greater narrative of rescuing the innate goodness of whites or the project of American democracy. Both concepts are fundamentally flawed when slavery raises its horrific and ugly head and casts its long, eerie shadow onto history. Perhaps because he is an Afro-British subject McQueen has no investment in the great American myth; as such, he can present the subject more honestly and candidly than was previously attempted in the annals of American cinematic history. Even then, the issue of nationality became a source of contention when it was revealed that not only is McQueen not African American but neither is the film's star, Ejiofor, who also hails from Britain via Nigeria, nor its rising star Lupita Nyong'o, who hails from Kenya via Mexico. Still, as McQueen flippantly remarked, "The only thing between us and African-Americans is my boat went one way and theirs went another" (quoted in Weiner 2014).

Here, McQueen invokes the African Diaspora, or more specifically the Black Atlantic that fellow Afro-Brit Paul Gilroy uses to "show that there are other claims . . . which can be based on the structure of the African diaspora into the western hemisphere" (Gilroy 15). Specifically alluding to the "slave ship" as the Atlantic-based disruption of our geographical locations and national identities, McQueen, like Gilroy, gestures less to a "universal" story and more toward a transnational approach to blackness by claiming the specifically African American history represented by Northup's narrative for a wider, more diasporic realm. Indeed, *12 Years a Slave* offers another layer in its reframing as a neo-slave narrative when interpreted in a transnational context. Referencing the casting of Nyong'o in an interview, Nigerian novelist Chimamanda Ngozi Adichie opined: "But if we're going to say, well, Lupita is Kenyan and so she can't play an African American, I'm thinking: The slave woman she's playing probably looked exactly like Lupita. Of course, these conversations are political; they're not about performance or art" (quoted in Hobson 2014). What Adichie points to here is the original African story of African American slavery, as Patsey—according to Northup's 1853 narrative—is supposed to be the daughter of a slave-ship African. Erasing national differences to assert the origins of the African Diaspora, even these casting choices complicate *12 Years a Slave* as a uniquely "African American" text.

In essence, *12 Years a Slave* is more than a film adaptation of an 1853 slave narrative. It is very much a millennial neo-slave narrative of our contemporary era, reflecting a filmmaker's artistic vision of the black body in pain without sentimentality or white supremacist apologia. It is also necessarily a transnational or Black Atlantic film that transcends its African American textual origins, even though it reproduces some of the same gendered and racialized trappings of a narrative composed specifically for an antislavery political agenda, while resurrected for a contemporary "postracial" society still struggling with issues of race and racism, as well as their intersections with sexuality and nationality.

Let us hope that *12 Years a Slave*, as superb as are its cinematography, direction, performances, and editing, is not the final word on slavery in cinema. If anything, McQueen has thrown down the gauntlet, inviting many of us to revisit the subject, confront our historical trauma, and heal from it. Toni Morrison may have hinted at the trauma in *Beloved*, but *12 Years a Slave* has the temerity to witness it candidly, and boldly calls on us to do the same.

Works Cited

All Def Digital. "Harriet Tubman Sex Tape." 2013. No Longer Available. http://www .youtube.com/user/AllDefDigital 14 Aug. 2013.

Amistad. Dir. Steven Spielberg. Distributed by Dreamworks, 1997.

Anzaldúa, Gloria, and Cherríe Moraga, eds. *This Bridge Called My Back: Writings by Radical Women of Color.* New York: Kitchen Table Women of Color Press, 1982. Print.

The Birth of a Nation. Dir. D. W. Griffith. Distributed by David W. Griffith Corps, 1915.

Collins, Patricia Hill. *Black Feminist Thought: Knowledge, Consciousness, and the Politics of Empowerment.* New York: Routledge, 1990. Print.

———. *Fighting Words: Black Women and the Search for Justice.* Minneapolis: University of Minnesota Press, 1998. Print.

Davis, Angela Y. *Women, Race, & Class.* New York: Random House, 1981. Print.

Django Unchained. Dir. Quentin Tarantino. Perf. Jamie Foxx, Christoph Waltz, Kerry Washington, and Leonardo DiCaprio. Distributed by The Weinstein Company, 2012.

Douglass, Frederick. *Narrative of the Life of Frederick Douglass.* New York: Library of America, 2014 (1848). Print.

Gates, Henry Louis, Jr. "Steve McQueen and Henry Louis Gates Jr. Talk *12 Years a Slave.*" *The Root.* http://www.theroot.com/articles/culture/2013/12/_12_years_a _slave_henry_louis_gates_jr_interviews_director_steve_mcqueen.html. 24 Dec. 2013.

George, Nelson. "An Essentially American Narrative: A Discussion of Steve McQueen's '12 Years a Slave.'" *New York Times.* 11 Oct. 2013.http://www.nytimes.com/2013/10/13 /movies/a-discussion-of-steve-mcqueens-film-12-years-a-slave.html?_r=0

Gilroy, Paul. *The Black Atlantic: Modernity and Double Consciousness.* Cambridge: Harvard University Press, 1993. Print.

Gone with the Wind. Dir. Victor Fleming. Perf. Vivien Leigh, Clark Gable, Hattie McDaniel. Distributed by MGM Studios, 1939. Print.

Hartman, Saidiya. *Scenes of Subjection: Terror, Slavery, and Self-Making in Nineteenth-Century America.* New York: Oxford University Press, 1997. Print.

Hobson, Janell. "Storyteller: A *Ms.* Conversation with Chimamanda Ngozi Adichie." *Ms.*, Summer 2014, pp. 26–29. Print.

Holland, Sharon P. "The 'Beached Whale.'" *GLQ: A Journal of Lesbian and Gay Studies,* vol. 17, no. 1, 2011, pp. 89–95. Print.

hooks, bell. *Reel to Real: Race, Sex, and Class at the Movies.* New York: Routledge, 1996. Print.

Hunger. Dir. Steve McQueen. Distributed by Channel Four Film, 2008.

Kempadoo, Kamala. "Women of Color and the Global Sex Trade: Transnational Feminist Perspectives." *Meridians: Feminism, Race, Transnationalism,* vol. 1, no. 2, 2001, pp. 28–51. Print.

Lindsey, Treva B., and Jessica Marie Johnson. "Searching for Climax: Black Erotic Lives in Slavery and Freedom." *Meridians,* vol. 12, no. 2, 2014, pp. 169–95. Print.

Mandingo. Dir. Richard Fleischer. Distributed by Paramount Pictures, 1975.

Miller-Young, Mireille. *A Taste for Brown Sugar: Black Women in Pornography.* Durham: Duke University Press, 2014. Print.

Morrison, Toni. *Beloved.* New York: Alfred A. Knopf, 1987. Print.

Northup, Solomon. *Twelve Years a Slave.* New York: Dover Publications, Inc, 1970 (1853). Print.

NPR News. "'12 Years a Slave' was a Film 'No One Was Making'" *NPR.* 24 Oct. 2013. http://www.npr.org/2013/10/24/240288057/12-years-a-slave-was-a-film-that-no-one-was-making

Obenson, Tambay A. "bell hooks, Melissa Harris-Perry on '12 Years a Slave,' 'Beasts of the Southern Wild,' and Much More . . ." *Shadow and Act.* 8 Nov. 2013. http://blogs.indiewire.com/shadowandact/bell-hooks-melissa-harris-perry-on-12-years-a-slave-beasts-of-the-southern-wild-much-more

Sankofa. Dir. Haile Gerima. Distributed by Channel Four Films, 1993.

Savali, Kirsten West. "Oscar Winning Screenwriter John Ridley's N***er Problem." *XOJane.* 4 Mar. 2014. http://www.xojane.com/issues/oscar-winning-screenwriter-john-ridleys-ner-problem

Selma. Dir. Ava DuVernay. Distributed by Paramount Pictures, 2014.

Shame. Dir. Steve McQueen. Distributed by Channel Four Film, 2011.

Spillers, Hortense. "Mama's Baby, Papa's Maybe: An American Grammar Book." *Diacritics,* vol. 17, no. 2, 1987, pp. 65–81. Print.

Stowe, Harriet Beecher. *Uncle Tom's Cabin.* 150th anniversary edition. New York: Oxford University Press, 1998 (1852). Print.

Tinsley, Omise'eke Natasha. "Black Atlantic, Queer Atlantic: Queer Imaginings of the Middle Passage." *GLQ,* vol. 14, no. 2–3, 2008, pp. 191–15. Print.

12 Years a Slave. Dir. Steve McQueen. Perf. Chiwetel Ejiofor, Michael Fassbender, Lupita Nyong'o. Distributed by Fox Searchlight, 2013.

"A Typical Negro." *Harper's Weekly.* 4 Jul. 1863, p. 429. Print.

Vineyard, Jen. "Michael Fassbender Explains Parallels Between '12 Years a Slave' & 'Wuthering Heights,' Talks Awards and More." *The Playlist.* 18 Oct. 2013. http://blogs.indiewire.com/theplaylist/michael-fassbender-explains-parallels-between-12-years-a-slave-wuthering-heights-talks-awards-and-more-20131018

Waxman, Sharon. "Harvey Weinstein on the Rise of African-American Film: 'It's the Obama Effect.'" *The Wrap.* 10 Sep. 2013. http://www.thewrap.com/harvey-weinstein-on-rise-of-african-american-film-its-the-obama-effect-exclusive/

Weiner, Jonah. "The Liberation of Steve McQueen." *Rolling Stone.* 3 Mar. 2014. http://www.rollingstone.com/movies/news/the-liberation-of-steve-mcqueen-20140303.

West, Kanye. *Yeezus.* Distributed by Island Def Jam Recordings, 2013.

White, Armond. "Can't Trust It." *City Arts.* 16 Oct. 2013. http://cityarts.info/2013/10/16/cant-trust-it/

Williams, Erica Lorraine. *Sex Tourism in Bahia: Ambiguous Entanglements.* Chicago: University of Illinois Press, 2013. Print.

Exposed on Film

The (Un) Promised Land of Nova Scotia
in the Miniseries *The Book of Negroes*

Emily Allen Williams

The six-part miniseries *The Book of Negroes* (2015) is an extension of the historical novel (of the same name) written by Lawrence Hill and first published in Canada (HarperCollins) in 2007. At the time of its publication the work created an international debate stemming from the use of the word "Negroes" in the title. Such was the controversy that when W. W. Norton & Company, Hill's American publisher, planned to release the novel later in that same year, the editor asked for a revisionary title as it was believed American bookstores would not purchase the book with the word "Negroes" in its title (Hill, pamphlet). The novel (then) was released under the title *Someone Knows My Name* in the United States, New Zealand, and Australia. During Hill's extensive book tour, he came to witness the varied and, at times, hostile reaction to the word "Negroes" in his novel's title. Hill mentions that in the United States, Americans hearing of the original titling of the work in Canada expressed varying degrees of displeasure, while the use of the word "Negro" in the Dutch title prompted a book burning in a public park in Amsterdam.

While there was, indeed, resistance to the use of the word "Negroes" in the title of Hill's novel, it is compelling to note that the U.S. Census Bureau used the word "Negro" on its surveys and forms until 2013, when options for identification changed to "Black" and/or "African-American." In charting the progression of this nomenclature, notably, the first U.S. Census was taken in

1790 and provided accounting in *only* three categories: free white, all other free persons, and slaves. It was not until 1900 that the word "Negro" appeared on U.S. Census surveys and documents as a means of identification for people of African descent. Robert Groves, a former U.S. Census Bureau Director, wrote a blog entitled "The Word 'Negro,'" wherein he asserts that the bureau failed to conduct any research on the public's reaction to the word "Negro" in the 2000s, and, summarily, he appears to dismiss the word usage as one constituting a *serious* controversy (Groves). Looking forward to Hill's focus on Nova Scotia (Canada) in *The Book of Negroes*, the identification of people of African descent or Blacks also is problematic via the Canadian Census, which was officially started by the Canadian government in 1871, with a scant recording of 21,500 Blacks, 0.6% of the population (Milan and Tan 3). George Elliott Clarke (born in Nova Scotia, a pivotal geographical site in Hill's miniseries) contends that even in the 1991 Canadian Census 43% of African Canadians did not identify themselves as "Black" (Clarke). Thus, while the use of the word "Negro" may have been more palatable in the title of Hill's work when it was initially published in Canada, it is not owing to an early historical classification or self-identification of peoples of African descent in the Canadian landscape.

Lawrence Hill contends that he was caught off guard by the opposition to the word "Negro" in his original title because it is based on an historical document—*The Book of Negroes* (1783), a 150-page British naval ledger—of the same name. This ledger came into use as written documentation of the men, women, and children who fought for and otherwise supported the British during the conflict known as the American Revolutionary War. Despite the document's historical underpinnings, it remains rather obscure in scholarly discussions of and research on how (some) people of African descent came to Canada based upon the *promise* of freedom and land for their loyalty to the British. Of the thousands of Blacks/slaves that fled to Manhattan to support the British cause, the ledger captures the names as well as brief biographical and physical characteristics (in as many as nine columns) of 3,000 individuals who would later become known as the Black Loyalists. The information in this document served as the primary *raison d'être* in moving these loyalists to "freedom" in ships from Manhattan to Nova Scotia, Canada—their "promised" land—for their allegiance to the British. In *Blood and Belonging in The Book of Negroes*, Brian Bethune addresses this document that lay largely dormant in scholarly files for over two centuries as a "marker of promises broken" by the British government (Bethune).

Black Entertainment Television (BET) expressed an interest in financing production of a miniseries a few years after Lawrence Hill won the Rogers

Writers'Trust Fiction Prize, Commonwealth Writers' Prize for Best Book, CBC Radio's Canada Reads, and Radio-Canada's Combat des Livres for his novel. Interestingly, and despite the "Negroes" word controversy, producers decided to return to the original title for the miniseries, which led to W. W. Norton & Company re-issuing the novel as *The Book of Negroes* in the United States. The re-titling, in itself, became a type of historical moment in making readers and viewers aware of the all-but-forgotten historical document—the British naval ledger—which catalyzed Lawrence Hill's naming of the award-winning novel and miniseries. The miniseries co-director also was initially opposed to the work when it first appeared:

> Clement Virgo, probably this country's [Canada] most notable black filmmaker, was unaware of the original document, but he knew of Hill's novel—and refused to read it because, he says, "I had my own reactions to the word 'Negro.'" Once Virgo did read it, though, the Jamaican immigrant was immediately entranced by the way it cracked open a door to the past of the entire New World African diaspora. (Bethune)

Born to American immigrant parents to Canada, a black father (Daniel Hill, Jr.) and white mother (Donna Bender Hill), Lawrence Hill asserts that James Walker's first book, *The Black Loyalists: The Search for a Promised Land in Nova Scotia and Sierra Leone, 1783–1870* (1976), was the initial catalyst for his research and, ultimately, the writing of *The Book of Negroes* (Hill, pamphlet). Engaging with the historical narratives of the Black Loyalists provided Hill with the factual materials that led to a fictive imagining of the lives of those men, women, and children who sought freedom through the back door of the American Revolutionary War. And while the trajectory of Hill's historical novel turned miniseries moves viewers from Africa to the Carolinas, to Manhattan, to Canada, back to Africa, and (then) to England, this essay focuses on Lawrence Hill's use of the moving image/film to depict a reality of Canadian slavery and indenture that is often incorrectly portrayed in historical and scholarly discourse on the topics. Not only has the myth of Canada as a land of "milk and honey" come under recent scholarly scrutiny but also in a report published in 1864, entitled *The Refugees From Slavery In Canada West: Report to the Freedman's Inquiry Commission*, S. G. Howe addresses this vastly undocumented myth:

> The distance was great; the path difficult and dangerous; and the land, instead of milk and honey, abounded in snow and ice. It was hardly

> a place in which white men could live, much less black men; who,
> moreover, were told monstrous stories about it, in order to deter them
> from fleeing thither. . . . Nothing invited the negroes to this cold re-
> gion, except the still small voice of Freedom; but some of them heard
> and answered that. . . . Some, not content with personal freedom and
> happiness, went secretly back to their old homes, and brought away
> their wives and children at much peril and cost. (Howe 11)

And while Howe's report vacillates between a positive and negative perception
of Canada as a site of "milk and honey" for slaves and indentured persons (based
on first-hand interviews from such persons), sufficient reportage exists in his
compilation to question a twenty-first-century acceptance of the more positive
and often historically described "milk and honey" perception of Canada during
and following the period of slavery.

A body of literature which emerged in the early 1970s—sufficient and ex-
ploratory, yet under-utilized in scholarly research—contributes to this discourse.
In "Black Canadian Historical Writing 1970–2006: An Assessment," David C.
Estes offers:

> The establishment of Black communities in Nova Scotia in the 1780s
> and Ontario during the early years of the 19th century marked the
> beginnings of a Black Canadian historical tradition. Early settle-
> ment patterns influenced the pattern of research as the majority of
> Blacks—whether slaves, Loyalists, refugees, or fugitive slaves—found
> their way in great numbers to these provinces. As a consequence, there
> is a rich body of literature that encompasses their experiences. (390)

Of importance is Robin Winks's *The Blacks in Canada: A History* (1971), the first
text to illuminate Black Canadian history. He returned to this scholarship in
1997 with a second edition of the work and announces, in the preface of the
second edition, the foundational thrust of his research:

> I wanted to examine the history and nature of African-Canadian
> life in Canada, to reveal something of the nature of prejudice in
> Canada, to inquire into Canadian attitudes towards immigration
> and ethnic identity seeing the Black story as a point of entry, to see
> how these attitudes differed from American attitudes, to show the
> African Canadian as an actor in the emerging national history of
> Canada, and to deal with a neglected aspect of Canadian-American
> relations. (Winks xiv)

James Walker's first book, *The Black Loyalists: The Search for a Promised Land in Nova Scotia and Sierra Leone, 1783–1870* (1976) added tremendously to the initial discourse of Winks's though taking a markedly different view of the positioning of persons of African descent in the Canadian landscape. Notably, Lawrence Hill cites Walker's work as a primary influence in the creation of his (historical) novel and miniseries, thus bringing viewers closer to his *modus operandi* for the riveting and introspective visuals (in the miniseries) of the day-to-day experiences of Africans (freed, enslaved, and indentured) in Nova Scotia. And, it is Daniel Hill, Jr.,[1] a noted sociologist and first director and chairman of the Ontario Human Rights Commission and Ombudsman for the province of Ontario, who adds to this early body of literature with several of his works, including *The Freedom Seekers: Blacks in Early Canada* (1981). While much of Hill's work focuses on Ontario (also referred to as Upper Canada), his 1981 work addresses the existence of slavery in Nova Scotia, Canada, as well as the overt and covert forms of opposition and resistance to its perpetuation.

It is to this early exploratory and rich body of literature that Lawrence Hill adds with this historical novel; moreover, he extends the transaction with readers by transitioning them to become cinematic viewers. In doing so, he presents an engaging—indeed arresting—visual narrative predicated upon history by creating an "eyes-on" emotional climate, exposing the brutality of slavery and indenture as a part of that "rich literature" that speaks to the lives of Blacks—past and present—in Canada. And while the plot lines of *The Book of Negroes* do not move *only* through the Canadian landscape, Nova Scotia serves as the fulcrum of Hill's narrative of scattered lives, broken dreams, and repaved pathways to a freedom which resists familial and communal erasure. Through the sender's (Hill) use of the genres of the slave narrative and the historical novel, a fiction is created that stirs the imagination of the viewers (audience) to seek the wellspring of such a fictive posturing situated firmly in the realities of the eighteenth century.

In his text, *Engaging the Moving Image*, Noël Carroll contends that "there may be epistemological questions about the way in which we come to recognize whether the *sender's* [emphasis mine] intention is fictive or non-fictive" (Carroll 204). Lawrence Hill's five years of research and writing easily could have given sway to another interesting yet staid historical text that bridged African-Canadian matters of slavery and indenture with those in the Carolinas, Manhattan, and England; however, through his employ of the slave narrative told by an eighteenth-century African female (whom viewers witness develop from an eleven-year-old girl into an elderly woman living out her last days in England), a different story of the lives of those sold across the Big River (i.e., the Atlantic

Ocean) is enabled, one that is suggestive of a contractual relationship with the *sender* (Hill) and *viewers* (audience). Carroll again comments on this relationship:

> The notion of the fictive intention looks at the matter from the author's side of the transaction; the notion of the fictive stance refers to the audience's part of the bargain. . . . The fictive stance, then, is a matter of the audience's imagining the propositional content of a structure of meaning-bearing signs whether they be of the nature of words, images, or something else. (203)

In his use of the historical novel coupled with the slave narrative as his chosen genres, Hill demonstrates the importance of intertwining historical facts with the act of creating a story of the self (Aminata Diallo's autobiography) through his foregrounding of the slave narrative as an emotional yet methodically structured exposé. To extend his reach in creating the emotional connect (or for some, disconnect), Hill has the story told from the vantage of a highly literate female in a flashback mode of narration. Aminata is able to read, write, and translate among several languages and, most importantly, as she says in the beginning of the film, as a *djeli*—or griot storyteller—she would "see and remember," skills which would help her find her way back home both physically and metaphysically. Viewers of this miniseries do not have the comfort of embracing a "happy" ending through Aminata's life-story, yet there is a veiled knowing that there is survival and continuance predicated on Hill's employ of the flashback technique intertwined with rivetingly disturbing yet creatively crafted moving images, African and English language usage, and a kaleidoscope of unique people seeking freedom on their own terms. Hill is able to create this visual fictive while interspersing it with historical events and people. In so doing, he makes the audience complicit in his manipulation of the genres. In the essay, "The Slave Narrative Tradition in Lawrence Hill's *The Book of Negroes*," Stephanie Yorke highlights critics' reticence to address how Hill destabilizes the slave narrative formula:

> Hill has infused *The Book of Negroes* with an historical and generic intelligence that allows him to generally adhere to the slave narrative story-form, while undercutting those thematic features that have created racial mythologies. Hill writes both within and against the abolitionist tradition, and presents a genuine fiction rather than a politically expedient one. He simultaneously works within and against the slave narrative genre, which evolved during the Enlightenment, and became increasingly popular and genre-determined in

America, Britain, and British Canada during the antebellum period. (129–30)

Hill's work ("within and against") is paramount in the scene where Aminata meets with British abolitionists who wish to use her story as the nexus of their freedom platform. Aminata appears poised, serene even, as she adamantly refuses the abolitionists any direct hand in the writing about her experiences of bondage, both endured and witnessed. She insists upon writing her story in the way she chooses or not at all, showcasing Hill's destabilization of the established and formulaic structures of the slave narrative genre. In an essay published years before Hill's novel, Sam Worley makes a comment that illuminates Aminata's refusal of an amanuensis:

> ...those narratives which rely on a white amanuensis are inherently less interesting than those which do not. The argument in this latter case is that however honorable his intentions, the amanuensis will inevitably shape the narrative to some extent, thereby undermining its authenticity both as history and autobiography. (243)

Hill also wittingly comments on the relationship of power and dominance in the realm of slavery by having Aminata reappropriate the power involved in the intervention of white abolitionists in the crafting of Black slave narratives. In her reappropriation of this power from the well-meaning but over-arching abolitionists, Aminata reaches for an agency denied to slaves. In *Slavery and Social Death*, Orlando Patterson asserts: "Slavery is one of the most extreme forms of domination, approaching the limits of total power from the viewpoint of the master, and of total powerlessness from the viewpoint of the slave" (1).

It is Aminata—solely—who will tell us of a calamitous and circuitous story of pain from being torn (with others) from her West African village to journey to the Carolinas, then to Manhattan, across to Canada, back to Africa, and then to England (the opening scene of the miniseries). What is different in the viewers' understanding of the power of slavery is the telling of this story on Aminata's own terms and in her own words. In her article, "*Book of Negroes* is a *Roots* for the 21st Century," Ellen Gray articulates Hill's vision of Aminata as protagonist:

> "I wanted to privilege a woman's story," Hill said, but he found few of the famous slave narratives had been written by women. "She's not just a slave," he said. "She's a woman. She catches babies. She has a lover. She has children who she loses. She has parents. She's literate.

I wanted to step deeply into her life and to portray a woman moving
in and out of slavery in the 18th century." (Gray)

While casual viewers may conveniently grasp a first level of discourse/exposi-
tion (who, what, when, and where), it is important that they not miss the more
inconveniently accessed sub-texts (second and tertiary levels of discourse) mov-
ing—often simultaneously—throughout the miniseries. For while this narrative
is Aminata's story, it is, moreover, a story of one female bearing witness to the
ever-evolving separation, loss, pain, and moments of hope for many men, women,
and children taken forcibly from their homes in Africa. Aminata's story, while
being one of enslavement, is also a love story, borne out of a coffle line on the
shores of Africa to end, after years of journeying, on the same shores in a recla-
mation of heritage after the death of her love interest, Chekura. This circuitous
physical, mental, and emotional odyssey of Aminata and other enslaved Africans
recalls the words of the great Caribbean poet Kamau Brathwaite, "When release
from further journey?" in *The Arrivants: A New World Trilogy* (21).

Viewers of the miniseries thus begin engagement with this circuitous tale
of slavery and brutality in the Prelude to Episode One of the miniseries, with
Aminata in London, England. A fragile and aging Aminata is testifying in the
House of Parliament (London 1807) advocating the eradication of the British
slave trade. While Aminata is fragile and aging, she is portrayed as both regal
in her dress and her (ad)dress to the Parliament. She opens her testimony by
saying, "I seem to have trouble dying." She continues by clearly stating her name
(Aminata Diallo), her parents' names (Mamadu Diallo, father and Sira Kulibali,
mother), and her place of birth (Bayo/Guinea). This naming and claiming of
ancestry and place become central in providing the foundation of Aminata's nar-
rative in responding—subversively—to what Orlando Patterson calls the "slave's
natal alienation" (5). Aminata has *not* forgotten *who* she is or *where* she is from
and clearly dispels any notion of a faulty memory, which is key in the believ-
ability of her testimony before Parliament. She tells the Parliament audience
that at an early age she knew she would become a *djeli* and says firmly, "I would
see and I would remember." Orlando Patterson underscores how important a
former slave's connectivity to his biological and geographical beginnings can be
in moving beyond alienation:

> Not only was the slave denied all claims on, and obligations to, his
> parents and living blood relations, but, by extension, all claims and
> obligations on his more remote ancestors and on his descendants.
> He was truly a geographical isolate. Formally isolated in his social

relations with those who lived, he also was culturally isolated from the social heritage of his ancestors. He had a past, to be sure. But a past is not a heritage. . . . Slaves differed from other human beings in that they were not allowed freely to integrate the experience of their ancestors into their lives, to inform their understanding of social reality with the inherited meanings of their natural forebears, or to anchor the living present in any conscious community of memory. (5)

Aminata is jeered by pro-slave traders in the Parliament gathering as they test the authenticity of (her penning) her autobiography via their staging of a hackneyed spelling-bee; she is asked to spell certain words that appear in her autobiography, beginning with the word "Deuteronomy," which she spells with no hesitation. Aminata then offers to spell "Leviticus," which sends shock waves throughout the Parliament. What is noteworthy here is that Aminata does not embrace any one religion or the other,[2] yet she effectively accesses and writes—into her narrative—terminology from the Bible, which is often used by pro-slavery adherents to justify their enslavement of other humans. Stephanie Yorke also notes Aminata's non-religious positioning:

Hill has chosen a neither-nor religious identity for his protagonist. Rather than synthesizing Christian and Muslim faiths, or exchanging one for the other, Aminata simply loses belief, revealing slave acculturation as a subtractive rather than an additive process. . . . It is noteworthy that Aminata's atheism becomes most pronounced after she has moved to Canada, which in slave narratives is so often presented as a *Canaan*. (141)

And while Hill, through his first-person narrator, writes from a fictive stance, he does so subversively by using the masters' language and references to aspects of their religion to contain their jeering tongues, an act of "rebelling against the master." In using the genres of the slave narrative and historical novel to advance Aminata's narrative, Hill extends the audience's fictive stance for viewers who come to realize that Aminata was a real person—one of the 3,000 former slaves listed in the original *Book of Negroes* (JBHE Foundation 28).

The Parliament scene immediately shifts to Episode One with a young eleven-year-old Aminata in her village of Bayo. Lawrence Hill comments on his decision to have his novel begin through the eyes of an eleven-year-old female:

At that age, just on the cusp of womanhood, she would be old enough to remember exactly where she came from and who her people were,

but young enough to dream the impossible: that one day she would
throw off the shackles of slavery and find her way home. Her story
would represent the wider story of the Black Loyalists who had
moved all around the world, in a sort of trans-Atlantic and inter-
continental milk run ... (Hill, pamphlet)

Lawrence Hill and co-director Clement Virgo display Aminata's home village
to viewers as an organized community, with Aminata presented as a happy and
loved child. Her mother is highly respected in the community as a midwife
("the child catcher"); Aminata is her young apprentice. Her father is literate
and has taught his daughter to read, write, and respect the tenets of the Koran.
There are, however, undercurrents of tension in the community that appear to
stem from female jealousy as Aminata asserts that she and Fanta (the village
chief's youngest and most attractive wife) have little affinity for one another.
This "caring" or lack thereof will shortly be tested in terms of unity and survival
as both females find themselves enslaved. Stephanie Yorke remarks on Fanta
as the "anathema to noble savage stereotypes" (136). And beyond this tension
between a young (Fanta) and a younger (Aminata) female, the aura of the
miniseries immediately darkens to signal an impending danger (for the larger
community) of the "man stealers" who recently took a farmer. The beginnings
of brutality and loss are depicted in the film as viewers see bloodied clothing
on the ground and witness the men of the community take up their spears to
engage in communal protection.

Aminata and her mother (after assisting with a birthing and seeing the
bloodied clothing of the stolen farmer) are seen traveling through a densely
wooded area engaging in discussions about finding their way home over paths
little known to the "man stealers." The imagery of the two females successfully
navigating the forest provides yet another depiction of Hill's disruption of the
slave narrative genre formula(s) for the telling of Aminata's story. Hill under-
scores the "directional" intellect of the female vision and voice within a space
traversed and seen largely as the sole domain of males. In "The Forest in Afri-
can Traditional Thought and Practice: An Ecophilosophical Discourse," Mark
Omorovie Ikeke confirms that in earlier African traditional thought "there are
forests in Africa that women were not permitted to enter, whereas males even
those of a younger age than such women are permitted to enter" (346). Viewers
witness Aminata and her mother not only enter but also safely emerge into the
clearing, only to be told later by Aminata's father that the two of them will not
be allowed to enter the forest alone again.

In viewing the forest as a place of mystery and danger, as well as a place of life in its fullest diversity (plant and animal life), there is a major foreshadowing of the life-long journeying that Aminata both witnesses and participates in with other enslaved men, women, and children. Ikeke asserts, "Equally important to state about the African concept of the forest is that every area of African life and culture is casted [sic] in a paradigm of communalism. The African communal attitude to life affected all elements of life" (348). It is that paradigm of communalism that pervades Aminata's testimonial narrative, through flashbacks in the forests and the communal living environment of her birth community, which she addresses before the British Parliament.

Co-directors Hill and Virgo create an arresting turning point (complication) in young Aminata's life by returning viewers to a forest scene, when, as promised, Mamadu (Aminata's father) accompanies Sira (Aminata's mother) and her on another "child-catching" journey. It is in the ensuing scenes that the forest embodies not only danger but also the finality of death as Aminata is taken into slavery after witnessing the murder of both of her parents by the dominating males within the forest. The foundation of African communalism is disrupted by the presence of the "man stealers" and the separation of Aminata from her parents into the womb of slavery. In crafting these fast-paced and brutal scenes of murder followed by bondage, Hill and Virgo present a pulling apart of the individual from the community in the construction of not only decimated images of the individual but also of the collective of men, women, and children as they are brutally shifted from forest to shore in coffle lines. A dramatic tension is created as viewers witness the movement from land to water of humans chained in a line.

While defining a line may be as simplistic as describing its ordering as horizontal, vertical, or circular, the coffle line is far from simplistic; the line is one of major (dis)order, lacking all aspects of simplicity. Viewers, instead, witness the tensions of men, women, and children of different ages, sizes, and dispositions (mental and physical health) pulling against one another as they attempt to understand their painful containment. And while communalism is emphasized as centrally important in Bayo and then decimated by enslavement, it is *still* in this dramatic loss and shifting from land to shore that Aminata meets her life-long romantic interest—Chekura—as she is taken into slavery as a young girl. While he (also) is a child and enslaved, he assists adult Africans (under the governance of white Europeans) to enslave others of his race. Chekura will later—as an adult—regret his complicity with the man-stealers and ask Aminata, "Do you blame me for taking you to the sea?"

In presenting this scene of *some* Africans—children and adults—assisting in the enslavement of *other* Africans, the directors of this miniseries excavate the long-standing discussions of "domestic" African slavery catalyzing the Atlantic slave trade. In his essay, "African Slavery and Other Forms of Social Oppression on the Upper Guinea Coast in the Context of the Atlantic Slave Trade," noted scholar Walter Rodney contends:

> It has come to be widely accepted that slavery prevailed on the African continent before the arrival of the Europeans, and this indigenous slavery is said to have facilitated the rise and progress of the Atlantic slave-trade. According to P. D. Rinchon, "from the earliest days of the trade, the majority of the Negroes were living in a state of servitude, and the native chiefs did not have far to seek for the human merchandise." Daniel Mannix, in one of the most recent accounts of the Atlantic slave trade, contends that "many of the Negroes transported to America had been slaves in Africa, born to captivity. Slavery in Africa was an ancient and widespread institution." . . . In the opinion of J. D. Fage, 'the presence of a slave class among the coastal peoples meant that there was already a class of human beings who could be sold to Europeans if there was an incentive to do so . . ." So the coastal merchants began by selling the domestic slaves in their own tribes. (431)

Aminata and Chekura are seen in the opening episodes as childhood survivors/ friends who bond together—initially—for physical warmth, shared food, and emotional support during their transition to enslavement in America. Chekura is removed quickly from his "status" as a young African slaver when he is deemed too partial to the well-being of Aminata during her early capture in Bayo. Chekura, too, becomes a part of the coffle line that viewers see as the newly enslaved (to include Fanta, previously mentioned) are plunged into a Hades-like world on a rugged sea journey to America. Co-directors Hill and Virgo provide a gripping visualization of the horrors of slavery in Aminata's unapologetic subversion of the tenets of the traditional slave narrative genre. In the essay, "Where Literature Fills the Gaps: *The Book of Negroes* as a Canadian Work of Rememory," Christine Duff concurs by saying:

> As a fictional slave narrative, or to use Ashraf Rushdy's term, neo-slave narrative, *The Book of Negroes* defies a significant constraint of the eighteenth and nineteenth century American slave narrative genre as described by Toni Morrison: that is, its distinctly political function

> as a tool in the movement for abolition. . . . In the traditional slave
> narrative, certain unpleasant realities were omitted in order to avoid
> offending the sensibilities of the whites that held the political power
> necessary to put an end to the slave trade. . . . This stands in stark
> contrast to *The Book of Negroes*, in which Aminata does not seek to
> shelter her reader from the reality of bondage. We are confronted
> with detailed scenes of the horrors of capture, the middle passage,
> and routine abuse at the hands of slaveholders and overseers. (242)

Aminata experiences a temporary survival bonding with Fanta on her passage
to the Carolinas, one that ends with the murder of Fanta and other mutinous
Africans on the slavers' ship. While in their village of Bayo, Fanta may have
exhibited jealousy towards Aminata as a future young(er) wife of her husband,
the village chief, yet she becomes a protector of Aminata and loses her life
on board the slavers' ship in her rebellious response to not only her own en-
slavement but also Aminata's and others from Bayo. The slavers' ship scenes of
decadence—drinking, sex, and murder—again underscore Aminata's refusal to
tell a story that satisfies the abolitionists' end goals without also divulging the
realities of a brutal passage from freedom into bondage. It is at this point that
Aminata also experiences her first of many separations from Chekura, her future
husband and impending father of her two children. And while a good portion
of the miniseries recounts and provides a disheartening and inhuman depiction
of Aminata's experiences on an indigo plantation in South Carolina—the rape
by plantation owner Appleby, the selling of her first born, and her subsequent
sale to Lindo (a Jewish merchant and conspirator with Appleby in the sale of
her child, May)—it is Hill and Virgo's capture of the first glimmers of freedom
for Black Loyalists in Nova Scotia that anchors the miniseries as a revisionary
view of Canadian slavery and indenture.

In the film, it is in Episode Four that the prospects of freedom begin to ap-
pear attainable for the enslaved Africans fighting for the British in the American
colonies. Viewers witness Aminata in a dramatically different scenario, living as a
"free" woman for eight years in New York City. While the American Revolution
ends with the defeat of the British, it is Captain John Clarkson (of the British
forces) who references Section Seven of the Provisional Peace Treaty to Aminata
as a means of reparation for those Negroes who stood with the British. Aminata
clearly states to Clarkson that the Negroes feel much betrayed by the treaty;
however, she agrees to register men, women, and children in the document later
known as *The Book of Negroes* as the basis for (their) free passage to Nova Scotia.
Aminata's childhood dream to become a "djeli" is played out in front of viewers as

she registers the "loyalists" into *The Book of Negroes*. She tells her husband Chekura that she is not "alone" as she listens to and registers a cavalcade of Negroes who bring their narratives—virtually their life stories as they can recollect—in exchange for the opportunity for freedom. Her powers as a djeli are portrayed as she enables and appreciates the narratives even as one of the British commanders tells her abruptly to enter one of the "loyalists" as a "lusty wench."

This extant yet still largely unknown and largely unreferenced document was the impetus for the watery movement of men, women, and children towards a life never before experienced; however, as viewers of the miniseries witness the frigidity—physical and metaphysical—of the new Canadian climes for those provided passage to Nova Scotia, they also witness Hill and Virgo providing a much different historical view of Canada than that pervasively held in scholarly or popular culture realms. Duff concurs on this point:

> In *The Book of Negroes*, Hill carefully peels back the layers of the popularly accepted Canadian historical record to expose not only the very existence of the Black Loyalists, but also their mistreatment at the hands of the British. In return for supporting England in the American War of Independence, the Loyalists were promised safe passage to Nova Scotia as well as a parcel of land to cultivate. While passage to Nova Scotia was provided, the commitment of land was not honoured, consigning the Black Loyalists to an extremely tenuous existence. Hill deals a significant blow to any celebratory image of Canadian nationhood ... (241)

Passages are never without complication, and Hill and Virgo provide audiences with a dramatic and fortuitous reversal of Aminata's fortune as the first in a succession experienced by the Black Loyalists on their journeying to Canada and after reaching Canada. Clearly, Aminata has brokered passage for not only herself but also her husband, Chekura; there is marginal comfort in the "promise" of impending flight and freedom for them both (via Captain John Clarkson). Indeed, at the moment of embarkation to Nova Scotia, Aminata is pulled from the ship. She is told by some of the British commanders that a man has a claim on her as a slave. Once again, Aminata is torn away from family in an extension of the natal alienation she experienced as a child.

In an essay written in *The Journal of Negro History*, John N. Grant underscores the *forced*, not *welcoming*, presence (emphases mine) of Negroes in Canada:

> The greater portion of the black population of Nova Scotia came not as a result of a trickling immigration but in three main waves. The

> three waves were similar in that each resulted from events completely external to Nova Scotian affairs and in that the immigrants were *driven* [emphasis mine], not drawn to Nova Scotia. Two wars between Great Britain and the United States and an internal squabble in Jamaica precipitated the immigration of blacks to Nova Scotia. (253)

So, while "driven" to Nova Scotia, as opposed to exercising free will, Aminata's journey is further complicated and temporarily aborted, as she stands before a judge to prove that she is not the property of Robinson Appleby, a plantation owner in South Carolina. With the assistance of her friend, tavern owner and freedman Samuel Fraunces (aka Black Sam), Solomon Lindo appears in court and confirms to the judge that she had been manumitted by him in 1775, two years after he bought her from Appleby. In this courtroom scene, Hill and Virgo create images which address the humanity of Negroes during this time, specifically the respect afforded to Fraunces in intervening for Aminata and the judge's actual hearing of her case without an abrupt dismissal. With her solidified freedom from the judge via Lindo's testimony, Aminata sets out to fulfill her journey to Nova Scotia in search of her husband, Chekura, and a new life. As Episode Four ends, viewers are treated to Aminata's thoughts: "I had lost my belongings, but I was going to see my husband. I had my legs which were in working order and a child growing in my belly. I wonder(ed) what would dawn bring in Nova Scotia."

Episode Five begins in much the same manner as the ending of Episode Four with viewers bearing witness to Aminata's interior monologue: "I had hoped to sail to Annapolis Royal, Nova Scotia, since that was where Chekura's ship was heading, but there was only one ship for me to take and it was going to Shelburne. I saw no vast farms or signs of cultivation. Was this the promised land?" Concurrent with Aminata's thoughts, the co-directors provide a panoramic view of a barren landscape as her ship pulls into the harbor. Aminata's questioning of this new landscape as the "promised land" is illustrative of pre-despair and disillusionment based on the representation of Canada as a place of new beginnings for her and other Negroes. Her body language (clutching her coat and scarf closely to her body) and the climatic conditions (icy cold and blustery winds) underscore her feelings as viewers acquire a sense of her disappointment in the highly touted promised land of Nova Scotia. Indeed, Aminata's disappointments over objects of her love—freedom, Chekura, and sense of place—all converge, however briefly, as she receives her first glimpse of Nova Scotia from the ship. In the essay "Pothos: Longing For Place. Commentary on 'The Other of the Body and the Language of the Margins," Edward Sieveking Emery addresses the three forms of eros:

> In the ancient lexicon of desire, distinction is made between three
> forms of eros—between himeros, anteros, and pothos. Himeros refers
> to the immanent specificity of incarnational desire, to the moment
> of spasm or breakthrough when desire is seized in the urgent pulsa-
> tion of its manifestation. Anteros is, in contrast, imaged more as
> responsive love, realized in dynamic exchange, in the reciprocity and
> dialectics (both those of master and slave as well as their sublated
> accomplishments) of the I and thou. . . . Pothos distinguishes itself
> as the longing for the unattainable and for the unrepresentable, for
> what is beyond grasp, what soars in the spirit of the ideal as the
> beckoning guiding light. (181–82)

And, it is in the opening of Episode Five that viewers see the pothos form of eros
taking predominance as Aminata seeks her new life in a new land with Chekura.
It is this place—Canada—that holds the promise which will enable the form
of eros, operating at a secondary level—anteros—to sustain itself. Her life with
Chekura is one of instability, with their experiencing long periods of absence
from one another, until their eventual togetherness that appears not to fully satisfy
Aminata. Her culminating dissatisfaction with Canada finds her looking towards
Sierra Leone, which precipitates her permanent separation from Chekura. Emery
again provides a consideration of Aminata's emotional and logical states:

> Pothos's obscure object of desire cannot be attained only through the
> fulfillments of himeros or those of anteros, though often the longings
> of pothos can be both derailed and fructified through the snares and
> joys of the closer-to-home erotic. . . . Pothos is nostalgic, less for a past
> that was or that, in the idolizations of innocence, never was, than for a
> future that is yet to be. The futural nostalgia of Pothos is the trajectory
> that advances the subject toward an elusive yet shapely sensuality of
> place more intimated than known, more felt than conceived, more
> sensed that discerned. Pothos beckons, whispers, pulls at the heart,
> awakens, haunts, disturbs, stirring the visionary imaginai for foreign
> lands and other places. (182)

Aminata's longing to return home to Bayo, near Sierra Leone (pothos), is inti-
mately intertwined with her love for Chekura (anteros), yet is informed *only* by
her eleven-year-old *and* limited knowledge of the place called home and any
recurrent negative emotions she may experience in loving Chekura, who took
her "to the sea."

In those moments when viewers see Aminata witnessing the Canadian
landscape for the first time, co-directors Hill and Virgo do an *amazing* job of

accelerating the "fictive stance" of the audience in synthesizing Aminata's child-hood, newly acquired freedom, desire to return to Bayo, and love for Chekura before she even disembarks from the ship. It is in this mythical—(only come *too* true)—land of Canada that Aminata and other Black Loyalists begin to sort out the fictions and realities of place. As Aminata disembarks from the ship, the first manifestations of xenophobia are evident as two white residents of Shelburne watch Aminata and one throws peanut hulls at her. In so doing, the man remarks: "They don't know what's here, they don't know what's waiting for them, they just keep coming" (Hill, *The Book of Negroes* miniseries). Aminata reaches down and picks up one of the hulls and tells the man that he looks famished. Both men look stunned, and one asks her what famished means. Here, again, Hill and Virgo present an educated woman who uses language that serves to intimidate those (whites) who view themselves as superior. It is at that moment that one of the resident Black Loyalists—Jason (one who Aminata signed into *The Book of Negroes*)—intervenes and takes her away from further incident. This scene provides viewers with an eerie foreshadowing of the impending strife between whites and blacks throughout Shelburne and Birchtown, Nova Scotia. Indeed, the thrower of the peanut hulls emerges later as a catalyst in the mistreatment of Black Loyalists and the eventual burning of Birchtown to the ground.

There is little warmth in Aminata's first moments in Nova Scotia, physi-cally or metaphysically, as Aminata moves from the docks with Jason. She is introduced to Daddy Moses (aka Preacher Man), who asks her if she has been saved. Aminata's response is light-hearted yet serious as she is pregnant with her second child; she asks Daddy Moses if he has somewhere for her to stay/sleep, and he replies in the affirmative that there is room on the "dog-end of the harbor, Birchtown." She responds with, "Then, I am saved." Aminata's re-sponse is artful in maintaining her communal impact while not alienating any belief group through her association with one faith or another. Jason and Daddy Moses, as her first contacts, provide connectivity to her African foundation, yet it does little to contain her feelings of despair in this "promised" land of freedom. Aminata's quick survey of the barrenness of the land, the frigid weather, the living conditions of even white Loyalists, and the death and decay along the path to Birchtown lead her to tell Daddy Moses that life is hard in Nova Scotia. In the space of less than one day, Aminata's reaction to her new, however temporary, home, illustrates her "longing for the unattainable and for the unrepresentable, for what is beyond grasp, what soars in the spirit of the ideal as the beckoning guiding light, pothos" (Emery 181–82).

The expectations of freedom and land were quite unequal for those known as Loyalists, a varied and sundry group of individuals. According to Laura Neilson

Bonikowsky, "They were as socially and culturally diverse as the nation they fled, comprised of soldiers and civilians, rich and poor, black, white and Indian. They shared little besides their plight as refugees" ("Black Loyalists"). Throughout Episode Five, Hill and Virgo show the immense divide between the white and Black Loyalists. Aminata's first encounter off the ship is further accentuated by a highly racist-tinged scene of work being parceled out to men on the docks to unload boats in Shelburne. The work boss shouts out his need for five white men to work for ten pence a day and five "black bucks" to work for five pence a day. Not only is the scene one of discord with men of all shapes, sizes, and dispositions eagerly vying for work but also the language used and the stated conditions for work show the inequity and lack of respect in a falsely advertised promised land of freedom for all. Young Black men are referred to as bucks, and they are offered only half of what white men are offered for, perhaps, the same or more labor. The scene of a physical struggle between Jason (freed Black man) and the same white man (who threw peanut hulls at Aminata as she left the ship) creates the complication in this episode which leads to a devastating climactic turn of events. The sheer poverty that is depicted among the Black Loyalists is presented in a stark and unforgiving manner by Hill and Virgo, further subverting the formula for the slave narrative in North America. As Aminata walks through a desolate town, she comments (through interior monologue) that no money and no goods pass among the people of Birchtown, as viewers witness a body hanging from the gallows in the background. Is this the promised land? Is this the final outcome for Blacks who fought with the British? According to Bonikowsky:

> African-Americans thought they would have equal claim to free land, but discovered that the land grant system had become corrupt. Some, after waiting six years, received a mere quarter acre. Most were given less desirable plots across the harbour from Shelburne. There they founded Birchtown, named for the British commander in New York who had signed their embarkation certificates. They became the objects of hostility and violence. Many sold themselves to merchants for a term of service, essentially returning to the slavery they had fled. ("Black Loyalists")

In an unrelenting manner, the scenes in Episode Five call into grave consideration, pervasively historic or otherwise, misconceptions of Canada as a place of safe haven and expansive freedom for Black Loyalists in the post-American Revolution period. As the episode unfolds, Aminata secures work at the Witherspoon Print Shop for tuppence (the equivalent of two pennies, a coin issued

under King George III) a day. Her situation, while marginal, does at least draw meager wages until Mrs. Witherspoon's son enters the shop and the mother asks him if he has found work. Her son is the white man who has struggled with Jason at the docks when he was not selected to unload boats in Shelburne. There is a moment of tension as Witherspoon's son witnesses Aminata setting type. Not only is he the man who despises the fact that Negro men are given work but also he is the man who threw peanut hulls at Aminata when she disembarked the ship for Nova Scotia. Mrs. Witherspoon's son does not answer but instead glares and storms out of the print shop. Later that evening on the trail home to Birchtown, Aminata encounters this same man who attempts to rape her. Jason intervenes, and there is a vicious struggle. Witherspoon's son has a gun, yet he is subdued by Jason, who kills him with a stone to the head.

Because of this murder, life becomes intolerable not only for Aminata and Jason but also for all Negroes throughout Birchtown—a strange and unforgiving land—as a campaign tinged with hatred and racism is mounted to further disenfranchise all of African descent. Poverty, rape, murder, hunger, and the burning of Birchtown pervade the images that Hill and Virgo pour onto the screen as viewers receive imagery and language that relate pain and sorrow in a land that was billed as holding so much promise. What is being offered to viewers is a revisionary understanding of Canada as a safe haven for *all* seeking freedom, regardless of race and ethnicity. Afua Cooper, historian and author of the historical novel (dealing with Canadian slavery) *The Hanging of Angelique: The Untold Story of Canadian Slavery and the Burning of Old Montreal*, weighs in on the cloaking of Canadian history, as it relates to Blacks, as something other than reality:

> Canadian history insofar as its Black History is concerned is a drama punctuated with disappearing acts. The erasure of Black people and their history in the examples of the Priceville Cemetery and Africville is consistent with the general behavior of the official chronicles of the country's past. Black history is treated as a marginal subject. In truth, it has been bulldozed and ploughed over, slavery in particular. (7)

Lawrence Hill's novel—*The Book of Negroes*—turned miniseries has joined the cinematic files alongside other slavery-focused films such as *Roots*, *Amistad*, *Glory*, and *12 Years A Slave*. As BET's first ever miniseries, *The Book of Negroes* opens up new territory not only in the presentation of slavery in several different geographic locations (Africa, United States, Canada, and England) but also through its female window of introspection. Notably, the riveting focus on slavery

(and indenture) brings viewers closer to Lawrence Hill's *geographical roots* as he takes on the brutal and unforgiving aspects of slavery and indenture in Canada, a country that has pervasively held the title as a promised land for those seeking safety from bondage. *The Denver Post* offers a review of the miniseries: "Graphic cruelty, not to mention violence, makes for difficult viewing in this lavishly produced miniseries. But it's worthwhile, especially as director Clement Virgo has opened a new window on the experience of blacks in Canada" (Obenson). As the miniseries depicts over a thousand Black Loyalists to Canada relocating to Freetown (Sierra Leone) and Aminata's witnessing to British Parliament, viewers are sharply reminded—close to the denouement of the miniseries—of the lesser told story of Negroes in Nova Scotia. Indeed, the voyage to Sierra Leone is precipitated by the harsh treatment of Negroes by whites in Nova Scotia, as well as the lack of land ownership and harsh weather conditions. In *Odyssey's Home* (2002), George Elliott Clarke comments on the limited embrace of the Black presence, owing in part to slavery, as an integral part of the Canadian landscape:

> African-Canadian writer Cecil Foster insists that African Canadians see "virtually no reflection of ourselves in the mainstream media and popular culture." . . . Responding to this invisibility, Carol Talbot jokes, in her memoir *Growing Up Black in Canada* (1984), "the term 'visible minority' is a misnomer." . . . Likewise, Adrienne Shadd asks, "What is the impact of this kind of invisibility [note the irony here!] of being a nonentity in your own country?" . . . The perpetual, white denial of Canada's own history of slavery, segregation, and anti-Black discrimination accents Black invisibility. (quoted in Beckford 463)

Aminata's life as an eleven-year-old girl in Bayo and her British Parliament testimony as an aging woman—worlds and miles apart—serve as the framing incidents for this narrative of lives moving from shore to shore in a quest for freedom. The events presented in Lawrence Hill's unveiling of little-known aspects of Canadian slavery and indenture are the defining ones that will resonate as his contribution to Black Canadian history.

Notes

1. Daniel Hill, Jr. is Lawrence Hill's father.
2. The young Aminata practices Islam and is whipped when she insists on praying, which may have caused her as an adult to keep a distance from religiosity.

Works Cited

Beckford, Sharon Morgan. "A Geography of the Mind: Black Canadian Women Writers as Cartographers of the Canadian Geographic Imagination." *Journal of Black Studies*, vol. 38, no. 3, 2008, pp. 461–83. Print.

Bethune, Brian. *Blood and Belonging in the Book of Negroes.* http://www.macleans.ca /culture/television/blood-and-belonging-in-the book-of-negroes/. Accessed 14 Nov. 2015.

"Black Loyalists." *Historica Canada.* http://www.thecanadianencyclopedia.ca/en /article/black-loyalists-feature/. Accessed 25 Dec. 2015.

Brathwaite. Kamau. *The Arrivants: A New World Trilogy.* Oxford UP, 1973. Print.

Carroll, Noël. *Engaging the Moving Image.* Yale University Press, 2003. Print.

Clarke, George Elliott. *The Complex Face of Black Canada.* http://news-archive.mcgill .ca/w97/black.htm. Accessed 11 Nov. 2015.

Cooper, Afua. *The Hanging of Angelique: The Untold Story of Canadian Slavery and the Burning of Old Montreal.* Toronto: Harper Collins, 2006. Print.

Duff, Christine. "Where Literature Fills the Gaps: *The Book of Negroes* as a Canadian Work of Rememory." *Studies in Canadian Literature*, vol. 36, no. 2, 2011, pp. 237–54. Print.

Emery, Edward Sieveking. "Pothos: Longing for Place. Commentary on 'The Other of the Body and the Language of the Margins.'" *Psychoanalytic Review*, vol. 92, no. 2, 2005, pp. 181–90. Print.

Estes, David C. "Black Canadian Historical Writing 1970–2006: An Assessment." *Journal of Black Studies*, vol. 38, no. 3, 2008, pp. 388–406. Print.

Grant, John N. "Black Immigrants into Nova Scotia, 1776–1815." *The Journal of Negro History*, vol. 58, no. 3, July 1973, pp. 253–70. Print.

Gray, Ellen. "*Book of Negroes* is a *Roots* for the 21st Century." http://articles.philly .com/2015-02-17/entertainment/59200755_1_negroes-american-revolution-roots. Accessed 20 Dec. 2015.

Groves, Robert. "The Word 'Negro.'" 19 Jan. 2010. http://directorsblog.blogs.census. gov/2010/01/19/the-word-negro/. Accessed 13 Oct. 2015.

Hill, Lawrence. *The Book of Negroes.* Dir. Clement Virgo. Perf. Aunjanue Ellis, Lyriq Bent, Ben Chaplin. BET, CBC TV, 2015. Film.

———. *The Book of Negroes: A Journey From Page to Screen.* 2015. Pamphlet in DVD Collection.

Howe, S. G. *The Refugees From Slavery in Canada West. Report to the Freedman's Inquiry Commission.* Boston: Wright & Potter, 1864. Print.

Ikeke, Mark Omorovie. "The Forest in African Traditional Thought and Practice: An Ecophilosophical Discourse." *Open Journal of Philosophy*, vol. 3, no. 2, 2013, pp. 345–50. Print.

JBHE Foundation. "What Was *The Book of Negroes?*" *The Journal of Blacks in Higher Education*, vol. 63, Spring 2009, p. 28. Print.

Milan, Anne, and Kelly Tan. "Blacks in Canada: A Long History." *Canadian Social Trends*, Spring 2004, pp. 1–7. Print.

Obenson, Tambay A. "What Critics Are Saying About *The Book of Negroes* Miniseries, Which Premieres Tonight on BET." *Shadow and Act: On Cinema of the African Diaspora*. 16 Feb. 2015. http://blogs.indiewire.com/shadowandact/what-critics -are-saying-about-the-book-of-negroes-miniseries-which-premieres-tonight -on-bet-20150216. Accessed 28 Dec. 2015.

Patterson, Orlando. *Slavery and Social Death*. Harvard University Press, 1982. Print.

Rodney, Walter. "African Slavery and Other Forms of Social Oppression on the Upper Guinea Coast in the Context of the African Slave-Trade." *The Journal of African History*, vol. 7, no. 3, 1966, pp. 431–43. Print.

Winks, Robin. *The Blacks in Canada: A History*. 2nd ed. Montreal: McGill-Queen's University Press, 1997. Print.

Worley, Sam. "Solomon Northrup and the Sly Philosophy of the Slave Pen." *Callaloo*, vol. 20, no. 1, 1997, pp. 243–59. Print.

Yorke, Stephanie. "The Slave Narrative Tradition in Lawrence Hill's *The Book of Negroes*." *Studies in Canadian Literature*, vol. 35, no. 2, 2010, pp. 129–44. Print.

On Film, Historiography, and Teaching the "Experience" of Slavery

Kristen Block

How can film be used to powerfully and deeply teach about the history of African enslavement—and its legacy—in the Americas? Based on my own pedagogical experience in five iterations of an upper-division course on Slavery in the Atlantic World (2007–2016), I argue that cinematic treatments of the subject provide a powerful way to both imagine the experience of slavery and to analyze changing popular narratives about slavery and its consequences in the Americas. Film makes it easy to teach the otherwise complex issue of historiography, and by analyzing individual films in-depth (as in this collection), students learn to juggle the intellectual and emotional demands made of scholars of slavery. In years past I have had the entire class screen Carlos Diegues's *Quilombo* (Brazil, 1989), Tomás Gutiérrez Alea's *The Last Supper/La última cena* (Cuba, 1976), Haile Gerima's *Sankofa* (USA/Ghana, 1993), with rotations between Steven Spielberg's *Amistad* (USA, 1997), Michael Apted's *Amazing Grace* (United Kingdom, 2007), Quentin Tarantino's *Django Unchained* (USA, 2012), and Steve McQueen's *12 Years a Slave* (UK/US, 2013). The proliferation of film and television depictions of slavery in the past ten years has made such limiting strategies unrealistic, so students in my Fall 2016 "Slavery in the Early Americas" course opted for individual research on films including Gil Pontecorvo's *Burn!/Queimada* (1984), Jeroen Leinders's *Tula: The Revolt* (2013), Amma Asante's *Belle* (2013), Peter Cousens's *Freedom* (2014); and TV series like *Roots* (1977 and 2016 versions), *The*

Book of Negroes (2015), *Underground* (2016), and *La Esclava Blanca* (2016). This essay examines the ease of teaching historiography through film, then discusses some positive outcomes and common problems in student analyses—especially the challenges of writing about films that fit the Hollywood model or were produced outside of the United States.

The history of slavery has seen dramatic shifts in terms of narrative focus and methodological interpretation in the half century since the Civil Rights Era. Today, most scholarship explicitly addresses the problem of sources available to historians, which overwhelmingly over-represent the perspectives of slaveholders and other white commentators, and reduce people of African descent to a conglomeration of negative stereotypes and dehumanizing calculations. Leading scholars of the early twentieth century like Columbia professor William Archibald Dunning (1857–1922) effectively solidified Social Darwinist ideas that the enslavement of Africans and their descendants served as a "school for civilization," despite the valiant efforts by early black scholars like W. E. B. Du Bois to stand firm in their stance that such histories explicitly hurt the black cause in America. By the 1960s a wider swath of scholars and the public began to explicitly challenge racist histories, and refutations proliferated of the "happy" slave, the psychologically damaged "Sambo," and the presumed criminality and degeneracy of enslaved people.[1] Studies of recovery and resistance provided "usable pasts" to help Civil Rights activists fighting for equality by learning from black struggles of the past. When scholarly trends in the 1970s and 80s turned to using statistical methods to calculate the numbers of captives who embarked upon and survived the Middle Passage, African American scholars denounced the profession's focus on numbers as dehumanizing. They made similar arguments against studies that counted calories in slave diets, as mainstream scholars and their readers essentially used that data to argue about where it was "better or worse" to be a slave.[2] Today historians of slavery continue to challenge the biases implicit in the historical discipline's privileging of written sources and the tendency to cast doubt on the few examples of slaves speaking in their own words: whether as dictated by abolitionist "agendas" (nineteenth-century slave narratives); as distorted by memory and subject-interviewer dynamics (the WPA narratives of former slaves collected in the 1930s); or as outright fabrications (the Equiano birthplace debate).[3]

Teaching the history of slavery in the Americas is extremely rewarding in that it is relatively easy to introduce students to the complex idea of historiography—they easily intuit the reasons why slavery's history has been written and re-written following shifts in race relations in various American contexts.

Television and film renditions of slavery also help to give vibrancy to historiography, as they serve as cultural artifacts reflecting how slavery is/was taught and remembered at the popular level. Through cinema, students can easily see how portrayals of enslaved people influenced—or were influenced by—the historical demonization or trivialization of African Americans. Talking about Southerners' explanation of slavery as a benign "peculiar institution" neatly parallels the story told in *Gone with the Wind* (1939)—where child-like slaves are depicted showing loyalty beyond emancipation. Most students today are too young to have first-hand experience of how *Roots* (1977) opened many Americans to a new consciousness of slavery's ills and its modern legacy, but they can observe a popularization of scholars' efforts to show Africans' resistance to enslavement, and the importance of family bonds in enslaved peoples' survival. Comparing scenes from the original *Roots* to the recent remake (2016), students can easily see how scholarship since the 1980s has helped new creative plotlines to emerge. In the scenes leading to Kunta Kinte's capture in the Gambia, creators of the new *Roots* focused on the complex regional politics of the Mandinka empire and the Kinte family's values defining justice in Jaffure—in 2016, the logistics of capturing and selling slaves in Africa becomes more than just a story of a few slave catchers with nets lurking in the bush.

The professoriate has shifted demographically in the past fifty years. Tracing that shift also provides an opportunity to show shifts in public histories of slavery in the U.S. Educational documentaries show the slow mainstreaming of historians' revision of old narratives. *Digging for Slaves* (1989) shows historians' collaboration with archaeologists to bring new analytical techniques that could tell the story of the enslaved. In it, archaeologist Leland Ferguson (University of South Carolina) traces the macro-level changes that slaves brought to the Carolina landscape (as "pioneers," digging hundreds of miles of canals for rice plantations—the "largest earthworks in North America"), and Smithsonian museum staff work with local artisans to celebrate traditions like basket-weaving and African-influenced foodways.[4] By the time of the release of PBS's *Africans in America: America's Journey through Slavery* (1998), the effort to show slavery's story through African American perspectives was evidenced by multiple scholars of color featured as expert commentators.[5] Most recently, Henry Louis Gates, Jr.'s mainstream appeal in the genealogy-focused *Finding Your Roots* (2012–2014) has helped promote his efforts in other scholarly documentaries, most recently by exploring the history of *Blacks in Latin America* (2011). As a white woman whose classroom teaching has been concentrated in white-majority student populations,[6] I am especially eager to highlight the profession's need for multi-racial

dialogues on the history of slavery—in terms of social justice, theoretical integrity, and interdisciplinary insight.

Documentaries express the best revisionist and progressive trends of their times, but it is equally important to include news stories and film clips that pay attention to scholarly controversies with racialized elements. We see from Prof. Norrell's essay in this volume that some white viewers in the 70s felt they could dismiss *Roots* as propaganda because of charges that Alex Haley had plagiarized or manufactured elements of his family's origins and history. Another more recent documentary, *Unearthing the Slave Trade* (1993), lays out the intense controversy that followed the discovery of an eighteenth-century African Burial Ground prior to the construction of a new federal office building in lower Manhattan in 1991–1992. Students have discussed the political complexities of how multiple factions debated how to properly relocate the human remains after their unearthing, and as leaders decided how to disseminate scholarly knowledge to the public and memorialize the history in a way that was sensitive to the shock of the site's (re)discovery. Students learn to empathize with the political decision to move the anthropological analysis of the human remains from a private firm to one headed by academics at HBCU Howard University.[7] Most importantly, they come to see how the historical depiction of slavery has always been freighted by the historians' present, and how popular (mis)conceptions surrounding race have been difficult to overcome.

Visual representations of slavery on the small or large screens invariably help to heighten students' emotional understanding of enslavement, and to explain historiographical debates. After reading a series of historians' debates about the numbers of captive Africans brought as slaves across the Atlantic and the starting assertion that first-hand witnesses like Olaudah Equiano may have engaged in "creative non-fiction" describing his capture and shipment across the Atlantic, I show clips from Martinican filmmaker Guy Deslauriers's *The Middle Passage* (2002), a sobering, trance-like first-person account of the Middle Passage, forcing students to sit through distressing depictions of the fear of that voyage, to see the actors' deadened eyes, hear about the smells (slave holds "reeking of filth"). In the film's depiction of the ubiquity of death and casual disposal of dead bodies, the submerged anger of the captives sits in stark contrast to slave ship registers that mention only the bare facts of loss: "August 25— One boye slave dyed. 27— 1 woman & 1 boye dyed." These are important points that historiographical debates can't always capture. Shortly after the release of Steve McQueen's Oscar-winning *12 Years a Slave*, students read the 1853 version to see how the filmmakers exercised their creative license in terms of characterizations and plot

variations. Students admitted that the film's stark representation of the brutality required to force Solomon to accept his new name and status at the slave "pen" in Washington, D.C., or the monotony and pressure of a day spent picking cotton, made them connect more viscerally with the psychological challenges enslaved people faced. When we read Gilberto Gil's utopian samba lyrics written to accompany the 1984 release of the Brazilian film *Quilombo*, or watch the bloody destruction of Candyland by a vengeful *Django Unchained*, we talk about what emotional needs those depictions might fulfill and how fictionalized elements grapple with serious gaps in both nationalist narratives that have devalued black experiences of the past and present. The rationality of classroom instruction—whether training students to read for "bias" in primary source analyses, or the tendency to force students to take sides as we talk about academic debates as "winner-take-all" questions—can distance us from our enslaved subjects, and sometimes also our own entanglement in the legacy of race. To fully understand slavery and its contentious historiographical legacy requires the ability to sit with emotional discomfort, and to openly (and with sensitivity) discuss everything from the intellectual to the visceral.

THE CHALLENGE

To engage students with both the emotional "experience" of slavery and the rigors of academic scholarship, their final project requires them engage in an in-depth analysis of one film (or television series). Students are challenged to research and write an extended essay answering some combination of the following questions: How might watching this film educate (or miseducate) an audience wanting to learn more about the subject of slavery and race relations in the Americas? How much of what you've learned about slavery [in Brazil, Cuba, or the U.S.] is included in this film? What is left out? What kind of changes would you make to the story if you were a director trying to educate the general public? Although the class is focused on the history of slavery, students must also research the historical moment that surrounded each film's creation. Other questions I urge them to answer are: How closely did the filmmakers follow the historical record? What sorts of criticisms have historians raised with regard to the film? Which criticisms do you think are justified? Which are not? Do films about slavery need to strictly follow historically documented "facts" to be "true"? Why or why not? This assignment teaches students to read for filmmakers' imaginative decisions, their cultural and historical context, and their engagement with scholarly debates of the era in which the film was created.

As much as possible, I try to integrate segments of film clips in class discussions of various historiographical developments and debates. We watch clips from the dining room conversations in *La última cena* featuring ribald jokes and trickster storytelling the same week we read a classic article about slave satire and learn how scholars in the 1970s borrowed methods from folklorists to bring depth to historical understandings of enslaved communities, where songs, fables, and oral traditions helped people survive the rigors of slavery (Piersen). We discuss the decisions made by Michael Apted and the team behind *Amazing Grace* about what it meant to feature the romantic heroism of William Wilberforce (and the political fight to abolish the transatlantic slave trade) instead of borrowing from scholarship that feature a broader range of activists in the moral campaign against slavery before and beyond parliamentary debates (such as Thomas Clarkson or Olaudah Equiano, the founder of the Sons of Africa). In a week on the topic of gender roles in enslavement, I paired a recent scholarly article about staged boxing matches between enslaved men on antebellum plantations with a clip showing Quentin Tarantino's vision of "Mandingo fighting"—taken not from antebellum history books, but straight out of the 1970s blaxploitation film *Mandingo* (Lussana).

It can be especially challenging to coach students to find evidence of historiography in visual depictions of slavery in Latin America. In Fall 2014, a handful of graduate students from the University of Tennessee's Hispanic Studies program read additional monographs on slavery in a range of Latin American contexts, especially the historiography of slavery and racial politics in Brazil and Cuba in the twentieth century.[8] Those students then teamed up with undergraduates to help guide them to better understand the context of Diegues's *Quilombo* (1989) and Gutiérrez Alea's *La última cena* (1976). We had already discussed how Brazil followed the U.S. in its historiographical trends—an early dominance of white scholars presenting a vision of relative interracial harmony under slavery (as in Gilberto Freyre's 1933 *Masters and the Slaves/Casa-grande e senzala*) giving way to the rise of black political consciousness in the 1960s and the birth of new projects of historical recovery. Students learned how the Cuban government supported Gutiérrez Alea's efforts to bring the country's "imperial heritage" to the silver screen, providing funding from the Cuban Institute for Cinematic Art and Industry (ICAIC), and enlisting historian Manuel Moreno Fraginals as consultant to help give the historical details of the revolt depicted in the film more gravity.[9] Students also learned that Carlos Diegues waited in exile until the waning years of Brazil's dictatorship in the 1980s before coming back to make his celebratory vision of the historic *quilombo* of Palmares—and by extension,

his utopian vision of Brazilian harmony based on communalist African ideals. In Fall 2016, students with an interest in the Caribbean and Latin America dug in deeply to explain to their classmates the little-known 1795 Curaçaoan rebellion named after its hero, a man named Tula, who led a strike and then a march for freedom after learning that new French laws abolishing slavery had been ignored by Dutch officials governing what was at the time officially French-claimed territory. Others explored the national memory of race and slavery in Colombia through the popular telenovela *La esclava blanca*, especially its problematic reliance on a "white savior" protagonist and insistence on celebrating modern Colombia as a "raceless" nation (the series's promotional slogan is "*Porque la sangre tiene el mismo color*" [We all bleed red]). Others discussed how a Canadian novel-turned-TV-series (*The Book of Negroes*) could help viewers in the United States move beyond our myths of national exceptionalism by following the determination of Black Loyalists in revolutionary-era New York (like the protagonist Aminata Diallo, a midwife, freedom-fighter, and storyteller) to evacuate with British troops to Nova Scotia and then return to Africa as colonists in Sierra Leone. By challenging students to speak to histories and cultures beyond the usual U.S. antebellum narratives, the course internationalizes our knowledge about slavery and racial conflicts throughout the Americas.

Helping students build careful and insightful analyses of their chosen film or series requires careful planning to structure their viewing, researching, and writing. The first few times I taught this class, I included two preliminary assignments to build independent critical thinking skills. The first required students to reflect on questions they had while watching the film, whether stimulated by what they saw on screen or by our class discussions about the politics of making films about historical slavery. They were asked to synthesize those reflections into several "interview questions" they would like to have asked the director, and were then tasked with reading whatever was necessary to discover how that person might answer the question. A second assignment borrowed from a Cinema Studies toolkit, challenging them to "read" a particular scene more closely through a *mise en scène* analysis, describing how everything a viewer could see (arrangement of sets, props, actors, costumes, and lighting, camera angles, and actor positioning) should be seen as articulating unspoken messages the director wished to convey. As students become more aware of how the film itself is an assemblage of decisions that portray both intentionality and latent meaning, they are better able to analyze the film in the context of their research.

In later semesters I adjusted these assignments based on classroom demographics (as in the group research presentations led by graduate students in

Hispanic Studies). That semester, students worked together on four "teams" (one for each assigned film) and were put in a competition to see which would compile the best annotated bibliography, which needed to include: 1) general studies of the film and/or its director; 2) interviews with the director/actors/ creative team; 3) newspaper or magazine reviews of the film; 4) historians' and educators' perspectives on the film; and 5) studies of racial politics for the time/ place in which the film was produced. The team structure infused some friendly competition into the assignment, fostered deeper conversations among team members, and helped students learn new research strategies from their peers. In the latest iteration of the assignment in Fall 2016, where students each wrote on a different film/series, I merged the *mise-en-scène* analysis with weekly clips elaborating individual students' work-in-progress, and break out research and writing tasks into two discrete stages—one annotated bibliography and paper just after midterm exploring historical (in)accuracies and the second on popular memory/historiography. Getting at the culturally specific "lessons" embedded in foreign or otherwise unfamiliar cinematic traditions can be difficult, especially for students who lack deep historical background on race relations in foreign countries. However, using either team-based research challenges or the extended multi-stage research development model led to a higher caliber of research and well-considered insights in student papers.

DISAPPOINTMENTS AND REWARDS

It can be challenging for students to write strong analyses of films from both a historical and historiographical perspective, even with significant coaching. I have always gotten mixed results as some students are easily able to make con- nections to our shared readings and scholars' arguments, while others found it hard to get beyond their own emotional relationship to the "story" onscreen in order to consider different perspectives. As is to be expected, the most "realistic" or conventionally Hollywood films are usually the most popular choices—stu- dents tend to view films with romantic plot lines and triumphant narratives more positively. Unfortunately, most of these films reinforce various conventional ways of thinking by relying on genre-pleasing narrative arcs. *Amistad, Amaz- ing Grace, Django Unchained,* and *12 Years a Slave* are all founded on the stories of hero protagonists (all male, sometimes problematically white) who prevail to secure an (at least relatively) happy ending. Mainstream-friendly produc- tions with female protagonists—like *Belle, La esclava blanca,* and *The Book of Negroes*—arguably privilege the pleasures of private romantic fulfillment over

the continued challenges for social justice that enslaved and free people of color faced in the Atlantic World.

Just as they find comfort in these familiar narratives, students often tend to buy into directors' publicity-narratives, excusing any historical missteps by holding up the creators' (good) intentions against a critical audience's "biased" or "unfair" responses. In analyzing *Amistad*, students often touted African American co-producer Debbie Allen's relentless drive to bring the *Amistad* story to life, especially her declaration that "only Spielberg . . . had the capabilities" to do things right. One student wrote that although they[10] thought that even though the film "pertained mostly to Africans," *Amistad* succeeded because it was a cross-over hit: "Amistad showed a glimpse of the [U.S.] judicial system and the Constitution, which somehow is intended to work for all men." That one word—*somehow*—was the only acknowledgement of our conversations about how the Founding documents of our nation explicitly excluded enslaved people from the new country's promise of "life, liberty, and the pursuit of happiness." They believed the film to be positive and patriotic reassertion of the Founders' ideals brought to life for modern audiences.

Several students who wrote papers on *Amazing Grace* thought that its uplifting generic message of "perseverance" made for a good enough take-away for viewers. Some emphasized the personal and romantic narratives—like Wilberforce coming back to push through the bill to abolish the slave trade with the encouragement of dutiful wife Barbara Spooner, his "driving force." Only a few students who chose to write about *Amazing Grace* gave much credence to critiques of the film by historians and the black community after its release—this even after shared class readings that noted the self-congratulatory impulse of Britain's 2007 bicentenary celebrations of laws abolishing the transatlantic slave trade (ignoring the continuance of slavery for nearly 30 additional years). If students mentioned reports in the British press complaining about the lack of significant roles for black actors in the film, they neglected to draw out deeper critiques about how such creative decisions are connected to deeper structural issues—providing (majority white) audiences with palatable (white) do-gooders makes money for studios, but deepens the silencing and marginalization of black radical critiques. But not all papers skimmed the surface. One perceptive student argued that, based on their own research of William Wilberforce's biography, *Amazing Grace* was fundamentally dishonest. The famed abolitionist never actually kicked his opiate addiction (in the film, shown as successful "for the sake of his newborn child"). This student wished that audiences of *Amazing Grace* could learn about Wilberforce as he was—not necessarily a hero, but a man of his

time, both an abolitionist and a racist who hoped that Africans one day would become "a grateful peasantry." The same student who felt that perseverance was the best part of *Amazing Grace* admitted disappointment that the film gave the impression that Britain ended the slave trade all over the world; they also agreed that it was a problem that more screen time didn't go to telling the enslaved and black perspective: "which makes sense to me, because who better to tell a story then [sic] someone who witnessed it firsthand?"

Even students with less sophisticated analyses of Hollywood's triumphant narratives could also experience significant levels of growth and critical thinking. Many remarked on the role that films played in raising their awareness not only of history but also of current-day politics. One student who wrote an excellent analysis of *Django Unchained* critiqued Tarantino's misuse of history but applauded the film's appeal to a younger generation of viewers. They argued that the film's pop/rap soundtrack could subtly draw younger viewers to examine parallels between the present and the past: "Through music, Tarantino begs the audience to consider the two as products of the same society and question whether Americans have truly evolved past issues of race and brutality." In another paper, a student revealed that they felt their own ignorance of African American history amounted to a type of mental and emotional "bondage" to political ideals like racial uplift and the politics of respectability. They personally connected to Ethiopian filmmaker Haile Gerima's story of trying to remain detached from African American politics upon his first arrival to the U.S., and his subsequent awakening (like the protagonist Mona in *Sankofa*) to a belief that history unites all people of African descent in the ongoing tragedy of racism.

As a historian of slavery, I always find myself torn between the professional desire to teach students how to uncover trustworthy stories about the past, and an ethical responsibility to teach them to analyze the historical fictions that prove to be as powerful as history. Yet if my course on the history of slavery is filled with inaccurate or incomplete cinematic portrayals, am I allowing emotionally satisfying fictions to embed themselves in students' minds? Indeed, over-simplification is always a historian's concern, but for me, the benefits of including cinema outweigh the risks. Even weaker students (those more likely to fall back on expressions like "not all slaveholders were horrible") confessed themselves more emotionally cognizant of the struggles of enslaved people and said they understood in a more profound way how such history affected current race relations. Students often become deeply invested in their film or TV show, sometimes even asking friends or family to watch with them, sparking conversations about race and ethical questions related to the memory of slavery. What they take away from the class

will doubtless shift with their personal journeys, their ability to engage in uncomfortable but honest dialogue with people of various racial backgrounds, and their continued exposure to the history of slavery and critical race theory. By providing students with the tools to find scholarly sources to verify or challenge what they see on screen, and encouraging them to work through the emotional intensity of reckoning with dark histories of slavery, my hopes are that they will apply those skills to their understanding of the politics of history and historiography.

Notes

1. Herbert Aptheker was one of the pioneers of such scholarship, with his *American Negro Slave Revolts* (New York: Columbia University Press, 1943). Other notable titles include Eugene D. Genovese, *From Rebellion to Revolution: Afro-American Slave Revolts in the Making of the Modern World* (Baton Rouge: Louisiana State University Press, 1979); Michael Craton, *Testing the Chains: Resistance to Slavery in the British West Indies* (Ithaca, NY: Cornell University Press, 1982); Lawrence W. Lavine, *Black Culture and Black Consciousness: Afro-American Folk Thought from Slavery to Freedom* (Oxford: Oxford University Press, 1977); Sylvia R. Frey, *Water From the Rock: Black Resistance in a Revolutionary Age* (Princeton, NJ: Princeton University Press, 1991).

2. Comparativist scholars picked up on earlier powerful (but more impressionistic) studies like those of Frank Tannenbaum, *Slave and Citizen* (New York: Alfred Knopf, 1946; reprint Beacon Press, 1992). Debates over the volume of the transatlantic slave trade melded with Africanists efforts to calculate the slave trade's demographic and political repercussions on the continent.

3. For defenders of these first-person perspectives, see Deborah Gray White, *Ar'n't I a Woman? Female Slaves in the Plantation South* (New York: W.W. Norton & Company, 1985); Michael Gomez, *Exchanging Our Country Marks: The Transformation of African Identities in the Colonial and Antebellum South* (Chapel Hill: UNC Press, 1998); Edward Baptiste, *This Half Has Never Been Told: Slavery and the Making of American Capitalism* (New York: Basic Books, 2004). For the firestorm that followed Vincent Caretta's questioning of Equiano's birthplace in his 2007 biography, see Paul E. Lovejoy, "Autobiography and Memory: Gustavus Vassa, alias Olaudah Equiano, the African." *Slavery and Abolition*, vol. 27, no. 3, December 2006, pp. 96–105, as well as Carretta's "Response to Paul Lovejoy's 'Autobiography and Memory: Gustavus Vassa, alias Olaudah Equiano, the African'" and Lovejoy's rejoinder, "Issues of Motivation—Vassa/Equiano and Carretta's Critique of the Evidence," in *Slavery and Abolition*, vol. 28, no. 1, April 2007 pp. 96–125; James Sweet, "Mistaken Identities? Olaudah Equiano, Domingos Álvares, and the Methodological Challenges of

Studying the African Diaspora," *The American Historical Review*, vol. 114, no. 2, 2009 pp. 279–306.

4. Jonathan Dent and David Brew, "Digging for Slaves." Originally released as a segment of the BBC television program *Chronicle* (1989).

5. Angela Basset narrated this Peabody Award winning program, which featured near parity in the numbers of white and black scholars interviewed on-screen: Catherine Ancholou (Awuku College of Education, Nigeria), Thomas J. Davis (Arizona State University), James Horton (George Washington University), Norrece T. Jones (Virginia Commonwealth University), Emma Lapsansky (Haverford College), Nell Irvin Painter, Akosua Perbi, (University of Ghana), Albert Raboteau (Princeton University), Fath Davis Ruffins (Smithsonian Institute), Julius S. Scott (New York University), Margaret Washington (Cornell University), John Edgar Wideman (Amherst College), Deborah Gray White (Rutgers University). Produced by WGBH Boston and PBS, 1998. See the full program online at http://www.pbs.org/wgbh/aia/home.html.

6. I taught at the Jupiter (northern) campus of Florida Atlantic University from 2007–2014, and thereafter at the University of Tennessee—Knoxville.

7. Tom Naughton, Nicolas Valcour, and John Rhys-Davies, "Unearthing the Slave Trade." Originally shown on the Discovery television program *Archaeology* (1993).

8. Readings included Frank Tannenbaum, *Slave and Citizen* (1947); Rachel Sarah O'Toole, *Bound Lives: Africans, Indians, and the Making of Race in Colonial Peru* (Pittsburgh, University of Pittsburgh Press, 2012); Laura de Mello e Souza, *The Devil and the Land of the Holy Cross: Witchcraft, Slavery, and Popular Religion in Colonial Brazil*, trans. Diane Grosklaus Whitty (Austin: University of Texas Press, 2003 [original 1986]); and David Sartorius, *Ever Faithful: Race, Loyalty, and the Ends of Empire in Spanish Cuba* (Durham, NC: Duke University Press, 2013).

9. Moreno Fraginals's 1964 history, *El ingenio/ The Sugarmill*, mentions the incident which led to the slave revolt depicted in the film, although it occurred in the early eighteenth century rather than after the Haitian Revolution.

10. I use the gender-neutral third-person pronouns *they-them-their* when referring to individual student responses to keep my commentary strictly anonymous.

Works Cited

Lussana, Sergio. "To See Who Was Best on the Plantation: Enslaved Fighting Contests and Masculinity in the Antebellum Plantation South." *Journal of Southern History*, vol. 76, no. 4, 2010, pp. 901–22.

Piersen, W. D. "Puttin' down ole massa: African Satire in the New World." *Research in African Literatures*, vol. 7, no. 2, 1976, pp. 166–80.

Additional Films about Slavery
(in alphabetical order)

Adanggaman (2000). Fiction film directed by Roger Gnoan M'Bala. West African film set in the seventeenth century. Depicts inter-ethnic strife that feeds the Atlantic trade in Africans.

The Adventures of Huckleberry Finn (1939). Based on novel by Mark Twain. The title character floats on a raft down the Mississippi River with an enslaved character he befriends. Directed by Richard Thorpe. Additional versions made in 1960, 1973, 1974, 1975, 1976, and 1993.

Aleijadinho: Passion, Glory and Torment. (2000). Melodrama about a disfigured Brazilian sculptor and architect, Antônio Francisco Lisboa, who is the son of a former slave. Though set mostly in the eighteenth century, registers ongoing racial dynamics of Brazilian society. Directed by Geraldo Santos Pereira.

Alex Haley's Queen (1993). TV miniseries based on the life of Queen Jackson Haley, Alex Haley's paternal grandmother. Directed by John Erman. Shows the problems enslaved and formerly enslaved biracial persons faced in the U.S. during both the nineteenth and twentieth centuries.

Amazing Grace (2006). Directed by Michael Apted. About William Wilberforce and the abolitionist movement in Great Britain during the late eighteenth century.

Amistad (1997). Directed by Steven Spielberg. About the well-known 1839 slave mutiny aboard the Amistad and the legal case that ensued.

Asientos (1995). West African film directed by François Woukoache about a young man in Senegal who meditates on the painful legacy of the Atlantic trade in Africans.

The Autobiography of Miss Jane Pittman (1974). Based on the novel by Ernest Gaines, traces the life of a woman born into slavery in the 1850s: events in her

life include enslavement, abolition, Reconstruction, and the Civil Rights Movement of the 1960s. Directed by John Korty.

Band of Angels (1957). A romantic drama film set in the American South before and during the U.S. Civil War, based on novel by Robert Penn Warren. Directed by Raoul Walsh. The wealthy daughter of a Kentucky plantation owner is revealed to have an enslaved mother. Stars Clark Gable and Sidney Poitier.

Belle (2013). Directed by Amma Asante. The mixed-race daughter of an admiral in the British navy inspires the abolitionist movement of the late eighteenth century.

Beloved (1998). Directed by Jonathan Demme. Based on Toni Morrison's 1987 novel, inspired by the story of Margaret Garner, a woman who escaped from slavery in the U.S. South.

The Birth of a Nation (1915). Controversial film directed by D. W. Griffith. Depicts two white families and their racist attitudes during the U.S. Civil War and the Reconstruction period that followed.

The Birth of a Nation (2016). Period drama film about the 1831 slave rebellion in Virginia led by Nat Turner.

Black Snake (1973). Low-budget, action-packed and erotically charged Blaxploitation film about a slave revolt on a nineteenth-century Caribbean island. A U.S. film filmed in Barbados, directed by Russ Meyer.

Brother Future (1991). Made-for-TV film directed by Roy Campanella, Jr., about a young petty criminal in Detroit in 1990; when he is hit by a car while fleeing police he awakes enslaved in 1822 Charleston, South Carolina.

Burn! (1969). An *agent provocateur* (played by Marlon Brando) tries to persuade slaves on a Caribbean island to fight for their liberation. Directed by Gillo Pontecorvo.

Chico Rei (1985). Brazilian film directed by Walter Lima, Jr. About an African taken to slavery in Brazil. He finds gold and purchases his freedom. His rise in Brazilian society has made him a folk hero.

The Confederate Spy (1910). Directed by Sidney Olcott. Romanticized look at happy, loyal enslaved persons in the U.S. South within context of Civil War.

Drum (1976). Loosely, a sequel to *Mandingo*. Blaxploitation film directed by Steve Carver starring Warren Oates and Ken Norton. About an enslaved man

who falls in love with a plantation owner's daughter. When the owner threatens castration, the slave plans a revolt.

Enslavement: The True Story of Fanny Kemble (2000). A U.S. made-for-TV film directed by James Keach. About a female British abolitionist who marries a U.S. plantation owner and sees first-hand the horrors of slavery.

La esclava blanca (2016; *The White Slave*). Colombian made-for-TV miniseries about an aristocratic woman who spent part of her youth as a member of a slave community.

A escrava Isaura (1976). Made-for-TV miniseries, produced by Brazil's Globo network. Details efforts by a light-skinned enslaved woman to prosper during the waning days of slavery in Brazil.

The Fight Against Slavery (1975). Made-for-TV BBC miniseries dramatizing the British Empire's efforts to abolish slavery.

500 Years Later (2005). Documentary about the history of transatlantic slavery and how Afrodescendants are still struggling for basic liberties. Directed by Owen 'Alik Shahadah, written by M. K. Asante, Jr. In 2010 the sequel *Motherland* was released.

The Foxes of Harrow (1947). Directed by John M. Stahl, this film was the first in the U.S. based on a book written by an African American. An Irishman comes to America and acquires a large plantation with many enslaved people.

Frederick Douglass and the White Negro (2008). A documentary directed by John J. Doherty about the abolitionist Douglass and his escape from slavery.

Freedom (2014). Directed by Peter Cousens. An enslaved family in 1850s Virginia escapes to freedom on the Underground Railroad; bounty hunters pursue them all the way to the Canadian border; a dramatic tale punctuated by uplifting musical numbers. Stars Cuba Gooding, Jr.

Ganga Zumba (1963). Directed by Carlos Diegues and not released until 1972, this film depicts Ganga Zumba, a seventeenth-century formerly enslaved revolutionary.

Glory (1989). Directed by Edward Zwick. About a black military company fighting for the North during the U.S. Civil War.

Gold Coast (*Guldkysten*, 2015). Danish historical drama directed by Daniel Dencik. About a Danish traveler to the African Gold Coast during the 1830s who must confront the realities of slavery and the slave trade.

Gone with the Wind (1939). Epic U.S. film directed by Victor Fleming with a romanticized look at southern U.S. culture around the time of the Civil War.

Goodbye Uncle Tom (Addio Zio Tom, 1971). Italian docudrama directed by Gualtiero Jacopetti and Franco Prosperi about antebellum America and the horrors of slavery.

A House Divided (2000). Made-for-TV courtroom drama set in Georgia after the Civil War but with flashbacks to the earlier slavery era. Jennifer Beals plays a woman fighting to maintain her inheritance from a wealthy landowning father even though her mother is a former slave. Directed by John Kent Harrison.

Jefferson in Paris (1995). Franco-American historical drama film directed by James Ivory. A semi-fictional account of Jefferson's activities in France and his relationship with Sally Hemings, a young woman who was his slave and perhaps his lover. Offers interesting ruminations on slavery within the context of the American and French Revolutions.

The Journey of August King (1996). Directed by John Duigan, a fiction film about a white widowed farmer who risks all his worldly possessions to help a runaway enslaved woman.

The Legend of Nigger Charley (1972). Blaxploitation film directed by Martin Goldman about a three escaped slaves in the antebellum U.S. South. *The Soul of Nigger Charley*, released a year later (Larry Spangler, director), recounts Charley's heroics after the Civil War.

The Light of Freedom (2013). Fiction film produced by Ohio-based Christian organization, set within context of the Underground Railroad and the beginning of the Civil War. Directed by Kim Robinson.

Little Senegal (2001). Directed by Rachid Bouchareb. About a tour guide in a Senegalese slavery museum who travels to the U.S. to learn about his ancestors who were sold into slavery; while in New York City he meets his distant relatives. A meditation on the legacy of slavery, and on relations between Africans and African Americans.

The Littlest Rebel (1935). Shirley Temple stars as young daughter of a southern plantation-owning family. All is peaceful for family and their enslaved workers when the U.S. Civil War erupts. Directed by David Butler.

Maluala (1979). Directed by Sergio Giral. One of Giral's films about Afrocubans. Centers on life on the *palenques* established by fugitive slaves.

Mandingo (1975). Directed by Richard Fleischer, fiction film set in a U.S. plantation during the nineteenth century. The master prefers a young enslaved woman over his wife; in revenge, the wife has an affair with an enslaved man (played by champion boxer Ken Norton).

Nat Turner: A Troublesome Property (2002). A docudrama showing the enigmatic qualities of the leader of the 1830s slave revolt.

Nightjohn (1996). Directed by Charles Burnett. About an enslaved girl in the U.S. antebellum South, where slaves were forbidden from learning how to read and write, and her tutelage under a rebellious but literate enslaved man.

The North Star (2015). A fiction film based on the story of Big Ben Jones, an enslaved man who escaped from a Virginia plantation in 1848. Directed by Thomas K. Phillips.

Plácido (1986). Directed by Sergio Giral. About a free biracial poet in Cuba during the 1840s who is accused of conspiring to overthrow slavery.

Prince Among Slaves (2006). A PBS historical documentary about Abdulrahman Ibrahim Ibn Sori, a West African prince who was sold into slavery in the U.S. Directed by Andrea Kalin.

Quanto vale ou é por quilo? (2005). Brazilian film directed by Sérgio Bianchi that shows how modern social inequalities in Brazil resemble the era of slavery in that country.

El rancheador (1979). Directed by Sergio Giral. About a brutal nineteenth-century Cuban "rancheador" or slave catcher.

Roots: The Next Generation (1979), and *Roots: The Gift* (1988). The second and third installments of Alex Haley's *Roots* TV miniseries. A "factional" (fact and fiction) rendering of Haley's family, spanning the 1880s to the 1960s. Multiple directors. See *Roots* essay by Robert Norrell in this volume for commentary on these sequels.

Roots (2016). Multiple directors. A made-for-TV remake of the 1977 adaptation of Alex Haley's novel.

Sankofa (1993). A black U.S. model is magically transported from a contemporary fashion shoot at a West African slave fort to enslavement in an antebellum U.S. southern plantation. Directed by Haile Gerima.

Santa Fe Trail (1940). A fiction film about the abolitionist John Brown and his attacks against the institution of slavery. Directed by Michael Curtiz.

The Scalphunters (1968). A Western directed by Sidney Pollack. Burt Lancaster plays an illiterate fur trader who encounters a cultured, Aesop-quoting fugitive slave (Ossie Davis) who claims he is part of the Comanche Tribe. Intriguing reflections on freedom and servitude.

Sinhá Moça (*Little Missy*, 1986; second version produced in 2006). Brazilian TV miniseries set in 1880s. About the daughter of a vehement racist who falls in love with an abolitionist.

Slave Ship (1937). A U.S. fiction film directed by Tay Garnett. About a slave ship captain who falls in love and tries to find a more respectable line of work.

Slavers (1978). West German film directed by Jürgen Goslar. About European slave traders in East Africa competing against each other for lucrative market.

Slaves (1969). A U.S. fiction film directed by Herbert Biberman. Follows the life of two enslaved persons (played by Ossie Davis and Dionne Warwick) in the U.S. South of the 1850s who decide to flee their plantation.

Solomon Northup's Odyssey (1984). Based on the true story of Solomon Northup, a free black man who was sold into slavery during the 1840s. PBS special directed by Gordon Parks.

Souls at Sea (1937). U.S. adventure film directed by Henry Hathaway. Gary Cooper plays an abolitionist who frees enslaved captives aboard a slave ship.

Tamango (1958). Franco-Italian film directed by John Berry, who was blacklisted by Hollywood. About a slave ship on its crossing from Africa to Cuba, the romance between the captain and a mixed-race enslaved woman (played by Dorothy Dandridge), and a slave rebellion during the voyage.

Tropiques amers (2007). French TV miniseries set in late eighteenth-century Martinique. About a plantation owner, his irresponsible wife, and his enslaved mistress.

La última cena (1976). Directed by Tomás Gutiérrez Alea. About a plantation owner in Cuba who uses his enslaved laborers to reenact Christ's Last Supper.

Unchained Memories: Readings from the Slave Narratives (2003). An HBO documentary directed by Ed Bell and Thomas Lennon. Features recreations of interviews conducted with former enslaved persons in the U.S. during the 1930s.

Uncle Tom's Cabin (1903). Directed by Edwin S. Porter. Based on Harriet Beecher Stowe's influential 1852 anti-slavery novel. There have been numerous additional film versions.

Underground (2016). Created by Misha Green and Joe Pokaski. A television mini-series on WGN America depicting a daring escape by enslaved workers from a plantation in antebellum Georgia.

Vivre libre ou mourir (1980). Directed by Christian Lara. Depicts the importance of slavery to the island of Guadeloupe and its history.

West Indies: Les nègres marrons de la liberté (1979). Musical epic directed by Med Hondo. A sweeping historical view of the Atlantic trade in Africans and its aftermath on the African continent and the Caribbean.

Xica da Silva (1976). Directed by Carlos Diegues. In eighteenth-century Brazil, a beautiful enslaved woman uses her sexual allure to get her way in a repressive colonial society.

Yambaó (*Cry of the Bewitched,* 1957). A Mexican-Cuban co-production directed by Alfredo B. Crevenna. Set in 1850s Cuba, a fiction film about a slave-owning family and their relationship with the mysterious, titular enslaved woman.

RUDYARD ALCOCER (PhD Comparative Literature, University of Iowa) is the Forrest and Patsy Shumway Chair of Excellence in Romance Languages and Associate Professor of Spanish and French in the Department of Modern Foreign Languages and Literatures at the University of Tennessee. Alcocer is the author of *Time Travel in the Latin American & Caribbean Imagination: Re-reading History* (Palgrave Macmillan, 2011) and *Narrative Mutations: Discourses of Heredity and Caribbean Literature* (Routledge, 2005). He is also the founding director of the UT Humanities Center's Faculty Seminar on Latin American & Caribbean Studies, and the founding faculty advisor of *Vernacular: New Connections in Language, Literature, & Culture*: UT's graduate journal in the modern languages. His essays, which oftentimes focus on cinema, have appeared in numerous peer-reviewed journals.

DANIEL ARBINO is a visiting assistant professor of English at Tulane University where he specializes in Caribbean and U.S. Latino literatures. He holds a PhD in Latin American Literatures and Cultures from the University of Minnesota and an MA in Hispanic Literature from the University of New Mexico. He has previously published in *PALARA*, *Callaloo*, *Journal of Caribbean Literatures*, *Caribe*, and *Sargasso*. His next project will examine Junot Diaz's short story "Monstro" from a neo-baroque framework.

MAMADOU BADIANE received his PhD in Hispanic studies from The University of Iowa. He is currently an Associate Professor of Spanish at the University of Missouri–Columbia, where he teaches Afro-Caribbean literature and culture. His research focuses mainly on the movements of *Negrismo* and *Négritude*. He also studies the ever-changing nature of Afro-Caribbean cultural identities as manifested in both *Antillanité*, and *Créolité*. Dr. Badiane's previous articles have appeared in *Afro-Hispanic Review*, *Negritud Journal*, *Revista Iberoamericana*, *Revista Cayey*, and *French review etc*. He is the author of *The Changing Face of Afro-Caribbean Cultural Identity: Negrismo and Negritude* (Lanham, MD: Lexington Books, 2010). Dr. Badiane is currently working on a book project entitled *The Return of Rhythm*.

KRISTEN BLOCK (PhD Atlantic and Women's & Gender History, Rutgers University) is Associate Professor of History at the University of Tennessee. Her first

monograph, *Ordinary Lives in the Early Caribbean: Religion, Colonial Competition, and the Politics of Profit* (University of Georgia Press, 2012), was a comparative microhistorical study of Christianity in the early Spanish and British Caribbean, focusing on the lives of marginalized groups in that colonial setting. Her current book project, *Health, Disease, and the Spirit: Religion and the Colonial Body in the Early Caribbean*, explores the ways that Caribbean peoples envisioned the body—its nourishment and the maintenance of healthy integrity, their dialogues about desire and sexuality across racial lines, and the behaviors and substances that people feared would hasten their bodily corruption.

ANNY DOMINIQUE CURTIUS is Associate Professor of Francophone Studies in the Department of French and Italian at the University of Iowa where she is also the Director of the Working Group "Circulating Cultures" at the Obermann Center for Advanced Studies. Her research lies at the crossroads of Francophone Studies, Postcolonial ecology, Comparative Caribbean critical theory and cultural studies, Francophone Indian diasporas of the Caribbean and the Indian Ocean, Sub-Saharan African Cinema, Intangible Cultural Heritage in the Global South, and Traumatic Memory of Slavery in Visual and Performing Arts. In addition to numerous articles, she is the author of *Symbioses d'une mémoire: Manifestations religieuses et littératures de la Caraïbe* (2006). Her second book, in progress, is titled *Dévoiler le camouflage: l'écopoétique caribéenne de Suzanne Césaire.*

DAWN DUKE (PhD Hispanic Languages & Literatures, University of Pittsburgh) is Associate Professor of Spanish & Portuguese and the Director of Africana Studies at the University of Tennessee. She also teaches in UT's Latin American & Caribbean Studies and Cinema Studies programs. Her research focuses on Afro-Latin American Literature with a special interest in women's writings. Her book, *Literary Passion, Ideological Commitment: Toward a Legacy of Afro-Cuban and Afro-Brazilian Women Writers* (2008), proposes a tradition of Afro-Hispanic and Afro-Brazilian women's writings initiated primarily during the nineteenth century and continuing with ever-increasing success into the twenty-first century.

DR. GLADYS M. FRANCIS teaches French and Francophone Studies at Georgia State University where she is also the Director of the South Atlantic Center of the Institute of the Americas through which she coordinates academic research and cultural collaborations between the southeastern region of the United States, the Caribbean, and South America. Her research offers a reading together of the literary, cinematic, and performing arts to arrive at a transregional (trans-Caribbean and transatlantic), trans-genre, and transdisciplinary conversation in

Post/Colonial, Women, Gender, Africana, and Francophone Studies. In addition to numerous articles, she has published two books: *Amour, sexe, genre et trauma dans la Caraïbe Francophone* (2016) and *Odious Caribbean Women: Palpable Aesthetic of Transgression* (2017). Her current works in progress include a book-length on immaterial cultural heritage of the Caribbean, in addition to an edited volume on writer and filmmaker Fabienne Kanor. Dr. Francis has given invited lectures in Africa, the Caribbean, Europe, and North America and is also the recipient of various national and international grants, awards, and fellowships (e.g., two Endowed Chairs in the Humanities, two Outstanding Teaching Awards).

DEXTER GABRIEL is an Assistant Professor of History and Africana Studies at the University of Connecticut. His research interests include the history of bondage, resistance, and freedom in the Black Atlantic, as well as interdisciplinary approaches to slavery within popular culture and media.

NEMESIO GIL completed a doctoral degree in Caribbean studies at the University of Puerto Rico with a second concentration in modern languages. His research interests include the aesthetics of blackness in colonial literature, visual culture in early modern Europe, and the representation of Atlantic slavery in cinema. He has also directed film and theater in San Juan, Puerto Rico.

MIRERZA GONZÁLEZ-VÉLEZ is Professor of Linguistics and Communications, and Acting Dean of Student Affairs in the College of Humanities at the University of Puerto Rico–Río Piedras. Her teaching and research interests focus on the cultural and social role of communication in the articulation of imagined identities. She is especially interested in the cultural and critical aspects of racial formations in Latino media discourse. Her research has appeared in a variety of academic publications, including *The Journal of Communication Inquiry, Political Communication, International Journal of Qualitative Studies in Education*, and *Sargasso*. González-Vélez holds a PhD in Mass Communication and Journalism from the University of Iowa and an MA in Communication and a BA in Journalism from the University of Puerto Rico. She has served as the Director of the English Department and is currently the Assistant Dean for Student Affairs in the College of Humanities.

JANELL HOBSON is an associate professor of Women's, Gender, and Sexuality Studies at the University at Albany, State University of New York. She is the author of *Venus in the Dark: Blackness and Beauty in Popular Culture* (Routledge, 2005, new edition forthcoming in 2018) and *Body as Evidence: Mediating Race, Globalizing Gender* (SUNY Press, 2012). She also writes and blogs for *Ms.*

Magazine, authoring a number of cover stories, including "Beyoncé's Fierce Feminism" (Spring 2013). She also guest-edited a special issue on Harriet Tubman for the peer-reviewed journal *Meridians: feminism, race, transnationalism* (vol. 12, no. 2, 2014). Her area of specialty includes black women's representations in historical and global perspectives.

IGNACIO LÓPEZ-CALVO is Professor of Latin American literature at the University of California, Merced. He is the author of seven books on Latin American and U.S. Latino literature and culture: *Dragons in the Land of the Condor: Tusán Literature and Knowledge in Peru* (Arizona UP, 2014); *The Affinity of the Eye: Writing Nikkei in Peru* (U of Arizona P 2013); *Latino Los Angeles in Film and Fiction: The Cultural Production of Social Anxiety* (U of Arizona P 2011); *Imaging the Chinese in Cuban Literature and Culture* (UP of Florida, 2007); *"Trujillo and God": Literary and Cultural Representations of the Dominican Dictator* (UP of Florida, 2005); *Religión y militarismo en la obra de Marcos Aguinis 1963–2000* (Mellen, 2002); *Written in Exile. Chilean Fiction from 1973–Present* (Routledge, 2001). He has also edited the books *Critical Insights: Roberto Bolaño* (Salem Press, 2015), *Roberto Bolaño, a Less Distant Star: Critical Essays* (Palgrave, 2015), *Magical Realism (Critical Insights)* (Salem Press, 2014), *Peripheral Transmodernities: South-to-South Dialogues between the Luso-Hispanic World and "the Orient"* (Cambridge Scholars Publishing, 2012), *Alternative Orientalisms in Latin America and Beyond* (Cambridge Scholars Publishing, 2007), and *One World Periphery Reads the Other: Knowing the "Oriental" in the Americas and the Iberian Peninsula* (Cambridge Scholars Publishing, 2009), and co-edited *Caminos para la paz: literatura israelí y árabe en castellano* (2008). He is the co-executive director of the academic journal *Transmodernity: Journal of Peripheral Cultural Production of the Luso-Hispanic World.*

ROBERT J. NORRELL holds the Bernadotte Schmitt Chair of Excellence at the University of Tennessee. After earning a BA and PhD at the University of Virginia, Norrell taught at Birmingham-Southern College and the University of Alabama in Tuscaloosa. His 2009 biography, *Up from History: the Life of Booker T. Washington*, was received nationally with acclaim. In 2005 he published a well-reviewed interpretation of U.S. race relations, *The House I Live In: Race in the American Century.* His *Reaping the Whirlwind: The Civil Rights Movement in Tuskegee* won the Robert F. Kennedy Book Award in 1986. He is the author of seven additional books and twenty scholarly articles. His most recent book is a novel, *Eden Rise*, set during the civil rights movement in Alabama.

HALEY OSBORN is a doctoral candidate in the Spanish program of the Modern Foreign Languages and Literatures Department at the University of Tennessee. She holds a master's degree from Loyola University in Chicago and a bachelor's degree from Hanover College. Haley recently served as the founding Editor-in-Chief of her department's graduate-student e-journal, *Vernacular: New Connections in Language, Literature, & Culture*. Additionally, she is an instructor of undergraduate Spanish courses and a Research Assistant. Her research interests are literary, cinematographic, and artistic adaptations in the Americas, meme theory and cultural evolution, trans-Atlantic relations, and identity discourses in the Caribbean.

RACHEL SARAH O'TOOLE is an Associate professor in the Department of History at the University of California, Irvine where she teaches classes on sex & conquest, race & empire, and the Atlantic & Pacific worlds. Her monograph, *Bound Lives: Africans, Indians, and the Making of Race in Colonial Peru*, received the 2013 Latin American Studies Association Peru Section Flora Tristán book prize. With Sherwin Bryant and Ben Vinson III, she co-edited *Africans to Spanish America: Expanding the Diaspora*. She has published articles on the construction of whiteness, masculinity within slavery, African Diaspora identities, indigenous politics, and gender influences on racial constructions.

DR. JULIA C. PAULK is an Associate Professor of Spanish and Director of Latin American Studies at Marquette University in Milwaukee, Wisconsin. Dr. Paulk's areas of research interest are comparative literature of the Americas, antislavery literature, Afro-Hispanic literature and culture, and literature by female authors. She has published articles in these areas in peer-reviewed journals including *Hispánofila, Afro-Hispanic Review, Luso-Brazilian Review, Latin American Literary Review*, and *Revista Hispánica Moderna*. Dr. Paulk's current research focuses on nineteenth-century antislavery literature from Cuba and the United States.

EDWARD R. PIÑUELAS is an Assistant Professor in the Department of English, Comparative Literature, and Linguistics at California State University, Fullerton. He received his PhD in Comparative Literature with a certificate in Critical Theory from the University of California, Irvine, in 2013. Piñuelas's research focuses on the influences of chattel slavery and colonization on historic and contemporary literature and film of the African Diaspora. He is currently working on two projects: *Sonic Blackness: Music, Noise, and Voice in Black Atlantic Literature*, which examines the role of the sonic in contemporary literature of the African Diaspora; and *Vernacular Maps: Figures of Black Space in the Atlantic*,

which focuses on the ways space is figured in contemporary literature and film in the Diaspora, particularly how notions of territoriality are molded by histories of enslavement and colonization. Though these projects are distinct, they share a common interest in locating alternative articulations of race outside the discursive and the ocular.

EMILY ALLEN WILLIAMS is the Chair of the Department of English at Texas Southern University. A Fulbright Scholar with a former residency at the University of the West Indies (Jamaica), she has served as Founding Dean of the School of Arts and Sciences at Paine College. She also has served as Founding Director of the MFA Professional Writing Program at Savannah College of Art and Design-Atlanta Campus and Tenured Professor of English at Morehouse College (Atlanta, Georgia). Williams is the author of *Beyond the Canebrakes: Caribbean Women Writers in Canada* (Africa World Press, 2008); *Changing Currents: Transnational Caribbean Literary and Cultural Criticism* (Africa World Press, 2006); *The Critical Response to Kamau Brathwaite* (Praeger Press, 2004); *Anglophone Caribbean Poetry, 1970–2001: An Annotated Bibliography* (Greenwood Publishing Group, 2002); and *Poetic Negotiations of Identity in the Works of Brathwaite, Harris, Senior and Dabydeen* (Mellen, 1999). Williams is the Founding Editor of *Caribbean Vistas: Critiques of Caribbean Arts and Cultures*, a peer-reviewed online journal. Her essays, interviews, and reviews appear in the journals *Wasafiri, Canadian Literature Review, African American Review, The Caribbean Writer, Journal of African American Men, CLA Journal*, and *Studies in the Literary Imagination*, among others. Williams has been interviewed on a number of international radio forums on Caribbean Literature, and has several forthcoming books (under contract) that focus on the internationally renowned author Kamau Brathwaite, Caribbean Women Writers in Canada, and The Harlem Renaissance.

Abbot, Abiel, 153
Abili, Obi, 252
Alexander, Margaret Walker, 36
Alexander, Michelle, 136
Allen, Debbie, 307
Allen, Marlene, xxviii, xxix
Allende, Fernando, 190–92, 195
Almeida, Pedro, 89
Almendros, Néstor, 5
Amaru, Túpac, 60
American Revolutionary War, 278–79
Anderson, Benedict, 200
Angerona coffee plantation, 150
Anzaldúa, Gloria, 269
Aponte Rebellion, 14, 44
*Autobiography of Miss Jane Pittman,
 The* (novel), xxvi, 30

Baldwin, James, 13, 28
Ballumbrosio family, 67
Bandeirantes, 89, 91–92
Beloved (novel), 138, 262, 274
Bhabha, Homi, 148–49, 242–43
Birth of a Nation, The (1915 film), xxi, 24,
 223, 263
Black Lives Matter movement, 266
Black Loyalists, 278
Blaxpoitation films. *See* slavery films
Boukman, Daniel, 123
Brathwaite, Kamau, 122, 141, 284
Brown, John, 225, 230
Burton, LeVar, xxxi, 32

Césaire, Aimé, 137–38
Chapman, Lía, 147

Chatwin, Bruce, 104–105, 113–14
cimarrones (historical figures), xxxiv, 8–9,
 59, 183
Cinema nôvo, 86–87
Cine Rebelde, 2
Civil Rights Movement, The, 26, 31, 33,
 35, 266
Civil War (U.S.). *See* United States
 South
Clarkson, Thomas, 304
Code noir, 160n11, 207, 219n24
Commission for Promotion of Films
 (COPROCI), 66

Davis, Natalie Zemon, x, xxix, 84, 88, 189
Delgado, Livio, 41, 47, 56
Del Monte tertulia, The, 1–27
DiCaprio, Leonardo, 222
Disney, Walt, xii
Djangoism, 224
Dolezal, Rachel, ix-x
Dominican Republic, xiii, xxiii
Douglass, Frederick, xxv, 169–70, 228,
 264
Dubois, Laurent, 43
Du Bois, W. E. B., 85, 300
DuVernay, Ava, 266

Éboué, Fabrice, 123
Ejiofor, Chiwetel, 263, 273
enslaved persons: and autobiographies,
 xvi, 25, 282; and codes of honor, xxiii,
 228; humanity of, xxx, 10, 104, 149, 170,
 263, 291; and mortality rates, 68. *See
 also* slavery, slavery films

enslavement. *See* slavery
Equiano, Olaudah, 300, 302, 304
Eurocentrism, 83, 85

Fanon, Frantz, 42, 83–84, 139–40, 148
Fassbender, Michael, 266, 268
Ferguson, Leland, 301
Ferrand, Carlos, 59
Foxx, Jamie, 222
Freyre, Gilberto, 304

Gaines, Ernest. See *The Autobiography
of Miss Jane Pittman*
García Espinoza, Julio, 3, 41–42, 56
Gerima, Haile, 123, 264, 299, 308
Gil, Gilberto, 96, 303
Gilroy, Paul, 274
Glissant, Édouard, 242
Glover, Danny, 252
Gone with the Wind (film), 6, 24, 230,
263, 301
Granados, Daysi, 43
Griffith, D. W. See *The Birth of a Nation*
Gutiérrez Alea, Tomás, xxxii, 3, 42, 299
Gutman, Herbert G., 27

Hayre, Carlos, 73
Hill, Lawrence, 277
history: academic disciplines of,
xix, 227; alternate versions of,
227; and archives, 61; constructed-
ness of, 19, 226; and filmmakers'
roles, 1, 226; forgotten histories, 59,
84, 124, 280; and microhistory, 90;
and official history, 2, 59, 85, 125, 198,
256; and pedagogy, xix, 299; and
revisionism, 24; of slavery, xix, 1; and
visual culture, 164, 188; as written by
victors, 193.
See also memory
Hounsou, Djimon, 122
Hudlin, Reginald, 223, 228–29

ICAIC (Instituto Cubano del Arte y
la Industria Cinematográficos), 2–5,
11–14, 41–43, 147, 304
indentured servitude, xiv, 83–84, 280
Indigenous Americans, xiv, 60, 99, 149

Jackson, Samuel L., 234

Kinski, Klaus, 106
Kinte, Kunta, xxvi, xxxi, 25, 301
Kotto, Maka, 122
Ku Klux Klan, 27–28, 34, 163, 227

Lara, Christian, 123
Leinders, Jeroen, 242
Ligon, Richard, 187–88
López, Rigoberto, 150

Mandingo fighting. *See* slavery films
maroons. *See* cimarrones
M'Bala, Gnoan, 123
McDaniel, Hattie, 272–73
McQueen, Steve: xxv, 113, 231, 262, 302
memory, xx, 284: construction of, 201;
counter-memory, 60, 66; and history,
42, 300; and
memorials, 126, 202; postmemory, 123;
public memory, 225, 305; rememory,
124, 262, 288; and trauma, 122, 127. *See
also* history
Middle Passage, xv, 69, 110, 121, 300:
horrors of, 124, 289; and the slave ship,
25, 134. *See also* slavery
Mitchell, Margaret. See *Gone with the
Wind*
Moraga, Cherríe, 269
Moreno Fraginals, Manuel, 304
Morrison, Toni, 138, 246, 262
Mosley, Walter, 122
music, 149, 247, 263, 308: film scores and
soundtracks, xxvii, 14, 73, 89, 185;
musical instruments, 96

Nascimento, Abdias do, 85
neo-slave narrative, xii, 173, 273
N'Gijol, Thomas, 123
Northup, Solomon, xx, 169, 263–70
Nyong'o, Lupita, 267

Obama, Barrack, 264–65
Ortiz, Fernando, 248
Ortiz, Iván Dariel, 180
Ortiz, Iván Gonzalo, 180

palenques, xxiv, 9, 59. See also quilombos
Palmares (Brazil), xxvii, xxxiv, 85, 304. See also palenques, quilombos
Perugorría, Jorge, 147
Pitt, Brad, 265
plantations, xxiii, 246: coffee plantations, 150; as conceptual space, 164; in Hollywood films, 225; horrors of, 183; economy of, 207; sugar plantations, 7, 107
Prager, Brad, 107, 113–15, 117
psychology: and anti-black unconscious, 177–78; of black people, 35; of Caribbean people, 141; damage from enslavement, 69, 127, 216, 300; of race and identity, 45, 139, 208; sadism of masters, 7, 67, 213, 222

quilombos, xxiv, xxxiv, 83, 304. See also palenques, Palmares

race: and postracial societies, 251, 264; and privilege, 8, 13, 61, 174, 253; and racist slurs, 202, 220n28; and whiteness, 48, 72, 192
Reconstruction. See United States South
religion: Candomblé, 95; Catholicism, 10, 49, 75, 93, 150, 247; Santería, 49
Renan, Ernest, 200–201
Ridley, John, 265–66, 270
Rushdy, Ashraf, xii, 288

samba enredos, 98
Sarkozy, Nicolas, 201–2
Savali, Kirsten West, 265–66
Sembène, Ousmane, 123
slavery: brutality of, xxx, 15, 37, 94, 107, 127, 231; inhumanity of, 31, 104, 126, 201, 227; justifications for, 110; market economy of, 169, 190, 211, 268; memorials, 126–27, 143n14, 202; as metaphor, 69, 104, 136; narrative accounts, xii, 26, 165, 226, 264, 282; as "peculiar institution," xxvii, 164, 230, 301. See also Middle Passage, enslaved persons
slavery films: and authenticity, 96, 112, 222; and Blaxpoitation, 222–23, 225, 229, 231; generic character types, 30, 176, 189, 229, 235, 271; depictions of coffle lines, 169, 230, 284; depictions of slave auctions, xxvi, 189, 267; depictions of suicide, 5, 54, 95, 131; Mandingo fighting in, 227, 232, 304; prizes and awards given to, xxv, 157, 180–81, 249, 307; and ticket sales, xxv, 123, 191, 203. See also white savior trope
slaves. See enslaved persons. See also slavery
Souchay, Cornelio, 150
Spaghetti Westerns, 212, 222–25, 229
Spielberg, Steven, 144n18, 229, 236–37, 264, 307
Steketee, Lionel, 123, 199
stereotypes. See slavery films / generic character types
Stowe, Harriet Beecher. See Uncle Tom's Cabin
Suárez y Romero, Anselmo, 1, 5–11, 15

Tarantino, Quentin, 195, 212, 222, 304, 308
Taubira, Christiane, xxxi, 116–17, 126, 202–3

Taubira Law. *See* Christiane Taubira
Taylor, Yuval, xvii
Telemaco, Pedro, 185–86
telenovelas, 191, 195, 305
Third Cinema, 15, 21n21, 60
tidalectics, 122, 137, 141
time travel, 131, 211, 264
trauma. *See* memory

Uncle Tom's Cabin (novel), 13, 27–28, 264
United States South: and Civil War, 27, 29, 189, 226; and honor in white southern society, 229, 239n18; and Reconstruction, 27–29, 164, 226. *See also* Ku Klux Klan

Viceroy of Ouidah, The (novel). *See* Bruce Chatwin
Villaverde, Cirilo, 17, 40

Waltz, Christoph, 222, 229
Washington, Kerry, 222, 231
white savior trope, 113, 243, 265, 305. *See also* slavery films / generic character types
Wilberforce, William, 304, 307
Williams, Seretha, xxviii, xxix
Wolper, David, 30–33
Woodard, Alfre, 231, 268

Xiorro, Marcos, 180

Zumbi dos Palmares, 89